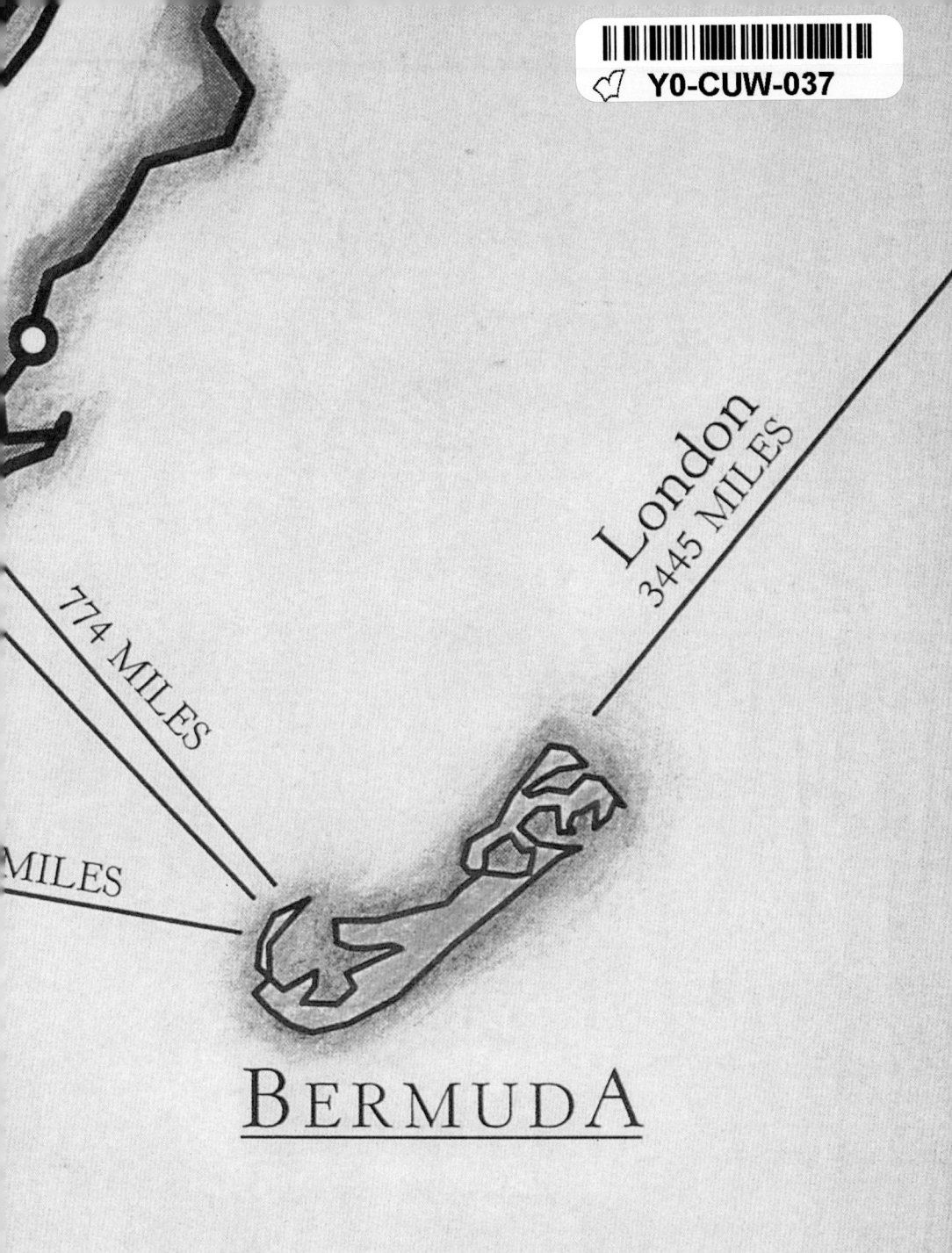

Another World
BERMUDA AND THE RISE OF MODERN TOURISM

Duncan McDowall

CARIBBEAN

For Roy Talbot and in memory of Douglas Stern,
who each in his own way sang Bermuda's praises.

© Copyright text Duncan McDowall 1999
© Copyright illustrations Macmillan Education Ltd 1999

All rights reserved. No reproduction, copy or transmission of
this publication may be made without written permission.

No paragraph of this publication may be reproduced, copied or
transmitted save with written permission or in accordance with
the provisions of the Copyright, Designs and Patents Act 1988,
or under the terms of any licence permitting limited copying issued
by the Copyright Licensing Agency, 90 Tottenham Court Road,
London W1P 9HE.

Any person who does any unauthorised act in relation to this
publication may be liable to criminal prosecution and civil
claims for damages.

First published 1999 by
MACMILLAN EDUCATION LTD
London and Basingstoke
Companies and representatives throughout the world

ISBN 0–333–72753–3

10 9 8 7 6 5 4 3 2 1
08 07 06 05 04 03 02 01 00 99

This book is printed on paper suitable for recycling and
made from fully managed and sustained forest sources.

Typeset by EXPO Holdings, Malaysia

Printed in Hong Kong

A catalogue record for this book is available from the
British Library.

Cover photograph courtesy of Bermuda Maritime Museum

The publishers have made every effort to trace the copyright holders
but if they have inadvertently overlooked any, they will be pleased to
make the necessary arrangements at the first opportunity.

Contents

Bermuda–maps
v

INTRODUCTION: 'Another World'
1

CHAPTER ONE: From 'Pesthole' to 'Juneland':
Bermuda's Place in Nature
7

CHAPTER TWO: Shaping 'Nature's Fairyland'
35

CHAPTER THREE: 'The Yanks are Coming, The Yanks are Coming!'
1914–30
73

CHAPTER FOUR: 'Trippers' and Clippers: Managing Success 1931–40
105

CHAPTER FIVE: '… this pint-sized paradise': Recapturing America
1941–55
141

CHAPTER SIX: Glory Years 1956–80
180

EPILOGUE: '… the still-vex'd Bermoothes'
221

Index
241

ACKNOWLEDGEMENTS

The great Swedish social scientist Gunnar Myrdal once advised his fellow scholars always to reveal their biases at the outset of their work. I do so here. To say that I like Bermuda somewhat understates my bias. I am, in fact, crazy about the place, and since 1976 have visited almost annually. I have come to know its nooks and crannies, to love its habitual 'good mornings' and to cherish its people. This book is therefore an attempt to bring scholarly insight to this lasting personal infatuation, to apply my training as an historian to understanding the appeal of the one place I have come to rely upon to relax the tensions of daily and professional life in my native North America. Why have hundreds of thousands of visitors so easily and so loyally succumbed to Bermuda's charms in the same way as I have?

I must first acknowledge those who introduced me to the delights of Bermuda. My father, a destroyer captain in the Canadian Navy, frequently returned to icy, winter-bound Halifax with tales of Bermuda's civility and warmth. My English godfather, Douglas Stern, wintered in Bermuda while I attended a British public school; his weekly letters opened a window on the Gulf Stream into the gloom of the British winter. It therefore took little insistence on the part of my fiancée, Sandy Campbell, to win me over to the idea of a Bermuda honeymoon in 1976, when I was first introduced to the wit, charm and warmth of Roy Talbot of Bermuda's best-known singing group, the Talbot Brothers. Without these introductions, my holiday ambitions might have turned elsewhere and this book, which Sandy first and always urged me to write, would never have been written.

The research for this book was in large part made possible by my appointment as a Visiting Scholar at Bermuda College in 1995–6. To President George Cook and the staff of the College go my sincere thanks. Similar thanks are due to the College's companion hotel, the ever-friendly Stonington Beach. Bermuda College also opened the way to a wonderful friendship with Dr A.C. Hollis Hallett, its former president. An avid local historian, publisher and living Bermuda encyclopedia, Archie, together with his genealogist wife Keggie, proved that after so many visits Bermuda could still yield pleasant surprises.

When this book was but an inkling in my mind, I was given encouragement to continue by the Bank of Bermuda, which saw the endeavour as valuable for Bermuda as a whole. In particular, Louis K. Mowbray, then the bank's executive vice-president, lent his own love of Bermuda's heritage to my work and the bank's financial backing to my research, especially in the collection of illustrations. More recently, I have been grateful to David Lang for perpetuating the Bank's interest. Bermuda Archivist, John Adams, and his staff made it possible for me to capture the documentary history of Bermuda tourism. Edward Harris, Jack Arnell and Karen Ashbury at the Bermuda Maritime Museum opened the resources of their fine enterprise to me. My thanks also to the staffs of the Bermuda Library, particularly Patrick Burgess, the New York Public Library and the Inter-library Loan at Carleton University Library for helping me assemble the jigsaw of secondary literature about Bermuda's tourism. Charles Barclay of *Bermuda* magazine shared his provocative perspective on Bermuda affairs with me and gave me an outlet for aspects of this research in article form in his lively magazine. Kevin Stevenson of Bermudian Publishing and Rosemary Jones of *The Bermudian* similarly took articles and egged me on.

I am grateful to the following knowledgeable and friendly people for their assistance: David Allen, Brian Archer, Daurene Aubrey, Jackie Aubrey, Alex Barclay, Angela Barry, Jolene Bean, Matthew Bellamy, Walton Brown, Tom Butterfield, Linda Fowle Carroll, Lyndon Clay, Reggie Cooper, Roger and Lee Davidson, the Hon. David Dodwell, Bobby and Nancy Fowle, Joan Fowle, Evelyn James-Barnett, Anna and Mike Jarvis, Liz Jones, Alison Masters, Cyril Packwood, Peter Parker, Diana Peers, Tony Pettit, Gary Phillips, Jocelyn Raymond, Geoff Rothwell, Sandra Rouja, Colin Selley, Al Seymour, Craig Simmons, Brian Smith, Hubert Smith, Peter Smith, the Hon. Yvette Swan, Mary Talbot, Andrew Trimingham, DeForest 'Shorty' Trimingham, Edward Trippe, Gil Tucker, Rodney and Wynette Tucker, Blair Vago, Joan White, the Hon. C.V. 'Jim' Woolridge and Leon Woolridge. A special thank you to W.J. 'Jimmy' Williams, who shared his decades of experience at the Trade Development Board so freely with me. I reflect with sadness that the late Sir Henry Vesey and Harry Cox did not live to see the publication of this book. David Farr in Ottawa lent his keen eye to reading and improving drafts of this book, as did Archie Hallett in Bermuda.

At Macmillan, I want to thank Nick Gillard and Michael Bourne, for their faith in this book, and Ann Goffin, for her prompt and efficient ministering to this author's inquiries.

Few books actually prove fun to write. This one was. That happiness was anchored by the year Sandy, McNab and I spent in 'Edgecombe' cottage overlooking the sea in Paget. We will return.

Duncan McDowall

Bermuda

'... the last surviving relic of Eden'
The Nautical Magazine, London, 1898

BERMUDA IS THE WORLD'S northernmost coral atoll and one of its most isolated inhabited islands. Situated 570 miles east of Cape Hatteras, North Carolina, and 774 miles southeast of New York, Bermuda lies at 32 degrees 18 minutes north latitude and 64 degrees 46 minutes west longitude. A mere speck in the mid-Atlantic, the 'island' is in fact a cluster of approximately 140 islands, seven of which are large enough to provide the principal landmass of 20.5 square miles.

The Bermuda Islands sit atop the pinnacle of a huge submarine seamount formed by a seabed volcanic eruption about 110 million years ago and subsequently pushed to the ocean surface about 34 million years ago. Around this cone of volcanic rock, coral formed, aided by the constant bathing of the new land mass by the warm waters of the Gulf Stream on its journey from the Caribbean to the North Atlantic. While geologists as renowned as Darwin and Agassiz have long debated the exact mechanics of Bermuda's formation, there is little doubt that as coral formed itself into a circular collar around the slopes of the volcanic cone, decaying sediment broke away and collected inside the reef around the cone itself. Over time the action of wind and wave shaped this coral sand into hillocks of aeolian sandstone. Unlike most coral atolls, Bermuda is thus hilly, reaching a maximum height of 260 feet. Between the hillocks, pockets of arable land and marshes appeared; elsewhere the island is covered with a thin layer of sandy soil, usually no deeper than four inches. There are no freshwater streams or lakes and only since the 1920s has the existence of underground cells of potable water been known. Bermuda has no natural resources beyond its abundant sunshine. From the air, Bermuda looks like a fishhook, the grey mass of the coral and its pink beaches contrasting sharply with emerald seas around it. The perimeter reef provides a frothing skirt of white around the entire island and to the north the dark shadows of just submerged coral boiler reefs extend for miles into the Atlantic.

Bermuda is not part of the Caribbean. It is instead a lonely, semi-tropical outpost in the mid-Atlantic, one of the few places on earth not part of a 'region'. Its climate is mild, humid and always without frost. The perpetual warming of the Gulf Stream regulates Bermuda's climate on a highly predictable basis; winter daytime temperatures in February and March average 65 degrees, while summer temperatures between July and September average 82 degrees. There is a daily average of 7.9 hours of sunshine throughout the year, and 60 inches of rain fall on average every year, favouring no particular season. Hurricanes may hit the island between June and November. The winter often brings damp winds; a south wind, Bermudians will invariably tell you, is always the precursor of some wet weather.

Bermuda is Britain's oldest colony. There are traces of early European contact by Portuguese and Spanish mariners in the sixteenth century, but the first irrefutable landfall by Europeans came in 1593 when an English sailor, Henry May, reported his shipwreck there while travelling on a French vessel. In 1609 a hurricane pushed the Virginia-bound *Sea Venture* onto Bermuda's craggy coral and forced the first, albeit involuntary and temporary, settlement of the islands. Before this, the islands were uninhabited. Subsequent colonisation was the product of the mercantilist ambitions of the Bermuda Company, which divided the island into parishes and delivered land ownership into the hands of its London shareholders. The collapse of the Bermuda Company in the late seventeenth century opened the way to Bermuda becoming a crown colony of Britain. Limited self-government was admitted as early as 1620, but full, universal suffrage was not achieved until 1968. The colony is still 'ruled' by Britain, but in reality controls virtually all of its own affairs, relying on a party system to offer Bermudians alternative styles of government. The issue of independence is seldom off Bermuda's political agenda; a national referendum in 1995 nonetheless decisively rejected severing the filial bond with Britain.

In 1991, Bermuda's population was 58 460. Blacks, who were first brought to the island in the 1610s as slaves and subsequently freed in 1834, comprise 60 per cent of this number. The remaining white population includes native-born Bermudians, a significant minority of Portuguese Bermudians (whose roots go back to the mid-nineteenth century when they came as farmers) and a large group of expatriate workers and residents. These expatriates constitute about 40 per cent of Bermuda's white population and live in the colony on a contractual basis without political enfranchisement. Marriage to a Bermudian or long-term residence can result in the winning of Bermuda 'status'. Bermuda society is one of high religious observance, with over thirty denominations holding sway in its midst. As a society, Bermuda enjoys one of the highest standards of living

in the world – literacy, educational attainment, life expectancy and a relative absence of poverty and crime all mark it, as many have remarked, as the 'Switzerland of the Atlantic'. Similarly, Bermuda has a high population density of 3160 per square mile (1991).

In 1815, the capital of the colony was moved from the town of St. George, near the site of the *Sea Venture* misadventure, to the more central settlement of Hamilton. The City of Hamilton, with a population of about 3000, today serves as the colony's principal port and business centre. The towns of St. George and Somerset, in the colony's west end, are the only other centres of commerce. The rest of the colony's population is spread evenly over its nine parishes in a fashion that many have likened to the well-groomed orderliness of the English countryside. Bridges and causeways link all Bermuda's major islands. There is no true wilderness in Bermuda; it is one of the most carefully 'built environments' in the world. 'Everything is so tiny,' an 1892 visitor observed, 'that one seems to be looking at life through the small end of an opera-glass.'[1] A distinctive local architecture, drawing on the abundance of coral stone as a building material and the necessity of collecting rainwater on white-washed roofs, has developed through the centuries. Although the stock of indigenous flora and fauna is surprisingly small, the colony's vegetation has been made resplendent by centuries of man's deliberate and accidental tinkering with nature. Flowers, fruit and colourful shrubbery abound. Situated on the flight path of many of North America's migratory birds, no Bermuda garden is ever without birdsong.

REFERENCE

1. Alice W. Rollins, *From Palm to Glacier: Brazil, Bermuda and Alaska* (New York, 1892), 98.

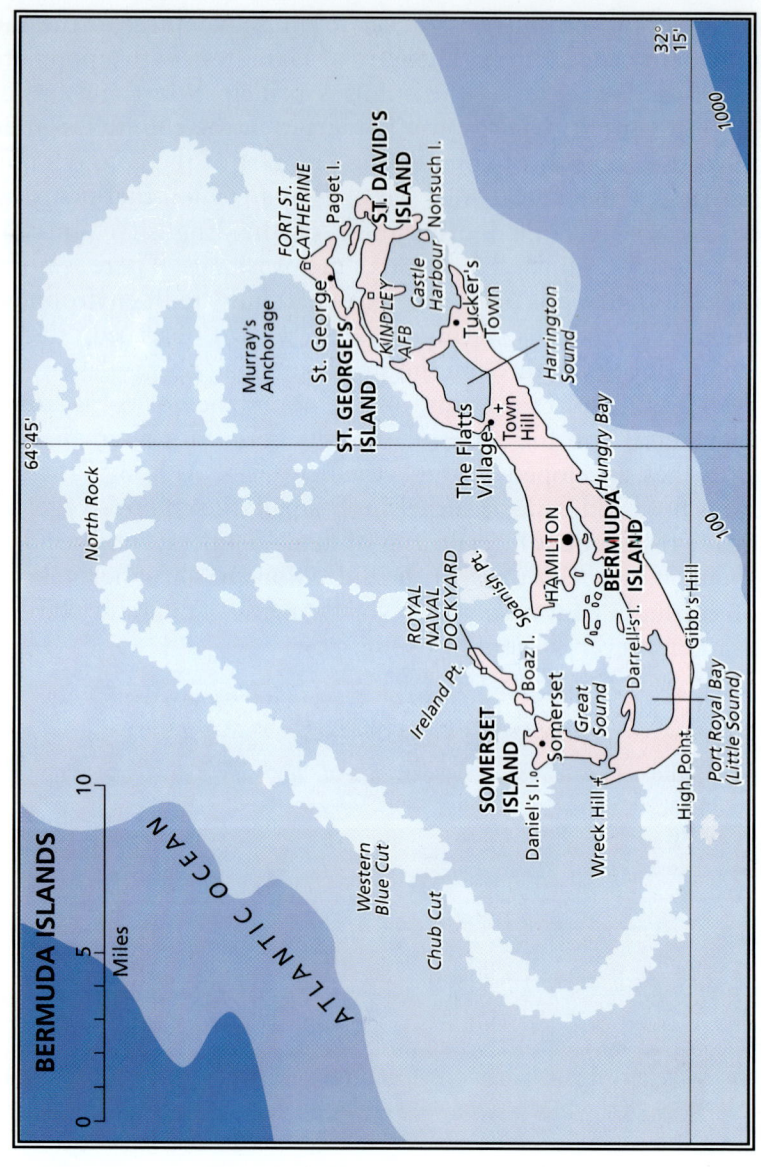

Outline map of Bermuda

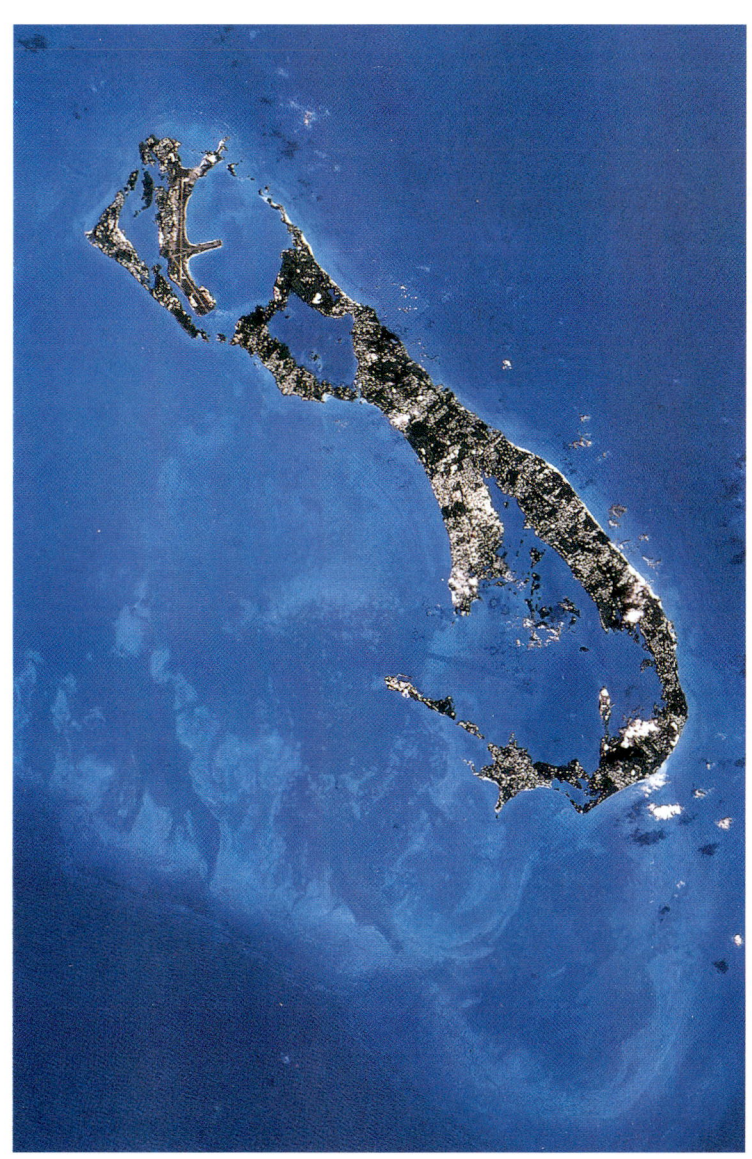

Bermuda from space: 21 square miles of mid-Atlantic coral. (Government Information Services, Bermuda)

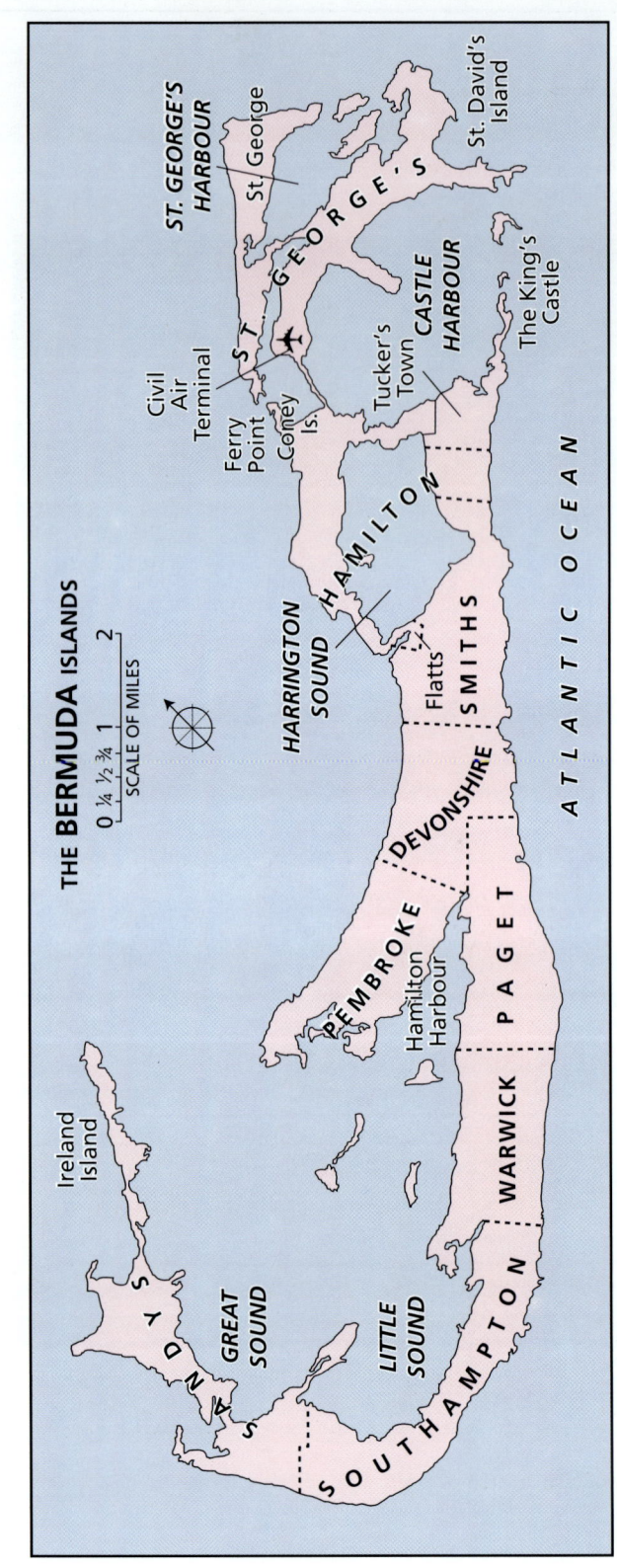

The parishes of Bermuda in the 1960s

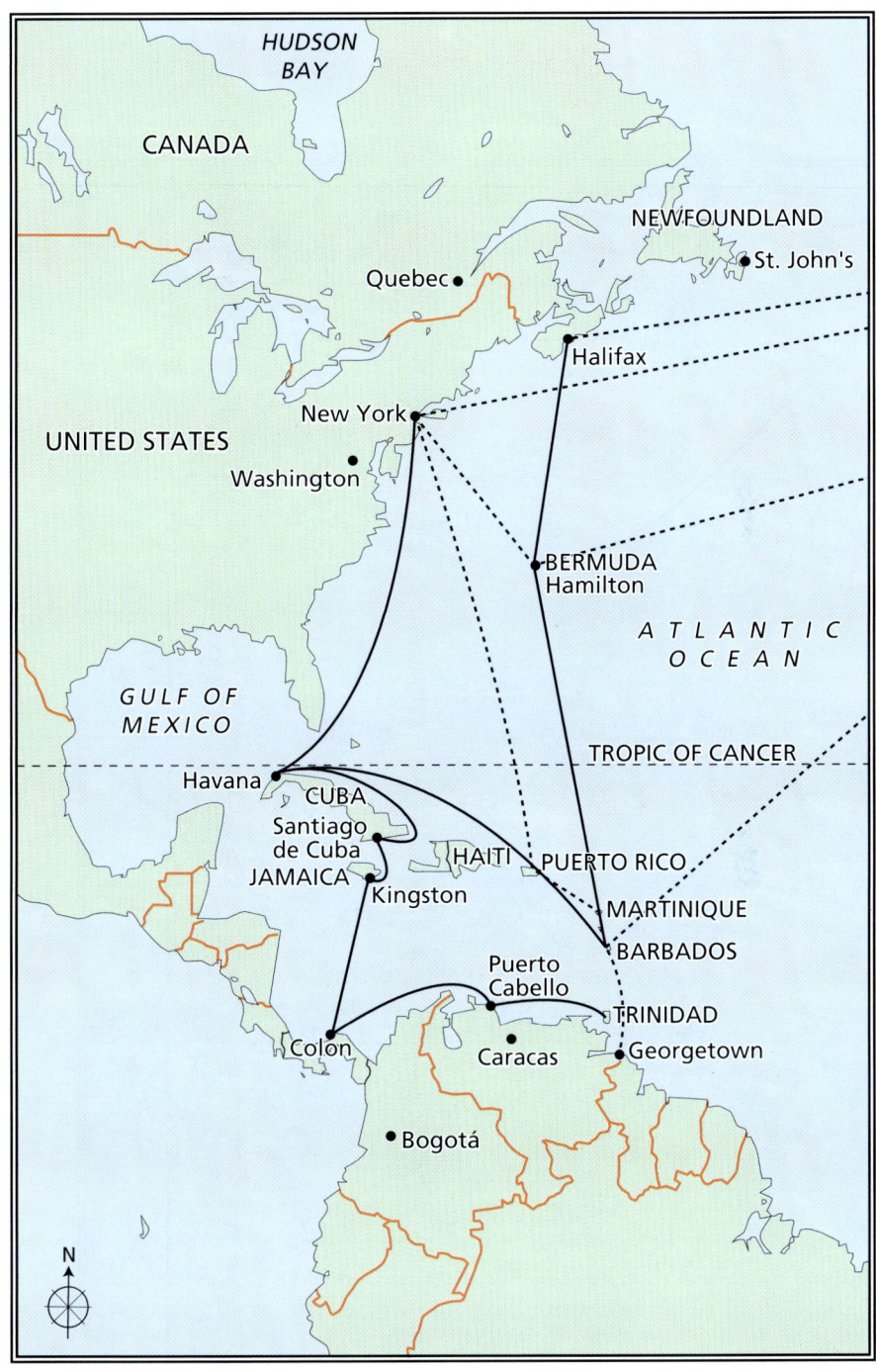

Bermuda – hub of North Atlantic steamship routes

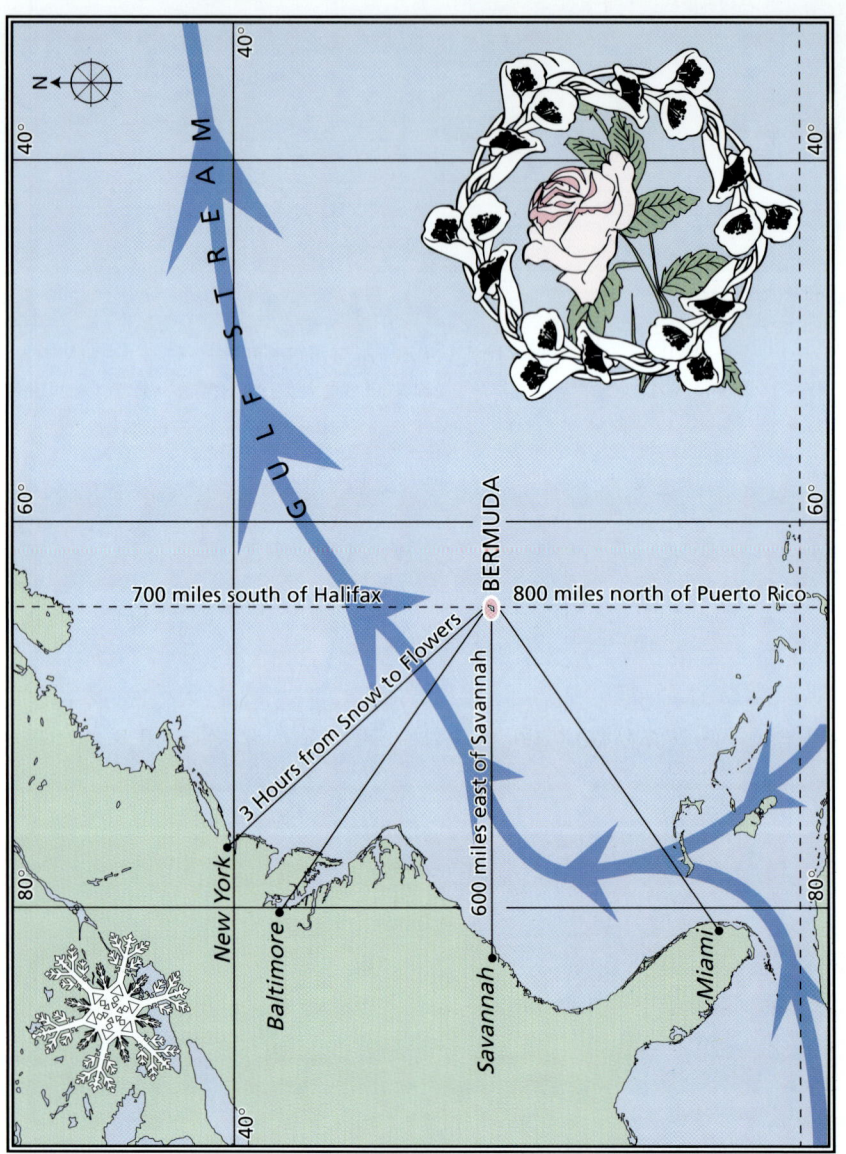

The course of the Gulf Stream between Bermuda and North America

Introduction

'... Bermuda is another world, seven hundred miles at sea.'
Hubert Smith lyrics, c. 1969

From the first glimmering of its tourist appeal in the late nineteenth century, Bermuda has always traded on the sense of being a world apart. Apart from the flood tide of North American hurry and material progress; apart from the erosion of rural tranquillity by urbanisation and industrialisation. In their first clumsy attempts to advertise their warm, mid-Atlantic sunspot, Bermuda merchants chose the slogan 'very unique' to project Bermuda's distinctiveness to its nascent North American market. 'If we scan the busy man in need of a rest and change we counsel his giving Bermuda a trial,' the *Bermuda Almanack* advised in 1897, 'because of its accessibility and its specially unique attractions which the tide of civilization cannot efface.'

The quest for the perfect vehicle for Bermuda's image continued. New slogans – 'The Land of the Lily and the Rose', 'the Isles of Rest' and 'Nature's Fairyland' – soon embellished the plainness of 'very unique'. Aware that tourism advertising was first cousin to modern popular culture, the promoters of Bermuda tourism eagerly enlisted film, gimmickry and music in their quest to project the essence of their island. In 1920, the colony paid the Burton-Holmes Lecture Company of New York $2000 to take the first aerial photos of the colony and to distribute them to North American cinema audiences. A mock Bermuda cottage surrounded by pink Bermuda sand and seashells was constructed at the Canadian National Exhibition in Toronto. Above the cottage, a sign invited Canadians to: 'Come on Over – Isle of Perpetual Summer'.

While colour and exotic artifacts tangibly conveyed the distinctive beauty of the island, the written or sung word seemed to hold more potential for projecting its spiritual qualities. Bermuda's native poets led the way. In the late nineteenth century, Bessie Gray had written in *Scribner's* of Bermuda's appeal as the 'Isles of bloom and balm/ Isles of rose and palm'. With a typical colonial sense of inferiority, Bermuda shunned its native

muses and turned to the motherland for literary inspiration. In 1926, a prize was offered through the London *Daily Express* for the best Bermuda poem. The goal was to generate what the island's colonial secretary described as 'some dignified propaganda' for the 'isles of rest'. A jury headed by an Oxford don waded through the resultant tide of syrupy doggerel. 'Sweet, charmed isle where Ariel did dwell' typified the genre. The winning entry was published in the *Poetry Review* and quickly allowed to fade from memory.

From poetry, the colony turned its attention to music. A Bermuda song became the order of the day. Again and again, the merchants who oversaw the colony's Trade Development Board were required to set aside their administrative responsibility for tourism and become music critics. They did not care for much of what they heard. There was much about 'beaming' tropical moons and 'dusky' Bermuda belles. Mack David's 1936 'Bermuda Buggy Ride' came close with its reminder that automobiles were banished from Bermuda roads. In 1939, the board trooped out of its boardroom to hear a recording of Glenn Miller and his band playing 'How I'd Like to be with You in Bermuda'. Bermuda, they concluded, was not a 'Big Band' type of place.

The quest for a Bermuda song persisted after the war. Ogden Nash, America's beloved poet and satirist, entered the race in 1949 with a song, 'Two in Bermuda', which he had penned with lyricist Vernon Duke. 'The seabirds were soaring, and the sunset was pouring like wine on the foam, the little pink houses where happiness drowses were calling us home', it ran. As late as 1965, Nash was pushing the song on Bermudian officials, arguing that it 'would certainly help you and your colleagues in your objective'. Perhaps Nash's reputation for flippancy undermined the song's chances, but it never received official sanction.

Finally, in 1969, Bermuda found what it wanted. Each fall, the tourism board despatched an elaborate dog and pony show to eastern North America to woo travel agents. Slides, music, sales pitches and cocktails were laid on in innumerable hotels from New York to Buffalo. Each year a theme – 'There's only one Bermuda', for instance – was chosen. For years the task of carrying this theme had fallen to Hubert Smith, a black Bermudian musician who was director of entertainment at the famous Hamilton Princess Hotel. Some weeks before the tour's 1969 debut, the colony's director of tourism, Jimmy Williams, phoned Smith to suggest that the theme that year would be that Bermuda was a 'different place'. Smith thought the idea was prosaic. How about, he countered, 'Bermuda is another world'? Williams liked it. Within days Smith had supplied lyrics and a lilting melody. 'Bermuda is another world,/ Turn around and you'll be gone,/ There will always be a memory that will linger on.' The song was an instant success at home and on the road. Smith sang it on the US

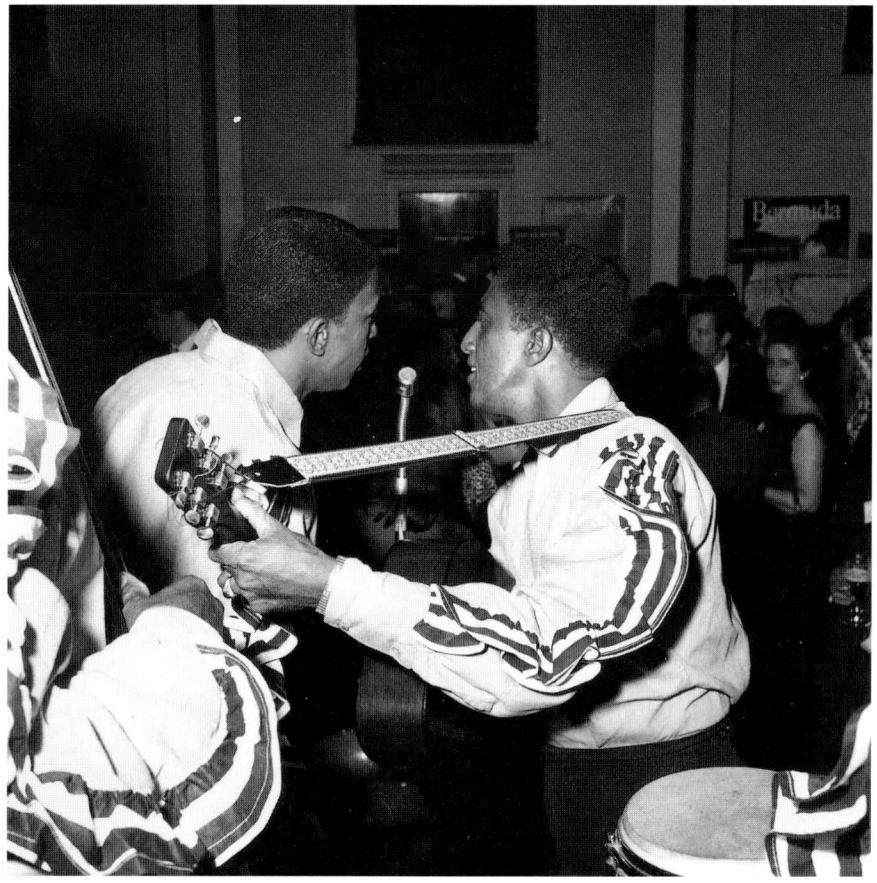

Hubert Smith and his Coral Islanders entertain American travel agents c. 1970. Bermuda's annual delegation to the east coast included hotel managers and officials of tourism, airline and shipping companies. Bermuda shorts, rum swizzles, and Hubert Smith singing 'Another World' were the order of the day. (Bermuda Archives: Bermuda News Bureau Collection)

talk show circuit. To this day, it has served as a kind of unofficial national anthem for Bermudians. Above all else, it reminds them that for over a century millions of tourists have found something 'very unique' in their little country.

Of all the twentieth century's children, tourism has proved the most exuberant. When the century dawned, travel was still largely the preserve of the affluent classes who wandered the beaten paths of Europe and North America. In the fading years of this century, tourism has extended its reach to every continent and every class. What began with the measured elegance of the eighteenth century Grand Tour has become in the twentieth century a global phenomenon barely checked by depression and war and ever flourishing on improving technology and international prosperity.

Tourism is now the largest segment of the world economy, pulling in its wake the production of goods and services as varied as Airbuses and advertising. Like any economic phenomenon, tourism has begotten its own specialised jargon. The World Tourism Organization in Madrid reports that 'world international arrivals' – quite simply, tourists arriving in holiday lands other than their own – now top half a billion arrivals a year and are growing at a healthy six to seven per cent annually. Moreover, this figure does not even include holiday trips taken within one's own country. The global economic impact of all this travel is reckoned to be an astonishing US$300 billion annually.

One of the most isolated inhabited islands in the world, the tiny Crown Colony of Bermuda is by most measures an insignificant factor in this huge tourist explosion. Through the early 1990s it has annually welcomed between 500 000 and 600 000 tourists into its midst, an annual volume that numbered 589 855 in 1994. An all-time record of 631 314 was set in 1987. Bermuda's tourism is thus but a thin sliver of the cake of international tourism. But, as Hubert Smith's lyrics suggest, it is a very delectable slice for several important reasons.

Bermudian tourism's distinctiveness begins with its pioneering role in island resort tourism. No other destination has for so long or so consistently and aggressively offered itself as an island get-away. Since the late nineteenth century, Bermuda has set the mark for island tourism. It has never been shy in boasting about this fact. When one of the colony's arch tourism promoters, Joseph Outerbridge, addressed the convention of the Canadian Tourism Association at Niagara Falls in 1952, he was quick to let his nationalism show: 'The Bermudas are the world's most famous "Island Resort" bar none and that is not a "commercial" but simply a statement of fact'. 'We were,' a Bermuda tourist official today boasts, 'the only game in town.' In the 1950s and 1960s, it was to Bermuda that other islands like Hawaii and Jamaica sent their people to learn the tricks of the trade.

From its modern inception in the years just before World War One, Bermuda has consciously developed its role as the trend-setting island resort with remarkable single-mindedness. No matter what the decade, the strategy has invariably been the same. In 1943, one of the colony's wartime politicians, John (later Sir John) Cox, captured the essence of the strategy: Bermuda's goal was 'to appeal to the better class of tourist trade. People with good taste who would appreciate the charm and simple pleasures that the islands had to offer. By attempting to attract the highest type of visitor the demoralizing effects of the trade were to some extent mitigated'.

Like most strategies devised by Bermuda's wily commercial elite, Bermuda's dedication to carriage-trade tourism is rooted in canny intuition about the island's strengths and limitations. A mere twenty-one miles square, Bermuda needs just the 'right' kind of tourist in order to thrive and

yet maintain its social and political stability. In Bermuda, **quality** has always won out over *quantity* in matters of tourism. Today – with one of the highest population densities in the world – Bermuda's 60 000 residents manage each year to share their living space with almost 600 000 visitors – a stunning ratio of 1:10. As a consequence, tourism has been the workhorse of the Bermuda economy, regularly contributing as much as 42 per cent of gross domestic product. In 1994, visitors spent $524 million in Bermuda; 'hotels and restaurants' represent the largest category of employment in the colony. Many more indirectly derive their livelihood from tourism. Only recently has 'off-shore' business, another high-value service industry deliberately groomed in Bermuda by its commercial elite, begun to challenge tourism's supremacy. Ironically, Bermuda's appeal as a place for off-shore reinsurance and tax-exempt corporate operations rests on a set of 'unique' values similar to those on which its tourism has so long relied: the colony is stable, safe and detached from North America.

Bermuda's ability to preserve its lucrative tourist niche reflects the triumph of a set of aesthetic values which have constituted the core of the island's appeal to tourists. These too have been the product of an adroit blending of natural endowment and deliberate cultivation. The Trade Development Board, tourism's principal overseer from 1913 to 1968, was never in doubt about its aesthetic mission: 'The type of people Bermuda would wish to attract were those to whom the natural beauty and charm of the Islands would appeal and every effort should be made to enhance this natural beauty and make the colony as attractive as possible'. Bermuda was to be the 'Isles of Rest'. It offered – in the words of DeForest 'Shorty' Trimingham, its tourism minister in the early 1970s – 'a sweetness, a scale and a charm' that very few places could rival. The preservation and the grooming of this aesthetic was both a goal and a legitimiser. In the words of a 1943 government report, the island was never intended to be a place of 'elaborate and hectic amusements' but a place of unsullied 'natural attractions … [of] sunshine, mild climate, sea, beaches, colour, general charm, romance, foreign atmosphere, tranquillity and opportunity for rest and relaxation'. By recognising and enhancing these intrinsic values, Bermuda has been able to build a distinctive image in the mind of its prime market – the affluent urban belt of east coast America – as a retreat from modernity and its attendant pressures. 'You liked Bermuda the way it was,' promised one of the island's advertisements in the 1970s, 'So that's the way it is.'

Bermuda thus offers a compelling case study of a meticulously groomed tourism industry; a near-perfect marriage of commercial purpose and natural opportunity. The fruitfulness of this union has emerged out of mutual recognition by tourist and colony alike of a core of durable aesthetic values which have been dominant throughout the colony's

twentieth-century existence. Today, however, there is talk of problems in paradise. Bermuda tourism is said to be 'in trouble'. Arrivals are down; competition is up. Bermudians are debating the price of maintaining the 'uniqueness' that has always served their tourism so well. Should American franchise operations like McDonald's be allowed to enter the colony? Is there a place for casinos in the 'isles of rest'? Can crime and traffic be controlled? Such questions are not new. In 1952, an article in *House and Garden* pinpointed '... the Bermudian's dilemma of having to entice vacationers to their islands, while trying to keep their 22 square miles of *lebensraum* bearable for themselves'. Today, the editorial columns of the *Royal Gazette* frequently slip into a nostalgic reverie about the 'glory years' of Bermuda tourism, when tourist and Bermudian were in perfect sync and a holiday in Bermuda was synonymous with detached mid-Atlantic elegance and sophistication. Now a Bermuda holiday is as likely to be measured in terms of cost, entertainment and service, not just its uniqueness.

Like so much nostalgic musing, such talk of the 'glory years' tends to overlook the effort and constant management that went into the century-long making of Bermuda tourism. This book is about that effort and its glorious rewards. There certainly were glory years – between 1920 and 1939 and then spectacularly again through the 'baby boom' down to the late 1980s. Before that, however, Bermuda's benevolent aesthetic of charm and tranquillity had to struggle for ascendancy throughout the nineteenth century. Opposed to it was a persistent belief that Bermuda had little to offer but pestilence and insecurity to both inhabitant and visitor alike. The resultant creative tension between the perception of Bermuda as an unhealthy, menacing mid-Atlantic reef and a growing belief in its salubriousness and tranquillity is thus at the heart of understanding the ultimate success of Bermuda as the 'isles of rest'. Our journey to 'another world' thus begins in the summers of 1828 and 1829 with the starkly opposed reactions of two early visitors to the colony.

CHAPTER ONE

From 'Pesthole' to 'Juneland': Bermuda's Place in Nature

'Besides the visitations of yellow fever, which on an average occur every seven years, typhoid is always hanging about.'
 Richard Dashwood, XV Regiment, 1868–9

'Bermuda is better than four or five or six million doctors ... the best climate in the world.'
 Mark Twain, 1908

CRUISING OFF RIO DE JANEIRO on HMS *Tribune* in late 1828, a young British naval officer wrote home to his father with news of his travels in the service of the Crown. In August, the *Tribune* had brought Featherstone Osler to Britain's mid-Atlantic colony of Bermuda. He had not been impressed. Despite the colony's rising importance as a naval bastion in the western hemisphere, Osler had found it a 'miserable hole, which is chiefly populated by convicts'. From seaward, the colony had a 'deceitful appearance' which disguised 'sunken rocks of the most dangerous description ...'. Once ashore, Osler found reason for further dismay. An initial appearance of fertility gave way to the reality of agriculture which could not support 'one twentieth of the inhabitants'. There were 'musquetoes ... almost as thick as bees'. Almost as plentiful were the convicts, transported from the slums of England to build the colony's fortifications and housed in sinister hulks anchored off-shore. Dinner in the colonial capital of Hamilton consisted of 'starved fowl and a little ham and eggs ...'. Everything was 'an exorbitant price'. Had Osler recalled his Shakespeare he would undoubtedly have trotted out the image of 'the still-vex'd Bermoothes'; virtually every other Bermuda visitor in the nineteenth century did.[1]

In the summer after the *Tribune's* ill-starred visit, the colony received another visitor who was to see Bermuda in a different light. In July 1829, a young Englishwoman, Susette Lloyd, arrived in the colony, attached to the family of Archdeacon George Spencer. She too saw the 'dangerous reefs', but she reported that once inside St. George's harbour 'the romantic beauties of this isle-girt harbour burst upon our sight in all their peculiar

loveliness'. She too detested the mosquitos as 'ravenous tormentors' which she swatted away with an oleander bough, but she also 'rambled' the colony's roads and visited Mr Trott's 'curious and beautiful natural fishpond' on Harrington Sound. Lloyd pondered the mysteries of Bermuda's coral reefs and how they reflected Lyell's *Principles of Geology*. Bermuda's negroes she found 'kind-hearted' and capable of the uplift which she confidently believed that emancipation would soon bring to them. She ate their cassava pie and watched their gombey dances. When Lloyd left the colony in 1831, she carried with her 'serene and happy thoughts' and remembered Bermuda as 'a green spot in memory's waste'.[2]

Neither Osler nor Lloyd were tourists in the modern sense. Neither had travelled for pleasure. Each encountered Bermuda out of duty; one as a naval officer, the other as a governess. In the nineteenth century, few possessed the time or the wherewithal to explore the world for reasons of either unalloyed curiosity or pleasure. Those who could were drawn to the sights of 'civilization' in Europe or to the cities of the new world. The primitive colony of Bermuda would have aroused little fascination. Its 'tourists' were instead visitors obliged to sojourn there: soldiers, clergy, seafarers and colonial officials in whose peripheral vision the colony first began building an external image. What they saw in the early nineteenth century was a primitive outpost of empire. Its only importance was as part of an Imperial shield that extended from Halifax in the north to the Caribbean in the south, giving Britain a perimeter defence around the newly-independent American republic. In the Napoleonic Wars, Bermudians had capitalised on this strategic position and, having fashioned small sturdy brigs out of local cedar, set sail on the high seas as privateers. Napoleon's demise took the lavish profit out of such adventure. By the time Osler and Lloyd appeared in the 1820s, the colony's maritime trade was declining, its agriculture rudimentary and the British military its only mainstay. Throughout the first half of the century, Bermuda – 'the Gibraltar of the West' – thus existed only as a creature of empire.

Against this backdrop, Osler and Lloyd offer two starkly opposed perceptions of early nineteenth-century Bermuda, one construct essentially malevolent and the other benevolent. Throughout the century, these images would contend for supremacy over the way that outsiders viewed Bermuda. The battle would be played out on various fields: in published memoirs, in periodical literature and in the public imagery lent to Bermuda by the presence and reaction of prominent visitors to the colony. Visual imagery would also join the fray as painters, sketchers and engravers portrayed Bermuda to the outside world. Only at the end of the century would the benevolent view triumph, allowing Bermuda to project its compelling image as the 'isles of rest' to the outside world. In the interim, a

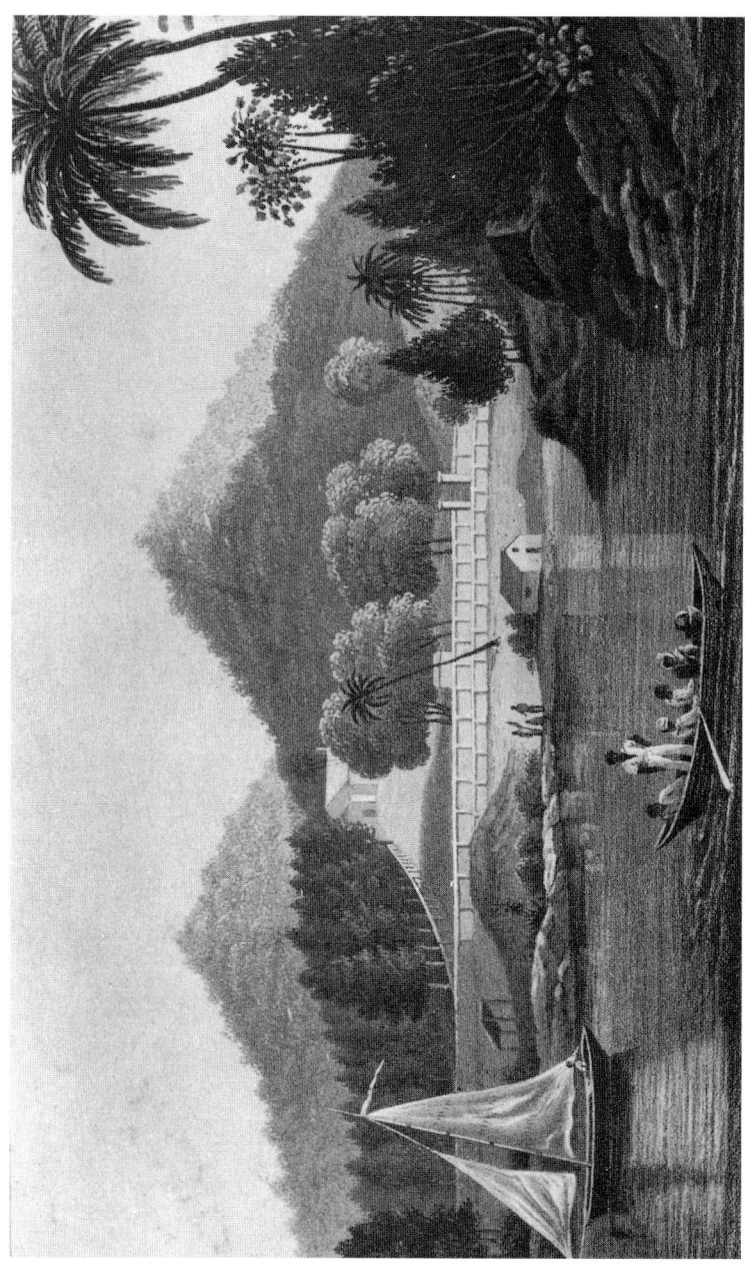

A plate from Susette Lloyd's 1835 *Sketches of Bermuda*, showing Paynter's Vale on Harrington Sound. Lloyd's infatuation with Bermuda is revealed in the liberties she took with the landscape – majestic palms and verdant scenery presented the colony as a paradise. Many others, however, saw it as a semi-tropical hellhole. (*Sketches of Bermuda*, Susette H. Lloyd, London, 1835)

mixed message was transmitted. Early in the century, disease, distance and disaster conspired to give the doomsayers the upper hand.

Since their first contact with Bermuda in the sixteenth century, Europeans had seen the island as an oddity. As a fragile coral outcrop sitting on a volcanic cone, it defied their geographical and geological knowledge. The sea around it might have been warm but it was also capricious; the coral, for all its beauty, was jagged and unforgiving. Europeans brought to the New World a predisposition to distrust the sea which was deeply embedded in their culture. The French intellectual historian Alain Corbin has noted that in classical times the sea 'inspired a deep sense of repulsion … Its roaring, its moaning, its sudden bursts of anger were perceived as so many reminders of the sins of the first humans, doomed to be engulfed by the waves …'. Most authorities believed that there was no sea in paradise. The ocean was what remained of the Flood that had engulfed man and his sins. It was a 'a watery monsters' den' from which misfortune issued.[3] The practical consequence of these perceptions was that in matters of pleasure Europeans stayed away from the sea; only commerce and religion reluctantly lured them into boats.

Only cautiously did Europeans approach the water. By the late sixteenth century, they began to seek out inland spas where they could recover their health. In Britain, southern towns like Bath and Tunbridge Wells attracted wealthy patrons and under the guidance of developers like Richard Nash acquired a social kudos that made them the first tourist destinations in the British Isles. When, for instance, Queen Anne 'took the waters' at Bath in 1702, the town's reputation was made. By the early eighteenth century, attention was slowly shifting to the seashore, where once again the combined lure of therapy – salt water healed – and social status broke down the phobia against the sea. Towns like Brighton and Margate flourished and by the early nineteenth century the lure of the sea was being felt by Britain's middle and working classes.[4] There is broad agreement that the beginnings of modern tourism can be dated to the marriage of the seashore and the early railways. In the 1840s Thomas Cook's cheap, one-day excursions to the sea offered the English worker his first taste of modern 'get-away' travel.[5] As usual, the British upper classes were one step ahead of the masses, having leapt the choppy Channel in the previous century to enjoy the delights of the Grand Tour. On the shores of the Mediterranean, they sought both culture and health.[6] The ocean, at least along the European littoral, had ceased to exercise its terrors. But rocky Bermuda in the lonely mid-Atlantic did not fit this pattern.

For one thing, the sea exercised its tyranny much longer in Bermuda. The first European visitors to Bermuda in the late sixteenth century all remarked on the terrible conspiracy of climate and geology that confronted them. In 1593, Henry May, an English merchant adventurer

stranded on Bermuda's reefs through the negligence of a drunken French crew, reported that he saw 'hie cliffs' surrounding a place 'subjiect to foule weather, as thundering lightning and raine'. Only once ashore did he moderate his opinion. Two years later Walter Raleigh described the 'Bermudas [as] a hellish sea for thunder, lightning and stormes'. The French explorer Samuel de Champlain sailed by in 1600 and similarly found that 'the sea is very tempestuous round the said Island and the waves as high as mountains'. Champlain found the island drenched in rain and witnessed 'thunder so often that it seems as if heaven and earth were about to come together'.[7]

The misfortunes of Virginia-bound Sir George Somers in 1609 on Bermuda's reefs are one episode of Bermuda history that requires no retelling, except to note that the news of the wreck of the *Sea Venture* when transmitted back to Europe simply reinforced the negative albeit sketchy

Bermuda's coat of arms captures the early belief that the colony was at the mercy of Nature. The *Sea Venture* is depicted as being dashed against a cliff; in reality it foundered on a reef. This notion of the 'Bermoothes' as a storm-wracked isle coloured European perceptions of the colony in the seventeenth and eighteenth centuries. (Government Information Services, Bermuda)

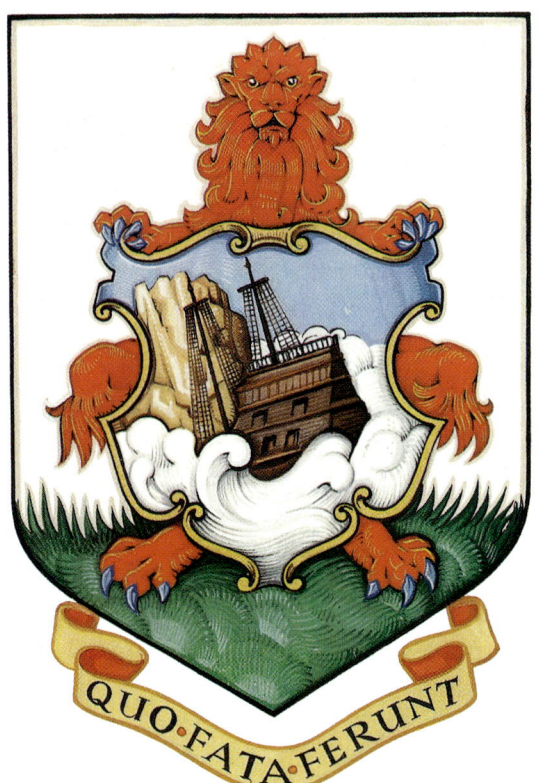

image of Bermuda. To this day, Bermuda's motto – *Quo Fata Ferunt/ Whither the Fates Carry Us* – seems to reinforce this tempestuous image. Silvester Jourdain's 1610 account of Somers' stranding talked of 'a most dreadful Tempest' offshore. William Strachey's account conveyed the impression of 'an hell of darkness … the dangerous and dreaded island, or rather islands, of the Bermudas …'. Both remarked on what was to become a distinctive Bermuda fear – 'the terrible cries and murmurs of the winds' cutting across the crevices of the coral.[8] To this day, the notion of 'deliverance' is central to Bermudian national mythology.

The progress of these vague threatening images from the rocks of Bermuda to Shakespeare's writing of *The Tempest* is the oldest bromide of Bermuda history. It is true that Shakespeare was personally acquainted with several of the investors in the Virginia Company and it is more than likely that he was aware of the accounts of Jourdain and May. But, as the great Shakespearean critic Frank Kermode has pointed out, the play was constructed out of a whole set of sensibilities about the New World. The play was certainly not set in Bermuda, since Prospero sends Ariel *to* the 'Bermoothes' to fetch the famous dew. Indeed, Kermode speculates that Shakespeare may have imagined the storm-swept island in the Old World – possibly in the Mediterranean. The playwright was clearly therefore drawing on the climate of opinion of the time and the general fascination with the New World and its mysteries. Nonetheless, two powerful images of Bermuda settled in the popular imagination in the wake of *The Tempest*'s first staging about 1611 and the play's publication in 1623. Both images are hellish. The famous image of the 'still-vex'd Bermoothes' reinforced the idea that the island was perpetually racked by malevolent nature. And Ariel's discovery that 'Hell is empty, And all the devils are here' was to tar Bermuda as an 'Isle of Devils' for centuries. The added presence ashore of Caliban – that 'salvage [savage] and deformed slave' – did not help matters.[9]

Through the next three centuries, the belief that Bermuda was a menacing place enjoyed continued currency. The 1797 edition of the *Encyclopedia Britannica* noted that it was 'universally agreed' that conditions in Bermuda had 'undergone a surprising alteration for the worse since they were first discovered'. The air was 'inclement', the soil 'barren', the water 'brackish' and the thunder 'dreadful'. The learned book concluded that 'the state of the Bermudas must daily grow worse and worse'. Few missed the message. As late as 1898, Rudyard Kipling wrote in *The Spectator* of 'the fantastic ill-esteem which Bermuda was held in early English verse'.[10] To the image of jagged rocks and vile devils was added the experience of some of those who actually persevered ashore in the colony or visited its shores. Elements of climate, disease, hunger and misfortune were added to the stereotype. Here only a sampling can be presented, perhaps at the risk of creating the impression of false coherence. The intent instead is to convey a sense that

the eventual triumph of the aesthetic of healthful serenity was by no means preordained in Bermuda.

Probably the most consistently sour group of visitors to Bermuda throughout the eighteenth and nineteenth centuries were the British military. They cannot be presented as proto-tourists, in that they were posted to the colony: they did not choose to come. Nonetheless, their reactions to the colony and their proclivity to take pen in hand meant that the views of the military had a profound effect on how others came to regard Bermuda. Military duty in the colony – often entailing the guarding of convicts – was arduous. Heat, rigid discipline and horrible epidemics of typhoid and yellow fever undoubtedly poisoned many a soldier or sailor on the Bermuda station. In 1829, one naval observer, Richard Cotter, who was – atypically – well disposed to the colony, decried 'the fashion among the officers of the various branches of the public service to ridicule Bermudians', even after partaking of the colonists' hospitality. The 'young naval punsters' had little flattering to say about Bermuda.[11] Perhaps the 'best' example of such defilement came from the pen of Richard Lewes Dashwood, an officer in the XV Regiment who served in the colony in the late 1860s. In his 1872 memoirs he seldom missed a chance to denigrate Bermuda. He was posted to the colony from the garrison in Halifax, which he 'wistfully' left behind as the 'abode of the moose, the caribou and the beaver'. Bermuda was but 'a bunch of rocks', the home of 'centipede, cockroach and jigger'.[12] With some justification, Dashwood focused on the ravages of the 1864 yellow fever epidemic in the colony. From 1860 to 1867, troops stationed in Bermuda had the highest mortality rate of 'any station in the globe where white troops are quartered, with the exception of China'. The 'dread pestilence' had seen soldiers 'buried like a dog without a coffin' and left the floorboards of the officers' mess indelibly stained by the victims' black vomit.

Few matched Dashwood's extreme animus against Bermuda. But there were other sceptics. In 1857, another field officer, Ferdinand Whittingham, published his recollections of an eighteen month stint in the colony under the derogatory title of *Bermuda: A Colony, A Fortress and a Prison*. Unlike Dashwood, Whittingham could at least see the colony's potential for tourism. The problem was local indolence: '… if nature has done much for Bermuda it has derived very little assistance from art'. Another military memoir of the colony, N.B. Dennys' 1862 *An Account of the Cruise of the St. George*, concluded with the unkind observation that all on board 'were glad to see the shores of St. George's Island astern' when they sailed for home.[13]

Other colonial officials often joined the dyspeptic chorus. By the mid-nineteenth century Bermuda's critics played on the strange juxtaposition between its inhospitable terrain and the indolence of its colonists. In

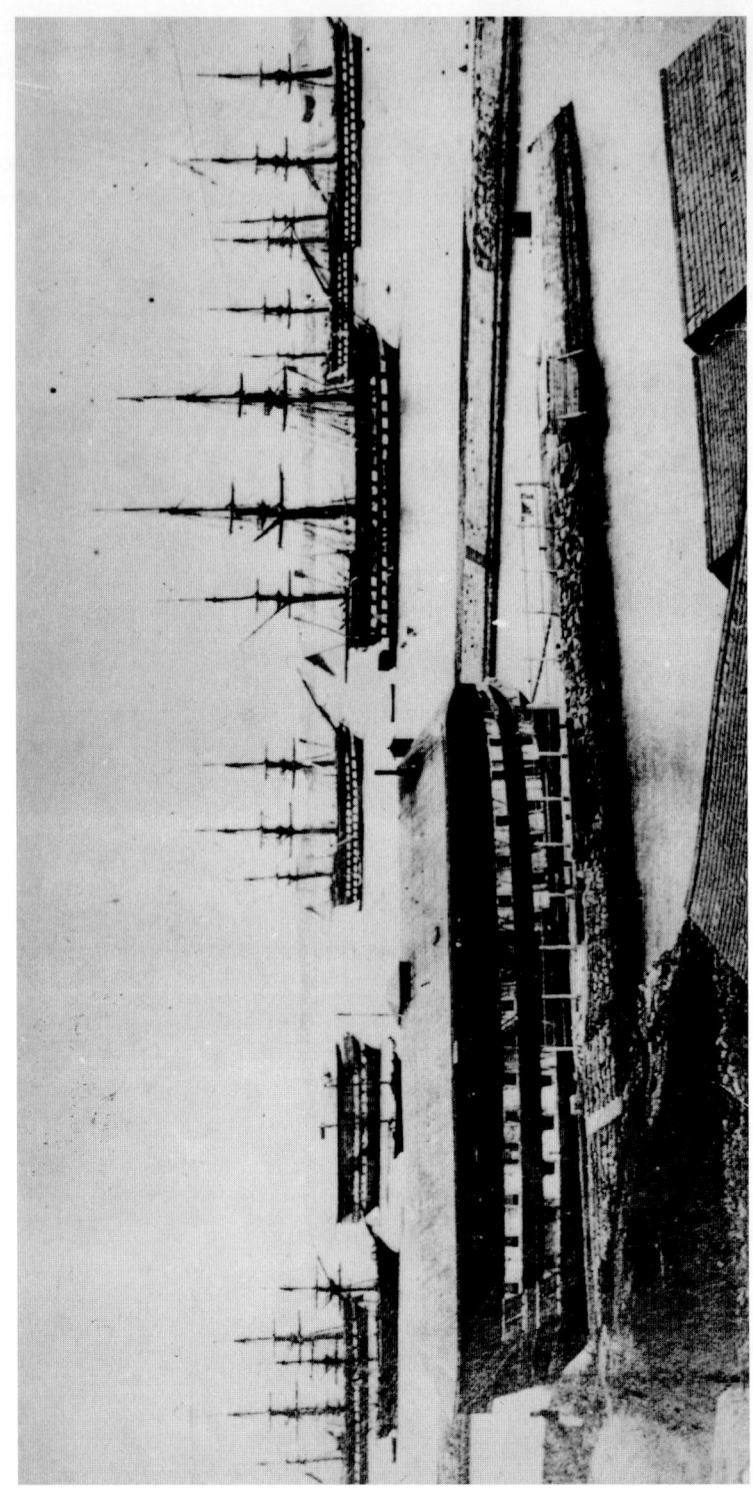

Convict hulks in the mid-nineteenth century. The floating colony of English convicts exiled to Bermuda to build its naval fortifications became a powerful and unflattering image of the colony in outside eyes. Transportation of criminals to Bermuda ended in the 1860s. (Bermuda Archives: Bermuda Historical Society Collection)

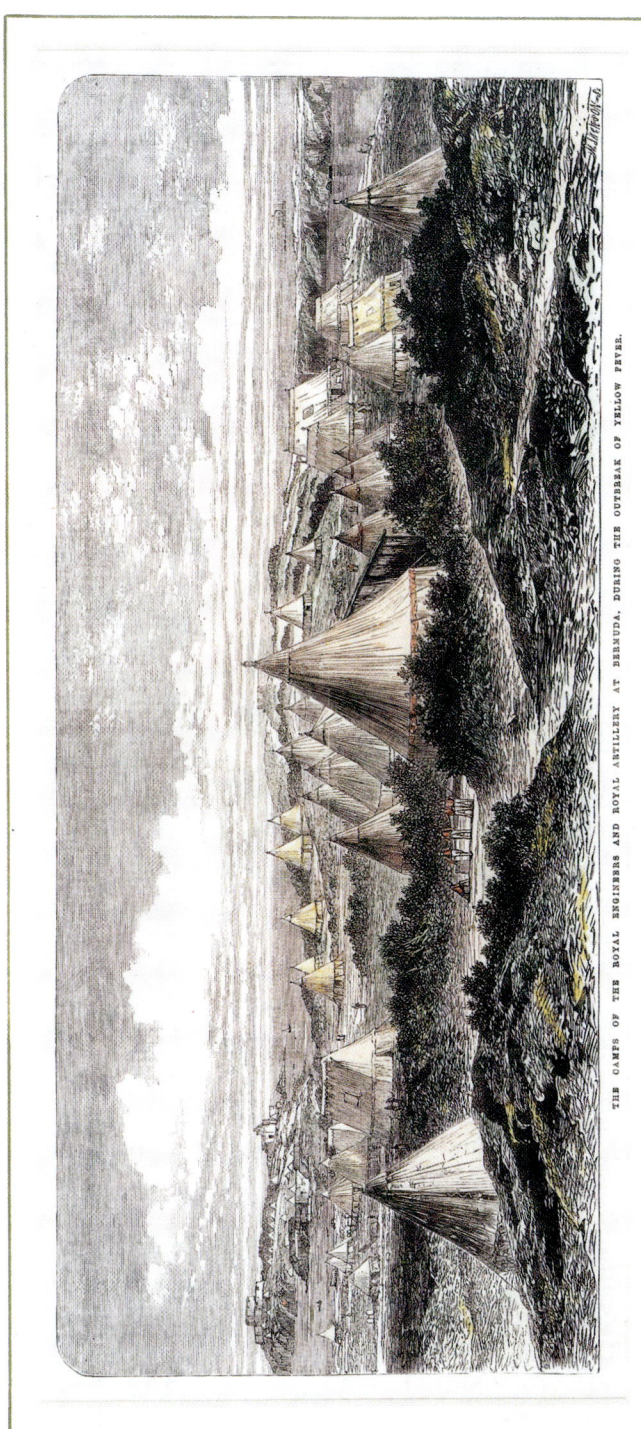

A British Army tent encampment above the town of St. George. Throughout the early and mid-nineteenth century, epidemics of typhoid and yellow fever swept through Bermuda, and troops were moved to tent villages to escape the appalling effects of these contagions. (*The Illustrated London News*, 1862)

1859, for instance, Anthony Trollope, returning from a postal inspection of the West Indies, passed a fortnight in Bermuda. He hated every minute of it. There could be 'no place in the world as to which there can be less said than there is about this island'. He detested the food, his only decent meal, he said, coming when he 'dined on rations supplied by the convict establishment'. Lassitude killed all initiative: 'The sleepiness of the people appeared to me the most prevailing characteristic of the place'. Back in England, Trollope penned a short story about Bermuda – 'Aaron Trow', published in 1861. It is a Gothic horror story in which an escaped convict kidnaps the fiancée of a Presbyterian minister. The story culminates with a struggle atop the cliffs with the villain plunging to his death on the rocks below. The traumatized couple predictably then leave Bermuda forever. Trollope slates Bermuda throughout: 'that Ariel would have been sick of the place is certain; and that Governor Prospero should have been willing to abandon his governorship, I conceive to be only natural'.[14]

Disease featured prominently in the minds of the Bermuda sceptics. In 1701, the Reverend Robert Barron began an unhappy tenure as an Anglican minister in the colony. 'Sickness we had a large share of … we consumed our days in sorrow and misery.' Of his two years and ten months in the colony, Barron's family was ill for fifteen months. They survived on a meagre diet of potatoes and well-water.[15] In the nineteenth century, the dates of the great yellow fever epidemics – 1853 and 1864 – would become etched in the consciousness of Bermudian and visitor alike. The author of the first tourist guide to the islands, Henry Tapp, himself died of yellow fever in 1853, the year after his pioneering work appeared. Few accounts of Bermuda in the nineteenth century failed to mention the fear excited by the sight of a yellow quarantine flag on a ship's mast.

Itinerant travellers also found the colony 'still-vex'd'. When HMS *Challenger* visited Bermuda on its global surveying expedition in the early 1870s, one of its passengers, Lord George Campbell, could only comment on the colony's 'villainous musquitoes' and its 'intense wearisomeness'.[16] The English adventurer J.W. Boddam-Whetham also arrived in the 1870s. While he could see the potential of the place, he also remarked upon its soporific qualities. It was 'a quiet land … where I have heard people ask, "Did you hear the dog barking yesterday?"'. In these years, the colony's ancient capital of St. George's acquired a particularly grim reputation as a backwater in visitors' minds. Whetham snidely remarked that 'two carriages in St. George's on the same day would be an exceptional event'.[17] Even non-Britons could disparage Bermuda. Shortly after President Lincoln appointed him American consul to Bermuda in 1861, Charles Maxwell Allen countered the Bermudian suspicion that the Union had its greedy eye on the colony. 'I told them today at the dinner

table,' Allen wrote to his wife, 'they need have no fears as our people would not have such a Godforsaken place as this if they could get it for nothing.'[18]

There were always those ready to find hardship in Bermuda. As late as 1912, the wife of an army officer could put together a guide for wives first arriving on the station. In some ways it was an 'ideal station'; in other ways it was barren of civilisation. There was 'no polo' and men 'can dress as badly as they please'.[19]

The foregoing eclectic survey of such naysaying is intended to demonstrate not that there was ever a coherent 'school' of anti-Bermuda thought, but simply that until well into the nineteenth century strong scepticism existed about Bermuda's aesthetic attractiveness. Few went as far as Featherstone Osler and Richard Dashwood in labelling it a 'miserable hole' and a cockroach heaven, but most echoed the Elizabethan view that man and nature were not to be trusted in the 'Bermoothes'. Not inconsequentially, in the late twentieth century the two books that have drawn the most attention to Bermuda have both played on this sentiment. Charles Berlitz's 1974 *Bermuda Triangle*, with its tale of ships devoured by mysterious magnetic forces, captured the imagination of thousands of readers. Twenty years later the catastrophic side of Bermuda would again be evident in Bob O'Quinn's *The Bermuda Virus*, a thriller about a flesh-eating virus that devastates the hurricane-racked colony, leaving a handful of survivors to sail away to a new life in a boat called the *Deliverance*.[20] The spirit of Caliban lingers on.

So too does that of Ariel. If in 1610 some of the original ship-wrecked newcomers to Bermuda chose to flee the 'isle of devils' in their jerry-built *Deliverance*, others would later decide to stay. From the earliest European contact, there were always those who looked beyond the reefs, the thunder, the epidemics and the humidity to see in Bermuda a bountiful garden. Indeed, even Henry May had been moved to admit that the islands 'yieldeth great store of fowle, fish and tortoise'. Similarly, Lewis Hughes, one of the first ministers to arrive in the colony, reported in 1614 that none of the 'strange reports' he had heard of the islands seemed true – 'here are no such things'. Bermuda was instead 'a place where the industrious will prosper'.[21] In the nineteenth century, the American writer Washington Irving celebrated Bermuda's first settlers – the three 'culprit' colonists left behind by George Somers – in his story 'The Three Kings of Bermuda'. With Biblical resonance, Irving portrayed the island as an Eden-like paradise where the three settlers initially enjoyed 'great harmony and much feasting' until the greed brought on by the discovery of ambergris sowed dissension in their midst. Spoilt man and unspoilt nature was to be one recurrent theme in the perception of Bermuda as a garden of plenty.[22]

In his seminal work *The Machine and the Garden*, Leo Marx argued that the New World evoked a powerful 'pastoral ideal' in Europeans who ventured across the Atlantic to its shores. America's earliest colonists were motivated by 'the dream of a retreat to an oasis of harmony and joy'. They sought their utopias, their Atlantis where the economic and religious pressures of the Old World would be lifted and paradise would be regained. News of the misadventures of the Virginia colonists on the reefs of Bermuda in 1609 did not diminish this hope in European observers. There was a deep fascination with the outcome of the meeting of civilisation and nature. As Marx pointed out, Shakespeare's *The Tempest* 'focuses upon a highly civilized European who finds himself living in a prehistoric wilderness. Prospero's situation is in many ways the typical situation of voyagers in newly discovered lands'.[23] Bermuda thus had the potential to serve as a garden to which many Europeans – and soon the earliest Americans – looked for tranquillity and escape.

Remarkably, many of the earliest writers to transmit this image never in fact visited Bermuda. The English poet Andrew Marvell, like Shakespeare, knew only what he heard of Bermuda on the streets of London. Indeed, in his 1681 poem *Bermudas*, the islands are depicted as 'remote'. But Marvell chooses to bless them with 'eternal Spring; Which here enamels everything'. The early seventeenth-century poet Edmund Waller imposed similar images on the young colony: 'So sweet the air, so moderate the clime,/ None sickly lives, or dies before his time'.[24] Two centuries later the Irish poet Tom Moore did set foot on the island and waxed lyrical not only about Bermuda's landscape but also about its women. Appointed to the colony by the Admiralty in 1804, Moore sojourned but three months. 'Such a place!', he wrote, 'Such a people! Barren and secluded as Bermuda is, I think it a paradise to any spot in America I have yet seen.'[25] Marvell, Waller and Moore cumulatively started to reverse the 'vex'd' image that *The Tempest* had given Bermuda. By the early nineteenth century, the narrow world of the English *literati* was coming to see Bermuda as Moore saw it: 'An island of lovelier charms; It blooms in the giant embrace of the deep'.

Throughout the nineteenth century, Bermuda's image would be further reversed by a succession of visitors to its shores. Few of these were 'tourists' in the hedonistic twentieth-century sense: they travelled instead for a variety of reasons. Some were colonial administrators with liberal interests and powers of observation which ran well beyond their official mandates. The intellectual curiosity of Governors William Reid (1839–46) and John H. Lefroy (1871–77) did more to amplify understanding of Bermuda, its people and landscape, than any other external force in the century. Others were drawn to Bermuda by a similar curiosity, aroused by the uniqueness of its natural environment. Geologists, botanists, palaeon-

The intrepid late-nineteenth-century tourists saw themselves as 'explorers', whether they came as naturalists, invalids, or refugees from America's burgeoning urban society. (Bermuda Archives: P.A. 2050)

tologists and oceanographers – some professional, many amateur – came to collect and categorize. Addison Verrill from Yale and Angelo Heilprin from the Academy of Natural Sciences in Philadelphia picked at and sampled Bermuda and then reported their findings to audiences of American amateur naturalists. Other early 'tourists' came for their health, believing that Bermuda's sun and sea air would cleanse them of the ills of urban, industrial life.

Collectively, these were Bermuda's nineteenth century tourists. They were an elite – a mere trickle of annual visitors until the last decade of the century and even then never amounting to more than several thousand a year. But their crucial dynamic role consisted in their power to fashion and transmit a new benevolent image of Bermuda to the world beyond, using media as diverse as paintings and editorial columns. Bermudians also picked up the message and would learn to mould the values held so dear by visitors to their 'Juneland' into the aesthetic core of one of the new century's most successful and carefully crafted tourist trades. A number of these values bear some elucidation.

The pessimists had damned Bermuda as a sweaty den of disease. Others, however, wondered whether the Gulf Stream that coursed past the colony year-round might not promote health, especially for those made sickly by the northern clime. The nineteenth century saw 'climatotherapy' come into vogue – the application of sunshine and fresh air to consumptive diseases. The emergence of the Franco-Italian Riviera by the 1860s best typified the association of health and climate. A Bath chair on the Promenade du Midi at Menton became the destination of those affluent enough to afford such sunny cures.[26] Bermuda fitted this pattern. As early as 1829, Susette Lloyd reported that 'several invalids', including the Governor of Nova Scotia, Sir Peregrine Maitland, had 'lately arrived here for the benefit of a milder climate'.[27] Henry Tapp's pioneering guidebook of 1852 made much of the fact that Bermuda's climate had 'greatly benefitted' its invalid visitors.

Given the distance and expense entailed by a journey to Bermuda, invalids seemed to resort to it only *in extremis*. An 1849 tombstone in St Paul's Churchyard, Paget grimly bears witness to Elizabeth Poole of Nova Scotia who 'came to these islands in search of health and found a tomb'. Nonetheless, North Americans increasingly linked Bermuda with health. The American Civil War had the effect of deflecting many northern invalids from their usual spas in the South to Bermuda. The American consul, Charles Allen, complained that many of these health-seekers ended up on his doorstep and at his dining table.[28] Even when peace returned in America, the invalids kept coming. In 1873, the fast steamer *San Francisco* was advertised by her Bermuda agents Trott & Cox as being of 'particular' interest to New York 'invalids'.[29] Allen continued to 'entertain' them: in

1887 a Rochester manufacturer wrote to thank the consul for his kindnesses while he 'cured' in Bermuda. 'My friends all say,' he wrote, '"How brown you are" and "how well you look" … we did nothing but talk Bermuda from noon til eve for the first few days.'[30] Allen himself suffered from what appeared to be recurrent tuberculosis.

More often than not, Allen was obliged to arrange the shipment of deceased invalids home to grieving families. This tended to underline a growing acknowledgement that Bermuda's high humidity and intense summer heat were not in fact a tonic for the respiratory system and that those suffering from tuberculosis would be better served by drier climates. 'Bermuda is not suitable,' the *Bermuda Almanack* advised in 1880, 'for those in the last stages of hope for more life, but it is eminently adapted for those who are in need of rest and change …' The theorists of climatotherapy concurred; dry and cool was better than hot and humid.[31] If Bermuda ultimately failed as a place to *restore* health, it flourished as a place to *preserve* health. If it could not heal tubercular lungs, it could soothe the nerves and bolster the constitution.

Of all the aesthetics of Bermuda, the image of the 'isles of rest' would prove the most durable. The image was formed out of an amalgam of isolation, semi-tropical warmth, an unhurried pace of life and resplendent nature. Bermuda was invariably described as a land beyond the icy grip of winter, a place of perpetual spring or, in the words of Governor Lefroy, 'this green oasis in the desert of Atlantic waters'.[32] 'We are in a little world of our own, distinct from either Europe or America,' wrote the American palaeontologist Angelo Heilprin as he led his students about the colony in 1888.[33] The common denominator in all these images was the Gulf Stream, which both physically and metaphorically separated Bermuda from North America. On the American continent were all the excesses of the Gilded Age in the Great Republic – a nation increasingly predicated on material accumulation and competition. Across the Gulf Stream lay Bermuda, a pastoral land seemingly unsullied by the financiers, the railways, and the hurly-burly of commerce.

Bermuda's uniqueness drew other visitors. Naturalists and geologists were intrigued by its singularity. It seemed so out of place: a warm, coral island parked off temperate, hard rock North America. How was it formed? What secrets did its sandstone contain? Darwin's *Beagle* never anchored off Bermuda, but the great English naturalist felt compelled to discuss the colony in his 1842 study of the formation of coral reefs. Drawing on the work of others who had visited Bermuda, Darwin noted that 'the size, height and extraordinary form of the islands' set them apart from normal coral atolls. Darwin concluded that Bermuda was the product of subsidence. Later in the century geologists like the great Swiss marine zoologist Alexander Agassiz and Angelo Heilprin of the Academy of

Natural Sciences in Philadelphia would chew over 'the coral reef problem'. Heilprin countered Darwin's subsidence theory with the notion that Bermuda was in fact the outcome of coral upgrowth.[34] Whatever the interpretation, Bermuda had established itself by the 1870s as a fascinating and close-at-hand research station for American geologists. Since Darwin's evolutionary theories had cast doubt upon the heavens, western man in the late nineteenth century had turned to geology – reading the rocks – to crack the secrets of the universe. Chipping away at Bermuda's coral was soon supplemented by the hunting for and categorizing of fossils, fish, flora and fauna. Bermuda, *The Canadian Naturalist and Geologist* reported in 1857, was 'a perfect paradise in which an earnest Naturalist may luxuriate'.[35] As early as the 1840s, amateur ornithologists like the British customs official John Hurdis had noted that Bermuda provided a spectacular platform from which to view migrating birds. Tropical birds, the picturesque Longtail gull and the docile and near extinct cahow all soon won notoriety in the eyes of Bermuda's early bird watchers.[36]

By the 1850s, therefore, Bermuda was beginning to amend its reputation. There was still pestilence: a dreadful bout of yellow fever in 1853, for instance. But its salubrious side was beginning to assert itself. An American visitor arriving in St. George's in 1850 reported that the locals were 'most hospitable' and that the town's white roofs created 'very much the appearance of snow' and that 'oranges and lemons [were] growing all over the place'. He bought souvenirs made by the convicts, went to a 'grand ball' and listened to the pipers of a regimental band. It was winter, 'but I sleep with my window open'.[37] A few years later, the best-selling Canadian humorist T.C. Haliburton, author of the famous 'Sam Slick' series, reported that he had found the colony 'a beautiful spot and very healthy', one of the 'few crack places in the world [that] come up to the idea you form of them beforehand'.[38] In a short story, Haliburton set Sam Slick to ponder the fishy mysteries of Devil's Hole. To cater to such 'strangers', Henry A. Tapp, a clerk of ordinance in the colonial administration, published Bermuda's first tourist guidebook in 1852; the place, he claimed, had a 'desirable climate and many interesting spots'.

Writers, invalids, naturalists and birders were not, however, the making of Bermuda's first tourist boom. War in the United States was. By the 1850s, Bermuda's once formidable seafaring economy had been in the doldrums since the end of the Napoleonic Wars; its agriculture struggled to keep the island self-sufficient. Imperial spending on the convict establishment, the garrison and the West Indies Squadron buoyed up the local economy, but these external supports did not disguise the lack of a vital economic centre for the colony's 11 000 inhabitants. The outbreak of the American Civil War in 1861 thus came as a godsend to Bermuda in every respect. While Britain maintained a policy of neutrality in the conflict,

Bermuda's canny merchants saw profit in the Southern cause. The federal blockade of Southern ports allowed Bermuda to play again its historic role as a seafaring middleman. The Confederacy desperately needed an outlet for its lucrative cotton exports and an inlet for its purchases of European weaponry and ammunition. The mid-Atlantic port of St. George's offered the perfect surreptitious entrepôt for such a trade. By late 1861, its harbour was alive with commercial activity as sleek blockade runners – stripped-down fast steamers, equipped for night running and largely manned by British crews – crowded into the cosy port to load coal and exchange cotton for guns in their holds. Local commission merchants like John Tory Bourne sprang into action as go-betweens in the trade; Bermudian lads found ready employment on the docks. A hothouse economy developed overnight. 'Truly the spirit of extortion is stalking through this land,' the wife of the Confederate agent posted to Bermuda wrote in 1863. 'We are *fleeced* on every side.'[39]

Blockade running was both profitable and dangerous. A captain bold enough to run the gauntlet of federal frigates and deliver his cargo into Charleston or Savannah might expect $5000 per trip. Ordinary crewmen might pocket $250, all paid in British gold or, ironically, US dollars. The syndicates backing such profitable dashes stood to reap returns as high as 700 per cent per voyage. But federal vigilance and the hazards of navigating at high speed at night in coastal waters took their toll. Even Bermuda's own coral snagged a few blockade runners. To all this illicit traffic Britain turned an official blind eye, its governor, Sir Harry Ord, administering a policy of official neutrality while quietly allowing blockade runners to coal and to transship cargo beneath his nose. Manchester's appetite for cotton and Britain's inclination to favour the South dictated such expediency. For their part, Bermudians acted out of their traditional pragmatism: alone in the mid-Atlantic on a sun-beaten piece of coral, they would take their opportunities wherever they found them.

With ships like the *Robert E. Lee* and the *Chickamauga* riding at anchor in St. George's harbour, more than the pace of warehouse life changed in Bermuda. The wartime economy brought new faces, new reactions and new possibilities to the colony. In a peculiar fashion, tourism stirred. 'What a perfect vision of beauty it seemed to my wearied heart!', Georgina Walker, the Confederate agent's wife, wrote on arrival in 1863. 'I thought I had never seen so lovely a spot; the little white cottages dotting the green hills ...'[40] She was not alone. An Atlanta boy serving on a runner recalled 'those beautiful islands ... knowing he was absolutely safe, in watching the bumboat women paddle their canoes around our steamers, offering for sale their tropical fruits'.[41] Once ashore the Southerners were readily accepted into Bermuda society. In 1859, Anthony Trollope had found Bermudian society 'triste'; by 1862 it had acquired a wartime vivacity. There were

balls, theatricals, house parties and picnics. On 4 July 1863, the officers of the blockade runners *Lady Davis*, *Emma* and *Eugenia* staged a 'splendid luncheon' under the calabash tree made famous by the Irish poet Tom Moore as a courting spot. Toasts were drunk to the Queen and President Jefferson Davis.[42] Charles Allen, the federal consul posted to the colony by President Lincoln, gloomily reported to Washington: 'These islands here are filled with Southerners – they seem to have plenty of money and have purchased largely from the merchants here'. By way of consolation, Allen also reported that the conflict had deflected many Yankee invalids from their usual haunts in the South to Bermuda, where they believed similar salubrious weather awaited them.[43]

Thus, despite all their bloody differences at home, Americans were for the first time discovering the joys of Bermuda. Their letters home and their journals all convey the sense that in Bermuda they found a respite from the agonies of life in warring America. Bermuda was different. They liked the weather: 'The climate of Bermuda is now perfect', Georgina Walker confided to her diary, 'I believe not surpassed by that of Italy or any other part of the world'. They liked its coral roads and quaint cottages. They were intrigued by its natural curiosities. The Walsingham Caves and the Devil's Hole fish pond seemed wrapped in Gothic mystery. Bermudians were 'honest plain people'. Southerners in particular were drawn to the hierarchical nature of Bermuda society; its blacks, while free, were 'polite and inoffensive'. They 'knew their place'. And the whole colony exuded a 'Britishness' that appealed to many Americans; here was pomp, circumstance and social decorum that seemed to reflect a society in which everyone knew their station. There was no 'mobocracy' in Bermuda; the colonial elite exercised power paternalistically by relying on a narrow property qualification for voting. The established Anglican Church and the presence of the British military also seemed distinguishing virtues of Bermuda in many an American mind. In May 1861, Bermuda had received its first royal visit – that of Victoria's young son Alfred as a naval cadet. In the following years, Americans delighted in retracing the prince's movements around the colony, to the Walsingham Caves, for instance. Sensing this nascent infatuation with their island, Bermudians reciprocated, inviting Americans to their homes, churches and regimental balls. Local photographers began advertising 'large views of Bermuda scenery' as souvenirs.

Not all the early 'tourists' were so eagerly embraced. Near the wharves of St. George's and along its narrow alleys, a lustier form of tourism thrived. The crews of the blockade runners – young, well-paid and looking for a 'good time' in a foreign port in a time of war – sought to put the tensions of war behind them for an evening or two. Grog shops, prostitution and cheap hotels sprang up. A rotund black woman won fame as 'Tea Pot

Sally' for dispensing grog from a teapot she concealed under her ample dress as she plied the town's streets. One crewman on the *Robert E. Lee* recalled how 'the sailors harmonized amicably and got drunk together ashore with mutual good will'.[44] Although they spent money like proverbial 'drunken sailors', few Bermudians beyond the grog shop owners were impressed by this class of visitor. Town lanes with picturesque names like Shinbone Alley had become places of debauchery and filth. The town's lone constable was overwhelmed. *The Royal Gazette* deemed 'the constant presence of hundreds of rollicking blades' in the town 'a real disgrace to any civilized community'.[45]

Under such conditions of 'drunkenness, dissipation and dirty habits', St. George's became an incubator for disease. In July 1864 the dreaded yellow fever arrived. The corporation responded ineptly by fumigating the homes of the victims, burning their bedclothes and hurrying their bodies to burial. A quarantine station was established and the town's health officer despatched to inspect blockade runners in the harbour. Ignorant that the disease was borne by mosquitoes breeding in stagnant water, the corporation was in effect battling a phantom, and through the heat of the summer yellow fever raged in St. George's. At 2:00am on the night of July 18, for instance, the mayor was informed that a man 'had just died in the road opposite the hotel'. By 3:15, his body was already in the ground.[46]

By the spring of 1865, the yellow fever had abated and the war was waning. And St. George's began to slip back into its pre-war somnolence. In March, one seasoned blockade runner arrived to find the harbour deserted: "Twas Greece, but living Greece no more'.[47] American consul Charles Allen informed Washington that the blockade had given an 'unnatural impetus' to Bermuda's economy unlikely to be sustained in peace.[48] He was right. For the next century, St. George's was to slumber, insensitively referred to as a 'backwater' by innumerable visitors and overlooked by Bermudians in their efforts to lure the 'strangers' back into their midst. But in the 1860s it had played a crucial role in tantalising Americans with Bermuda's charms. Two unconnected yet powerful post-war coincidences would complete the seduction.

In the 1870s, Bermuda scrambled to reorient its economy. Unable to translate its wind-driven seafaring prowess into a role in the age of steam and iron, the colony began to build up its agriculture. Its mild winter and relative proximity to the American east coast allowed Bermuda to become the 'market garden of New York'. Each spring Bermuda farmers raced to harvest and deliver their onions, potatoes, beets and carrots to the greengrocers of New York before their North American counterparts had roused from their winter rest. Again, Bermuda began to impress itself upon the American imagination; Bermudians even began to affix their nationalism to the growing of vegetables, proudly referring to themselves

as 'onions'. There was, however, little room in the onion patch for tourism. Climate, ample labour and a ready market drove out consideration of other economic activities. The woeful state of Bermuda's hotels and the absence of any reliable passenger service to New York completed the situation. Throughout the 1870s and 1880s, only a trickle of invalids, naturalists and adventurers frequented Bermuda, finding space on steamers crammed with cases of vegetables. One such adventurer was Samuel Clemens, known then and now to his readers as Mark Twain, America's beloved humorist. More than any other person in the late nineteenth century, Twain would help to turn Bermuda's image in North American eyes from that of a vegetable garden into a playground for relaxation.

The Northern victory in 1865 opened the door to America's unbridled industrialisation and urbanisation. Post-bellum affluence also set Americans free to travel. In June 1867, the editor of a San Francisco newspaper, the *Alto California*, commissioned Twain, then an up-and-coming popular writer, to travel to Europe, see its sights and then entertain his readers with accounts of his journey. Twain's goal was to produce a new style of 'travel book', one unmarked by the 'gravity … profundity … and impressive incomprehensibility' that usually marred the genre. Instead, his was to be an account of a light-hearted 'pleasure trip'. Two years later, the letters were published as a book under the title *The Innocents Abroad*.

For all its frivolous billing, Twain's European swing was a gruelling affair and by the time he departed for home from Cadiz in November he was truly exhausted. Twain's steamer broke its journey in Bermuda and Twain reported an immediate infatuation with the place. The 'beautiful Bermudas' lived under the 'flag of England'. 'We were not a nightmare here,' he wrote, 'where were civilization and intelligence in place of Spanish and Italian superstition, dirt and dread of cholera. A few days among the breezy groves, the flower gardens, the coral caves, and the lovely vistas of blue water … restored the energies dulled by long drowsing on the ocean.'[49] Thus began a ritual that would stretch until the last weeks of Twain's life: whenever he felt 'dulled' by the demands of writing, he instinctively headed for Bermuda. Bermuda offered a respite from the cares of the world. 'There are no newspapers, no telegrams, no mobiles, no trolleys, no trains, no tramps, no railways, no theatres, no noise, no murders, no fires, no burglaries, no politics, no offenses of any kind, no follies but church, and I don't go there,' a dying Twain wrote to a friend from Bermuda in 1910. 'You go to heaven if you want – I'd druther stay here.'[50] When Twain's coffin lay in the Brick Church on Fifth Avenue a few weeks later, it was surrounded by Bermuda lilies.

After his first visit in 1868, Twain returned to Bermuda in the summer of 1877, claiming that it was the first trip he had ever undertaken 'for pure recreation, the bread-and-butter element left out'. For ten days he roamed

the island, revelling in its 'marvellous cleanliness', its 'snow-white houses peeping from the dull green vegetation' and its friendly 'darkies'. 'Our darkey said that here everybody knows everybody.' Twain seemed to imply that a trip to Bermuda was like a trip to the Old South; he loved the way in which coloured Bermudians saluted the tourists on the street, aping the custom of saluting practised by the British military. Twain concluded it was 'much the joyousest trip I ever had' to the readers of *Atlantic* magazine in a four-part series under the title 'Rambling Notes on an Idle Excursion'. The essay was reprinted in *Belgravia* in England and then appeared in 1882 as part of a book, *The Stolen White Elephant*, published in Boston. Thus Twain almost single-handedly became the most effective transmitter of Bermuda and its charms into America. He not only heightened its profile but he also gave it legitimacy in the eyes of those harried urbanised Americans who now had the money, the time and the need to seek escape from the pressures of modern American life. The American historian John Sears has suggested that throughout the nineteenth century Americans began to delight in scenery, using the affluence and technology that their material progress afforded them to seek out 'transcendental meaning' in nature's wonders. Niagara Falls, Kentucky's Mammoth Caves, the Catskills and Yosemite were all 'sacred places' which satisfied North Americans' craving for the sublime.[51] Twain and his ilk now pointed them towards Bermuda.

Twain soon became a fixture of Bermuda social life. He befriended the American consul Charles Allen and could be found at Allen's home, 'Wistowe' in picturesque Flatts, or on the veranda of a local hotel, cigar in hand, amusing admirers with tall tales, aphorisms or puzzles. He trotted about the island in a small cart, pulled by his favourite donkey, 'Maude'. Dressed in a white linen suit, Twain became the colony's first celebrity tourist. He soaked up the attention, despite his professions of coming to Bermuda to escape the public's eye. With theatrical flair, he always pronounced the island's name 'Bermooda'. As Britain and America cautiously patched up their war-strained relations, Twain became a kind of unofficial Anglo-American ambassador. When a British admiral invited him to visit his flagship's wardroom, Twain accepted and was ferried to his appointment in the admiral's barge. Once aboard, he recited Kipling to the officers.

Twain proved an effective apostle for the colony. He brought his friends and converted them to life under 'the pink cloud of the oleanders'. They in their turn would spread the gospel in America. Prominent among them were fellow writers Charles Dudley Warner and William Dean Howells. Warner, a Massachusetts lawyer turned popular writer and editor, had in 1873 co-authored *The Gilded Age* with Twain. In it, they had dissected the ills of modern industrial America, denouncing its materialism, congestion

and pace. Given these sentiments, Warner was a easy convert to Bermuda and as editor of *Harper's Magazine* became one of its most widely-read proponents in America. 'This protection from the noise and excitement of modern life is one of the great charms of the island,' he told his readers in 1894. Bermuda's society was 'hospitable, refined and pleasingly provincial, altogether English in tone' with 'little haste and not much worry'.[52]

In William Dean Howells, Twain found a very kindred spirit. A luminary of the Boston and New York literary scene, Howells had also served in the 1860s as the American consul in Venice and was a devotee of things Italian. A biographer of Lincoln, playwright and author of travel books, Howells had declined an offer from Twain to accompany him on his 1877 'pleasure' trip to Bermuda but later fell into the habit of escaping to Bermuda each spring. He too wrote for *Harper's*, eventually becoming its editor. He rhapsodised about the island: 'If we go home the next day, we do not quiet down, but if we stay a week we become of an almost Bermudian calm. A fortnight makes us over in the image of the colonial English who have been in the islands for generations'. After such arcadian rests, Howells bemoaned the 'steep slant back to New York'.[53]

Mark Twain and his circle thus introduced Bermuda to modern, affluent Americans. He carried its benevolent aesthetic into their drawing-rooms and into their consciousness. Some of them he even brought with him; pictures of the American oil tycoon Henry R. Rogers touring the island with Twain reached the American papers early in the new century. Significantly, Twain never used Bermuda as a backdrop for his fiction. It was too close to his own ideal of a fantasyland to tamper with, so he simply reported his 'rambling notes' of the place. In Bermuda, there was nothing to escape from.

In the winter of 1883, Bermuda's fantasy image received another benevolent boost. On the morning of 29 January, the British warship HMS *Dido* arrived in Hamilton harbour bearing a royal visitor. For weeks it had been rumoured that Queen Victoria's daughter Louise, wife of the Marquis of Lorne, Canada's governor-general, would escape the rigours of an Ottawa winter by coming to Bermuda. By any standard, Louise was an unconventional princess. Tall, blonde and blue-eyed, she was also moody, artistic and neurasthenic. Her marriage to the marquis was childless and often rumoured to be one of convenience, full of conflict and marred by his sexual ambiguity. In London, Princess Louise maintained a wide, distinctly unregal circle of bohemian friends, including Oscar Wilde. Louise had quite literally never warmed to Ottawa; its frigid winters and parochial society grated on her sensibilities. In the late fall of 1882, the vice-regal couple toured the Canadian west coast, where Louise took to the flowery beauty of Victoria. A Christmas holiday in California followed. The couple then took the train to Charleston in South Carolina, where under a cloak

of secrecy made necessary by the Fenian threat to the British Crown, Louise boarded the *Dido*. Lorne returned to the snows of Ottawa.

Bermuda appealed to Louise, and her advisers, because it was British soil. Had she remained in the United States, she would have been a foreign tourist, unshielded from curious republican eyes. In Bermuda, she wanted privacy. Despite this, news of her impending arrival kept carpenters working all night to erect a welcoming dais and triumphal arch on Hamilton's Front Street. A crowd of 3000 awaited her the next morning, as did six speeches of welcome. Mayor Nathaniel Butterfield proffered the hope that the princess would avail herself of the same 'mildness and salubrity of our winter climate' that was drawing 'visitors from the neighbouring continent'.[54] The speeches were all so much 'colonial taffy', the *New York Times* reported. Thus greeted, the princess slipped away to Inglewood, the newly constructed home of local merchant James Trimingham, who had graciously vacated it to accommodate Bermuda's most distinguished guest. For the next two and a half months, Louise clung to her privacy. She moved quietly in local social circles, sailing, playing tennis and croquet and attending amateur dramatics. Wandering away from Inglewood, she captured the colour and shade of nearby laneways and beaches in a series of exquisite watercolours. And then on 10 April, she departed, borne away after more speeches on HMS *Tenedos*. A week later, she was back in Ottawa, 'as brown as a berry' and 'as bright and happy as a schoolgirl'.[55]

Princess Louise's visit indelibly stamped Bermuda on the North American consciousness, not so much by what she did, but simply by the accident of her presence. Learning of her decision to go to Bermuda, the *New York Times* had hastily despatched a reporter to cover the visit. At first the colony's gala welcome for the princess furnished good copy: she was 'the first real live Princess who ever gladdened Bermuda with her presence'. *Times* readers were 'not used to this kind of lollipop in New York'. But then Louise disappeared behind the hedges of Inglewood, where detectives specially hired by the Colonial Secretary guarded her privacy. Stuck with an assignment that had suddenly become a *cul de sac*, the frustrated reporter turned his attention from the princess to Bermuda. Over the next months, thirteen long articles appeared in the *Times* featuring Bermuda. Snow-bound New Yorkers learned that 'seventy hours from the depth of winter' lay a place where 'birds sing, crickets chirp, and people drink cherry cobblers'. To clinch the point, the reporter described his habit of picking bananas in his hotel garden. There were pieces on local history, the colony's intense religious life, gardening, early tourist excursions and the social doings of American visitors. 'Onions are all very well, and there may be fortunes in strawberries, but visitors from the States pay best of all.'

Hamilton welcomes Princess Louise in 1883. Her choice of Bermuda as a winter resting-place was the event that most effectively projected the colony's virtues into the minds of potential travellers. (*The Illustrated London News* – author's collection)

By early April, the *Times* correspondent boasted that he had 'done up Bermuda to the last coral reef'. Nowhere in the stories was there a hint of typhoid or yellow fever, for indeed yellow fever had not returned since 1864. Bermuda's benevolent aesthetic glowed through paragraph after paragraph. And it was all free publicity from America's premier newspaper. 'The people are too modest,' one story concluded. 'Bermuda needs only to be known to be appreciated ... It is not a little paradise, but it is as near it as any place I know.'[56] After the departure of Princess Louise and her American journalistic shadow, Bermuda would never again be the same. Louise's visit and the marvellous *Times* coverage did not open the floodgates of tourism; there were too many practical obstacles still in the way of large-scale, convenient tourism. But together they sowed the seed of an image that Bermuda was a regal place to visit, where the right kind of Americans mingled with the right kind of colonials and where the torments of North American life were dissolved by the warm Gulf Stream.

In 1878, Harper Brothers, the New York publishers, brought out a prescient travel book that seemed to capture Bermuda's transition from a pesthole to a Juneland. Written by S.G.W. Benjamin, *The Atlantic Islands as Resorts of Health and Pleasure* argued that islands, once regarded as fetid, disease-ridden destinations, were 'becoming more the resort of the invalid and the pleasure-seeker'. Benjamin provided chapter-length treatment of islands as varied as the Azores, Madeira and even Prince Edward Island. Each had its virtues for the body and the mind. Together they constituted 'the sanitary islands of the North Atlantic'. 'I am convinced,' he concluded with late-nineteenth-century moral sternness, 'that the love of islands, and especially for small islands, is rational and improving. It enables one to gratify the roving propensity, and at the same time to combine with it the attainment of information, breadth and catholicity in judging men ...' Bermuda, Benjamin concluded, fitted this pattern perfectly. 'For those in vigorous health, Bermuda offers a delightful but enervating climate.'[57] For all its humidity, the colony had friendly people and beautiful sights. As usual, Mark Twain found more eloquent words to reach the same conclusion: these were the 'Islands of the Blest'.[58]

REFERENCES

1. Public Archives of Ontario, Osler Family Papers, Featherstone Osler to his father, 12 October 1828, and *Records of the Lives of Ellen Free Pickton and Featherstone Lake Osler* (printed for private circulation, 1915), 49–50. My thanks to Michael Bliss of the University of Toronto for these sources.

2. Susette Lloyd, *Sketches of Bermuda* (London, 1835), 16, 21, 26, 50, 155, 250 and 258.

3. Alain Corbin, *The Lure of the Sea: The Discovery of the Seaside in the Western World, 1750–1840* (Cambridge, 1994), 1–5, 7–8.

4. J.A.R. Pimlott, *The Englishman's Holiday: A Social History* (London, 1947), Chs. 1–4. James Walvin, *Beside the Seaside: A Social History of the Popular Seaside Holiday* (London, 1978).

5. Piers Brendon, *Thomas Cook – 150 Years of Popular Tourism* (London, 1991), Ch. 1.

6. See: John Pemble, *The Mediterranean Passion: Victorians and Edwardians in the South* (Oxford, 1987) and Jeremy Black, *The British and the Grand Tour* (Beckenham, 1985).

7. All these impressions are recorded in Major General J.H. Lefroy, *Memorials of the Discovery and Early Settlement of the Bermudas or Somers Islands, 1515–1685*, Bermuda Historical Society reprint (Hamilton, 1981), volume 1, 7–9 and volume 2, appendix.

8. Silvester Jourdain, *A Discovery of the Barmudas*, 1940 facsimile edition published by Scholars' Reprints, New York, 1940, v; and William Strachey, *A True Reportory of the Wrack and Redemption of Sir Thomas Gates ... upon ... the Bermudas*, in Louis B. Wright, ed., *The Elizabethans' America*, Cambridge, Mass., 1966, 189–94.

9. See: Frank Kermode, ed., *The Arden Edition of the Works of William Shakespeare: The Tempest* (Cambridge, 1958), introduction.

10. Cited in William Griffith, ed., *Bermuda Troubadours: An Anthology of Verse*, New York, 1935, ix. Kipling drew happier conclusions after his own two trips to the colony.

11. Richard Cotter, *Sketches of Bermuda or Somers Islands* (London, 1828), 26, 43. Cotter was a purser in the Royal Navy.

12. Richard Lewes Dashwood, *Chiploquoran* (London, 1872). Reprinted in the *Bermuda Historical Quarterly*, Vol. XIV, #1 (Spring, 1957). There are no caribou in Nova Scotia. Interestingly, the *BHQ* must have felt somewhat defensive about publishing this scathing memoir in the midst of the colony's huge post-war tourist boom and therefore entitled the reprint a 'Minority Report'.

13. N.B. Dennys, *An Account of the Cruise of the St. George on the North American and West Indian Station* (London, 1862), 117.

14. Anthony Trollope, *The West Indies and the Spanish Main* (London, 1860), 367–73; and 'Aaron Trow', in *Public Opinion and Literary Supplement*, 1861, 211. Trollope admitted that his views on Bermuda were based on 'cursory observation'.

15. Rev. Robert Barron as quoted in A.C. Hollis Hallett, *Chronicle of a Colonial Church – 1612–1826 Bermuda* (Bermuda, 1993), 125.

16. Lord George Campbell, *Log-Letters from the Challenger* (London, 1877), 18.

17. J.W. Boddam-Whetham, *Roraima and British Guiana with a Glance at Bermuda, the West Indies and the Spanish Main* (London, 1879), 13, 21.

18. Bermuda Archives [hereafter BA], Allen Papers, loose letters, Charles M. Allen to Susan Allen, 29 Dec. 1861.

19. Mrs Percy Hope Falkner quoted in *The Bermudian* (August 1938).

20. Charles Berlitz, *The Bermuda Triangle* (Garden City, 1974); and Bob O'Quinn, *The Bermuda Virus* (Hamilton, 1995). 'Your worst nightmare is just a breath away!' warns the cover of *Virus*. One might also point to the example of an 1892 boys' adventure book – Capt. W.E. Meyer's *Wrecked on the Bermudas* (Providence, RI) – in which 'the irresistible influence of wind and waves' acts as the hand of fate.

21. Lewis Hughes, *A Letter Sent into England from the Summer Islands*, published in 1615 and reprinted in Wright, ed., *The Elizabethans' America*, op. cit. at note 8, 202–4.

22. Washington Irving, 'The Bermudas', *The Knickerbocker* (January, 1840), 22.

23. Leo Marx, *The Machine and the Garden: Technology and the Pastoral Ideal in America* (New York, 1964), 3, 9, 35.

24. 'The Battle of the Somers Islands'. There is a faint chance that Waller may have visited Bermuda. See: J.C. Lawrence Clark, *Tom Moore in Bermuda: A Bit of Literary Gossip* (Lancaster, Mass., 1897).

25. *ibid.*, 11 and *The Poetical Works of Thomas Moore* (Paris, 1827). On the power of travel narratives to implant stereotypes of foreign places in metropolitan minds, see: Mary Louise Pratt, *Imperial Eyes: Travel Writing and Transculturation*, London, 1992.

26. Pemble, *Mediterranean Passion*, op. cit. at note 6, 84–96. See: Mary Blume, *Cote d'Azur: Inventing the French Riviera* (New York, 1992).

27. Lloyd, *Sketches*, op. cit. at note 2, 77.

28. National Archives, Washington, United States Consular Reports – Bermuda, MF series T – 262, Roll #6, Allen to Hon. William Seward, March 12, 1864.

29. *The Bermuda Almanack* (Hamilton, 1870).

30. BA, Allen Papers, loose letters, Henry J. Moore to Allen, 15 April 1887.

31. See: S.A. Knopf, *Pulmonary Tuberculosis: Its Modern Prophylaxis and the Treatment in Special Institutions and at Home* (Philadelphia, 1899), 290.

32. General Sir John Henry Lefroy, *The Botany of Bermuda*, in *Contributions to the Natural History of the Bermudas*, Bulletin #25 of the National Museum (Washington, 1884), 35.

33. Angelo Heilprin, *The Bermuda Islands: A Contribution to the Physical History and Zoology of the Somers Archipelago* (Philadelphia, 1889), 6–7.

34. See: Charles Darwin, *The Structure and Distribution of Coral Reefs*, London, 1842; James Dana, *Corals and Coral Islands*, New York, 1872; Angelo Heilprin, *The Bermuda Islands*, Philadelphia, 1889; and Alexander Agassiz, *A Visit to the Bermudas*, Cambridge, Mass., 1895.

35. Rev. Alex Kemp, 'Notes on the Bermudas and their Natural History', *The Canadian Naturalist and Geologist*, Vol #2, Montreal, 1857, 148.

36. John Hurdis, *Rough Notes and Memoranda Relating to the Natural History of the Bermudas*, London, 1897.

37. Journal of Edward Barton Grant, 1850, in the Papers of the St. George's Historical Society, BA.

38. T.C. Haliburton, *Nature and Human Nature*, London, 1859, 307.

39. D.F. Henderson, ed., *The Private Journal of Georgina Gholson Walker 1862–1865*, Tuscaloosa, 1963, 60. See: Frank E. Vandiver, *Confederate Blockade Running Through Bermuda 1861–1865*, Austin, 1947.

40. Henderson, *op. cit.* above, 40.

41. Francis B.C. Bradlee, *Blockade Running During the Civil War*, Salem, 1925, 102.

42. *The Royal Gazette*, 7 July 1863.

43. Allen to Secretary of State Seward, 3 April 1863 and 12 March 1864, US Consular Reports, National Archives, Washington, MF T–262.

44. J. Wilkinson, *The Narrative of a Blockade Runner*, New York, 1877, 161. My thanks to Michael Jarvis of William and Mary College for Tea Pot Sally.

45. *The Royal Gazette*, 28 July 1863.

46. Minute Book #3 of St. George's Corporation, July and August 1864, BA.

47. Wilkinson, *op. cit.* at note 44, 247.

48. 'General Report of the Bermuda Islands with Statistical Tables', 30 Sept. 1866, US Consular Reports, *op. cit.*

49. Mark Twain, *The Innocents Abroad*, Library Classics edition, New York, 1984, 511.

50. Elizabeth Wallace, *Mark Twain and the Happy Island*, Chicago, 1913, 139.

51. John Sears, *Sacred Places: American Tourist Attractions in the Nineteenth Century*, New York, 1989, 3–11.

52. Charles Dudley Warner, 'Answers to Questions about Bermuda', *Harper's Weekly*, 1894. In their new-found affection for Bermuda, Twain, Warner and other patrician American visitors to the colony reflected a mood of antimodernism in late-nineteenth-century America. As T.J. Jackson Lears has remarked in *No Place of Grace: Antimodernism and the Transformation of American Culture 1880–1920* (New York, 1981), antimodernists craved 'authenticity' as a tonic for the 'evasive banality' of modern culture (304–5). Bermuda's authenticity helped to build a 'therapeutic world view' in their minds.

53. William Dean Howells, 'A Bermudan Sojourn', *Harper's Weekly*, Dec. 1911, and 'Editor's Easy Chair', *Harper's Magazine*, June 1901.

54. Minute Books of the Corporation of Hamilton, 9 January 1883, BA.

55. Robert Stamp, *Royal Rebels: Princess Louise and the Marquis of Lorne*, Toronto, 1988, 201.

56. *New York Times*, 22, 28 January, 6, 11, 25 February, 4, 11, 25 March and 1, 8, 15, 22, 29 April 1883.

57. S.G.W. Benjamin, *The Atlantic Islands as Resorts of Health and Pleasure*, New York, 1878, 256.

58. Cited in John Cooley, ed., *Mark Twain's Aquarium: The Samuel Clemens Angelfish Correspondence 1905–1910*, Athens, Georgia, 1991, 271.

CHAPTER TWO

Shaping 'Nature's Fairyland'

'... Over 50,000 American travellers seek the soft air of Florida every Winter. I have never met one who had seen both places that did not prefer Bermuda. Is it not worthwhile to attract some of them to St. George's?'

Governor Sir John H. Lefroy, 1875

'... There is only one automobile in Bermuda, and that, I was delighted to learn, broke down almost immediately after coming here.'
Princeton University President Woodrow Wilson, 1907

NOT EVERYBODY LOVED Bermuda at first sight. In the late nineteenth century, the transformation of Bermuda's aesthetic had been driven by external forces – urban North America's hankering for places of salubrious tranquillity. For their part, Bermudians had done little to aid and abet this shift. Lulled by the easy profits of market gardening for the eastern American market, Bermudians hardly stirred themselves to attract American visitors to their sunny shores. In agriculture, Bermudians sensed that they had a natural monopoly – the delivery of vine-ripened produce to New York every spring. Tourism was another matter; here there was competition from places with similar climates as well as demands for skills and capital that were not readily at Bermudians' command. The decision was rational and throughout the 1890s it paid handsomely. In 1899, a staggering 446 551 crates of Bermudian onions found their way to North American greengroceries. Beets, potatoes, tomatoes and carrots rounded out the feast. Back in Bermuda, however, the trickle of intrepid tourists who responded to what they had read about the place in *Harper's* or steamship company brochures often felt slighted by a colony that clearly put farming before catering to 'strangers'. Many complained.

The most prominent and persistent obstacle to Bermuda tourism was the sea. The island's advocates had portrayed the warm and faithful Gulf Stream as Bermuda's best friend, its guarantee of semi-tropical weather when North America shivered. What they neglected to point out was that

to get to Bermuda one had to sail ***through*** the Gulf Stream. This entailed embarking on a relatively small steamer and sailing diagonally across the choppy north-flowing current. The result was predictable. 'The creaking of the ropes, the throbbing of the engine, the waves against us and pouring over us as though longing to devour us, the crockery knocking and tumbling about, the retching, vomiting, and coughing of the unhappy victims of sea-sickness,' an American visitor of 1875 reported, 'these are the sounds that constantly greet the ear.'[1] Even Mark Twain was forced to concede that 'Bermuda is paradise but you have to go through Hell to get there'.

There were other torments on board the Bermuda steamer. An English tourist of 1879 complained of the service on board the Quebec Steamship Company's *Canima*: the 'French-Canadian stewards, whose dirty appearance made the greasy food less appetizing, if possible, than it otherwise would have been. A more ghostly and half-starved lot of travellers never arrived at their destination.'[2] Arrival in Bermuda was similarly aggravating. To dock in Hamilton, steamers had to creep through the islands' perimeter reefs, await a good tide and even then endure a lengthy process by which the ship was lashed to the dock by long timbers to prevent it from scraping bottom at low tide. News of an incoming steamer was telegraphed by a flag hoisted at Admiralty House on the north shore and, since the steamer also carried the much-awaited mail, Bermudians hurried to watch the spectacle of a ship's arrival. Steamer day thus became the social event of the week. Mail and a glimpse at the new strangers dressed in their New York finery rewarded those who came. Since docking usually took an hour, passengers had to endure the gawking eyes of the crowd. 'A crowd of whites and blacks, soldiers and civilians, guests and natives, stand at the wharf to meet us,' an American woman wrote in fashionable *Godey's Magazine*, 'and to pass remarks, mercilessly critical, upon our more or less forlorn appearance.'[3]

Once ashore, the hotel situation was not much better. A perennial theme in early travellers' accounts was the lack of affordable, comfortable and obtainable accommodation. Julia Dorr, an American writer arriving for the winter season in 1883, complained that 'you must trust to luck in the matter of quarters' and that her luck was bad: 'No rooms at the hotels for love or money'.[4] Boarding houses took in the luckless. Many of those fortunate enough to find a room complained. The snobbish English adventurer Lady Brassey arrived in 1883 under the impression that a 'nice little hot dinner' awaited her at the city's leading hotel. 'But alas! we were doomed to disappointment for the "nice little hot dinner" consisted of some tepid and tough cutlets – made all the tougher by having to be cut with the bluntest silver knives – and some cold greasy potatoes ... peas like buckshot, boiled potatoes like cannon-balls.'[5] In 1877, Mark Twain and his

'Staging' a steamer at the Front Street wharf, c. 1890. (Government Information Services, Bermuda)

travelling companion encountered even worse treatment in poky St. George's, where the owner of the Globe Hotel explained 'that they had but one boarder and were unprepared for an inundation of two strangers'. Dinner that evening consisted of 'hellfire' soup and 'iron clad chicken'.[6] In later years, Twain's friend and biographer Albert Bigelow Paine noted that Twain did 'not like hotel life' in Bermuda and schemed to stay at the American consul's home.[7]

Early travellers laid other complaints at Bermuda's tourist doorstep. It was expensive. James H. Stark, a Bostonian who produced a series of guidebooks to the colony in the 1890s, found the hotels 'exorbitant'. Julia Dorr suggested that room and board could be obtained for $2–$3.50 a day, but that Bermuda on $10 a week was out of the question. With the exception of English goods, shopping was expensive and bound to disappoint New Yorkers. There was also pervasive annoyance at Bermudians' unhurried ways. Few went as far as Ferdinand Whittingham's cruel 1857 judgment that they were 'living vegetables', but most would have agreed with Julia Dorr that she frequently felt 'a little natural Yankee grumbling at Bermudian slowness'. The American geologist Angelo Heilprin complained that the colony suffered from that 'class of easy-going inhabitants whose hardest labour appears to be that of doing nothing'. There was, of course, a vein of hypocrisy in all these complaints; the very tranquillity, easy-going friendliness and release from North American pressures Americans liked in Bermuda were also grist for the complaint mill when it came to obtaining a hot meal or a clean bed. Few were, however, deterred by this logic from registering their complaints in paradise.

Many early Bermuda lovers tried to nag the colony into doing more for its would-be tourists. In her inimitable ladylike way, Julia Dorr suggested in 1883 that 'Bermuda is not progressive in the way of modern improvements'. Matthew Jones, the author of an early visitors' guide in the mid-1870s, was blunter: '… unless the Bermudians bestir themselves and afford more facilities for visitors enjoying themselves in the way of innocent amusements … not a tithe of the number of visitors who would otherwise come, will wend their way to pass a winter in these pretty yet expensive isles'.[8] Some of the colony's more astute governors spotted the opportunity that tourism offered Bermudians to diversify their economy away from its dangerous reliance on agriculture. Governor Sir Robert Laffan worried in 1878 that the 'prosperity of the whole community depends now almost entirely upon that of the agricultural class'. Diversification was imperative as insurance against any downturn in the export of vegetables.[9] Laffan's predecessor, Sir John H. Lefroy, itched to improve the colony and often found himself bucking the conservative instincts of its propertied class. Lefroy was one of those polymaths whom colonial administration seemed to produce; soldier, amateur scientist, naturalist, historian and explorer. A

born reformer, Lefroy wanted to shake Bermuda out of its comfortable and, he felt, unimaginative ways.

Lefroy's interest in naturalism had taken him to the Smithsonian in Washington. In the United States, he had witnessed Americans' growing propensity for travel – to Europe for culture and south to Florida for sunshine. If 50 000 Americans sought the 'soft air' of Florida every winter, he asked Bermudians in 1875, why should their colony stand idly by in the race to the sun? As was often the case, Lefroy was powerfully prescient and the Bermudian elite was powerfully conservative. While Bermuda languished, Florida blossomed as 'the sunshine state' in the 1880s and 1890s. Florida proved to have not only the sunshine, but also the entrepreneurship. A Gilded Age oil tycoon, Henry Morrison Flagler, arrived in St. Augustine in 1885 and proceeded to turn it into the 'Newport of the South', a winter haven for the northern rich. Flagler built railways to transport the resort-goers south and then erected grand hotels in which they could relax and play. In the early 1890s, he single-handedly fashioned West Palm Beach out of marshland into the 'Queen of the Winter Resorts'. Flagler crowned Palm Beach in 1894 with the Royal Poinciana Hotel, the largest wooden structure in the world, and surrounded it with golf courses. The key to Flagler's strategy was to ensure harried northerners a place in the sun where they would find their own class and their favourite diversions. As Flagler's biographer has noted, West Palm Beach 'provided an idyllic environment set apart from reality'.[10] Across the Atlantic, the same process was unfolding along the French Riviera. On the shores of the sparkling Baie des Anges at Nice, *hivernants* strolled the season away along the Promenade des Anglais. By 1874, the foreign colony in Nice numbered 25 000 and, in the opinion of its chronicler, Nice 'became the first western city to have a tourist-based economy'.[11] Bermuda continued to grow onions.

Slowly, new impulses began to be felt in Bermuda. They emanated not from the colony's commercial class, but instead from its government. Habituated to seafaring, trading and accumulating real estate, Bermuda's merchants were little inclined to take the long-term risks that tourism promotion entailed. Tourism was a long-term, capital-intensive proposition; seafaring and trading were in some ways riskier, but the capital needs were fewer and the return quicker and usually more lucrative. In 1883, the American consul bemoaned the fact that there was 'but a small field for speculative enterprise' in Bermuda and that its inhabitants seemed to be locked into a cycle of renting land and contracting short-term debt.[12] Ten years later, Mary Child observed that the average Bermudian ran 'his business on a safe basis, goes as far as he can afford and no farther, dabbles a little in outside ventures like lily or onion growing'. Under these circumstances, the building of hotels seemed a long bet in Bermuda.

The old and the new, c. 1885. A donkey cart laden with crated onions destined for the New York market passes a steam yacht at anchor in the harbour – a hint of Bermuda's growing attraction as a playground for rich Americans. (Bermuda Maritime Museum)

Bermuda was not without hotels. Since the War of 1812, a string of small hotels had fitfully existed in Hamilton. Many were no more than upgraded taverns. In one of these, Featherstone Osler undoubtedly ate his 'starved fowl' in 1828. Their clientele consisted of military men and the occasional commercial traveller or invalid. None lasted. By the 1840s, there was agitation for a grander hostelry. As the colony's capital since 1815 and now a city, Hamilton felt the urge for respectability. Efforts were made to tidy up Front Street, where the debris of trade and the filth of the garrison privies blighted the waterfront. A new city hall was opened in 1854. Queen Street, sweeping up a gentle hill from the harbour, was beautified. Cornerstones for new churches and a Mechanics' Institute were laid with much pomp and promise.[13] Hamilton wanted to be 'modern', and when Henry James Tucker was elected its mayor in 1851 he was quick to add a hotel to the city's list of ambitions. There would be 'considerable profit' in a hotel, he told his council, since it would allow the 'accommodation of strangers who come here – some in search of health, some to avoid the severity of colder climates than our own; and others for pleasure'. A hotel appropriate to this trade, he estimated, would cost a princely £2600.[14] The hitch, he conceded, was that local merchants were not likely to rise to the challenge 'because it is not likely to pay'. They would 'get less interest' from a hotel than from investing in English 3 per cent Consols. If the merchants demurred, then the city, Tucker concluded, should build the hotel. 'The government lose, but the People gain,' Tucker wrapped up his case.

There were instant critics. Local landowners, fearful of 'heavy debt', presented a protest petition. The invalids preferred guest houses, they contended, and shipping was in decline. A counter-petition rallied to Tucker's support: 'Our geographic position may brim with attractions, but can the stranger seek them?' A hotel would be an 'indispensable and permanent utility'.[15] Tucker pushed ahead. A city-owned site was found on Church Street at the head of Queen Street hill and soldiers were set to work excavating the foundation. In August 1852, Governor Elliott set the cornerstone in place. For the next decade construction proceeded in fits and starts; by 1860 £3182 of city money had been spent on the project. Finally, in 1861 the Hamilton Hotel was ready, a two-storey building with 26 rooms, a grand balcony overlooking the harbour, elegant dining and reading rooms and its own water-closet system. The council was determined that the hotel would be operated 'on the American principle' and therefore called for tenders to operate the hotel in advertisements placed in the New York, Philadelphia and Halifax papers. In December 1862, David Crowell, an American hotelier with experience in New York and the Adirondacks, signed a five-year lease. The terms were liberal – $100 rent for the first year rising to $500 in subsequent years. But Mayor Tucker had

never seen the hotel as a profit-maker; it was instead a loss-leader for local tourism.

For the next forty years the Hamilton Hotel lived a precarious existence. Dedicated to a winter season, it had to be closed down each summer. Repairs were costly; improvements like electricity costlier. Proprietors came and went. All complained of 'considerable expense, hard work and no profit'. But by the early 1870s, the hotel had acquired a solid reputation as an American-managed place that pampered invalids. By 1875, there were 100 rooms; a west wing was added. When management of the hotel passed in 1886 to Walter Aitken, an American who boldly took a long-term lease, the hotel's success seemed assured. Aitken had the capital, built up by, among other things, installing the funicular railway on New Hampshire's Mt Washington, to sustain the hotel. He epitomised the early pattern of Bermuda resort hotel-keeping: winter hotels ably run by American managers whose loyal customers followed them each summer to resorts in the Adirondacks or on the Jersey shore. In 1893, Hamilton's mayor Thomas Dill wrote to Aitken to praise the hotel's 'efficiently' run operation, a feeling he said was also held by 'our American visitors'.[16]

By the 1890s, the Hamilton Hotel was the centrepiece of Bermuda's fledgling tourist industry. Sitting atop what was now called 'Hotel Hill', it had become a symbol of local pride, appearing on early postcards and advertised in New York papers. A young Canadian visitor in 1895 found it 'massive and inspiring ... white as snow, glittering in the sun' and superbly managed, 'for the Americans are really the model hotel-keepers of the world'.[17] Henry James Tucker's gamble of 1852 was beginning to pay a dividend. Local entrepreneurs began to take note. Small hotels – the Victoria, the Metropolitan, the Brunswick House and the American House – began to appear on Hamilton streets. On steamer day, touts in rowing boats yelled out hotel names to incoming passengers. At dockside, carriage drivers prepared for the scrum of disembarkation, when the poshest newcomers were whisked up Queen Street to the Hamilton and others dispersed to more modest establishments. Livery stables affixed themselves to hotels, ready to furnish transportation for adventurous visitors. In 1894, Aitken of the Hamilton helped to spearhead the drive to establish a cottage hospital in Hamilton. 'Bermuda is growing in favour as a winter resort,' he told the *Royal Gazette*, 'and visitors to these islands will feel safer with such an institution.'[18]

Bermuda's hotel industry reached critical mass in the mid-1880s when the Front Street merchants finally mustered sufficient courage to plunge in on their own. Harley Trott, head of the Trott & Cox steamship agency and supplier of meat to the British forces, issued a prospectus for a 200-room hotel worth £15 000 to be built on Pitt's Bay, just west of Hamilton harbour. His Bermuda Hotel Company boasted American connections,

Luxury on the waterfront – the Princess Hotel in 1886. (*The Bermudian*)

secured through Emilius Outerbridge, a Bermudian who represented the Quebec Steamship Company in New York. When Imperial defence regulations blocked the company's way by prohibiting 'aliens' from controlling large land holdings in the colony, Trott took control and pushed ahead with a smaller 70-room resort hotel. The much-publicised appearance of Princess Louise in the winter of 1883 gave the quick-witted Trott a name for his creation – the Princess. What made the Princess special was that it was Bermuda's first waterfront hotel; sea vistas, sailing and promenading were in vogue as the pleasure seekers began to outnumber the more sedate invalids. Trott's Princess was also a wooden structure, built to absorb the humidity. Its guests were offered the luxury of hot and cold running seawater, Belgian carpets, billiards and the comfort of knowing that the management was in American hands. Its first two managers carried credentials from two of America's leading summer resorts – the Mansion House in Williamstown, Massachusetts and Mizzen Top in Pawling, New York.

Through the late years of the century, the Hamilton under Walter Aitken and the Princess under Nathan Howe and the redoubtable Leo Tworoger (whom Howe had hired at Mizzen Top as a steward in 1885 and who would stay with the Princess until 1940) raced to outdo each other with telephones, electricity, elevators and fancy cuisine. Gradually, the Princess pulled ahead by opening the colony's first hotel golf course and its first hotel swimming pool and expanding to 104 rooms early in the new century. In these same years, Mark Twain fell into the habit of taking an afternoon stroll over to the Princess from the Pitt's Bay home of his friend the American consul, William Allen. On the hotel's spacious veranda, guests crowded around the great writer seeking autographs, yarns and pictures.[19] Like Twain, the Princess soon became synonymous in the American mind with Bermuda's charms.

Bermuda's hotels may have become charming, but its tourists still had to brave the rigours of the sea journey that opened and closed their vacation. Here too the colonial government pioneered improvement. As Bermuda's itinerant seafaring economy declined in mid-century and as export agriculture emerged, the colony required regular communication with the American east coast. The steam revolution made this possible. The constraint was that exporting produce was a highly seasonal trade, reaching fever pitch in the spring. For the rest of the year, a steamship operator would have to rely on the fickle flow of invalids, colonial administrators, mail and provisions to make regular visits to Bermuda pay. Bermuda consequently occupied a marginal place in North Atlantic shipping; in the 1840s the great Samuel Cunard's son visited the colony and directed that his Royal Mail Steam Packets begin stopping at St. George en route to the Bahamas and New York. In 1850, Cunard abandoned the

route, arguing that its passengers could find no accommodation in the colony, thus prompting soon-to-be-elected mayor Tucker to begin agitating for a municipal hotel.

As they had for the Hamilton Hotel, elements of the colonial commercial elite began arguing that it fell to the government to introduce regular steam communication with America. From the outset, a direct sea link with Britain was of secondary importance. Trade tended powerfully towards the United States; traffic to the mother country could be routed through New York and Halifax. In 1862, the Assembly passed an act to encourage 'steam communication' with New York; a year later a subsidy of £500 was offered. For the next half century, the size of the steamship subsidy and the performance of its recipient would be a brittle bone of contention in Bermuda politics. The tension always lay in devising a subsidy that would ensure reliable service without bankrupting the colony or delivering its trade into the hands of a monopolist. The hothouse Civil War economy temporarily solved Bermuda's shipping worries, but in 1869 the colony sought tenders for a subsidised service in the New York and Halifax papers. Only one bid emerged: the New York steamer *Fah Kee*, represented by local agents Trott & Cox, secured a contract to make weekly visits to Hamilton. For each round trip, they would collect £240.[20]

From the beginning there were problems. The ships were small and unreliable. The passengers were seasick; there was not enough capacity in the spring crop-moving season. The owners complained that even with the subsidy there was no profit. The Assembly squabbled with the Legislative Council over who had the political power to oversee the subsidy. Finally, in 1874 an unlikely deal was struck with the Quebec Steamship Company, which was aggressively represented in New York by Bermudian A. Emilius Outerbridge. The Canadian company promised a bigger contract steamer – the *Canima* with its twenty staterooms and ample cargo space – and a second ship in crop-moving season. For the next four decades, the Quebec Steamship Company boats would be a familiar sight in Hamilton harbour. They were 'all staunch iron boats' and their names – *Canima*, *Georgia*, *Trinidad*, *Orinoco*, to cite a few – became synonymous with the Bermuda trade in vegetables and tourists. The company's base at Manhattan's Pier 47 became Bermuda's gangplank to North America. In 1904, Quebec Steamship commissioned the first vessel tailor-made for the Bermuda run, the British-built, 5530 ton twin-screw *Bermudian*. Passengers complained that she rolled violently and that they arrived in New York reeking of onions, but she nonetheless had the grace and elegance of a modern liner. Despite all this, relations between the colony and the company were perpetually fractious. Practised monopolists themselves, Bermudians regarded the Canadian company as an 'octopus', whose subsidy was squeezing colonial coffers. 'It was *gold* that they wanted,' an Assemblyman ranted in 1877.

BEAUTIFUL BERMUDA
Delightful Throughout the Year

REGULAR SAILINGS FROM NEW YORK BY FAST STEAMSHIP
"BERMUDIAN"
ALL INFORMATION HERE
QUEBEC STEAMSHIP COMPANY
Operated by Canada Steamship Lines, Limited

The *SS Bermudian*, c. 1905. Like all the Quebec Steamship Company's vessels on the Bermuda run, it carried mixed cargoes of tourists and vegetables. As the first North American commercial champion of Bermuda tourism, the company used pamphlets and commissioned art to lure early tourists. (The Masterworks Collection, Bermuda)

'They would like to be treated according to the *golden* rule. Dollars and cents!' 'The Quebec Steamship Company and myself,' Outerbridge retaliated, 'are not autocrats. We do not own anything but the few steamers we have, and we cannot prevent other steamers coming in and taking away the plum. If it is a very big one, they would come and take it …'[21]

By the 1890s, the relatively smooth journey from Pier 47 to the foyers of 'Hotel Hill' had made a winter stay in Bermuda more enticing and less prone to chance and sea-sickness. Subsidies and municipal ownership had eased Bermuda into the modern age of travel. Given the narrow base of Bermuda politics, a canny observer would soon conclude that the colony's merchant class, uncomfortable with the risk of promoting tourism themselves, had simply shifted the burden onto the broader shoulders of the Assembly. Once the infrastructure was in place, they would begin to exploit tourism's potential. It is worth noting, for instance, that Harley Trott built his commercial base as the Bermuda agent for the Quebec Steamship Company and *then* branched into the hotel business in the mid-1880s once he could be assured of a steady flow of tourists from New York. As perennial members of Hamilton city council and as influential members of the Assembly and the Legislative Council, the merchants of Front Street proved most dextrous in diversifying their interests. Hamilton, for instance, repeatedly voted monies to deepen the two channels – Two Rock and Timlin's Narrows – at the mouth of its harbour. They did this not just to admit larger steamers and thereby expedite the flow of vegetables and tourists, but also to fatten their municipal revenues, since wharfage was their principal source of income. Similar mixed motivation underlay the building in 1871 of a causeway that linked St. George's parish in the east to the 'mainland'; defence of the colony was made easier, but so too were internal commerce and tourist excursions. Thus there were hints of tourist development in many of the colonial improvements of the late nineteenth century: the Halifax cable in 1891, a rudimentary telephone system in the late 1880s and electricity in 1904.

Around this emerging core of assured services and infrastructure, the Bermuda tourist industry began to grow. Now that there was an identifiable product, rudimentary advertising began. The Quebec Steamship Company, which had the most to gain, led the way. Shortly after winning its 1873 contract, it circulated 45 000 illustrated pamphlets 'among physicians, clergymen, merchants and all classes of the community' it imagined might yearn for some winter sunshine. *The Bermuda Islands: a Convenient, Picturesque and Salubrious Winter Resort* acknowledged that the colony was once 'unknown' and plagued with 'indifferent accommodation'. That was changing. Now 'New York and its myriad of hard worked brain-racked citizens' could lay down $30 in gold and step aboard the *Canima* and head for Bermuda. Shrewdly, the company retained

Thomas Cook & Son as its New York passenger agent to supplement Outerbridge as its general agent. Cook's had pioneered the art of all-inclusive travel in Europe, carrying well-heeled Englishmen as far afield as Italy and Egypt. In the 1870s, it had turned its attention to America, opening a New York office and offering tours to Florida, 'the land of flowers'. Bermuda followed. 'Within seventy hours' travel from New York,' the Cook's brochure promised, 'it is hardly possible to find so complete a change in government, climate, scenery and vegetation as Bermuda offers.'[22]

With advertising came product differentiation and market identification. The market was New York and the cluster of urbanised and industrial states around it. One 1883 Quebec Steamship brochure employed the testimonial approach. A work-weary New York literary editor boards the *Orinoco* and finds 'a refuge from new books, telegrams, fresh American plays and all the rest of it' in sunny Bermuda, where 'all the coughing, sneezing, epizootic population of the "States"' should now resort.[23] Conscious that Florida could make the same pitch, Bermuda began to differentiate itself from the Sunshine State. It was 'very unique', the *Bermuda Almanack* boasted. Florida and California were 'monotonous' and their weather was less reliable. Bermuda was 'British' and genteel, 'a place less stained by riot and disorder'. 'Frosts and violent changes, which occur so frequently in Florida and other southern states, are alike unknown in Bermuda,' the Princess Hotel promised its guests.[24]

Attracting visitors was one thing, *amusing* them was quite another challenge. Since the steamer came but once a week, early tourists were left with seven or fourteen days to fill with diversions. To a large degree the colony continued to rely on its overall ambience rather than specific attractions to amuse its guests. In 1883, the *New York Times*, for all its infatuation with Bermuda, conceded that there were 'few standard places here to go sight-seeing'. In 1880, the Bermuda *Almanack* rather arrogantly informed newcomers to the colony: 'There will be found a little of everything, and very much of nothing'. Restfulness and tranquillity nonetheless had to be interspersed with doses of stimulation. Enticing visitors to 'see the sights' also entailed moving them out of Hamilton, where the steamers and the hotels had tended to concentrate them. In a horse-drawn society that relied on narrow crushed coral roads, getting around was not easy. The twelve-mile trip out to St. George's was, for instance, a daunting outing, doubly so if undertaken as a day trip.

In the last decades of the century, Bermuda began to promote its 'attractions'. Livery stables provided carriages to carry the tourists out of town; ferries and rowing boat taxis were available at the Front Street wharves. Hardier tourists could be rowed across the harbour and then walk to the dunes and beaches of the South Shore. In the 1890s, bicycles

Late in the nineteenth century, livery stable owners began renting bicycles to tourists. The crushed coral roads drained quickly and were ideal for peaceful cycling – and local advertisers soon supplied road maps. (Bermuda Archives: No. 508)

brought new freedom. An American girl on a spring visit to Bermuda in 1897 recalled 'bicycle parties' of young tourists passing her grandparents' home in Flatts. Undaunted by the spectacle of one cyclist spilling into a puddle and then 'scraping the mud off his clothing with a bit of cedar', she too mounted a 'wheel' and rode to St. George's with Miss Trimingham, with 'grandma' following in a carriage.[25] By the turn of the century, one guidebook reported that Bermuda was a 'wheelman's paradise' with 'over one hundred miles of hard, smooth roads that are not probably surpassed the world over'.[26]

Tourists used their new mobility to inspect the island from end to end. 'The time has arrived,' one wintering visitor noted in 1895, 'for hundreds of excursionists, dressed in pea-jackets and telescopes [sic] and accompanied by umbrellas, to inflict themselves on the quiet denizens of these islands and disturb the calm monotony of Bermuda life.'[27] Harrington

Sound with its enclosed seawater lake was a popular destination. Here they could stop at the Walsingham crystal caves, rent a torch and descend from the 'glorious sun' into a world of 'sparkling crystals'.[28] Close by was Devil's Hole, a sink-hole in the coral in which fish teemed. The prim American artist Jane Eames reported a 'delightful drive' to the Sound in 1875, followed by a titillating visit to Devil's Hole, 'a shockingly bad name', with its 'horrid' groupers 'with thick, red lips, and great teeth'.[29] There were also outings to St. George's, universally reported as historically quaint but backward. Tucker's Town beach with its Natural Arches of coral also drew the intrepid. The Gibb's Hill Lighthouse in Southampton, an iron structure built in 1846, offered a grand view of the whole colony and a chance to inspect a bit of Imperial engineering wizardry. When it opened in 1879, the St. David's Light became a beacon for both navigation and tourism, its guest book soon bearing the names of British princes and American princes of commerce. On calm days, there were boating excursions to craggy North Rock, where pictures were taken and picnics eaten. Nearer shore, large rowing boats were equipped with glass panels so that tourists could discover the mysteries of the coral reef. In 1896, the Assembly voted monies to establish a Public Garden near Hamilton, where the colony's agricultural and horticultural potential could be developed and displayed to visitors. Late in the century, as Bermudians and visitors alike began regarding the sea as something for swimming in and not just walking beside, White's Island in Hamilton harbour was leased by the corporation as a bathing and picnic spot. A few years later an aquarium opened on nearby Agar's Island.

To bring order to these attractions, guidebooks began to appear. The *Bermuda Almanack* in the 1870s offered visitors a 'Bermuda Itinerary' with three- and ten-day suggested patterns of seeing the colony. By 1880, this had become a regular supplement, *The Tourist's Handy Guide to Bermuda*, which came laden with lists of hotels, guest houses, livery stables and steamer schedules. As bicycles freed the tourist to explore the island on his own, the first crude maps of the colony appeared, showing the most picturesque way to St. George's or the South Shore. Fully-fledged guidebooks followed. In the mid-nineteenth century, European publishers like Karl Baedeker and John Murray had shown the need to prepare travellers for their journeys with guidebooks. These combined practical advice with the preconditioning of tourists for what they were about see. Bermuda soon fitted this pattern. Matthew Jones' 1876 *The Visitor's Guide to Bermuda, with a Sketch of its Natural History* was clearly written to project Bermuda's winter salubrity to an east coast American audience. Playing to the nineteenth-century fascination with nature, Jones enhanced his discussion of hotels and climate with detailed lists of local molluscs, birds and insects. *Stark's Illustrated Bermuda Guide*, published in 1890, also emphasised the

colony as 'a quiet, winter home', but downplayed the naturalism and added much about the island's social and political arrangements. Other guidebooks followed. An English journalist, John J. Bushell, was said to have brought the first typewriter to the island and used it in 1895 to produce *Bushell's Handbook to Bermuda*, a decidedly boosterish guide to the 'most equitable climate in the world'. A few years later, a young American, Euphemia Bell, sojourned in the colony and then returned to New York to produce *Beautiful Bermuda*, a more lyrical guide that abounded with roseate prose about the colony's 'soft, balmy, sweet-scented air'. All these guides were periodically updated and found a ready place in American, Canadian and British bookshops.

Guidebooks were complemented by the appearance of other services geared to tourists' needs. Shopping improved, somewhat. At the corner of Reid and Burnaby Streets in Hamilton, S. Nelmes established himself in a turreted emporium called The Tower and advertised his ability to supply everything 'from a pin to a piano'. Nelmes also co-published Bermuda guidebooks with London, Boston and New York publishers. The Tower became Bermuda's first informal visitors' centre, a crossroads for social gossip and promenading. But, if The Tower didn't have it, it didn't exist in Bermuda. Local photographers began plying their trade to tourists. N.E. Lusher & Sun (sic – a deliberate pun) on Front Street furnished visitors with photographic vistas of the colony and could be commissioned to take portraits against these backdrops. Photo souvenirs were soon joined by other distinctively Bermudian mementoes. Bermuda cedar and the white lily it was profitably exporting to America each spring were favourite motifs. At the Woman's Work Exchange on Reid Street, a tourist of the early 1890s could choose from a 'selection of fancy articles of Bermuda make – hand made laces, wool work, palmetto and shell work, paintings of Bermuda scenery, cakes, hot sauces, etc.', all made by local women. A holiday in Bermuda was thus acquiring a material distinctiveness that enhanced the aesthetic pleasure of visiting the place. Souvenirs allowed tourists to retain their memories of Bermuda and, when displayed or given as gifts, to project that pleasure into the minds of others. When the Washington Postal Congress permitted the mailing of privately produced postcards in 1897, another powerful means of projecting the aesthetic was put at Bermuda's disposal. Nelmes of the Tower jumped at the opportunity and was soon selling hand-tinted postcards – 'Steamer Day' or 'An Excursion to Devil's Hole' – with a message section on the back. Each one of these despatched abroad became a kind of miniature billboard for the island's charms.

Thus, by the early 1890s, Bermuda had a 'tourist trade'. It was not yet in the league of Palm Beach or Nice; its emergence had been slow and haphazard and had required a good nudge from colonial and municipal

'Steamer Day', an early colour postcard. (Bermuda Archives: Albury Collection)

politicians. There were still conspicuous gaps in its fabric. It was unduly crowded around Hamilton, the colony's port, and the tourists only came in the winter. The numbers were still small. The records of Trott & Cox, the agents for the Quebec Steamship Company, provide a reasonably accurate picture of first-class arrivals from New York, Bermuda's all-important feeder point. In the winter of 1879–80, 429 walked down the gangplank. A decade later, there were 1425 and by the last winter of the century there were 2192.[30] In 1883, the *New York Times* estimated that a thousand Americans came to Bermuda, most of whom came for extended stays to 'escape the cold'. In 1888, the American consul reported to Washington that the number of tourists 'coming to Bermuda from the United States and other countries is constantly and steadily increasing'. The winter of 1887–8 had seen 1416.[31]

In the decades straddling the turn of the century, two factors would combine to turn these small numbers into a real tourist boom: Bermuda's fabled agricultural sector began to falter and the colony's merchant class finally began to apply their creative skills in earnest to exploiting North Americans' growing predisposition to visit the 'isles of rest'. Since the Civil War, the leading sector of the Bermuda economy had been the export of spring produce to American greengrocers. By late April each year, stevedores along Front Street laboured hard to cram crates of onions, potatoes, beets and celery into the holds of the contract steamer. On 17 May 1899, for instance, the *Pretoria* left Hamilton with a record 64 590 crates of succulent Bermuda onions packed aboard. Forty-eight hours later, the *Pretoria* docked at Pier 47. Within days, the *Royal Gazette* proudly reported that this record cargo had fetched £7946 when consigned to Courtlin, Golden & Co on New York's William Street. Small wonder that Bermudians were nicknamed 'onions'. But the 'onions' soon discovered that they had an Achilles heel.

Bermuda spring vegetables only commanded handsome prices *if* they arrived in New York before other early vegetables grown in Florida and California. Bermuda's window of opportunity opened in mid-April and closed in mid-May, after which the price of new potatoes, onions and other winter-grown vegetables dropped steadily. A poor winter in Bermuda, a warm one in Florida or improved transportation across the continent could all undercut the colony's advantage. Furthermore, wily American farmers began to copy the Bermuda strain of onion – a sweet, translucent delicacy – to such an extent that the term 'Bermuda onion' soon became a generic on greengrocers' shelves. To this day, Bermudians trot out the myth that a town in Texas actually changed its name to Bermuda in order to fox northern consumers. The onion patch's declining competitive advantage was further crimped by America's growing protectionism; the 1890 McKinley tariff slapped heavy duties on Bermuda

produce before it even left Pier 47. Thus by the 1890s, cracks were appearing in Bermuda's once vaunted export trade in vegetables. Agriculture's export earning power in fact peaked in 1890 at £120 075; onions peaked in 1897 at £84 112 and then steadily slumped. By 1913, 65 074 crates of onions fetched a meagre £8126. By 1926, there were only 140 acres of onion fields left in the colony. Bermuda's window of agriculture opportunity did not suddenly slam shut, but it slid downwards without pause. Well into the 1930s, the chill-rooms of the contract steamer continued to carry Bermuda vegetables to American larders, but by then their economic impact on the colony was marginal.[32]

By the end of the century, there was a dawning realisation that the colony again faced a dramatic shift in its economic orientation. Just as seafaring and shipbuilding lost vitality in mid-century, so too was agriculture beginning to wither. For a small, rocky mid-Atlantic island barren of natural resources, such shifts carried galvanic consequences. Instinctively, Bermudians realised that they must reconnect with some new external market or lose their colonial wellbeing. In 1895, Governor Thomas Lyons sensed the mood of unease when he opened Parliament: 'Though the outlook for the agricultural classes of the colony appears gloomy at present, in other directions the prospects seem brighter; for I observe that the popularity of these islands as a winter resort appears to be increasing. A failure in one resource makes it the more important that the other resources of the colony should be carefully guarded.'[33] Captain Nathaniel Vesey, an Assemblyman from Devonshire who owned land and had sailed the seas, caught the mood more picturesquely: '... they say that the people of Florida live on fish during the summer months and on Yankees in the winter time – and they might say that the people of Hamilton live on farmers during the spring and on the Americans during the winter ... We have arrived, as it were, at a parting of the ways.' The facts, Vesey concluded, were 'staring us right in the face'.[34]

The intuition that tourists must replace onions was never, of course, captured in a manifesto or an overnight departure in policy. Instead, it percolated through the colony's merchant elite in the early years of the new century. Eventually it would find institutional form in the 1913 creation of the Trade Development Board. In the interim, the colony and its inveterately pragmatic commercial leaders groped to find a means of building what they knew to be the colony's tremendous aesthetic potential for tourism – a potential that had already borne small but promising results by the 1890s – into a viable commercial strategy.

Like a beacon, the aesthetic strengthened in the new century. New American faces appeared in the colony and lent their prestige to the fledgling tourist trade, and at the same time helped to define its values further. In 1899, America's greatest nineteenth-century nature painter,

Winslow Homer, *Inland Water*, 1901: a powerful projection of Bermuda's salubrious climate and soft aesthetic, and typical of the artist's Bermuda work. It is now in the Bermuda Masterworks Collection, a foundation dedicated to restoring the colony's visual heritage. (The Masterworks Collection, Bermuda)

Winslow Homer, arrived in Bermuda and settled into a guest house in secluded Somerset. Homer had won initial fame as a visual chronicler of the carnage of the Civil War, but had then turned to nature. By the 1890s, he was seeking out places where colour and light played boldly against the landscape; the emerald seas, pink beaches and vivid vegetation of Bermuda delighted him. Typical of Homer's Bermuda canvases was *Flower Garden and Bungalow, Bermuda*: the long horizontal of the sea transfixes the viewer while the green of the bay grape and the white-roofed cottage provide an unmistakably Bermudian scene. Other foreign painters – like E. Ambrose Webster and Hannah Rion – discovered the same power of light and colour in Bermuda, but none so effectively as Homer. A return visit in 1901 added to his stock of Bermuda canvases. Twenty-one of them were exhibited at the 1901 Pan American Exhibition and others were sold into the drawing-rooms of America's affluent by Knoedler & Co. in New York.[35]

If Homer emphasised Bermuda as a garden of colour and light, other American visitors reemphasised its tranquillity and added a touch of social exclusivity. In 1911, the English-born writer Frances Hodgson Burnett arrived at the Princess Hotel and soon after rented a home in Bailey's Bay on the quiet north shore of the colony. Burnett had found fame in the United States as a children's writer. Her 1886 *Little Lord Fauntleroy*, a sentimental tale of boyhood, only prepared the way for the immense popularity of *The Secret Garden*, published in 1911 and destined to be one of the greatest evocations of the wonders of childhood ever written. *The Secret Garden* brought wealth and the pressures of fame. Burnett thus turned to Bermuda as her own secret garden. At Bailey's Bay, she planted a huge rose garden. 'They will bloom,' she wrote to a friend, 'when New York is seventy degrees below zero and London is black with fog or slopped with mud and rain. And on all this island there is not a motor or a train, or a smoking, rattling thing.'[36]

Such sentiments were shared by another prominent American visitor. On 14 January 1907, the *Bermudian* landed Woodrow Wilson, the president of Princeton University, in the colony. Within hours he was writing to his wife from his room in the Hamilton Hotel: 'It is mid-June here, warm and soft and languid, the white limestone houses and white streets shining intensely in the vivid sun and everybody in summer garb'. Wilson's attention had probably been drawn to Bermuda by Francis Landey Patten, his Bermuda-born predecessor as Princeton president. A staunch Presbyterian, Patten was Bermuda's most famous native son and had returned to Bermuda in retirement; his son Jack had met Wilson at dockside. Wilson came to Bermuda on doctor's orders in an attempt to cure a bout of neuritis brought on by academic in-fighting at Princeton and to draft a series of public lectures. Presbyterian will-power kept Wilson at his

The cover of Bermuda's first official guidebook, published in 1914. Its pastel colours, together with the book's gentle text, projected the colony's soft, un-American aesthetic: 'a wholesome, noiseless country, without factories, railroads, trolley cars and automobiles'. (Bermuda Archives)

desk every morning, but in the afternoons he became a tourist. He found Bermuda 'one great garden set for pleasure'. He loved the colours: '... such soft blues and greens and greys and pinks I have seldom seen, or such tenderness and harmony of colour everywhere'. He explored on a rented bicycle, in a glass-bottomed boat and on foot. 'Our excursions,' he reported to his wife, 'have now covered practically the whole length and breadth of the islands ... Innumerable by-ways, quaint and secluded as anything in the old world, yet await exploration ...' Thus soothed, Wilson's health returned; 'all big affairs' in Bermuda seemed 'remote and theoretical'. He compared the colony favourably to Palm Beach. Return visits in 1908 and 1910, again without his wife, seemed to indicate that he preferred Bermuda, principally for its sense of 'detachment'.[37]

In Bermuda, Wilson gravitated into the small, jolly and affluent community of wintering Americans. Mark Twain presided over this group, with American consul William Allen's Pitt's Bay home or the Princess Hotel frequently serving as its stage. Dinners, cotillions, picnics and afternoon teas allowed Americans to mingle with British officers and the colony's leading families. The Governor's Wednesday afternoon tea, replete with croquet and regimental band, was a favourite American pastime in Bermuda. 'The conversation,' one guidebook advised of these teas, 'may, or may not, be indifferent; you may hear the household gossip, or talk about India during the rebellion, about China, the scenery of Jamaica, the gay life at Malta, or of dear old England.'[38] In this convivial atmosphere, Wilson slipped into a friendship with an American grass widow, Mary Peck. Peck was rich and vivacious, and had been wintering in Bermuda since 1892. Every autumn she escaped her husband, a New England textile magnate, by coughing in front of her doctor. 'Ah, the Bermuda cough!', he invariably responded and sent her home to pack for the 'isles of rest'. Peck was immediately smitten with the earnest and idealistic college president. Wilson reciprocated, and they soon found themselves sharing walks and confidences on the South Shore beaches. Wilson revealed that he was wrestling with his future. Politics beckoned: the governorship of New Jersey and possibly a run at the presidency. 'The life of the next Democratic President', Peck remembered Wilson saying one day on the beach, 'will be hell – and it would probably kill me'.[39] The Peck-Wilson relationship has long fascinated historians: was it a platonic affair or was there a deeper betrayal of partners left behind in the United States?[40] Wilson's letters to Peck in 1910 talked of a return visit to a bougainvillaea-covered cottage on the South Shore where they had once met alone: 'All my pulses throbbed as I entered and lingered in it'.[41] There is no conclusive evidence. Nonetheless, rumours of the affair lurked in the background throughout Wilson's rise to the White House. In later years, Wilson admitted (possibly under threat of blackmail from a jilted Mrs Peck) to his

Mary Peck's rented Bermuda home. Woodrow Wilson (by the pillar), Mrs Peck (next to him, laughing) and others gather round the seated Mark Twain. (Bermuda Archives: Bermuda National Trust Collection: P.A. 2148)

soon-to-be second wife that he was 'ashamed' of the Peck liaison, and described it as 'a passage of folly and gross impertinence'.[42]

Whatever the morality of Wilson's conduct, his affection for Bermuda served to further its image in America as a 'lotus land', to use Wilson's own description. Having won the presidency in 1912, Wilson took his family to Bermuda so that he could collect his thoughts before the inauguration. There, in a home lent him by Mrs Peck, the president-elect pondered his cabinet and policies. He asked reporters to respect his privacy and when a photographer failed to do so Wilson called him down as 'no gentleman' and threatened to 'thrash' him if he returned.[43] Later, the president-elect went bicycling with his daughters.

Like Twain, Homer and Burnett, Wilson had drawn Bermuda deeper into America's consciousness. They had conditioned Americans – wealthy, eastern, urban white Americans – into thinking of Bermuda as their kind of place. There was no better form of advertising. A prominent American advertising executive later detected this leverage in his own discovery of the colony:

> ... I entertained for a long time the wrong impression of Bermuda. I knew its location, area, population and productions, but I held the very common idea that it was a flat, sandy and uninteresting place, with a climate too cold in winter for much comfort. As long as I held this conviction, I was proof against any advertisements ... Then I saw by accident a picture of Mark Twain under a palm tree, fan in hand, and a picture of the winter home of Mrs. Frances Hodgson Burnett. I felt that I knew these people. It was as if they said: 'We are here because we find Bermuda interesting and delightful'. It was another story entirely. They had no axe to grind ... made further inquiries. Otherwise, I should have been spending the past six months in California.[44]

With recognition and numbers both rising, Bermuda's merchants realised that tourism could no longer be left to happenstance. The industry needed shaping and coordination like any other economic activity. One man in particular seemed to realise this more than anyone else. Goodwin Gosling was a jack of many trades. Born in 1873 into a prominent family of liquor and provision merchants, Gosling grew up to teach at the colony's prestigious Saltus Academy, and then in 1895 was appointed assistant clerk of the Assembly. Friendship with Twain and the American naturalist Addison Verrill made him aware of the island's tourist potential. In the spring of 1906 another wintering American, the publisher Frank N. Doubleday, drifted into Gosling's circle. Doubleday owned a string of prominent periodicals, including *World's Work*, *The Garden Magazine* and *Country Life in America*, and he doted on Bermuda. He was convinced that advertising

Celebrity golf, c. 1907: Mark Twain and Woodrow Wilson practise their putting on the lawn of the American Consul's home outside Hamilton. (Bermuda Archives: National Trust Collection: P.A. 2148)

was the handmaiden of tourism. Together with his New York sales staff, Doubleday schemed how to 'turn the searchlight of publicity on poor little Bermuda out there in the solitudes of the Atlantic'. The 'liberal use' of advertisements in leading magazines and national weeklies was the

key, followed by a 'beautifully printed, well illustrated booklet'. Then each 'satisfied visitor' would become 'a walking advertisement' for the colony. To succeed, such a plan needed 'some definite statement' of what Bermuda's merchants could do to support tourism. Gosling listened and then acted.[45]

Late in 1906, the Bermuda Tourist Association was born. Intended as a clearing house for information useful to tourists, the association was backed by those who might profit from the trade's progress. Members included the Quebec Steamship Company, the colony's two banks, Gosling Brothers liquor merchants, the photographer N.E. Lusher, *The Royal Gazette*, commission merchants like Hand and Trott and Front Street retailers like H.A. & E. Smith. Over £200 was collected in fees and an office rented on Queen Street across from Par-la-Ville Park and just up from the steamer sheds. A sign was painted and John Bushell employed as a hired pen. Gosling became the honorary secretary. The association offered tourists 'gratuitous services in connection with any information desired relative to Bermuda, but does not act as an Agency'.

The association's goal was to project the colony's welcoming image into North America and then to smooth the tourist's way into the colony. A slogan was adopted: Bermuda was 'The Land of the Lily and the Rose'. To clinch the point, the association's envelopes were adorned with advertising copy. Bermuda was only 704 miles from New York. It was 'semi-tropical', had 'no malaria' and was 'not in the West Indies'. There was 'no heat prostration in summer' and it had 'flowers all year round'. It had 'bathing, boating, fishing, cycling, driving, picnics' and year-round sports. It was 'British'. Not trusting to envelopes alone, the association paid $1000 for a special edition of the *New York Commercial* in February 1907. This was Bermuda's first deliberate effort to advertise itself abroad. Negotiations followed for the mailing of the Bermuda supplement to over 40 000 'wealthy people' whose incomes were said to be in excess of $10 000.[46]

Gosling and his friends had got the message, the means and the market right, but that was about all. The association soon ran out of money. It had also picked a bad year to launch its campaign: a financial panic gripped Wall Street in 1907 and temporarily suppressed wealthy America's appetite for travel. Most importantly, the association failed to realise that tourist promotion was more than a one-shot affair and that it was more than the simple provision of information. Success in tourism depended not just upon product recognition, but on control of the product itself. It required a long-term strategy, hands-on attention to infrastructure and deep pockets. As a voluntary grouping, the Bermuda Tourist Association could generate none of these. By early 1908, it was dead. But Goodwin Gosling – the father of modern Bermuda tourism – would learn from his mistakes.

A turn-of-the-century military parade at Prospect Camp. Such parades, along with regimental music, admirals' barges and gala balls, emphasised Bermuda's Britishness and appealed to Americans denied an 'imperial' life. (Bermuda Archives: P.A. 2243)

Ironically, the demise of the association ushered in the first real boom in Bermuda tourism. It was a pell-mell affair, triggered by America's again resurgent economy, expanded hotel capacity at the Princess and Hamilton Hotels, new hotels in St. George and, for the first time, on the South Shore, and the Quebec Steamship Company's vigorous advertising of winter excursions to Bermuda on its sleek *Bermudian*. The numbers astonished the colony and removed any lingering sense that North America's infatuation with Bermuda was a passing fancy. In 1908, 5418 tourists came to the colony. In 1909, the total jumped to 12 509 and then to 15 530 in 1910. In the wake of a staggering 27 049 arrivals in 1911, the Governor was quick to inform the Assembly that the 'new stage of development upon which Bermuda now entered may be summed up in the fact that the persons visiting these Islands during the year actually outnumber the total resident population'.[47] Perhaps more convincing to legislators was the way in which tourism resuscitated the colony's finances, which had been depressed by falling agricultural exports. Not only did revenues climb from £57 068 in 1908 to £83 629 in 1912, but the colony's cash balance and investment fund were generously swollen.[48] Here was an industry that could pay its way.

There were disturbing elements to the tourist windfall of 1908–12. The influx was unregulated, largely driven by Quebec Steamship's aggressive selling of cheap package deals to the colony. At the height of the spring season, the hotels were full to overflowing and the excess had to be accommodated on steamers anchored in the harbour. There were even disconcerting stories of people sleeping in Victoria Park. Worse still, some of the new tourists were the wrong sort of people: New Yorkers in search of a cheap holiday and oblivious to the decorum and charm that the Twains and Wilsons so prized in Bermuda. Wilson, himself a visitor in these years, warned of 'reckless tourists who would care nothing for local opinion'.[49] A joke circulated on Front Street that many of the new tourists arrived with a dollar and a collar and in the course of the next week changed neither.

The 1908–12 tourist boom was thus a mixed blessing. But it pointed the way to the future in two fundamental ways. It hardened the resolve of Gosling and his merchant friends to take control of the industry, to bind its working elements, from steamers to hotels, into a cohesive, shapeable entity that could be managed with relatively predictable outcomes. Their opportunity came in 1913 when the American economy slumped and tourist arrivals slipped to 22 918. Fearful that its new-found goose might stop laying golden eggs, the Assembly eagerly approved a motion from a young merchant member from St. George. Stanley Spurling operated a grocery and livery business and was a tireless booster of his parish. The opening of the St. George Hotel in 1907 had given the town a first

Front Street fashion: stylishly-dressed tourists strolling along Front Street in 1911. American holiday-makers brought with them their social pretensions and, in consequence, New York's latest fashions. (Bermuda Archives: P.A. 447)

glimpse of tourism's potential; Spurling would fight to keep it. He proposed a select committee of the Assembly 'to consider the decline in the volume of this Colony's tourist business and to report to the House what measures it is advisable to adopt in order to foster and increase this business'. The committee worked hard and fast. A delegation headed by Gosling went to New York to interview the steamer companies. In less than a month, the report was ready. Tourism was in trouble, it bluntly concluded, because of inadequate steamer service and the lack of systematic advertising.[50] The challenge was to get the 'wealthy class' to return.

The Assembly acted without hesitation and in July 1913 created the Trade Development Board as a kind of master control room for Bermuda tourism. The board was charged with resuscitating Bermuda agriculture and extending its tourism. To do this its members were invested by the Governor with wide powers to make contracts, hire experts and spend government money. While dependent upon the Assembly for its annual budget, the board implicitly understood that it would enjoy great discretion in pursuing its mandate. When Goodwin Gosling, its first chairman, entered the Trade Development boardroom first, on 27 August 1913, he saw nine familiar faces. With names like Spurling, Butterfield, Bluck, Ingham, Wilkinson, Pearman, Smith and Darrell, there could be little doubt of their mercantile prowess. Bermuda tourism was open for business.

The 1908 boom left a second, less tangible but far more indelible legacy on Bermuda tourism. The new masters of Bermuda tourism instinctively knew that they could not forsake the aesthetic that had made their island attractive in North American eyes. Their thinking was conditioned by the reality of Bermuda's postage-stamp size – 21 square miles – and the realisation that large-scale tourism in the colony could never be cordoned off from the rest of its society. Strangers came to Bermuda *because* of its ambience, not in spite of it. From the outset, therefore, the Trade Development Board determined to make the industry and the society that supported it conform to the aesthetic. Bermuda would not be like West Palm Beach; it would not be an artificially created community, cut out of virgin land and sealed from the society surrounding it. Nor would it be a Niagara Falls, an island of aesthetic aberration that bore no relation to the society around it. Instead, Bermuda would *fuse* genuine elements of its aesthetic into the living fabric of its society. It would shape and preserve the colony's society and landscape to oblige the sensibilities of its most promising tourist market – wealthy, east coast North Americans. The goal was a reciprocity in which Bermudians groomed their island paradise to satisfy outsiders' expectations while outsiders played their part by comporting themselves according to the colony's aesthetic. Those who did not conform to this pattern – Woodrow Wilson's 'reckless' compatriots – were not welcome. Bermuda wanted 'visitors', not 'tourists'.

Par-la-Ville Gardens, by Catherine Tucker. She and her sister Ethel projected Bermuda's aesthetic abroad with their pastel renderings of lanes, gardens and blue waters, which appeared on millions of postcards and notecards sent home by tourists. From 1909 to the late 1950s, the sisters sold their art and other souvenirs from the Little Green Shop on Queen Street. (Duncan McDowall)

The impulse to groom Bermuda into an elysium for patrician Americans was evident even before Goodwin Gosling nursed the Trade Development Board to life. With the new century, Bermuda, like America, discovered the automobile. By 1905, the colony had a few horseless carriages chugging along its coral roads. The Assembly responded to this incursion by passing the Motor Car Act of 1905: automobiles were to proceed no faster than 6 mph and must be closely supervised on the road. A motorised bus soon appeared on the island and was nicknamed the 'Scarlet Runner'. The Runner carried passengers on the island's main trunk roads, principally to the South Shore and St. George. But livery stable operators complained that it frightened horses and created pollution. The tourists soon joined the chorus. There were motor buses in Boston and New York; 'rapid transit' was not why they came to Bermuda. The matter came to a head in early 1908 when, egged on by Mark Twain, Woodrow Wilson drafted a petition to the Bermuda Assembly demanding that automobiles be banished from Bermuda. Automobiles in Bermuda were an affront 'to persons of taste and cultivation'. They were 'dangerous' on the colony's narrow roads and they eroded the 'quiet and dignified simplicity' of life in Bermuda. They would encourage 'reckless tourists' to come. 'This is one of the last refuges,' the petition concluded, 'now left in the world to which one can come to escape such persons.' Wilson and Twain circulated the petition around Hamilton's hotels and, 111 signatures later, despatched it to the *Royal Gazette*.[51]

The threat was clear. Get rid of the automobiles, or the tourists would look elsewhere for their peace and quiet. The protest was music to the livery stable owners' ears. A month later, the 1908 Motor Car Bill was introduced to the Assembly. Its sponsor, Clarence Peniston, trotted out the noise, safety and livery stable arguments, but only as a prelude to his clincher: 'I think a great many people from America come here to get rid of these things'.[52] The Act would ban all motor cars from Bermuda, leaving it a horse-drawn society. By May, it was law, narrowly approved by both houses of the legislature. The Act would remain in force until 1946.

There were other things that visitors did not like seeing in Bermuda. In 1886, for instance, Lady Brassey complained that the 'hideous [bill]boards of enterprising tradesmen' had blighted the islets of Hamilton harbour.[53] Many locals concurred. In 1900, a young Bermuda lawyer, Tom Dill, married a New Jersey girl and, predictably, headed for Niagara Falls on honeymoon. What he saw appalled him: '... [F]lorid billboards advertising patent medicines, soft drinks, tobacco ...' ruined one of nature's wonders. 'If someone doesn't do something about it,' Dill told his new bride, 'in time Bermuda will be ruined by this sort of thing. If it doesn't continue to offer visitors an escape they won't keep on coming.'[54] Dill determined to be that 'somebody'. A decade later, as a member for Devonshire parish, he

Another of the Tucker sisters' enterprises, the tea garden on Pitt's Bay Road became a magnet for tourists; writers like Mark Twain and Charles Dudley Warner mingled with the likes of the Prince of Wales. When World War I came, the sisters briefly moved the tearoom to Ontario's Muskoka Lakes and then to Lake Placid. (Bermuda Archives: Leonard Album)

introduced the Advertisements Regulation Act of 1911 into the Assembly. When passed, it banned all 'unsightly advertisements' from the colony. Merchants could advertise in their shop windows, but that was all. There were to be no 'sandwich men', no billboards, no commercial flags or even kites carrying commercial messages. Front Street was to look like a nineteenth-century English high street. To this day, there are no neon signs in Bermuda.

One of the first acts of the Trade Development Board was to commission the 'beautifully printed, well illustrated booklet' which Frank Doubleday had urged on the colony way back in 1906. In 1914, the colony's first 'official tourists guide book' appeared. Entitled *Nature's Fairyland*, it spoke of 'a wholesome, noiseless country, without railroads, trolley cars and automobiles' awaiting Americans in the mid-Atlantic where 'ice-laden winds' could not reach them.

The tourists thus got the Bermuda they wanted. 'Nature's Fairyland' awaited them.

REFERENCES

1. Jane E. Eames, *Letters from Bermuda*, Concord, NH, 1875, 4.

2. J.W. Boddam-Whetham, *Roriama and British Guiana with a Glance at Bermuda, the West Indies and the Spanish Main*, London, 1879, 2

3. Mary E. Child, 'Bermuda's Sunny Isles', *Godey's Magazine*, May 1894, 558.

4. Julia Dorr, *Bermuda – An Idyl of the Summer Islands*, New York, 1886, 6–7.

5. Lady Brassey, *In the Trades, the Tropics and the Roaring Forties*, London, 1886, 50.

6. F. Anderson, L. Salamo & B. Stern, eds, *Mark Twain's Notebooks and Journals*, Vol II, Berkeley, 1975, 29–30.

7. A.B. Paine to W.H. Allen, 3 Jan. 1910, Allen Papers, BA.

8. Matthew J. Jones, *The Visitor's Guide to Bermuda with a Sketch of its Natural History*, London, 1876, 117.

9. Laffan to Colonial Secretary Carnarvon, 30 Oct. 1878, Governor's Despatches, CS 6/1/12, BA.

10. Edward N. Akin, *Flagler: Rockefeller Partner and Florida Baron*, Kent, Ohio, 1988, 159.

11. Mary Blume, *Cote d'Azur: Inventing the French Riviera*, New York, 1992, 37.

12. C.A. Allen to John Davis, Asst. Sec. of State, 10 July 1883, US Consular Reports, T–262, National Archives, Washington.

13. See: Jean de Chantal Kennedy, *Biography of a Colonial Town – Hamilton, Bermuda 1790–1897*, Hamilton, 1962.

14. Until 1970, Bermuda employed the British system of pounds, shillings and pence. Historical conversion of pounds to dollars is difficult, but historians agree that a conversion of one pound to five US dollars provides a good yardstick. After 1970, Bermuda adopted a decimal dollar system pegged to the US dollar.

15. Corporation of Hamilton Minute Book, 27 Feb. 1851, 29 Dec. 1852 and 16 Feb. 1854, BA.

16. *Ibid.*, 14 April 1893.

17. 'Placidia', *Letters from Bermuda*, Toronto, 1895, letter #2.

18. 27 March 1886. See: Ronald Williams, *Care: A Hundred Years of Hospital Care in Bermuda*, Hamilton, 1994.

19. Marion Schuyler Allen, 'Our Friend Mark Twain', n.d., Allen Papers, BA.

20. Details of the steamship contracts are best followed in the Minutes of the Privy Council of Bermuda, EXCO1/1/22–26, 1850–92, BA.

21. House of Assembly *Debates*, 1877, 27; *The Royal Gazette*, 1 July 1884; and 'Address by A.E. Outerbridge to the Bermuda Shippers and Growers Association', n.d., Outerbridge Papers, Bermuda Maritime Museum Archives.

22. House of Assembly, *Debates*, 1877, 22; *Cook's Excursionist and Tourist Advertiser*, American edition, Dec. 1877 and 15 Oct. 1879; and files from the Thomas Cook Archive, London. See: Piers Brendon, *Thomas Cook – 150 Years of Popular Tourism*, London, 1991, Ch. 9.

23. *Winter Resorts in Southern Seas*, New York, c. 1886, 6–10.

24. The *Bermuda Almanack*, 1887 and 1897; and Aardvark Advertising, *A Century of Royal Hospitality: The Princess 1884–1984*, Hamilton, 1984.

25. The Journal of Myra Genevieve Abrams, 29 April 1897, BA. Abrams was the granddaughter of Charles Allen, the American consul.

26. *Stark's Illustrated Guide*, Boston, 1902, 140.

27. 'Placidia', *op. cit.* at note 17, letter #37.

28. 'A Visit to Walsingham Caves', *The Argosy*, Oct. 1871, 311–5.

29. Jane E. Eames, *Letters from Bermuda*, Concord, NH, 1875, 30–1.

30. Hereward T. Watlington, 'Beginnings of Bermuda's Tourist Trade', *Bermuda Historical Quarterly*, Autumn 1972, 213–7.

31. 'Report of Henry W. Beckwith, Consul', 30 June 1888, Report #106, US Consular Reports, Vol #30, National Archives, Washington.

32. See: Duncan McDowall, 'State of the Onion', *Bermuda*, Spring 1996, 28–33.

33. *Debates of the House of Assembly*, 29 May 1895.

34. *Ibid.*, 4 Jan. 1899.

35. See: Patti Hannaway, *Winslow Homer and the Tropics*, Richmond, Virginia, n.d., 103–18; and Gordon Hendricks, *The Life and Work of Winslow Homer*, New York, 1979. Webster (1869–1935) began visiting Bermuda in 1910 and Rion (1874–1924) took up residence in Warwick parish early in the century.

36. Ann Thwaite, *Waiting for the Party: The Life of Frances Hodgson Burnett*, London, 1974, 227.

37. All Wilson quotations are taken from his letters to his wife Ellen, written on 14, 15, 22, 26, 30 Jan. 1907, in Arthur S. Link, ed., *The Papers of Woodrow Wilson*, Vol 17, Princeton, 1974, 1–27.

38. *Stark's Illustrated Bermuda Guide*, Boston, 1902, 64.

39. Mary Allen Hulbert, *The Story of Mrs. Peck: An Autobiography*, New York, 1933, 171.

40. See: Frances Wright Saunders, *First Lady Between Two Worlds: Ellen Axson Wilson*, Chapel Hill and London, 1985, Chs. 22–3, and Duncan McDowall, 'The President and Mrs. Peck', *Bermuda*, Spring 1995, 44–9.

41. Wilson to Peck, 28 Feb. 1910, *The Papers, op. cit.* at note 37, vol 20, 185–8.

42. *Ibid.*, 'Admission' to Edith Bolling Galt, 20 Sept 1915, Vol 34, 496.

43. *The Trenton Evening Times*, 22 Nov 1912, cited in *ibid.*, vol 24, 556.

44. Johnson Macadams to Howard Trott, quoted in Stanley Spurling to Colonial Secretary, 26 Oct 1921, File # CS2143, BA.

45. H.H. Houston to F.N. Doubleday, 11 April 1906 and F. Presbrey to Doubleday, 11 April 1906, F. Goodwin Gosling Papers, BA.

46. All details of the Bermuda Tourist Association in the Gosling Papers, BA. See: *New York Commercial*, 22 Feb. 1907.

47. Acting-Governor W. Brook-Smith, *Debates of the House of Assembly*, 11 Oct. 1911.

48. *Debates*, 1913/4, 240.

49. 'A Petition', 1 Feb. 1908, in Link, ed., *The Papers, op. cit.* at note 37, vol 18, 608.

50. *Debates*, 1912/3, 385 ff.

51. Link, ed., *Papers, op. cit.*, Vol 17, 609–10. The back of Wilson's draft of the petition carried the salutation: 'My precious one, my beloved Mary [Peck]'. Unknown at the time, this greeting would fuel future speculation by historians about the Wilson-Peck friendship.

52. *Debates*, 1908, 399.

53. Brassey, *In the Trades, op. cit.* at note 5, 50.

54. Lloyd Mayer, *Colonel Tom Dill, OBE: Lawyer, Soldier and Statesman*, Hamilton, Bermuda, 1964, 66–7.

CHAPTER THREE

'The Yanks are Coming, The Yanks are Coming!' 1914–30

'... lessons in the pursuit of happiness.'
William Howard Taft, *National Geographic*, 1922

'... this haven, this ultimate island, where we may rest and live toward our dreams with a sense of permanence and security that here we do belong ...'
Eugene O'Neill, 1927

'The bull market in Bermuda started with the War.'
John R. Tunis, *Harper's*, 1930

THE AMERICAN CIVIL WAR dispelled any notion that modern warfare and tourism could coexist. Early in the war, in July 1862, news reached Washingtonians that a key battle loomed to the southwest of their city at Manassas Gap. Equipped with picnic hampers and parasols, federal supporters headed out of town intent on turning the anticipated victory into a tourist excursion. What they saw instead was the Battle of Bull Run, a rebel victory that destroyed Northern hopes that the South might be quickly vanquished. By nightfall, horror-struck picnickers found themselves fleeing Manassas along roads choked with routed Yankee soldiers. Even in tranquil Bermuda, war squeezed tourist pleasure to the margins. Early in the conflict, American theatrical troupes still played the Garrison Theatre in St. George and the wife of the Confederate agent, Georgina Walker, hosted galas reminiscent of genteel plantation life. But, by the war's end, drunken sailors brawling in Shinbone Alley were the only sign of tourist gaiety in Bermuda. Much the same pattern would be evident in the Great War of 1914–18, when German submarines, not federal blockade patrols, cut the colony off from its North American supply lines.

Late 1913 found the new Trade Development Board (TDB) trying to regain the momentum of the 1908 tourist boom. From a peak of 27 045 in 1911, tourist arrivals had slipped to 22 915 in 1912 and were dropping

to 21 595 in 1913. Gosling and his colleagues were convinced that better steamer service, more hotels and aggressive advertising were the key to revitalisation. Their intuition told them that none of this was possible without outside help. Bermuda lacked the capital and the expertise to fashion its own tourist success. Some things were relatively easy. Advertisements were placed in the *New York Times* and negotiations for further placements were held with quality magazines such as *The National Geographic*. Local journalist John Bushell was commissioned to write articles on Bermuda's charms for the *Canadian Magazine*. A booth was rented at the Canadian National Exhibition in Toronto to sell Bermuda onions and beaches. Torontonians would be treated to free showings of 'Neptune's Daughter', an aquatic thriller filmed on Bermuda's Elba Beach. The silent film featured Australian star Annette Kellerman and a bevy of beauties decked out in mermaid flippers. Back home, a Hotel Men's Association was formed and its member hotels urged to stick 'Bermuda' labels on their guests' luggage.

Other matters proved more tricky. In 1913, the Quebec Steamship Company had been swallowed in a merger that had seen the creation of a huge Canadian shipping conglomerate, Canada Steamship Lines. The New York-Bermuda run did not stand high in the new company's priorities, especially in the light of the Quebec Company's fractious relations with the colony. Throughout late 1913 and early 1914, the board negotiated with the new Montreal company for a renewed steamer contract. The colony wanted a bigger, faster contract ship, and a second steamer to augment service in the peak spring season. Canada Steamship in turn wanted a bigger subsidy – £16 000 a year for each ship it placed on the route. It baited the hook with promises of a 10 000-ton, 18-knot liner that would enter service early in 1915. Canada Steamship also insisted that its Bermuda service would only pay if the colony spruced up its hotels and began to offer new amenities like golf to its visitors; these would allow the company to sell the colony to Americans. As early as 1910 a syndicate of foreign hotel and railway capitalists headed by Emilius Outerbridge in New York had offered to develop 'all aspects' of Bermuda's tourist trade from steamers through advertising to hotels as a package deal.[1] Bermudians distrusted such monopolies, but now the TDB believed that in Canada Steamship it had found a 'strong and progressive British company' that would assure the colony's future. The 1914 New York Steam Communication Act was thus pushed through the Assembly. Many still objected. A lot of tourists would have to come ashore to recoup a £16 000 subsidy. The contract was like 'placing the neck of the Colony under the heel of the Company'.[2] In the face of such opposition, the Trade Development Board demonstrated its power and determination to dictate the tourism agenda in Bermuda. The contract signed, the board passed a

resolution on 3 March 1914 praising Goodwin Gosling's role in negotiating the deal.

War in Europe toppled the board's well-laid plans. When Britain went to war, so did her colonies. On 7 August 1914, the Assembly passed a motion of loyalty to His Majesty, and Governor Sir George Bullock warned that 'inevitable dislocation' lay ahead. A week later the colonial secretary informed the board that war had obliged the government to 'cut down the expenditure of funds to the lowest possible limit'.[3] The board immediately cancelled its Toronto movie show. Worse news followed. Canada Steamship informed the colony that 'owing to the decline in the tourist trade' service to Bermuda would be reduced. Somebody – Bermudians suspected Floridians and Californians – began circulating scurrilous rumours that British troops were accompanying tourists through Hamilton's streets. It was also alleged that neutral Americans now needed passports to enter the belligerent colony. Passportless entry had been a pre-war inducement to visiting Bermuda. The colony's agent in Boston reported that he was doing his 'utmost to encourage the business, but we are not having much success'.

The rumours passed, but there was no avoiding the shipping crisis that grew with every day of hostilities. German torpedoes and the need to feed Britain's war economy with primary resources soon put a premium on shipping. The two companies providing scheduled services to Bermuda – Canada Steamship and Royal Mail Steam Packet – both began complaining of the cost and danger of sailing to Bermuda. A hastily-formed local company, Bermuda-American Steamship, attempted to fill the breach in late 1914. Spearheaded by local commission merchants like John P. Hand and hoteliers like Howard Trott from the Princess, the new company promised to charter a ship to carry vegetables out of Bermuda and tourists in – *if* the Assembly gave them a subsidy. In January 1915, the *Oceana* initiated the colony's first independent steamship service. Within three months, the company went bankrupt, stranding passengers in the colony. A TDB inquiry into the fiasco concluded that such a company, which had begun operations with only £3000 in operating capital, 'could only end in disaster'. The Governor concluded that the failure 'must tend to shake public confidence both here and abroad in the reliability of Bermuda business methods'.[4] The episode vividly underlined Bermuda's unavoidable reliance on foreign capital and expertise; without access to these, the Trade Development Board was impotent.

Bermuda's darkest night came in 1917. Canada Steamship asked to cancel its contract with the colony, citing its inability to build the new liner it had promised in 1914. The TDB agreed on the understanding that the company would keep the *Bermudian* on the route. In March, even this hope was dashed when the British Admiralty requisitioned the speedy liner

as a troop carrier. Colonial Secretary Walter Long told the colony that he 'deeply regretted' the decision, but that England had higher priorities than Bermuda tourism.[5] With the *Bermudian* gone, the board's secretary, Henry Eve, candidly admitted that tourism, 'one of Bermuda's principal assets, this season is practically nil'.[6] The statistics bore out Eve's pessimism. In 1917, Bermuda received a paltry 3213 visitors; the following year only an intrepid band of 1345 arrived. The colony's agricultural exports were similarly strangled. Only the jolt of British wartime military spending by the garrison and at the Dockyard sustained the colony's economic pulse. In the Assembly, there were allegations that the TDB had bungled the task of promoting Bermuda's economic development, that without regular steamer service post-war Bermuda would be still-born. The mood darkened with news that food shortages were developing in the colony and that the *Bermudian* – whose projected return offered the last straw of post-war hope – had capsized and been abandoned on an Egyptian sandbank.

Finally, the beleaguered board began to show its mettle. Since the Napoleonic Wars, the merchants of Front Street had developed a wily pragmatism, a knack – conditioned by the intuition that there was no room for failure on their lonely mid-Atlantic island – for finding a way. In the summer of 1917, Goodwin Gosling, John Hand and Stanley Spurling headed for Washington. There they lobbied the British Embassy and the United States Shipping Board for a ship. They pointed out that Canada Steamship was trying to make do on the Bermuda run with a ship, the *Cascapedia*, which lacked any chill-room capacity to carry the colony's produce exports. Furthermore, the company was obliging the colony to pay the crippling cost of war insurance on the ship. The Americans diverted a few military transports to the colony, but it was Lord Northcliffe at the British Embassy who came to the rescue. A geriatric naval cruiser, the *Charybdis*, lay immobilised from a collision in Bermuda dockyard. The Admiralty was willing to lease the vessel to the colony if the colony assumed the cost of fitting the ship for the New York run. Gosling seized the offer. A new Steam Communication Act was passed authorising a £40 000 loan to be taken out to underwrite the cost of converting the old fighting ship into a carrier of passengers and vegetables. In later years, a heroic folklore grew up around this act of desperation. Moving the decrepit *Charybdis* to a Baltimore shipyard for its conversion entailed a hazardous voyage from Bermuda. Members of the board volunteered. Stanley Spurling never tired of telling the story of how he spent the entire voyage stoutly manning the cruiser's bilge pump.[7]

The *Charybdis* was a stopgap – an expensive stopgap. By the time she was returned to the Admiralty in 1920, the colony had spent £80 000 on refurbishing and operating her. Monies were paid to Canada Steamship to operate the vessel, all at an 'enormous loss'. But the *Charybdis* kept the

arteries of Bermuda commerce open through the grimmest hour of war. She also cured the board of any notion of going into the shipping business itself and again reinforced the realisation that a post-war shipping partner had to be found abroad. By the war's end in 1918, the colony's relations with Canada Steamship were so strained that there was no thought of reestablishing the Canadian link that had served the colony since the 1870s. Reviving the export of vegetables and the import of tourists was imperative. In 1913, the government estimated that each tourist visiting the colony generated £1.10.0 in revenue. Wartime military spending had temporarily replaced this, but now the British were going onto a peacetime footing and the small American submarine-chasing base was being closed. Early in 1919, the Trade Development Board reported to the Assembly that 'the losses to investors in tourist enterprises since the outbreak of war have been enormous, and the burden cannot be carried much longer'. A 'prompt resumption of our tourist trade' was the key; without it the colony faced 'possible disaster' and the 'poorer classes' would be the first to feel its effects. But German U-boats had left their legacy: '… there is not a single passenger ship to be had today for the New York-Bermuda route'.[8]

From the outset, the members of the TDB proved great delegators. When a problem arose, a committee or delegation was picked to address it. Results were expected. The desperate need of a ship in the spring of 1919 was one such problem. Its solution lay in New York. The duty fell to three canny Bermuda merchants: Stanley Spurling, John Hand and Arthur Bluck. Spurling's avid belief in tourism's potential had gained him the chairmanship of the board in 1918; Gosling would move on to the assistant colonial secretaryship. 'J.P.' Hand was an American-born commission merchant who had come to Bermuda at the age of seventeen and had stayed on to prosper on Front Street as a commission agent and hotel promoter. Arthur Bluck was the city of Hamilton's most energetic booster: its mayor since 1913 and president of both the colony's largest bank, the Bank of Bermuda, and Bermuda Fire and Marine Insurance. Now the trio went looking for a ship in New York. They had two leads. One was an American promoter, George Allen, who had long wintered in Bermuda and had just before the war approached the colony with plans to build a trolley system as a surrogate for automobiles. Allen had also had a hand in developing the colony's hotels and electricity service. He claimed to be well connected to American capital. But in 1919, he had, the Bermudians discovered, 'no definite proposals', and his talk of a ship was 'mere paper'.

Bermuda's last hope lay in the New York offices of the English steamship company Furness Withy. Founded in 1891 to consolidate the shipbuilding and shipping interests of the Furness and Withy families, the company had carved a niche for itself as a freight operation that spanned the globe. Management had devolved to the progeny of founder

The 'frantic Atlantic' in the 1920s, the high noon of liner travel. Furness Withy deliberately designed its Bermuda ships with luxury in mind; stylishly-dressed tourists relax en route, their winterish garb indicating that they were nearer to New York than to Bermuda. (Bermuda Archives: Russell Ball Collection)

Christopher Furness, but by the First World War men with stalwart English names like Marmaduke Furness had begun to run out of steam in plotting the company's future. By 1919, Furness Withy's managing director, Frederick Lewis, believed that the company must reduce its shipbuilding and reorient its fleet in a post-war world that he believed would see contraction and bitter competition on the seas. In the summer of 1919, Lewis bought control, shunted the Furness family aside and started to reshape the company.[9] He shrewdly guessed that liners, not freighters, were the best peacetime bet. The war had left the market glutted with cargo ships and desperate for liners to reconnect the pleasure-seekers of Europe and America. The Atlantic was about to become 'the frantic Atlantic', crisscrossed by palatial big liners. 'A ship,' one commentator cheekily noted, 'is a combination hotel and honeymoon lodge in the wilderness ... There is nothing to do on board ship except sleep, drink, gamble and eat, in the order named.'[10] As yet unchallenged by commercial aviation, the liners would rule the waves of tourism for the next two golden decades by offering 'a kind of Grand Tour afloat'.[11] Lewis wanted to be part of this lucrative traffic. Bermuda did not enter into his initial calculations.

For years Furness Withy had acted as the Quebec Steamship Company's port agent in New York. London financiers friendly with Lewis had engineered the 1913 absorption of Quebec Steamship into Canada Steamship. Harry Blackiston, Furness Withy's man in New York, had been instrumental in finding an American shipyard to refit the *Charybdis*. When Canada Steamship announced that it had no post-war plans to return to Bermuda, Furness Withy put an option on the *Bermudian*. These hints of future opportunities prompted Bluck, Spurling and Hand to call at Furness Withy's New York office on 24 June 1919. Blackiston did have a proposal: Furness Withy would rescue the *Bermudian* from her Mediterranean sandbank, refit her and put her on the Bermuda run in return for a $15 000 annual subsidy for five years. On the whole, Furness Withy was 'not keen' on Bermuda; it saw 'no large profit' in the business. Europe looked like a larger and more rewarding long-term market. But Bermuda had two immediate advantages: it was closer to America and it was undamaged by war. Act fast, Blackiston told the Bermudians, or look for a better offer elsewhere.[12]

A huge gamble confronted Bluck, Spurling and Hand. War-strained Bermuda would not look kindly on paying a $15 000 annual subsidy to another foreign company, especially since the subsidy in effect endowed it with a monopoly. But they also knew that there was no better offer and that without a ship Bermuda agriculture and tourism would wither. There was 'an absolute dearth of passenger ships', they cabled home. Furness was an 'active and progressive' company and a deal must be 'clinched'. Two

days later, the committee returned to Blackiston and signed the agreement. Within days the Governor asked the Assembly to ratify a new subsidy bill. The Governor's closest confidant, the Colonial Secretary, believed the deal a good one; Furness Withy was a 'large and powerful organization' that could rekindle Bermuda's economy. In mid-July, the Governor received a reassuring cable from Lord Milner, the Colonial Secretary in London: Furness Withy had assured him that no expense would be spared on the *Bermudian* to make her the 'finest possible'.[13] Bermuda had a ship. It also had a partner. Although shaped by desperation, the 1919 Furness Withy deal would prove to be the single most important decision Bermuda ever made in building its tourism industry. For almost a half century – until 1966 – Furness Withy and Bermuda were to act in wonderful concert. For hundreds of thousands of Americans, a trip to Bermuda invariably meant first a trip to the travel agent for a Furness Withy ticket.

On 13 December 1919, the *Royal Gazette* hailed the arrival of the refitted *Bermudian*, now named the *Fort Hamilton*, as the first 'tourist-laden' Furness Withy liner to grace Hamilton harbour. A sister ship, the *Fort Victoria*, followed. Despite the journalistic boosterism, 1919 had been an abysmal year for Bermuda tourism: only 3010 visitors. Both Furness Withy and the Trade Development Board knew that more than just a ship was needed to restart tourism. The tourists must be *attracted* to Bermuda. The appeal of the pre-war aesthetic had been largely passive: sun, warmth and rest. 'The Isles of Rest' were a pleasant mid-Atlantic sanatorium whose visitors needed few diversions. In the 1920s, Bermuda would learn to add two crucial new active ingredients to this formula: activities geared to pleasure and social exclusivity. The 'Isles of Rest' would become a 'Mid-Ocean Playground'. The shift from rest to active pleasure entailed integrating new elements into Bermuda's aesthetic: sports, sun worship (and hence a shift to summer visits) and a social kudos that flattered east coast patrician America. Even before the war, the board had sensed the necessity of this shift. In 1913, it had investigated the cost of establishing a golf links in the colony. Again in 1916, it endorsed the local Chamber of Commerce's belief that a golf and country club 'would be an additional attraction to induce tourists to visit Bermuda'. There was also much talk of the need for 'high class accommodation'.[14] By the war's end, Bermuda thus sensed that it must invigorate, but not forsake, its existing appeal with new values and new attractions. In all this, Furness Withy proved an eager and able partner.

In October 1919, Frederick Lewis had himself sailed to Bermuda on one of his freighters to inspect the colony. With him were the architects of Bermuda's new tourism. Harry Blackiston, Furness Withy's New York vice-president, acted as his guide and introduced him to the board.

Blackiston had already intimated what his president wanted; in July he had told the board that Furness Withy was intent on the 'immediate construction of [the] best obtainable eighteen hole [golf] course and club house close to Hamilton'. Now Lewis arrived with Charles Blair Macdonald, the 'father of American golf', and the New York architect Charles D. Wetmore. Macdonald was America's premier golf course designer and Lewis wanted him to design a Bermuda course 'built by golfers for golfers'. Wetmore would crown it with a splendid club house.[15] Lewis later told Governor Asser that as a seafaring entrepreneur he felt uneasy scouting out golfing real estate. 'Our business is a steamship one pure and simple … but the success of the steamship business depended upon the attractions of the Island.'[16] And in the early 1920s, there was no better attraction than golf.

With over four million avid enthusiasts, golf had become the unquenchable recreational passion of North America's affluent classes. Golf combined athleticism and social exclusivity. America's industrial revolution had created a new plutocracy – Fricks, Carnegies, Rockefellers, Morgans *et al*. For all their wealth and ostentation, the new rich also craved seclusion, part of an urge to shelter themselves from the hurly-burly of commerce and the griminess of the industrial giant they themselves had created. They built 'great camps' in the Adirondacks, sailed their opulent steam yachts to the Mediterranean and took refuge in exclusive country clubs. In all these activities, they sought the serenity of being with 'their own'. A nostalgic impulse was also at work. America's new aristocracy would apply its industrial gains to the creation of unsoiled rural enclaves where life was once again made simple and tranquil. Golf, with its groomed pseudo-rural backdrop, quickly became the preferred game of the new elite. Thus behind golf club gates and along the shores of Long Island, 'select' communities sprouted in the late nineteenth century. Their names – like New York's Tuxedo Park and Montreal's Mount Bruno – became synonymous with wealth and privilege. In its pre-war toying with the idea of a golf course, the TDB had sensed golf's power over North America's affluent. Now Frederick Lewis made golf a Bermuda reality. He later told Governor Asser that Furness Withy came to Bermuda with two steadfast 'essentials' in mind. The colony must 'be kept free of the tripper element and not be allowed to degenerate into what is generally known as a Coney Island'. And, secondly, that 'to get a sufficient number of the right kind [of quality tourists] it was necessary to provide some amusements for them'.[17] A state-of-the-art golf and country club set in the mid-Atlantic was the post-war order of the day. Build it, Lewis told the Bermudians, and they will come.

Nobody built golf courses as well as Charlie Macdonald. Canadian-born and American-raised, Macdonald had attended the University of

St. Andrews in Scotland, where he had watched the 'royal and ancient' game played in its homeland. He returned to the States in 1875 just as golf began to catch Americans' fancy. In 1895, he built the country's first 18-hole course for the Chicago Golf Club. He loved the game, conceiving the Walker Cup series to promote its spread. He also made 'golf architect' a lucrative American profession. Macdonald's courses were thinking man's courses; each hole a challenging masterpiece, often deliberately modelled after the great holes of Scotland and England. To do this, he always chose seaside locales; a links was both picturesque and tricky. He loved to improve nature by shifting earth into hillocks and twisting fairways into treacherous doglegs. Arrogant and haughty, Macdonald is remembered by golf historians as the 'perfect personality to try something different and daring'.[18]

In October 1919, Lewis and Macdonald looked for something 'daring' in Bermuda. They did not find it near Hamilton; Pembroke Parish had little to entice the golf architect. Instead, they roamed the colony until their fancy fell on Tucker's Town, a secluded pocket of St. George's Parish. Here was a hilly, seaside landscape that narrowed into a majestic spit of land jutting out into Castle Harbour. Tucker's Town was off Bermuda's beaten track. Intrepid tourists ventured out to Tucker's Town in carriages to walk its beaches, to inspect the curious Natural Arches carved by the sea and wind in its cliffs and to spy on the soaring longtail gulls.[19] Here was a piece of Eden. While there is no documentary proof, it is very likely that Goodwin Gosling led the Furness Withy scouting party to Tucker's Town. Since 1907, Gosling had maintained a fishing and shooting cottage – 'The Clearing' – in Tucker's Town and was said to have assembled a hundred acres of land around it by the late 1910s.[20] It was also probably no coincidence that Gosling's successor as chairman of the Trade Development Board, Stanley Spurling, sat for St. George's Parish in the Assembly and had been on the dash to Harry Blackiston's office in New York earlier in the year.

Lewis added one last element to his development strategy. No matter how attractive Macdonald's golf course, it would be miles from the colony's tourist centre of Hamilton and, in carless Bermuda, there was a danger that the tourists might not come. Furness Withy would therefore make its development self-contained. It would transport Americans to Castle Harbour off Tucker's Town, tender them ashore, accommodate them in its own luxury resort hotel and offer them a mid-ocean playground. The crown jewel of this colony within a colony would be a posh residential community where wealthy Americans could winter amongst their own kind beside one of the world's best golf courses. Furness Withy was thus offering to set in place the foundation of Bermuda's edifice of quality tourism.

In February 1920, Stanley Spurling unveiled the grand plan when he presented a petition on behalf of the steamship company and 'certain capitalists' to the Assembly. The petition painted a bold canvas of 'the construction of first-class golf links and tennis courts, provision for seabathing, yachting, fishing, riding, and other outdoors sports, and the erection of a Country Club and hotels and cottages for winter and summer visitors to Bermuda'. Tucker's Town was to be the site of this nirvana. A total of 510 acres of land in St. George's and Hamilton Parishes was required, three-quarters of which had already been bought up. The land was 'backward and undeveloped', of 'little economic value' and very sparsely populated.[21] The Assembly was mesmerised. One member from Sandys Parish described Furness Withy's plans as the 'most stupendous project which has ever occupied the attention of those who control the destinies of our Island home'. Action was imperative. The Trade Development Board had heard that Nassau, a potential rival tourist destination, was considering a similar scheme. Was Bermuda, one enthusiast argued, now 'to pause and shiver on the brink lest the waters be deep or the current swift?' Egged on by Spurling, the Assembly prepared to take the plunge. In July, the steamship company, which for its Bermuda run had already created a separate subsidiary, the Furness Bermuda Line, was given a charter for the Bermuda Development Company to develop Tucker's Town. Bermudian by law, the company was British in substance and American in purpose. Its board of directors was evenly split between Bermudians and foreigners: Lewis, Blackiston, Macdonald and Wetmore sat for New York and London. Four familiar Bermudian faces joined them: Spurling, Hand, Gosling and Henry Watlington, Furness's agent in the colony. Two months later, Gosling resigned his post as assistant colonial secretary and became the company's secretary. Governor Willcocks wrote to London that it was 'not surprising ... that Gosling should be tempted by the far wider prospects of tourism'.[22]

There was, however, one nagging uncertainty. Lewis's entire strategy hinged upon the acquisition of real estate – not just some but *all* of the land in Tucker's Town. And, as much as the promoters portrayed the area as a backwater, this meant displacing the existing Bermudian community in Tucker's Town. By 1920, Tucker's Town was home to a tightly-knit, isolated community of about 400 black Bermudians. They were fishermen, boat builders and small farmers who had built schools, churches, cricket grounds and a rich, if rustic, community life. When work ceased, the men of Tucker's Town loved to retrieve an old Frith's rum barrel, swish water through it and then sample the resultant screech down at the cove during an evening of chowder and cards. No rich American, the developers now reasoned, was going to buy an expensive mid-Atlantic building lot if there

was the slightest chance that their serenity might be troubled by Saturday night rum and chowder parties by local coloured[23] farmers and fishermen. They had to go. The development company promised 'liberal' payment for their land. The problem was that some Tucker's Towners wanted to stay put regardless of price, an opposition that became evident with the presentation to the Assembly of a petition signed by 24 freeholders. Backed by the local Anglican minister, the petitioners attacked Furness Withy's plans as a 'speculative and precarious business' that would curtail the 'political and commercial freedom and independence of the people of this Colony'. They professed 'a natural love and attachment for their lands, houses and homes', an attachment that outweighed the needs of American golfers.[24]

Most other Bermudians disagreed. Tucker's Town was the sparkplug that would ignite the engine of post-war tourism; without it the colony would stagnate. As Furness Withy told the Assembly, 'the apathetic or unreasonable attitude of a few small land holders should not be permitted to block an enterprise of such great importance to the development of the Colony as a tourist resort'. The company's friends in the colony were less judicious in their annoyance. Spurling alleged that Tucker's Town coloureds were 'undoubtedly going backwards, the standard of morality, the standard of the people themselves was receding'.[25] Thus armed with economic and racial rationales, the majority had its way. In July 1920, a second Development Company Act was passed, setting up an expropriation process by which recalcitrant Tucker's Towners could be separated from their land. In terms of the due process of the law, the expropriations were probably fair and the prices paid to hold-out landowners probably at or above market value. Throughout the whole proceeding, Goodwin Gosling acted for the development company, negotiating prices and ultimately signing the cheques to displaced Tucker's Towners. Some took straight money and others were offered new homes and farm plots elsewhere in the colony. As his 1968 obituary noted, Gosling 'sold his own property to the company and smoothed over many difficulties'.[26] The Tucker's Town expropriations galvanised the colony: in the space of two years an entire community was dismantled and a new alien landscape of golf and hedonism implanted.

By the summer of 1923, the process had run its course. In the end, only one Tucker's Towner was actually physically evicted from her old homestead. Dinna Smith lived in a small house near Tucker's Town Bay. Short and pugnacious, she had never wanted to leave. She signed the original protest petition and stood her ground. Gosling told the Governor that she was a 'lunatic'. The expropriation commission awarded her a new home in nearby Smith's Parish, but she refused to move. Finally, late in 1923, the police were called. Her possessions were put in the road and she was

carried out. Her home was boarded up and old Tucker's Town ceased to exist. Smith remained bitter the rest of her life. She seldom left the porch of her new 'home', whiling away the hours sitting on an orange crate smoking a pipe. Whenever anyone passed, she was sure to recite a ditty that captured her version of the controversial events of the early 1920s:

> Goodwin Gosling is a thief
> And everyone knows it.
> He carries a whistle,
> And Stanley Spurling blows it.[27]

While Dinna Smith puffed her pipe, the new Tucker's Town took shape. Furness Withy worked hard and fast. A three-pronged plan for Tucker's Town was set in motion. Charlie Macdonald and a small army of landscapers worked through 1921 carving an 18-hole golf course out of what had once been farms and brushland. In July, Gosling treated the members of the Assembly to a picnic at the site. When the course was opened in early 1922, it met with rave reviews. The dogleg fifth hole was an adaptation of the notorious Redan hole at the North Berwick course in Scotland. The editor of the *American Golfer* called it 'one of the most wonderful courses he had ever seen'.

The golf course was to be the centrepiece of what was to be called the Mid-Ocean Club. As the fairways took shape, Charles Wetmore's club house rose beside the sea. Tennis courts, beach houses and bridle trails followed. The company's second ambition was to sell up to 300 one-acre lots dotted through its new Tucker's Town domain. On these, 'quality' residential tourists could build tasteful 'bungalows' in which they could spend the winter months in Bermuda warmth and seclusion. The first of these lots was sold with much fanfare to Theodore Roosevelt's nephew, George Roosevelt. The company's lavish promotional brochures for the club pointed out that servants and livery carriages were locally available and that there was 'no income tax, and the land tax is almost negligible'. The company also employed the famous Boston landscape architects Olmsted Brothers to groom the new Tucker's Town; the firm's founder, Frederick Law Olmsted, had designed New York's Central Park in the 1850s. Mindful of the powerful Bermuda aesthetic, the company stressed that the new Tucker's Town would conform to the decorum of Bermuda's white-roofed architecture; there would be no garish castles. These enticements soon fattened the sales list. Thomas Lamont, the New York financier; Mrs Rockefeller Milton; Morgan O'Brien, the premier New York divorce lawyer; automobile mogul Edward Stettinius and Childs Frick all soon sported new Bermuda addresses.[28] American celebrities – Babe Ruth, most notably – were soon pictured swinging golf clubs on Mid-Ocean fairways.

Frederick Lewis was always adamant that Furness Withy's investment in Tucker's Town real estate was not a short-term speculation, designed to make a quick profit on rising land prices and to be followed by a withdrawal from the colony's future development. The golf course and the colony of wealthy North Americans were intended to act as a prestigious magnet to draw up-scale tourists to Bermuda. Mid-Ocean members were carefully screened by an admissions committee, a process backed up by the colony's stringent 'alien' residency laws. Golfing memberships cost $2500 and a 'homesite' member paid $500 plus the cost of a site. Despite this, Lewis doubted that Furness Withy would ever get 'an adequate return' on real estate sales. The profit for company and colony alike was in the steady flow of well-heeled visitors to Bermuda. This would fill the cabins of the Furness ships and populate the colony's hotels.

Furness Withy's real profit would come from the third element of its grand strategy: building up the colony's hotels. In 1921, the company bought the St. George's Hotel, renovated it, added an indoor swimming pool and began ferrying its guests directly from their liners to the hotel. A second hotel, the Bermudiana, was added in 1924. Designed by Wetmore, it sat in 15 acres of gardens on the Hamilton waterfront. Its 450 guests were pampered by a staff overseen by the former manager of Château Lake Louise in the Canadian Rockies. In 1923, construction began on Furness Withy's landmark hotel, the Castle Harbour. Perched on a bluff overlooking the emerald waters of Castle Harbour, the hotel was built out of Bermuda stone and welcomed its guests by tender at its own dock, from which an elevator lifted them to the hotel's grand foyer. The hotel with its 400 rooms allowed its guests to bask in the aura of the nearby Mid-Ocean Club. A separate golf course (designed by Macdonald protégé Charles Banks), a pool and tennis courts were built for the hotel. The emphasis was on outdoors activity and sunshine; 'You can do everything or nothing at all ... Luxuriously', promised the advertisements. The age of elegance had arrived in Bermuda's hotel industry. Foreign-owned and foreign-managed, the Furness Withy hotels soon became synonymous with unparalleled resort living. The company's *tour de force* was completed when the sleek new liner, the *Bermuda* – with its weekly load of 690 first-class passengers – entered service in 1928. The *Bermuda* had art deco lounges, an indoor pool and an outdoor dance platform for 400 couples. She was, the company boasted, a 'veritable mechanical isle of beauty'.

Bermuda acquired other crucial oceanic allies in the 1920s in its drive to become a 'mid-ocean playground'. While Furness Bermuda dominated the all-important New York run, other steamship lines – Canadian Pacific, Elders & Fyffes, Canadian National Steamships and Royal Mail Steam Packet – provided less frequent but steady service to Canada, England and the West Indies. To each, the Bermuda government gave a subsidy, never

A 1920s postcard carrying the caption 'The Yanks are Coming, The Yanks are Coming!' captures Bermuda's often ambivalent attitude to the American tourist invasion that saved its economy after the collapse of its agricultural staple. (Bermuda Archives: Donnelly Collection)

as large as the Furness subsidy, but enough to ensure that Hamilton became a favoured port in the 'frantic Atlantic'. After lunch with Stanley Spurling in 1924, a Canadian steamship representative reported home that 'Bermuda's prosperity depends almost entirely on her tourist trade and every possible facility is provided to assist and encourage it'.[29] This was exactly the message the Trade Development Board had wished to transmit since 1913; the local press now frequently carried photos of grinning members of the TDB welcoming new captains to their port.

The other indispensable handmaiden of Bermuda tourism's growth was advertising. Without effective advertising, the sleekest liner in the world would sail empty. Long-term, carefully crafted and targeted advertising was, as board member Harry Watlington told the Assembly in 1922, 'the foundation of our getting the business. We must remember that we have Miami and other resorts making a strong bid for the tourist'.[30] In 1922, the board hired the Wales Advertising Agency of New York to spearhead its campaign to capture America's attention. James Albert Wales, the agency's head, quickly became a Bermuda addict himself and for over a decade colony and advertiser enjoyed a warmly productive relationship. Wales instinctively understood the uniqueness of Bermuda. He insisted that all its advertising be designed to reach the 'higher class of tourist' and to deter the 'undesirable' tourist, the so-called 'tripper' who spent little and abused Bermuda's delicate aesthetic. Wales always reminded the board that 'it was not a question of how many visitors came to the Islands as how much visitors to the Islands spent while here, and asked the pertinent question "Are the visitors this year of as high a class as last year?"'[31] Wales believed that the best way to reach this market was through the upper end of the American magazine market, not through the daily press. Posh magazines were read by the 'right' kind of reader – wealthy east coast WASPs – and they lingered on coffee tables and were passed about to friends. Newspapers were read by the masses and were gone with the day's trash.

Magazine advertising had one other wonderful advantage: it allowed Bermuda to convey its beauty in colour. There was universal agreement with the 1926 opinion of board member L.B. Harnett that 'colour was the principal thing that Bermuda had to sell and that colour advertisements sold the idea of coming to Bermuda whilst newspaper advertisements told how to get there'.[32] Winslow Homer had understood the allure of Bermuda's bright colours and now so too did the merchants of Front Street. The Victorians had shunned the sun, raised parasols against it and clothed their bodies against it. Their offspring in the 1920s chased the sun to the beach, donning briefer swimwear and tanning their bodies.[33] One historian of modern tourism has noted that in the 1920s 'the suntan became the golden emblem of beauty and freedom' for modern workers

condemned to sunless office life.[34] Nothing conveyed the lure of Bermuda's sun-drenched pink beaches and floral lanes better than colour photography. 'Colour always told the story,' Wales preached, 'and was the only logical manner in which to depict Bermuda.'[35] Thus Bermuda became the first resort systematically to employ colour to promote itself. It was expensive, but Wales was convinced it worked. Throughout the decade, full-page Bermuda advertisements appeared in carriage trade magazines like *Yachting*, *The American Golfer*, *Harper's Bazaar*, *The Literary Digest*, *Town and Country* and *Vogue*. Late in the decade, the most precious and lasting of these relationships began when the first advertisements were placed in a chic and cultured new magazine dedicated to east coast sophisticates, *The New Yorker*.

The publicity instinct began to pervade the board's every deliberation. The colony's official guidebook, *Nature's Fairyland*, was printed in batches of 100 000 and shipped off to travel agents. Theme exhibits – 'Wave Washed Shore … Sun Kissed Land' – were staged every year at the Canadian National Exhibition in Toronto. A mock Bermuda cottage and a miniature landscape of the new Tucker's Town were sent to the 1924 British Empire Exhibition in London. In 1924, a news bureau was set up to 'plant' flattering Bermuda stories in the foreign press. 'Send good surf-bathing picture', Wales typically cabled from New York. The strategy worked well; in 1923–4 the bureau reported only 838 mentions of Bermuda in American newspapers, but by 1926–7 there were 2927.[36] When former American president William Howard Taft wrote an article for *The National Geographic* in 1922 praising Bermuda's ability to provide 'lessons in the pursuit of happiness', the board paid for the illustrations. Two months later, it spent $1800 on two advertisements in the same magazine. The Burton-Holmes Lecture Company was hired in 1920 to shoot aerial footage of Bermuda for free distribution to movie theatres. Travel agents were indulged: in 1925 a Charlotte, North Carolina agent was sent a projector, lantern slides and films of Bermuda to boost Bermuda's recognition in the South. Prominent editors were treated to Bermuda trips. The Colonial Post Master was prevailed upon to frank all outgoing mail with the slogan 'Come to Bermuda – Mid-Ocean Playground'.

Once a year, the board struck an agreement with the hotels and the steamship companies to share the cost of this advertising. This 'pooling' covered the cost of broad-brush Bermuda advertising; individual hotels and ships were left to publicise their own particular wares. In 1924, the board received a hint of how effective its advertising campaign was: the Florida Development Board wrote to compliment the Bermudians on their success and to ask how they did it. The board was flattered, but politely declined to explain. Advertising was their most powerful tool in shaping their tourist fortunes and their Bermudian mercantile instinct had trained them never

The Bermuda stall at the Canadian National Exhibition of 1924 – part of the TDB's strategy of creating a market by carrying Bermuda's charms to North Americans. (Bermuda Archives: J.J. Outerbridge Collection)

to share trade secrets. Through the judicious adjustment of the steamship subsidies and the refocusing of its advertising, Bermuda's merchants of tourism learned to manage their market. A hike in the steamer subsidy might encourage Furness Bermuda to lay on more summer visits to Bermuda; a series of colour advertisements in the *American Golfer* would pull registrants to the Bermuda Amateur Golf Tournament. The Canadian market could be fanned by placing advertisements in *The Canadian Magazine* to complement feature stories by local authors like Victoria Hayward and the suspiciously pseudonymous 'Paget Hamilton'.[37] With its control of the twin levers of transport and advertising, Bermuda was able to carve new tourist niches in the 1920s to enhance its appeal.

The most obvious of these was the addition of sports to Bermuda's aesthetic: wholesome, decorous, middle-class sports. In 1922, the board appointed a sports director to implant these in the tourist's image of Bermuda. Golf was the leading contender. Accessibility of golf in the colony was broadened beyond the elite Mid-Ocean and Castle Harbour courses by the addition of new or enlarged courses at Riddell's Bay, the Belmont Hotel and the Frascati Hotel, all designed by New Yorker Devereux Emmet. The TDB promoted the cachet of these courses by bringing professional golfers to play them, hosting tournaments and donating trophies. Tennis was another natural. There is reliable evidence that the game of tennis was introduced into North America from Bermuda in 1874 when Mary Outerbridge, the sister of Bermuda's New York steamship agent Emilius, visited her brother and took with her a set of 'Sphairistike' rackets, balls and nets given her by a British officer. The Outerbridges played the game at the Staten Island Yacht and Cricket Club and America was soon hooked. Like golf, tennis could be played by men and women and lent itself to convivial socialising afterwards. Trophies, visiting professionals and amateur tourneys emphasised its appeal.

Yachting was another natural for Bermuda. The venerable Royal Bermuda Yacht Club, with its royal charter from 1846, was a showcase for the Bermudian elite's seafaring skills; virtually all the members of the tourism board were members. Here American sailors found ready competition and an entrée into the best of Bermudian society. In the mid-1920s a local sailor, Kenneth Trimingham, teamed with Norwegian Bernard Aas to design a fast, small yacht – the International One – which could be raced by locals and visitors alike. The 'Berwegian' boat allowed Americans to compete evenly with their hosts. The same was not true with the Bermuda fitted dinghy races which the board sponsored. Here was real Bermuda men's sailing. Even more adventurous sailors began racing across the Gulf Stream to Bermuda. Yachting, tennis and golf all tended to tie Bermuda to the affluent classes of east coast America; these were their games too. The locker rooms of Bermuda contained the 'right' kind of people. From the

board's point of view, these were also summer sports and thereby helped Bermuda shift its image from a tranquil winter rest spot to a summer playground. Image was everything and the board was careful to groom its sporting reputation. Baseball was deemed 'detrimental to the British atmosphere' of the colony, even if the Americans were perplexed by cricket. Similarly, power boat racing was unwelcome; it was too vulgar and abrasive to the colony's serenity.

The kudos of being seen knocking golf and tennis balls about in Bermuda was matched by the kudos of honeymooning in Bermuda. Here too was a niche that the colony deliberately cultivated, a niche opened by a fundamental shift in the nature of American marriage. In the nineteenth century, weddings were invariably followed by a 'nuptial journey'. These were very public affairs which required the newly-weds to undertake an extended tour of family relations who had been prevented from attending the ceremony by work or distance. As the historian of American courtship has noted, 'the need for affirming community ties' superseded the more personal romantic needs of the couple.[38] As America industrialised and urbanised, weddings became more gregarious affairs. Efficient transport and arranged leave from work allowed more Americans to attend weddings, thereby leaving couples to their own devices afterwards. Late in the nineteenth century, the honeymoon took on its modern form. For many middle-class Americans, the nuptial journey became 'a honeymoon of repose, exempted from claims of society'. Couples began to seek out romantic destinations where in isolation they could discover their new relationship. Niagara Falls excelled in this role, its cascading waters redolent with symbolic meaning for young newly-weds.[39] This quest for a sublime setting for one of life's great transitions was the theme of William Dean Howells' 1871 popular novel *Their Wedding Journey*, in which the Falls separate the couple from the 'carking cares of business and of fashion' and arouse their feelings of 'youth, faith, rapture'. As has been seen, Howells became one of Bermuda's early prophets in North America. Here too was a sublime setting. Bermuda's garden-like environment and well-mannered society appealed to harried American couples in search of a romantic setting to begin their life together. It seemed so different, yet was so safe.

Although honeymoon cottages had been advertised as early as the 1890s, the advent of luxurious, regular liner service in the 1920s made honeymooning a growth industry. Since weddings generally took place in the late spring and the fall, honeymooners appealed to the TDB because they offered another means of pulling summer visitors to the colony. A happy honeymooner was also likely to be a repeat visitor. Advertisements were therefore strategically placed in *Bride's Magazine* and the steamer companies were encouraged to feature Bermuda as a nuptial paradise in their literature. 'A word to the bride,' one pitch ran. 'A Bermuda honey-

'The Yanks are Coming, The Yanks are Coming!' 1914–30

A Bermuda honeymoon – safe, sunny and stylish; strikingly different from home yet only two days' journey away. (Courtesy Bermudian Magazine)

moon is a chance to show the lucky man he was luckier than he dreamed when he chose you. Bermuda is foreign, you know ... you can boast of a bridal trip abroad ... a pleasant but harmless bit of swank.'[40] If Niagara had its falls, Bermuda had its moon. The image of silver moonlight playing on Bermudian water became a standard-issue metaphor in honeymoon advertisements. As if to emphasise the synergy of the moon and new love, Bermuda in the 1920s became dotted with coral stone moongates, under which couples kissed and were photographed as an omen of well-being.[41] By the decade's end, a 'Bermuda honeymoon' had become a well-bred east coast girl's dearest ambition. The masses went to Niagara Falls.

In addition to these deliberately cultivated niches, Bermuda had a hidden, unadvertised asset in the twenties: drink. Just as the social consequences of industrialisation had pushed some Americans towards the tranquillity of Bermuda, it pushed others to the moral fervour of prohibition. Arguments of wartime sacrifice converted fervour into Prohibition and with the passage of the 18th Amendment in 1919 America went dry and stayed dry until 1933. Bermuda did not. The merchants of Front Street benefited from Bermuda's alcoholic uniqueness in two ways. The colony became a hub of rum-running into the United States; vast quantities of liquor were transshipped from local warehouses into schooners and fast yachts ready for surreptitious voyages to the States. 'Two or three rum runners were in here the other day and filled up with liquor to smuggle into the United States,' a young American boy wintering in Bermuda in 1923 wrote to his father. 'The head man is staying at the Inverurie Hotel.'[42] Indeed, like their Civil War forebears, the rum-runners became tourists in their own right. 'There's no doubt these are lovely islands,' one smuggler recalled in his memoirs, citing the 'dashed good' dinners he enjoyed there.[43] Liquor that was not exported was served to thirsty tourists.

The absence of Prohibition in Bermuda presented tourism's promoters with a dilemma. To advertise the availability of liquor would tend to contradict the idyllic aesthetic that the colony had so long built and might well offend patrician America, which had generally, if somewhat hypocritically, endorsed its country's decision to go dry. Thus, one scans Bermuda's tourist literature in vain for any hint of liquor; the task of selling the colony as another world in the alcoholic sense was left to word-of-mouth advertising. The Trade Development Board in fact went out of its way to suppress any open hint of liquor in paradise. When word reached the board in 1927 that an American company was in the colony making a film that depicted liquor smuggling and drinking, chairman J.P. Hand was sent to tell the 'man in charge' to cease and desist.[44] A similar reaction followed news that postcards of tourists drinking in the Royal Prince Hotel bar were being printed. Hudson Strode's 1932 *The Story of Bermuda* (which

Thirsty Americans in 1926 escape from Prohibition to raise their glasses at a New Year celebration in the Bermudiana Hotel. (Government Information Services, Bermuda)

was subsidised by the board) rather sanctimoniously concluded that the 'average Bermudian has never been a particularly heavy drinker' and that the island's favourite tipple was an innocent local concoction called Milk Punch.[45] Behind the smokescreen, drink was undoubtedly a powerful inducement to visit Bermuda in the 1920s. If one liked to golf with one's own, the same was true of drinking. When asked in 1926 why more British tourists did not come to Bermuda, the board's London advertiser answered that the English did not like to 'mix' with the Americans who came because there was no Prohibition and 'consequently life in the hotels was one continual carousal'.[46] The board quietly ignored his suggestion that more tea be served.

As pleasure began to supersede rest in the tourists' expectation of Bermuda, the board devoted itself to providing entertainment. Emphasis was placed on the colony's Britishness. Regimental bands were employed to serenade the visitors in Hamilton's parks. An Orthophonic Victrola was installed to fill Par-la-Ville Park with recorded music. A Winter Water Carnival was staged at the pool in the St. George Hotel, and American swimming celebrities like Johnny Weissmuller and Helen Meany were brought in to thrill the spectators. The line was drawn at garish entertainment; in 1925 a proposal for a casino was quashed because it would bring 'an undesirable class of people' to the colony.[47] In 1928, the board enthusiastically supported the opening of a government aquarium at Flatts and a biological research station at Ferry Reach. Each was an extension of the nineteenth-century interest in Bermuda's natural bounty. An earlier aquarium had fitfully existed on Agar's Island, but now a dedicated facility was built with government money. Bermuda-born marine biologist Louis Mowbray was lured away from the Miami aquarium to be curator of the new museum. Mowbray soon struck up a close friendship with the American millionaire Vincent Astor, who was building a home in Bermuda and was eager to help stock the new aquarium. Since the turn of the century, American academics had been using the Frascati Hotel as a summer research station. Now, with help from the Rockefeller Foundation, a permanent station was established. Goodwin Gosling, who had once prevailed on Mark Twain to lecture on behalf of biological research in Bermuda, sponsored the station's incorporation bill in the Assembly. Prominent marine researchers like the flamboyant, deep-diving Dr William Beebe soon began frequenting Bermuda. Beebe's laboratory on Nonsuch Island in Castle Harbour reawakened interest in the 'abyssal loot' hidden in the deeps off Bermuda.[48] Tourists were offered books of coupons that allowed them to glimpse these same wonders in safety at the aquarium, sea gardens, and caves. Late in the decade, heritage entered the visitor's agenda with the annual staging of the Somers Day Pageant (replete with Stanley Spurling dressed as the famous admiral) in

St. George's. To coordinate all these activities, a Visitors' Service Bureau was established on Front Street in 1928.

The *real* coordination of Bermuda tourism took place in the upstairs boardroom of the service bureau, where once a week the Trade Development Board met. The words clique, cabal and coterie in no way exaggerate the board's power. The *Bermuda Report*, an annual report card on the colony's affairs sent to London, described the board as being 'entirely composed of unofficials'. Not only were TDB members unelected, they were intimately tied to the political structures of the colony – the Assembly and the Legislative Council. Political power in Bermuda was derived from the narrowest and most exclusive of democracies. Only landowners with sixty shillings' worth of property voted. Indeed, a strong aspect of Bermuda's appeal in the eyes of patrician Americans was the very conservatism of its politics. Former American president William Howard Taft told the readers of *The National Geographic* in 1922 that Bermuda had a 'unique record in popular government', 'a government of landed holders and not of manhood electors'.[49] What the board wanted, it almost always got. By the end of the decade its annual appropriation from the government was the second largest item in the colonial budget, surpassed only by the public works department. There was occasional griping in the Assembly about the size of the budget. The Furness Withy subsidy was usually the largest single item in colonial expenditure and therefore an easy target for those intent on bashing foreign monopolists. Advertising was also criticised; its effectiveness defied easy measurement and it stood up poorly in comparison to more tangible items of parochial spending. Others complained of the board's secrecy. But, perhaps trimmed a bit, the budget was always passed.

The board's influence went far beyond the power of the purse. The Assembly obliged the TDB's tourist agenda in many other ways. When yachting became a board priority, the Assembly waived all import duties on the International One boats that were being built to lure American sailors. When a British capitalist proposed a light railway for the colony in 1924, much of the subsequent debate was couched in terms of whether a railway was good for tourism. The railway's parliamentary patron, Harry Watlington, was a long-time TDB member and, while the board kept its distance from the actual project, its concerns were always evident in the debate. The railway, it was argued, would allow Bermuda to maintain its ban on automobiles and it would help the tourists to get around without choking the roads. The board's power was evident in a myriad smaller ways. Operating through a series of standing committees – entertainment, advertising, overseas communications, and so on – the board practised what is today called 'micro-management'. No aspect of Bermuda tourism was too small to be overlooked. Ever conscious of the appeal of the

colony's aesthetic, the board quite literally groomed the look of Bermuda so as to appeal to the tourists. Promoters of the Sea Garden excursion were told to curb 'the excessive zeal manifested by their solicitors' on Front Street: this was not Coney Island. When the Bermuda Drug Company began selling postcards 'depicting supposedly sea-sick scenes on the Bermuda route', the board asked that they be withdrawn. In 1927, the board insisted that wrecks on the shoreline be blown up so as 'not to mar the beauty of Bermuda'.[50] Litter was picked up, beaches raked and hedges trimmed, all on TDB orders and all because the board's actions had the powerful legitimacy of promoting tourism.

The board's grooming of Bermuda went beyond the physical; it soon became a kind of social engineering designed to remind Bermudians that tourism was a part of the fabric of their society, not just a hotel façade. 'The greatest need in the development of our tourist trade,' Joe Outerbridge, the board's secretary since 1922, told its chairman J.P. Hand in 1928, 'is to get Bermudians as a whole, and this includes hotel managers and shop keepers, to accept the principle that our "visitors" are our *guests*, and that they should be treated as such.'[51] In the twenties, Bermudians acquired the universally-felt instinct that Bermuda *was* tourism and that certain types of behaviour – discourtesy, rowdyism, littering – were in fact anti-social actions that undermined not just the colonial livelihood but the very essence of Bermudian life. As later chapters will show, this seamless integration of tourism and society also reflected the unstated but rigid racial segregation of Bermuda society. So-called 'undesirable' visitors, like Jews and people from the Bronx, found themselves entirely excluded from Bermuda's formula for tourist success. The definition of this national personality was largely crafted by the TDB, and a cynic might well argue that a 'friendly' Bermudian was a Bermudian who put money in the pockets of Front Street. The board would have countered that its policies brought prosperity to all Bermudians and, more importantly, were allowing Bermuda to preserve a quality of life and a social order that was, as the advertising claimed, the envy of North America. Board member Kenneth Trimingham put his finger on this mixture of self-interest and altruism: '… we had a responsibility to the next generation'.[52] The next generation in Bermuda would never inherit a Coney Island.

The success was undeniable. From a nadir in 1918 when a trickle of 1345 tourists came to Bermuda, the colony experienced an exponential growth in tourism in the twenties. By the end of the decade, the weekly Furness Withy shuttle from New York was depositing over 43 000 visitors a year in Bermuda. Other routes – from London and Halifax – bolstered the trade, but the grey-hulled Furness Bermuda ships with their red and black funnels were the unquestioned prime carrier to 'Nature's Fairyland'. By 1926, tourism had clearly surpassed agriculture as the leading sector of

the colonial economy; the *Bermuda Report* called it the colony's 'most important source of revenue', accounting for 80 per cent of the colony's annual take. In 1919, the Assembly had imposed a ten-shilling tax on all tourists leaving the colony, so that by 1930 the passenger tax on 43 249 visitors paid nearly half of the TDB's £51 676 budget. Tourism moved into the profit column when the board reported that the average visitor stayed ten days and spent two pounds a day. There were also wharfage paid by the liners, import duties on what the tourists consumed and the powerful ripple effects of tourism through almost every reach of Bermuda employment.[53] Blacks forced out of old Tucker's Town were by the decade's end returning there as maids, caddies and gardeners. One young boy remembered walking barefoot every morning to fetch American laundry for his mother in Tucker's Town. The Americans had come, he recalls today, and it was 'a blessing to see them'.[54]

The market was unshakeably American. For all its 'Britishness', Bermuda could not attract the British tourist. A few came on the infrequent direct sailings from London, but the English generally shunned Bermuda, not just because the Americans drank in the hotels, but because it was so much farther than Madeira and because it was too expensive for their strained post-war budgets. Canada – closer and more affluent – seemed a better bet. An advertising agent was hired in Toronto, advertisements placed in posh Canadian periodicals and exhibits mounted in key cities. And each winter, the Canadians came, but never in great numbers. In the summer, Canadians stayed home. The market was central Canada – Ontario and Quebec. A typical Ontario visitor was Canada's prissy bachelor prime minister, W.L. Mackenzie King, who in 1930 took one of his infrequent foreign vacations in Bermuda. 'It was like mid-summer, I have never seen anything lovelier', he wrote in his famous diary, and then with true Canadian reserve noted that the 'men, women and girls' bathing at the Mid-Ocean Club did so in 'much abbreviated suits'. St. George, King fastidiously pronounced, was like Italy 'without smells and dirt'.[55] Canada's Maritime provinces were closer to Bermuda but too thinly populated and poor to patronise it. A solid 85 per cent of Bermuda's visitors were therefore east coast Americans. New York and New England were the heartland of Bermuda's tourism. Here were people with the time, money and inclination to visit Bermuda. 'Only two days from New York', the advertisements promised, but 'a million miles from Wall Street'. And it was a market that could be manipulated. In the twenties, Americans were trained to think of Bermuda not just as a winter resort but also as a summer resort. In the 1929–30 season, Bermuda received 21 564 tourists between December and April and 17 487 between June and October.

The American invasion was driven by two impulses. The old aesthetic of Bermuda as a retreat from the hurly-burly of North America was still

evident, especially in the winter season. In 1923, for instance, Harvard architect John Humphreys reported his discovery of Bermuda's quaint architecture to America. Bermuda's unique homes appealed 'to the imagination with suggestions of a life apart from the rest of the world, one in which peace and ease replace the confusion and strenuousness of the more energetic North'.[56] A year later, the American playwright Eugene O'Neill arrived in the colony, rented a South Shore home and set to writing. He found Bermuda a 'haven, this ultimate island where we may rest and live toward our dreams'. Three plays followed: *The Great God Brown*, *Lazarus Laughed* and *Strange Interlude*. The chronicler of O'Neill's Bermuda years notes that his work in Bermuda focused on the need to reject North American materialism, 'the sickness of today'.[57]

Alcohol, a love affair and the end of a marriage intruded on O'Neill's happy routine in Bermuda. So did a succession of New York literary friends like Kenneth Macgowan, the editor of *Vanity Fair*. The twenties thus witnessed the beginning of an infatuation of New York's smart set with Bermuda. What O'Neill began, James Thurber, E.B. White, Sinclair Lewis and others would perpetuate. A favourite haunt of American writers was the Little Green Door Tea Room overlooking Hamilton harbour. Run by two Bermudian sisters, Ethel and Kate Tucker, the tea room had served strawberries and cream every winter afternoon since before the war. Twain and Warner had initiated the tradition of filling the afternoon with Tucker Sisters' tea and literary talk. O'Neill continued it after the war. On Queen Street in Hamilton, the Tuckers ran a gift shop where they sold their own watercolour views of Bermuda lanes and cottages and kept the Bermuda aesthetic alive. 'Match blue green of sea as close as possible ... keep these subjects as bright and clean as possible', Ethel (who had trained with the great English commercial artist Raphael Tuck) instructed her English lithographer.[58] The Tuckers provided just the sort of gentility that America now lacked.

A few years later Katherine Anne Porter followed in O'Neill's steps, renting a house in Bailey's Bay to work on a biography of Cotton Mather. 'I spent eight months of self-elected hermit life in Bermuda, out of season,' she wrote to her publisher in 1932, 'and it is really my kind of Paradise, all brilliant colour and tropical sun and fruitfulness, and the British colonials there are the most reassuringly well-mannered and decent people.'[59]

There was also a new type of American abroad in Bermuda, brought there by the aesthetic of sun and pleasure. Six hundred or so of them arrived every time the *Bermuda* docked. They were in a sense faceless, in that they were not celebrities. They were instead affluent Americans in search of a good time. In 1927, an American Express executive advised the board that Bermuda's 'special appeal to men should be "Bermuda – a place

where successful businessmen go'". The appeal to women should be 'social vanity'.[60] American historian Paul Fussell has more recently noted that the twenties were the 'final age of travel', when travel implied seeking and adventure. Twain and O'Neill had been 'travellers' to Bermuda. The new arrivals were 'tourists' in search of the 'security of pure cliché'. Their goal was 'to raise social status at home and to allay social anxiety; to realize fantasies of erotic freedom; and most important, to derive secret pleasure from posing momentarily as a member of a social class superior to one's own ...'.[61] Bermuda, with its Britishness, golf, and the Astor yacht in the harbour, fulfilled their dreams. A glance at the social page in the *New York Herald* early in the decade captures the mood: 'Bermuda Winter Season Near End', 'Mrs. Robinson Has Bridge Party in Bermuda' and 'Visitors to Bermuda Enjoy Summer Sports'.[62]

The American invasion was not without frictions. The local elite sometimes found the tourists a little too intrusive. Mary Gray, daughter of Sir Brownlow Gray, one of the colony's leading legal and social lights, complained in 1930 of 'the whole of the South Shore being over run with Yankees'.[63] The visitors also found fault; in 1923 guests at the Princess complained that the regimental band did not play the American national anthem.[64] Some aficionados of the 'old Bermuda' worried that the colony was selling its birthright. The American sports writer John Tunis came to Bermuda for the tennis and by 1930 he did not like what he was seeing. The 'American idea' was colonising Bermuda. Tucker's Town had been the Trojan Horse. Now the Twains, 'who loved to wander aimlessly about the sea front or ride a bicycle up and down the coral roads have been replaced by a gentleman who is not a light drinker, who cares little for scenery, and less for riding a bicycle along a coral roadway beside the translucent sea', he warned the readers of *Harper's*. 'He wants his liquor, his golf, his coffee with cream, his room with bath in a hotel complete with elevators and all American accessories.'[65]

Others doubted that the 'bull market in Bermuda' would ruin the colony. An Alabama historian, Hudson Strode, detected the same tendencies as Tunis: 'American gold is tempting, and progress is insidious'. But, he noted, Bermudians were 'instinctively conservative, reactionary' and their sultry climate 'inclines them to be instinctively unsympathetic to any change that will disturb their semi-tropical *dolce far niente* disposition'.[66] Whatever the future held, there was no doubt by 1930 that Bermuda had made itself America's favourite island resort. The Trade Development Board in fact took great delight in reports that California and Florida were indulging in negative advertising about Bermuda. One advertisement on radio station WABC in New York retailed the far-fetched story of how an American lad had been debauched by liquor while on holiday with his family in Bermuda. The competition seemed to be clutching at straws. A

few years later Douglas Malcolm of American Express complimented the board on Bermuda's marvellous reputation. Its tourism campaign in the twenties 'had almost made Bermuda a suburb of New York as practically every Sunday paper in that city carried a feature on Bermuda'.[67] Whether the visitors came for swizzles, sailing or seclusion, the men of the Trade Development Board had staked out Bermuda's place in the sun. And in many an American heart.

REFERENCES

1. 'Proposal for incorporation of the Anglo-American Syndicate to develop all aspects of business and tourist trade in Bermuda, 1910', Outerbridge Family Papers, Bermuda Maritime Museum Archives, Acc. #85–23–109.

2. See: *Debates of the House of Assembly*, 1914, 234–50.

3. Trade Development Board Minutes [hereafter TDBM], 12 August 1914, BA.

4. *Debates*, 1915, 288–326.

5. *Ibid.*, 1917, 483.

6. Eve to R.J. Crouch, TDBM, 22 Feb. 1917.

7. *Charybdis* details in: Sir James Willcocks to Secretary of State for the Colonies, 29 Dec. 1917, CS 6/1/28, BA; Colonial Secretary's file #893/8: Shipping 1918–; *Debates of the House of Assembly*, 1917–8 and TDBM, 1917–8.

8. TDB Report on Transportation, 11 Feb. 1919, in Colonial Secretary's file #893/8, 1918–.

9. See: David Burrell, *Furness-Withy, 1891–1991*, London, 1992, 81–9.

10. Basil Woon, *The Frantic Atlantic: An Intimate Guide to the Well-Known Deep*, New York, 1927, 4.

11. J.A.R. Pimlott, *The Englishman's Holiday: A Social History*, London, 1947, 266. See: Piers Brendon, *Thomas Cook – 150 Years of Popular Tourism*, London, 1991, 264 ff.

12. TDBM, 28 June 1919.

13. Report of A.W. Bluck, S.S. Spurling and J.P. Hand, June 1919, and subsequent correspondence in CS file #2041, BA.

14. TDBM, 26 Nov. 1913, 5 June 1914 and 6 Feb. 1916.

15. 'Agreements with Furness Withy', CS file #2041, BA, and Jean Arrowsmith, 'The Mid-Ocean Club', *The Bermudian*, Sept. 1953.

16. Lewis to Governor Sir J.J. Asser, 15 Aug. 1923, 'Hotels: 1920–59 – Bermuda Development Company', Colonial Secretary's Papers, BA.

17. Lewis to Asser, 15 Aug. 1923, *ibid.*

18. Geoffrey S. Cornish and Ronald E. Whitten, *The Architects of Golf*, New York, 1991 edition, 54 and 330–1.

19. See: Walter Hayward, *Bermuda: Past and Present*, New York, 1910, 155.

20. *The Royal Gazette*, 20 Nov. 1968 and *The Bermudian*, Dec. 1953.

21. *Debates of the House of Assembly*, 27 Feb. 1920, 499–502.

22. Willcocks to the Secretary of State for the Colonies, 6 Sept. 1920, Governor's Despatches, CS 6/1/28, BA.

23. Until the 1960s, the term 'coloured' was universally used to describe Bermuda's black citizens. Only with the end of Bermuda's *de facto* racial segregation in that decade did the term 'black' gain currency in Bermuda.

24. The petition was presented to the Assembly on 23 July 1920 (*Debates*, 1920, 994) and printed in full in the *Journals of the House of Assembly*, 1920, 328–30.

25. *Debates of the House of Assembly*, 4 June 1923, 874.

26. *The Royal Gazette*, 20 Nov. 1968.

27. Author's interviews conducted in Bermuda, 1995–6. A full history of the dramatic events of the early 1920s in Tucker's Town deserves to be written. For an initial attempt, see: Duncan McDowall, 'Trading Places', *Bermuda*, Summer 1996.

28. Bermuda Development Company, *Mid-Ocean Club*, n.d., BA and 'Tucker's Town Assessments – St. George's Parish', ANG/SG/PAS 15, BA.

29. 'Bermuda Report by J.C. Brown', 27 Sept. 1924, file 5400-5, vol. 10049, RG #30, National Archives of Canada.

30. *Debates of the House of Assembly*, 11 Dec. 1922.

31. TBDM, 4 March 1925.

32. *Ibid.*, 13 April 1926.

33. See: James Walwyn, *Beside the Seaside: A Social History of the Popular Seaside Holiday*, London, 1978, Ch. 6.

34. Maxine Feiffer, *Going Places: The Ways of the Tourist from Imperial Rome to the Present day*, London, 1985, 216.

35. TDBM, 26 April 1933.

36. TDBM, 23 May 1927.

37. Victoria Hayward, 'Rediscovering Bermuda', *The Canadian Magazine*, Jan. 1925 and Paget Hamilton, 'Spending the Winter Under the British Flag', *ibid.*, Jan. 1927.

38. Ellen K. Rothman, *Hands and Hearts: A History of Courtship in America*, New York, 1984, 175.

39. See: Elizabeth McKinsey, *Niagara Falls: Icon of the American Sublime*, Cambridge, 1985.

40. *The Bermudian*, May 1933.

41. See: Norris Brock Johnson, 'Moongate Mythology', *The Bermudian*, August 1995.

42. Dee Gray to Albert Gray, 1 Feb. 1923, Mrs Albert Gray letters, BA.

43. Alastair Moray, *The Diary of a Rum Runner*, London, 1929, 70–3.

44. TDBM, 19 Jan. 1927.

45. Hudson Strode, *The Story of Bermuda*, New York, 1932, 118.

46. TDBM, 10 March 1926.

47. TDBM, 9 April 1925.

48. William Beebe, *Nonsuch – Land of Water*, New York, 1932 and 'Mount Bermuda', *Atlantic Monthly*, Feb. 1931.

49. William Howard Taft, 'The Islands of Bermuda', *The National Geographic*, Jan. 1922, 19.

50. TDBM, 22 April 1924, 15 Dec. 1926 and 17 Aug. 1927.

51. J.J. Outerbridge to J.P. Hand, 18 Oct. 1928, Outerbridge Papers, BA.

52. TDBM, 11 March 1931.

53. All statistics from the *Bermuda Reports* and the TDB *Annual Reports*, 1920–30, BA.

54. Author interview.

55. W.L. Mackenzie King Diary, entries for 15 and 18 April 1930, MG 26 J13, National Archives of Canada.

56. John S. Humphreys, *Bermuda Houses*, Boston, 1923, 10.

57. Joy Bluck Waters, *Eugene O'Neill and Family: The Bermuda Interlude*, Hamilton, 1992, 81.

58. Tucker Sisters collection in possession of Joan Fowle, Bushy Park, Somerset, Bermuda.

59. Isabel Bayley, ed., *Letters of Katherine Anne Porter*, New York, 1990, 87.

60. TDBM, 6 April 1927.

61. Paul Fussell, *Abroad: British Literary Travelling Between the Wars*, London and New York, 1980, 39–42.

62. Clippings in the Allen Papers, BA. For a fictionalised account of the American impact on Bermuda, see: Amy Baker, *The Painted Lily*, London, 1921.

63. Mary Gray to E. Brownlow Gray, 28 Aug. 1930, Gray Papers, BA.

64. TDBM, 14 Feb. 1923.

65. John R. Tunis, 'Bermuda and the American Idea', *Harper's Monthly Magazine*, March 1930, 456.

66. Strode, *The Story of Bermuda*, op. cit. at note 45, 152–4.

67. TDBM, 5 April 1932.

CHAPTER FOUR

'Trippers' and Clippers: Managing Success 1931–40

'It does seem odd that people should fly here at 250 mph in order to be able to ride a bicycle.'
<div align="right">E.B. White, 1936</div>

'Restricted Clientele'
<div align="right">Elbow Beach Hotel advertisement, 1937</div>

'I must say that it seems terribly sad that this lovely place should be ruined by that foul man Hitler.'
<div align="right">Colonial Secretary Eric Dutton, 1939</div>

SOMETIME BETWEEN THE two world wars, tourism became an 'industry'. In the wake of the Great War, the traveller became the tourist. Of old, travelling had been an individualistic affair; now tourism was collective behaviour. Many factors prompted the shift. There was the immense psychological release from the carnage of the Great War, a desire to escape its memory and to capitalise on the freedom and affluence that the war had supposedly won. The means of travel improved; it became easier to move across the face of the globe. Post-war currency differentials prompted people to seek their pleasure where their money went furthest. And by the 1930s, some of the more affluent democracies began legislating holidays with pay for their citizens. For the first time, broad reaches of society had paid leisure time at their disposal. The word 'holiday' acquired a powerful social and economic meaning.[1]

Governments quickly learned to respond to the holiday urge by trying to manage its outcomes. Nineteenth-century travel had seemed a chaotic business, peripheral to the creation of national wealth and governed only by individual whim. Governments then thought of their role in the economy largely in terms of fostering goods production, not services. Modern tourism promised to stimulate economic growth both through direct demand for services and indirect demand for the goods that supported these services. The post-war surge in travel showed that tourism

could be measured and thus shaped and controlled. In 1927, the International Statistical Institute began tracking tourism as an industry. Tourist movements were measured in terms of border crossings, hotel occupancy, length of stay and per capita spending. Travellers were segregated into groups – business travellers and holiday travellers – each with distinct motivation and behaviour. Academics began studying tourism as an industry. Tourism, one English scholar wrote in 1933, was 'the most noteworthy single example' of modern consumers spending ever more of their disposable income on services rather than goods.[2] Others noted that the tourism industry was becoming 'one of the most highly competitive in the world'.[3]

With such 'scientific' data at their disposal, governments began establishing national agencies to promote tourism. The Italians were quick off the mark in 1919 with the creation of the Ente Nazionale per le Industrie Turistiche. The French followed in 1928 with the Office National du Tourisme. The Travel Association of Great Britain followed a year later. North America soon joined the parade; in 1934 the Canadian Travel Bureau was born. Above all else, governments sensed that tourism was *discretionary* spending, that tourists could be lured from one destination to another if the cost, infrastructure and aesthetics were sufficiently appealing. The reward for getting tourism right was employment and a healthy balance of payments.

By these global standards, Bermuda's Trade Development Board was a humble affair. There were no 'scientific' data and no academic wisdom at hand. Unlike Europe, Bermuda did not feel the hot breath of competition; it was in fact carving out its own exclusive niche. Yet, since 1913, Bermuda had in its parochial way been pioneering the art of managing national tourism. How? By combining its innate aesthetic advantage with clever advertising, a remarkable degree of local control and careful attention to its tourist infrastructure. The alacrity with which Bermuda mastered the management of tourism reflected the fact that tourism in Bermuda was not just an industry, but was in fact its *leading* industry.

The onset in late 1929 of what was to prove the most persistent and debilitating economic depression in modern industrial times stalled tourism's growth. Depression strangled the demand for travel by removing the discretionary spending that was its lifeblood. At the same time, nationalism and ideology began erecting barriers to tourists' ambitions. Rebels roamed Cuba; Europe began to feel the convulsions of fascism. But, however dire the straits in which nations found themselves during the Depression, tourism remained part of the national economic recipe. As people grappled with the challenge of rekindling growth, they continued to think of tourism as an industry. Roosevelt's New Deal, for instance, promised Americans park and roadway construction as a stimulus to

employment and future tourism. When Britain passed the Holidays With Pay Act in 1938, private entrepreneurs like William 'Billy' Butlin responded by opening seaside holiday camps where Britons could become 'happy campers' for two weeks every year.

In Bermuda, the challenge of the Depression was threefold. There was the question of absolute demand: the affluent east coast of America whose loyalty the colony had so carefully cultivated was the epicentre of the 'crash' of 1929. Carriage trade tourism paid handsomely in the roaring twenties, but would it wither in the 'dirty thirties'? If the rich proved reluctant travellers, would Bermuda have to forsake its dedication to quality and pursue quantity? When the reduced circumstances of Depression America prompted new, less expensive forms of travel, Bermuda found itself doubly challenged. Cruise ships bearing budget-conscious 'trippers' threatened to undermine Bermuda's traditionally successful reliance on luxury liners and resort hotels. Technology created a third challenge in the form of increasingly reliable commercial aviation. When the first scheduled flying boats kissed the waters of the Great Sound in 1937, Bermuda's precious mid-Atlantic seclusion became endangered. New York was now just hours away. Did the Clippers spell the end of gracious ocean travel? Could Bermuda's aesthetic of tranquillity be preserved?

The instinctive pragmatism of Bermudians told them that Depression challenges were also opportunities. And while the decade contained its share of squabbles, disappointments and rancour, Bermuda managed Depression tourism with remarkable success. In crude statistical terms, the colony neatly doubled its annual tourist take in the decade. In 1929, the liners had landed 37 163 tourists in Bermuda. They were the colony's bread and butter, referred to in the Trade Development Board's annual reports as 'first class' tourists. Throughout the thirties, their loyalty was maintained and expanded. In 1938, 56 625 walked down the gangplanks and headed for the hotels. Tourism's added growth in the Depression came, however, from the carefully negotiated entry of cruise ships to the colony. With its usual eye to quality, the board admitted only the best 'trippers', obliged them to frequent St. George and severely curtailed their desire to sleep aboard their ships while in port. Thus by 1938, the 'cruisers' brought Bermuda an additional 25 437 tourists.

If the cruise ships somewhat lowered the common denominator of Bermuda tourism, the Clipper flights placed it in the vanguard of posh air tourism. The crescendo of tourist growth in the thirties – peaking at 82 815 in 1937 – allowed Bermuda to avoid the worst ravages of the Depression. Thanks to tourism, Bermuda avoided the dual Depression curses of unemployment and debt. In 1936, Governor Astley-Cubitt reported to London that the colony seemed to be 'on the eve of a period of prosperity'. A year later, his successor, Sir Reginald Hildyard, wrote home

that there was 'no unemployment in Bermuda among "employables"' and that its 'debt position' was 'almost negligible'.[4] If Depression Bermuda proved another world in the social and fiscal sense, the credit was due to Bermudians' ingrained understanding that Bermuda *was* tourism and to the Trade Development Board's ability to employ this precept to manage their 'industry' with remarkable verve.

Cruise ships were not an invention of hard times. Before the First World War, passenger ships had been largely conceived of as a means of direct transit, primarily between the old and new worlds. First-class passengers paid for opulence but their goal was the same as the lower-deck passengers – to arrive. After the war, the expanding leisure class discovered cruising. The rich had long taken their yachts on luxurious circuits of the Mediterranean and on ocean voyages to exotic islands. In 1886, the mayor of St. George had proudly recorded in his diary that the Duke of Sutherland's yacht, the *Sans Peur*, had dropped anchor in his harbour.[5] Now cruise ships began following in the yachts' wake. After the Great War, Cunard built the *Franconia*, a custom-designed 20 000-ton cruising ship which was soon being offered by Thomas Cook for round-the-world tours. A cruise offered social exclusivity, premeasured adventure and romance, a suspension of life's mundane routine. Cruises transformed life, albeit temporarily. As one wag noted of shipboard romance, 'the young man with uneven features and large ears is discovered, before Eddystone Light is sighted, to be a veritable Adonis'.[6]

In the twenties, cruise ships began calling on Bermuda. Posh liners like the *Lapland* and *La France* paid short visits to the colony. Their passengers toured, shopped and sampled Bermuda swizzles, but returned to their cabins by night. The colony saw these ships as a welcome fillip to its tourism and was soon endeavouring to lure them into port. Advertising and direct mail campaigns were employed to draw special cruise conventions to Bermuda. In 1930, for instance, 500 sales representatives of the Philco Radio Corporation were rewarded by their employer with a Bermuda trip on the *Arcadia*. Furness Bermuda was untroubled by these occasional intrusions on its privileged position as the colony's contract steamer. From an early date, the argument was advanced that tourists who first saw Bermuda from the deck of a cruise ship would soon return as regular tourists. Furness Withy's new liner, the *Bermuda*, was designed to emulate the hedonistic amenities of the cruise ships. Tourists were invited to dance, drink and dream their way to Bermuda.

The Depression upset this equilibrium. By eroding the affluence of the late twenties, hard times put pressure on cruise ship operators to keep their vessels full. Cruises became shorter, the tickets cheaper and the competition vigorous. For beleaguered eastern American tour operators,

Bermuda was an inviting destination for these cut-rate cruises. Just two days from New York lay cheap liquor and shopping for British goods on Front Street. And passengers could sleep – and drink – aboard their ships while in port. The 'cruisers' began appearing with increasing frequency throughout 1930, docking beside the Furness Withy boats in Hamilton, sometimes going to St. George or riding at anchor in the Sound. The crisis came early in 1931 when it became clear that the cruisers were a threatening trend, not a passing fad. The February visit of the American liner *California* provoked a debate on where the cruise ships were taking Bermuda tourism. The phrases 'cheap people' and 'trippers' began to punctuate the TDB minutes and the Assembly debates. There was talk of the unseemly 'deportment' of tourists and of litter strewn along Front Street. The board's American advertising agent, Albert Wales, came to the colony to warn that American tour operators were 'dumping' tourists into Bermuda at cost just to keep their volume up. The Hotel Men's Association concurred, arguing that the cruisers were leaving them with empty beds. Furness Bermuda chimed in, complaining that the cruises were not only impinging on their shipping trade but were taking guests from their resort hotels. Concern turned to panic when, on 16 June 1931, Furness Bermuda's pride and joy, the sleek *Bermuda*, caught fire and had to be scuttled at dockside. The TDB did its best to suppress photos of the pall of greasy, grey smoke hanging over Hamilton. Although Furness was able to charter Cunard's *Franconia* as a substitute, the cruisers seemed poised to inflict further damage on the colony's quality tourism.

Board chairman J.P. Hand sounded the alarm. The cruisers, he told the Assembly, were unfair competition. They added little to colonial revenues; their passengers consumed provisions bought in the United States. Worse still, they undermined the colony's 'policy of high class travel for which the Board has worked for so many years'. Cruises meant a 'policy of volume' which would 'inundate the country with large numbers of people'. Once a place got a reputation 'for being a cheap resort', Hand warned, 'the nice people eventually cease to go there'. Not everybody agreed with the board's preference for 'class' over 'mass'. Front Street retailers, their profits pinched by the Depression, welcomed the 'trippers'. Wharfage paid by cruise ships fattened Hamilton's coffers. Others argued that Bermuda could not buck the cruising trend: cruises were a tonic for America's Depression anxieties and even 'the wealthiest men in America' were cruising away from their troubles. Trippers would become regulars. 'One hour's view of Bermuda on a day like this,' one Assembly member contended, 'is worth six months' advertising in magazines.' And any attack on the cruisers might raise the protectionist hackles of American shipowners and provoke retaliation against British-owned Furness Withy.[7]

Even Hand was forced to acknowledge that the cruise question had aroused a 'sharp difference of opinion' in the colony. After an initial attempt to impose direct taxes on cruise ships and to close local bars whenever a low-class cruise ship appeared over the horizon, the colony fell back on its more usual pragmatism. Through the rest of the decade, the TDB sought to capture the best aspects of cruising and to ward off its worst aspects. This entailed denying port privileges to 'cheap cruises' and carefully regulating the cruise ships' ability to act as 'hotel ships' while in port. Some were permitted to sleep their passengers if they stayed at anchor in the Sound; others were accorded the same privilege if they docked in tourist-starved St. George. In 1938, the Passenger Ship Act was passed to formalise the ban on hotel ships and to vest the board with the right to issue exemptions. One-day stops in Bermuda were prohibited. Ships that flouted the colony's will would be fined. 'One of Bermuda's greatest attractions to nice people,' read the press release accompanying the Act, 'is the fact that the islands are not crowded, that life moves serenely and without that nervous restlessness which permeates everything with which crowds become associated.' 'Cheap inclusive cruises' endangered 'tranquillity'.[8] If the Trade Development Board had an abiding *bête noire*, it was 'cheap people'.

While Bermuda kept the cruisers on a tight rein, it loosened its control over Furness Bermuda and reaffirmed its belief that the company was a 'co-partner' in the colony's tourism. In 1934, Lord Essendon – as Frederick Lewis was now known – came to Bermuda to tell the Board that cruise ship competition had 'seriously diminished' his earnings. Essendon reminded the colony that the company had demonstrated its faith in Bermuda tourism by building two new liners to replace the wrecked *Bermuda*. The 'pleasure-built' *Queen of Bermuda* and her twin, the *Monarch of Bermuda*, both 22 500 tons, were fast and ultra-modern. They were, for instance, the first liners to offer a bathroom in every cabin. Soon after the *Queen* entered service in 1933, New Yorkers, accustomed to seeing her depart every Saturday afternoon, nicknamed her the 'honeymoon ship'. Mindful of Essendon's 'courage' in building the *Queen* 'in these difficult days through which the shipping industry is passing',[9] the TDB renegotiated its contract with Furness Bermuda, allowing the company to divert some of its scheduled New York summer sailings into the cruise business. These were designated 'triangle' cruises because they visited both Bermuda and Nassau, longer cruises which were believed to attract bigger spending and better-behaved tourists. Several notorious cruise ship disasters in this decade – most notably the 1934 *Morro Castle* inferno when an American liner burned off the Jersey Shore – were held up by the board as evidence of the wisdom of shunning the cheap cruisers.

To etch the image of Bermuda as a destination of quality tourists into the North American consciousness, the board's New York advertising

Vincent Astor inspecting a model of the *Queen of Bermuda*, the latest word in cruise ship technology, c. 1935. Astor, who had built himself a home on Ferry Reach overlooking Castle Harbour, was one of Bermuda's most active friends in America, and when war fractured the colony's steamer link with New York, he worked hard behind the scenes in Washington to restore a regular service. (Bermuda Maritime Museum)

agency brought a young Colorado-born artist, Adolph Treidler, to Bermuda in 1933. Treidler immediately caught Bermuda's social ethos and distinctive colours. He was soon producing vividly coloured, hard-edge poster art that captured the *Queen of Bermuda* majestically making her way through the islands of the Sound. The first of these posters were deployed at the 1933 Rotary International Convention in Boston, where the right kind of tourists for Bermuda could be found. For the next three decades, Treidler would enjoy the status of Bermuda's *de facto* official artist, and his most potent image was always the glory of cruising to Bermuda. Treidler's brush and Furness Withy's dedication to impeccable ocean service thus made the *Queen* and *Monarch of Bermuda* the abiding visual symbols of Bermuda tourism. 'Bermuda means Furness', the advertisements proclaimed. Back at the Trade Development Board, the statistics confirmed that the trippers had not overrun the colony and that quality still prevailed. Attracting quality tourists was expensive. Treidler's posters, steamship subsidies, up-market advertising and things as small as donating sports trophies all continued to swell the TDB budget. In almost Keynesian fashion, Bermuda learned to stimulate its market and to prime its tourism pump. In 1937, for instance, the board's £71 000 budget succeeded, as one local magazine noted, 'in getting our friend, John Tourist, to part with the tidy sum of £1 682 655'.[10]

In the thirties, thanks to Furness Withy and the better cruise ships, Bermudians were again reminded that the sea brought them their fundamental prosperity. On occasion, however, they were obliged to turn from the sea to catch a glimpse of the future in the blue sky. While the liners enjoyed their age of dominance, aviation was struggling through its infancy. The first flight over Bermuda came in May 1919, when a US Navy float plane, part of an astronomical expedition headed for Africa, was dropped into St. George's harbour from its tender and sent to reconnoitre the colony. Governor Willcocks put on some goggles and a helmet and became the first resident to see the island from the air: 'The reefs seemed to stand out like islands in solid relief'. Indeed, the first outcome of aviation in Bermuda was to alter the colony's precious aesthetic. Sea-borne visitors to Bermuda had always remarked how flat, grey and uninteresting the colony had looked from the sea. Only once ashore did its splendours materialise. Approached from the air, however, it appeared a green oasis in an emerald sea. 'I never knew till yesterday how truly beautiful are the islands when looked down on from above', another intrepid aviator remarked. 'The whole scene reminded me of the Arabian Nights.'[11] Technology had finally given visual reality to the long-standing literary imagery of Tom Moore and Andrew Marvell. Man could now see that Bermuda was indeed 'An island of lovelier charms; It blooms in the giant embrace of the deep'.

In early aviation, there was, however, a huge leap from adventure to practicability. Aviators in the 1920s considered the colony too 'vex'd' for their attentions. Bermuda was a proverbial dot in the ocean. Few aircraft had the reliability to sustain the 700-mile flight from the American coast; the colony lacked the beacons and direction-finding equipment to ensure that aircraft could actually find the place. The absence of flat, open space in Bermuda also meant that only water landings were possible, and float planes were slower and shorter ranged. Beyond technology, there was also Britain's desire to maintain control of Imperial aviation. Bermuda could not be allowed to become an air colony of America. Nor did Bermudians want foreigners to control air access to their trade and tourism.

Despite all the obstacles, the Trade Development Board never doubted that air travel would play a key part in the future of Bermuda tourism. Aviation offered the colony an opportunity to stay on the cutting edge of tourism, especially since air travellers were undoubtedly going to be the 'right' type of tourists, not 'cheap people'. The board also sensed that attracting the air traveller to Bermuda was going to be a race with its competitors. Cuba and the Bahamas, for instance, had the advantage of being closer to North America. In 1927, an aggressive American aviation promoter, Juan Trippe, had started a Miami-Havana service. Two years later, Trippe's Pan American Airways began flying to Nassau.

For her part, Bermuda received her first air visitor in 1926, when the American dirigible *Los Angeles* delivered mail to the colony. Slow and awkward to dock in windy Bermuda, the airship did not return. Fixed-wing aircraft offered the colony more. In 1919, a couple of wartime aviators had set up an air charter service, grandiosely named the Bermuda and West Atlantic Aviation Company, to fly tourists over the colony and out to sea to spot whales. It soon failed. Conscious of the power of aerial views, however, the TDB commissioned an American firm to film the colony from the air in 1920. Despite these flickerings, would-be Bermuda pilots remained daunted by the 700 lonely miles between the colony and a North American landfall. But Lindbergh's 1927 solo flight across the Atlantic broke the spell. Within months, New York advertiser Albert Wales was reminding the board of the 'centring of public attention on aviation'. There was glamour in aviation and where the aviators flew, the press and the well-heeled tourist were sure to follow. Accordingly, in July 1927, the board unveiled an Aviation Contest: a £2000 prize to be awarded to the first aviator to reach Bermuda from the United States within the next four months. The Assembly dutifully voted the prize money and advertisements were placed in the *Aero Digest* 'to stress Bermuda as the land of future aviation tourist services'.[12] In 1926, Hawaii had offered $25 000 to the first pilot to reach Honolulu from San Francisco. The winner of that contest assured the TDB that 'the possibilities of commercial aviation between the

American Continent and Bermuda were great'. Return tickets at $250 would bring rich tourists and sterling publicity to the colony. Still, nobody entered the contest. As the Director of the National Aeronautical Association in Washington pointed out, there was 'a considerable element of danger' involved. Flying from New York to Bermuda entailed passing from cool coastal air to balmy Gulf Stream air; icing and turbulence were possible. And, since Bermuda had no radio beacons, there was a good chance that intrepid aviators might overfly their destination and fly on to mid-Atlantic oblivion.[13] The competition was quietly allowed to lapse. Bermuda had nonetheless caught the air bug, and one local editor boldly prophesied that by 1940 'hundred passenger air yachts' would daily be stocking Bermuda's hotels and beaches.[14]

In April 1930 the first airplane reached Bermuda from North America; but only just. A Stinson float plane, the 'Radio Pilot', left New York one morning, landed sixty miles north of Bermuda at nightfall and then flew the next morning to Murray's Anchorage off St. George, where it ran out of fuel, was refuelled and then triumphantly flew on to land in Hamilton Harbour. The *Literary Digest* in New York likened the feat to 'finding a pinhead in the ocean'.[15] The board fêted the three-man crew, gave them a thousand dollars each and donated the plane's compass to the historical society. The next caller was not so lucky. In January 1931, a woman pilot, Beryl Hart, found the colony from Hampton Roads, Virginia in her float plane, the 'Tradewind'. The morning after a celebratory banquet at the Princess, Hart took off again, bound for the Azores. She was never seen again. Eight months later, a crash in Grassy Bay took the life of another pilot. Such sorry happenings obliged the board to refocus its enthusiasm for aviation from lonely heroics and publicity-seeking to the building up of local infrastructure and seeking partnerships with commercial aviators. The board's chairman, J.P. Hand, rapidly became Bermuda's leading booster of aviation. Hand had sailed out to the marooned 'Radio Pilot' with extra gasoline in 1930; now he turned his attention from aircraft to airlines. As had been the case with the luring of the Furness Withy liners to the island, Hand realised that Bermuda needed a foreign partner in the air. From a commercial perspective, New York beckoned, but London's imperial sway could not be overlooked.

Aviation was an Imperial responsibility, and from the outset London was determined to keep the Yankees at arm's length. In 1924, the British government had subsidised the creation of Imperial Airways as a kind of *de facto* national flag carrier. Routes were established into Europe and then by hops to India. Other nations were playing the same game. The Dutch created KLM. In America, Juan Trippe had created Pan American Airways in 1927 and soon had its Fokker Trimotors on the Miami-Havana run. A banker whose weak eyesight had kept him out of the navy air service in the

The float plane 'Radio Pilot' in Hamilton harbour, opening the air age in Bermuda. It would take another half a decade to make flights to the colony safe and reliable. (Bermuda Archives: R. Williams Collection)

war, Trippe developed brilliant vision for the possibilities of peacetime flying. His genius lay in realising the global potential of aviation. Commercial aviation was not just a hop and jump affair; it was about linking continents. Trippe was soon marketing his airline as a 'system'. His planes bore a stylised globe logo and an American flag on their tails; Pan Am thus became America's *de facto* national airline. Other airline promoters complained that wherever they went, Trippe had left the night before with a landing rights contract in his pocket. Such prizes went to the nations quickest off the mark. The Atlantic, a formidable body of water that defied the reach of 1920s air navigation and design, was both the choicest plum and the biggest obstacle to these ambitions. Nonetheless, an air bridge across the Atlantic became the abiding hope of aviators and governments on both sides of the great ocean. Trippe, for instance, retained Lindbergh as a consultant. Given the limited range of early passenger aircraft, Atlantic islands like Bermuda and the Azores soon began figuring in these schemes as oceanic way stations. Closest to America and dependent on her tourists, Bermuda seemed destined to fall under the shadow of American wings.

London was alarmed by the spectre of American wings over its colony. 'It is manifest that the whole tendency at present is to let aviation in, and to let Bermuda fall into the hands of Americans,' Governor Bols reported to London in 1928. This would be 'very regrettable'.[16] The Front Streeters on the Trade Development Board felt the same. Local control was crucial to controlling tourism. Thus in 1928 the Assembly voted monies for an engineer from Imperial Airways to conduct a feasibility study for a British-flagged air service between Bermuda and the States. The outlook was not promising: Bermuda had no landing facilities and no radio direction-finding and Britain had no four-engined aircraft capable of making the 700-mile flight. The report did however float a proposal with a familiar Bermuda appeal: a 'small subsidy' might remove promoters' initial reluctance to fly to Bermuda. The colony might also construct an aerodrome for flying boats, thereby allowing it to control air access.[17] The TDB quickly displayed its entrepreneurship. It first convinced the Assembly to vote monies for a meteorological station which would pump good news about Bermuda's weather into east coast America and at the same time provide pilots with weather reports. Hand and several of his colleagues then headed for Baltimore, where they held talks with the Armstrong Seadrome Development Company. When Armstrong's bizarre plan to build a floating aerodrome halfway between the colony and America proved impracticable,[18] Hand moved on to other contacts, one of whom was Juan Trippe.

Trippe and his Clippers carried Bermuda onto the stage of global aviation. Throughout the thirties, the colony was able to play a bit part in a grander Anglo-American negotiation of how mail and passengers were to

be flown across the Atlantic. Trans-Atlantic aviation was a complex mix of technology and diplomacy. From the outset two routes were considered feasible: a northern route via Newfoundland, Iceland and Ireland and a southern route with fuelling touchdowns in Bermuda and the Azores. Flying north was shorter but the weather was riskier. The southern option added distance but had the virtue of better year-round weather. Whatever route was chosen, an elaborate chain of fuelling bases and radio beacons was required. This meant involving Canada, Iceland and Portugal in the negotiation. It also meant developing aircraft that were sufficiently reliable and 'long-legged' to hop across the Atlantic.[19] From the beginning, the Americans were in the ascendancy. Trippe and Pan-American wanted access to the lucrative British and European market. Americans were also the world leaders in building long-range flying boats. Sikorsky and Boeing were beginning to supply Trippe with four-engined aircraft that could straddle the oceans. This culminated at the decade's end with the introduction of the Boeing 314 – the classic silver-hulled Clipper that gave transcontinental flying its wonderful 'Flying Down to …' image. For its part, Britain was more cautious about the Atlantic. It was lagging in the race to build big Clippers and navigational guidance systems. The British were also wary of Trippe's European ambitions; but it was just this ambition that prompted the Americans to seek a cooperative approach to bridging the Atlantic. Trippe could not afford to alienate the doorkeepers of the rich British market and the Empire beyond. By 1935, Pan Am and Imperial Airways were negotiating a cooperative assault on the Atlantic.

Bermuda's dilemma in all this was that it was not much interested in *trans*-Atlantic aviation. Britain had always represented only a thin slice of Bermuda tourism, mainly because of distance and expense. A direct air link with Britain might be convenient but it was also likely to be expensive. Bermuda was instead intent on the potential American air passenger who had more money and less distance to contend with. If trans-Atlantic flights refuelled in Bermuda, so much the better. The colony thus wanted to graft its aviation ambitions onto any Anglo-American air accord; it could not buck Britain's Imperial agenda, but it had to ensure that American wings had ready access to the colony. The untimely death of J.P. Hand in 1933 left the board without its principal aviation lobbyist. Hand's place was ably filled by Ambrose Gosling, a Front Street liquor merchant, member of the Assembly and nephew to the redoubtable Goodwin Gosling. Gosling was soon angling to lure the flying boats to Bermuda. Pan Am executives were invited to the colony.[20] In 1934, the Assembly decided to subsidise the construction of a seaplane base on Darrell's Island in the harbour off Hamilton. Ramps, jetties and a huge steel hangar were erected during the summer of 1936. Then, just as it had with the early steamship companies, the colony offered Imperial Airways a five-year subsidy to operate the base.

Such Bermudian enticements played on the realisation by both Pan Am and Imperial that trans-Atlantic commercial aviation was now feasible but still risky. Flying boats on survey flights did manage to hop their way across the 'pond', but both Pan Am and Imperial recognised that the risk was still too great for commercial service. Bermuda seemed more feasible, especially if it might be used as a test bed for the bigger challenge of the Atlantic. Thus, in 1934, Pan Am and Imperial signed a cooperative agreement for a New York-Bermuda mail and passenger service. An Imperial Airways 'Empire' class flying boat fitted with special long-range tanks and based at Darrell's Island, and a Pan Am Sikorsky flying out of Port Washington on Long Island, would provide the colony with an alternating Anglo-American service.[21] From the outset, the British were at a disadvantage. Their aircraft, the *Cavalier*, lacked the range to fly from Britain to Bermuda and had to be shipped by sea and then laboriously assembled in the colony. The Americans knew that delivery of their new Super-Clipper, the Boeing 314 – with its 4275 mile range – was only a year away.

At last, on 12 June 1937, Bermuda entered the age of commercial aviation. At 11:00am, the *Cavalier*, loaded with journalists, took off from the Great Sound. 'I am unprepared for the astounding beauty of the Bermuda Islands', one local scribe jotted down in his diary.[22] At 4:52pm the *Cavalier* flew past the Empire State Building and went on to land at Port Washington. Meanwhile, Pan Am's *Bermuda Clipper* was arriving at Darrell's Island, where Gosling and his colleagues took the crew and passengers in hand for a reception. Like everything else about Bermuda tourism, flying to the colony acquired a style all of its own. Bermuda-bound passengers checked in at the Pan Am office in the Chrysler Building in downtown Manhattan and were taken out to Port Washington in a Cadillac limousine. With them went their 44 lbs of luggage, invariably including golf clubs. Heavy trunks were despatched free of charge on the next steamer. Shortly after 11:00am, the passengers were staring down on the 'beautiful country homes' of Long Island. The *Cavalier* had large windows, capacious seats and the cabin space of a first class railway car, with a promenade passageway where passengers could stretch their legs, smoke and stare down at the sea as it changed from the murky darkness of the Continental Shelf to Bermuda azure. 'A Scotch highball comes quickly,' an early passenger noted of the white-jacketed stewards, 'and as you light your cigar or cigarette and sip your drink you become retrospective.'[23] Luncheon – begun with a Bacardi cocktail and honeydew melon – was served on linen tablecloths with silver service. Americans were offered HP sauce with their steak. Coffee, cheese and brandy rounded out the meal. The 'stoutest epicure never had lunch in such luxury', noted the *Literary Digest*.[24] Just before four o'clock the *Cavalier* touched down in the Sound; what had taken forty hours by ship could now

Lunch in the clouds: air travel combined speed and luxury. (Bermuda Archives: E. Chappell Collection)

be done in five. Customs formalities followed and then a fast launch carried the tourists to Hamilton and a carriage ride to their hotels. What had begun in a Cadillac in downtown Manhattan ended with the clip-clop of horse hooves in Bermuda.

Air travel did not revolutionise Bermuda tourism overnight. Statistically, the impact was slight. Even with the introduction of the bigger Boeing 314s in 1939, the flying boats were but a thin layer of icing on the colony's 80 000 tourist intake in the late 1930s. But the advent of commercial aviation had an immense qualitative impact. The flying boats kept Bermuda on the cutting edge of North American elite tourism. There was glamour in flying down to Bermuda. The Trade Development Board was quick to distribute photos of the latest celebrity disembarking from a Clipper – a grinning Tyrone Power stepping onto the Darrell's Island jetty with the silvery Clipper in the background. The board capitalised on this cachet: Easter lilies were despatched to First Lady Eleanor Roosevelt in Washington every Easter by air. Still, some worried that flying jeopardised Bermuda's uniqueness, that the island might become simply a weekend playground for garish New Yorkers. The visual imagery suggested otherwise. Late 1930s photographers loved the image of the Clippers cast against the backdrop of 'old' Bermuda – sailing ships, carriages and floral lanes skirting the water's edge. It was as if the Clippers offered a speedy escape to a world untouched by the very pressures that spawned commercial aviation. The American writer E.B. White holidayed in Bermuda in 1938 and revelled in the 'almost instant salutary effect on the system' of riding a Raleigh bicycle around the colony. 'It does seem odd,' he wrote to a friend, 'that people should fly here at 250 m.p.h. in order to be able to ride a bicycle.'[25] The Clippers thus underlined, rather than undermined, Bermuda's separateness.

The Bermuda Clippers left two other legacies. They contributed to the perfection of trans-Atlantic commercial aviation. In 1937, Pan Am and Imperial signed an agreement for reciprocal service across the Atlantic. The war would cut short its full development, but could not deny its potential. Although the *Cavalier* was lost at sea in 1939 on its 290th scheduled trip to Bermuda, the Pan Am Boeings quickly proved that over-ocean flying was safe and reliable. From the colony's point of view, the most lasting legacy of 1930s aviation was the friendship of Juan Trippe. Pan American Airways now joined Furness Withy as one of the colony's most dependable 'partners'. Imperial Airways – British Overseas Airways Corporation after 1939 – remained in its shadow, important but not essential to the colony. By contrast, Trippe instinctively knew that Bermuda had lasting potential as a rich and loyal market for his aircraft. Trippe soon developed a personal affinity for the colony. His wife Elizabeth was a sister of Edward Stettinius, the American automobile and steel mogul who had built in Tucker's Town. Trippe loved to golf and was soon enticing his

Tourists load their bicycles onto the Bermuda Railway in the late 1930s. From 1931 to 1947, the railway was the fastest way round the carless colony – but it was never profitable, and was squeezed out of business by the post-war admission of automobiles. (Government Information Services, Bermuda)

New York friends onto his Clippers for get-away weekends at the Mid-Ocean Club. In the 1950s, he too would buy in Tucker's Town. More importantly, Pan Am aircraft would be in Bermuda's skies for the next half century.

By limiting cruise ship access, by protecting Furness Bermuda and by welcoming the Clippers, Bermuda brilliantly managed to protect its tourist volume in the 1930s. It resisted the temptation of cheapening its market appeal, continued to build up its summer trade and thereby rode a crescendo of growth at a time when North America knew only economic retraction. Through all this, the Trade Development Board's meticulous grooming of the colony and its aesthetic continued without pause. By 1939, Bermuda was much the same sort of place it had been in 1930, only with more tourists. Throughout the decade, the board dedicated itself to keeping Bermuda quaint. In 1933, the board's New York advertising agent had some blunt advice for his mid-ocean clients: 'Don't become Americanized'.[26] And indeed they didn't. When litter and oil from the cruise ships began appearing in Hamilton harbour, the board asked the corporation to clean it up. The Board of Agriculture was similarly asked to stop stripping the roadside oleander hedges because with their loss the 'beauty of the Colony would be impaired considerably'. When artist Paul Ickes sketched the colony for advertising purposes, the board told him his work was 'excellent' but asked him to change the colour of Harrington Sound. The blue was not quite right. This aesthetic guardianship spread throughout Bermuda society. The Young Folks' Cycle Club campaigned against dirty bicycles by tying tags to them reading: 'I keep my bicycle neat. Do you?' In 1937, the Assembly passed the Amenities Act which set up a commission to stop the uncontrolled division of land and to protect trees. In the same year, a Bermuda Historical Monuments Trust was established to polish the colony's historical legacy.[27]

In the spirit of tranquillity and picturesqueness, a 1931 TDB advertisement promised tourists that the 'isolated Bermudas refuse to bow down to the modern gods of speed and noise'. Throughout the decade, the 1908 prohibition on automobiles stood firm. But there was mounting pressure for change despite the colony's insistence on a non-American aesthetic. Between 1921 and 1931, Bermuda's population had grown an astonishing 40.6 per cent to 26 522, a reflection of the good times that tourism had brought. In the thirties growth slowed to 11.4 per cent, but by 1939 Bermuda's 29 547 citizens were also obliged to cope with an annual invasion of 80 000 tourists. With such density, getting to work and getting to the beach were becoming arduous for visitor and Bermudian alike. By 1939, for instance, even Governor Hildyard was complaining that he was unable to fulfil his duties given that his only means of quick transport was a motor launch. The Colonial Secretary complained that the Governor

was 'to some extent marooned' in his residence. When the Assembly intimated that a special clause might be inserted into the Motor Car Act to permit a gubernatorial automobile, the Legislative Council killed the idea. The Governor sulked. The *Crown Colonist* lampooned the crisis in a mocking editorial headlined: 'Daddy wouldn't buy me a bow-wow'. Hildyard soon left the colony. Two members of the local elite tried to make amends by promising the incoming Governor a carriage and four. The immediate reaction of the new Governor's aide-de-camp was that he had stepped back into a horse-drawn Victorian world with its 'Dickensian smell of horse-droppings, horse sweat and saddle soap'.[28]

The stock response to the traffic question was that the colony had approved the building of a railway in the twenties. The idea of some sort of trolley running along the central spine of the colony had been mooted since the 1890s, but had always run afoul of the Bermudian phobia about foreign capitalists worming their way to the centre of the local economy. In 1924, however, a British syndicate aligned itself with Harry Watlington, steamship agent, water entrepreneur and TDB member, and obtained a charter for the Bermuda Railway Company from the Assembly. Buried in the charter was a pledge that motor cars would be kept out of the colony. Opposition to the railway was stiff. Some objected to the 'intolerable smell of gasoline' that the trains would bring to the colony, others to the noise. Stanley Spurling complained that the railway was 'fraught with the most disastrous possibilities to the Colony from the financial obligation'. Watlington countered that without some form of rapid transit many American tourists would not return to slow-moving Bermuda.[29]

Through the late 1920s, construction of the railway inched forward. Recalcitrant landowners bogged down the land expropriation process along the railway's route. To avoid such delays the company resorted to building bridges across coastal inlets. Costs soared. Every year the company reappeared before the Assembly, wiser and poorer, to request an extension to the deadline for completion or some further favour. By 1930, the Governor candidly reported to London that there was 'no general confidence that the railway would prove a remunerative undertaking'. There was talk that, on a per mile basis, Bermuda was building the world's most expensive railway. The Assembly proved a very indulgent parent; mainly, the Governor concluded, because the alternative was the admission of cars, which meant expensive road work and affronting the tourists, '… on whom … the prosperity of the Colony so largely depends'.[30]

Finally, in October 1931, the railway was finished. Governor Sir Thomas Astley-Cubitt drove the last spike and cut a ribbon. In many ways, the railway complemented Bermuda's quaintness. Running from Somerset through Hamilton and on to St. George, it wound its way through floral-lined cuttings and over bridges that offered unimpeded sea views. In

Bailey's Bay Station in the 1930s, thronged with tourists who were probably heading for the beach. Unlike carriages and bicycles, the railway offered all-weather mobility. (Bermuda Archives: P.A. 436)

keeping with Bermuda's sabbatarianism, the railway did not run on Sundays. Its first-class cars had comfortable wicker seats, and conductors willingly loaded tourists' bicycles into the baggage cars. Tourists could now contemplate day-long excursions to distant St. George or Somerset, and Bermudians could now commute to their jobs in central hotels or Front Street shops. For all its charm, however, the railway did not solve Bermuda's traffic problems. Its capital costs were never met by its earnings. Imported diesel fuel was ruinously expensive. Bermuda's humid and salt-laden air corroded the rolling stock. Ridership was disappointing; there were too many stops. The railway's single line missed entire sections of the colony. Most Bermudians clung to their beloved bicycles. Stanley Spurling used to astound visitors by telling them that every year he put 10 000 miles on his machine by cycling from his St. George home to Hamilton. On a weekday, Front Street became choked with hundreds of bicycles and carriages through which the train had to make its cautious way.

Throughout the thirties, pressure grew for a solution to Bermuda's transportation woes. The railway's English owners increasingly treated their investment as an albatross not worthy of another penny. A Horse Lovers' League was formed to protect the colony's beleaguered horse population. Exemptions were made to the Motor Car Act to allow doctors to drive cars. Even the Trade Development Board, long the champion of a carless Bermuda, had to acknowledge the problem. Furness Withy and American travel agents reported complaints that tourists could not reach the golf courses and beaches because the railway was too slow or failed to go near the new Castle Harbour Hotel. Some advocated better livery service; others better ferries. Some even said that the time had come for the controlled introduction of motor buses. The board found itself caught in a cross-fire of interests. Tourists did not vote in Bermuda; livery stable owners did. The tourists nonetheless waded into the debate. In 1934, the author Sinclair Lewis came to the defence of the Bermuda aesthetic he and so many other Americans had come to love. In an open letter, he confessed his fear that Bermuda's oleanders and hibiscus might give way to 'nice red petrol stations, presumably with hot dog sandwiches and other American home comforts'. Soon the once-quiet roads would be invaded by buses of 'shrieking tourists waving beer bottles at you as they roar through the dust'. Cars would make Bermuda just like Detroit and Pittsburgh and then 'why should the citizens of Detroit and Pittsburgh take the trouble to come at all?'[31] As the decade closed, the guardians of Bermuda tourism sensed that the aesthetic and practical demands of their precious industry were in conflict. Since the practical ultimately supported the aesthetic, the TDB began to bend. Some form of motor transport seemed in the offing; the war would settle the debate. In the interim, cars remained, as one Colonial Office official noted, as scarce as 'snakes in Ireland'.

Cars were not the only unwelcome thing in Bermuda in the 1930s. If Bermudians sensed that North Americans came to their island to escape the material pressures of their lives, they also sensed that Americans came to find relief from other, more social phobias. The colony had always gone to great lengths to keep out the so-called 'cheap people' who offended the patrician values of its well-heeled clientele. Now other darker values that reflected the racial prejudices of the decade came into play in grooming the colony for its guests. Jewish visitors found themselves increasingly unwelcome in paradise. As with all viruses, it is difficult to pinpoint the origins of anti-semitism in Bermuda tourism. Two factors stand out, however.

First, Bermuda's proximity to New York put it on the doorstep of America's largest Jewish community. Sophisticated and affluent Jewish Americans soon took a liking to Bermuda; during the Christmas season 70 per cent of the tourists in Bermuda were Jews intent on escaping the great Christian festival and finding some warmth. Furness Bermuda calculated that 20 per cent of the Americans it annually brought to Bermuda were Jewish. The bond was reinforced by the fact that 40 per cent of the travel agents on the east coast were reportedly Jewish.[32] While there was no overt targeting of the Jewish market as such, the colony was quick to publicise the arrival of prominent Jewish tourists like Albert Einstein, Walter Chrysler, Harpo Marx and Irving Berlin.[33] Early in the 1930s, however, this welcome began to wear thin in many a Bermuda hotel.

Bermuda's hotel infrastructure had grown handsomely in the twenties. The stalwart Hamilton Hotel still anchored the industry, but there were plenty of challengers. The Elbow Beach Hotel on the South Shore put visitors right on the edge of the colony's most glamorous beach. The Castle Harbour Hotel was new and offered an inclusive resort package. The stately Princess in Hamilton was rebuilt early in the decade. An aggressive local entrepreneur, Howard Trott, had built up a chain of hotels – the Frascati, Inverurie and Belmont – which offered 1300 beds across the colony. Trott had cut his teeth in the hotel business as a $15-a-month desk clerk in the Princess, before moving on to a partnership with J.P. Hand. His Bermuda Associated Hotels specialised in golfing holidays and had booking offices in New York.

While the big hotels perfected the art of golf and glamour in the twenties, the colony's small hotels and guest houses surged in popularity. They offered quiet intimacy, impeccable service and a sense of exclusivity that the more anonymous resort palaces lacked. There was something *recherché* about staying at a Bermuda guest house. Perhaps the most illustrious of these was Pomander Gate, picturesquely tucked away at the narrow end of Hamilton harbour at the Foot of the Lane. Founded by a Canadian, Howard Buck, and an American, Jay Lynk, just before the war, Pomander

The Castle Harbour Hotel c. 1950. Opened by Furness Withy in the early 1930s, it offered an early and luxurious form of package holiday – liner from New York, tender to the hotel, golf, swimming and social prestige. Few people realised that the hotel and the adjacent and exclusive Tucker's Town residential enclave had been built on land expropriated from black Bermudian farmers and fishermen in the 1920s. (*The Bermudian*)

Gate combined chintz, antiques, fine food and English gardens to attract a loyal and snobbish clientele. Wags joked that guests needed 'a birth certificate, a vaccination mark and a coat of arms' to register at Pomander Gate. As passengers disembarked from the *Queen of Bermuda*, locals would comment that the best dressed were 'Pomander Gate class'. Buck was said to have once evicted a guest for eating peas with a knife. Helen Hayes honeymooned at Pomander Gate; Charles E. Hughes, former governor of New York, came frequently. The last thing departing guests did each year was to make their booking for the next year.[34]

Into this atmosphere of exclusivity, anti-semitism crept. In part, it came in the minds of bigoted American tourists who feared that the same 'pushy' and 'rowdy' Jews they encountered at home were now overrunning their favourite resort. Bermuda hoteliers, fearful that their loyal WASP clients might desert them, soon acquired the phobia. When these two anxieties converged in the late twenties, Jewish visitors began discovering that places like Pomander Gate were no longer accepting their reservations. Specious explanations were offered. Travel agents in the United States were quietly informed that no Jews or only 'good' Jews were welcome. To avoid embarrassing mix-ups, the agents devised a code system for their hotel listings: an oleander symbol for hotels wanting only gentiles and a hibiscus for those taking Jews.[35] By the mid-thirties, Jewish tourists, now largely excluded from the guest houses, turned in greater numbers to the big hotels. Here the reaction was more overt: the Elbow Beach, for instance, began inserting the term 'restricted clientele' into its advertisements. Everybody knew what it meant. Bermuda never passed any blatantly anti-semitic law giving force to this insidious trend, but in Bermuda everybody knew the game. In 1930, the Hotel Keepers' Protection Act was passed, allowing hoteliers to turn away would-be guests, a legal right that flew in the face of the old English common law obligation of innkeepers to take in weary travellers. Bermuda, the law's defenders alleged, was too small a place for a traveller to be weary.

In the spring of 1937, the silence broke. Newspaper articles in London and New York alleged that at least five Bermuda hotels were refusing Jewish guests. The Board of Deputies of British Jews immediately wrote to the Secretary of State for the Colonies in London demanding an inquiry into 'anti-Jewish discrimination' in a British colony.[36] Back in Bermuda, a Furness Bermuda vice-president, E.P. Rees, appeared before the Trade Development Board to warn that the colony was playing a dangerous game. As more hotels became 'restricted', he warned, fewer Jewish passengers would sail on the *Queen* and *Monarch*. If volume fell off any more, Furness might withdraw one of its ships. Rees also suggested that if the Hearst newspaper chain took hold of the story, Bermuda tourism might be 'killed'. Rees pointed out that his company's three Bermuda

hotels – the Castle Harbour, St. George and Bermudiana – still accepted Jews.[37]

Everybody squirmed, but nobody acted. The Colonial Office in London concluded that, since Bermuda was a largely self-governing colony, the issue was 'a matter for the hotel proprietors in which Govt. could scarcely intervene'. In the colony itself, Governor Hildyard took much the same line. The Hotel Keepers' Protection Act was valid colonial legislation over which he had no sway. The issue would 'blow over' once 'the rowdy section complained of by the better class of tourists to Bermuda' was rooted out and only 'better Jews' remained.[38] Members of the TDB generally took refuge in the specious argument that Jewish exclusion was really a question of business development and property rights, not human rights. Howard Trott believed the issue to be 'neither racial nor religious'. Hotel owners had the right to refuse 'rowdy' clients who damaged the colony's precious decorum. Perhaps, he suggested, travel agents should be encouraged 'to use their discretion in sending only the better type of Hebrews' – Jews like the auto magnate Walter Chrysler – to Bermuda? Rees crisply replied that the agents, many of whom were Jewish, would have a difficult time distinguishing 'good' and 'bad' Jews across their desks in New York. Nobody mentioned that the colony's hotels were amply supplied with carousing WASPs whom nobody sought to 'restrict'. Sensing intransigence, Rees concluded by asking that the 'no Jews' policy be 'soft pedalled'.[39]

And there the matter rested. As in so many other issues, Bermuda was insulated from the flow of world opinion. There were no boycotts or inquiries. Some Jewish visitors kept coming. There was, as London always pointed out, 'no absolute ban' on Jews entering the colony. When war came to Bermuda, so too did a handful of Jewish refugees. In 1940, the Colonial Secretary reported to London that Bermudians 'do not like them here and resent their coming and endeavouring to buy up property in Bermuda'. Fearing that Jews would become absentee landlords, the colony passed regulations preventing non-residents remitting money to Bermuda to buy real estate.[40] The post-war world would be less inert in the face of Bermuda's discriminatory hotel policies.

Race intruded on Bermuda tourism in another quiet way. Since the mid-nineteenth century, Americans had reported their affection for Bermuda's gentle racial relations. Bermudian blacks were invariably described as 'friendly', 'easy going' and 'happy'. This was a society where everybody knew their 'place': a fantasy in which whites ruled but never lost sight of their *noblesse oblige*; blacks obeyed but expected their due. In 1939, *House and Garden* reported that Bermuda was 'America's admirable antidote', where visitors settled 'back into the more comprehensible life of the Nineteenth Century'.[41] The American popular writer Frederick Lewis Allen told the

readers of *Harper's* in 1938 that particularly 'in its handling of the colour problem does the ruling class show how to be conservative gracefully'. There were 'no insulting Jim Crow arrangements' in Bermuda.[42] Nonetheless, there was *de facto* segregation in Bermuda. Property meant political power in Bermuda, and few 'coloureds' had sufficient land to vote. The entire administrative apparatus of the colony was in white hands; there were, for instance, no black members on the Trade Development Board. Retail and hotel management was always in white hands, even if that meant importing foreign hotel workers. Front Street zealously guarded its prerogatives; the 1931 Non-Resident Businesses Act, for instance, made it difficult for outsiders to set up shop in the colony. While there were no official barriers, blacks were not allowed to frequent the colony's tourist facilities. In 1938, for instance, an attempt was made to evict them from the one beach at which they could freely swim. White property owners on Spanish Point complained that black swimmers disturbed their peace. A smaller beach at Deep Bay was suggested as a replacement. Governor Hildyard reluctantly intervened to restore the original beach: 'The provision of one small beach may seem a trivial matter, but it is the denial of such things as these that is often the cause for serious outbursts, from which hitherto Bermuda has happily been free'.[43]

Despite the bitter pill of racial segregation, the colonial economy created employment and relative prosperity for black Bermudians in a decade when American blacks led a desperate existence. Black labour – from the docks in Hamilton to housekeeping in the hotels – was the great practical foundation of Bermuda tourism. Despite their reliance on this labour force, one of the great phobias of white Bermudians in the thirties was black overpopulation. In 1934, a committee of the Assembly went so far as to suggest that compulsory sterilisation be introduced to curb illegitimate black births. When the Colonial Office found this notion 'startling' and British women's rights activist Lady Astor called it a 'disgrace' to the Empire, the idea was dropped.[44] Whenever coloured Bermudians expressed resentment over their lot, the white elite suggested that they ponder the lot of their impoverished brothers in the Caribbean, where tourism had yet to wave its wand of prosperity. Don't rock the boat was the implicit message. The message permeated all corners of Bermuda society. It began in the schools. A 1938 children's book set in Bermuda, *Banana Tree House*, laid out the role model. Bermuda is portrayed as a 'huge box of brilliant paints' full of happy blacks. Sukey, the book's young coloured protagonist, befriends 'two elegant white ladies' and finds herself guiding them around the colony in a carriage. 'The ladies asked so many questions, the carriage halted many times, and Sukey felt like a complete guide to the Bermuda Islands.'[45] All Bermudians should be like Sukey, the subtext ran – friendly and quaint.

In the thirties, some of Sukey's compatriots began to question their role in Bermuda society. As early as 1924, coloured Bermudians had found an outlet for their concerns with the founding of their own newspaper, *The Recorder*. In keeping with the pervasive gradualism and conservatism of Bermuda as a whole, there was little stridency in their demands for a broader, more inclusive franchise, access to free education, better health care and an end to what one Bermudian historian has called their status as 'second class citizens'.[46] There were, for instance, virtually no labour laws to protect workers whose efforts on the docks or in hotel housekeeping provided the muscle power of Bermuda tourism. But there was also an enervating lack of leadership in the Bermudian black community, an inability to create the kind of solidarity that the white merchants of Front Street had mustered so effectively. There were stirrings. In 1936, a group of black small businessmen banded together into the Emergency Business Association, a 'get-to-gether club' to promote commercial uplift. Dinners and speeches were held. Problems were discussed – '… the spirit of the masters predominates …' – and there were calls for blacks to capitalise on tourism. One member said that the time had come for blacks to entertain the tourists. The association soon collapsed, again underlining the lack of leadership in the black community, an understandable consequence of its economic isolation and restricted opportunities.[47]

Slowly, more forceful leadership emerged. Ironically, it was largely imported. A fiery Trinidad-born doctor, Edgar F. Gordon, began agitating for better labour laws and universal suffrage. Gordon's rhetoric grated on the elite's sensibilities. A Guyanese-born school teacher, Edward Richards, was less grating but just as persistent in his editorials in *The Recorder* against the invisible barriers that confronted Bermuda's coloured population.[48] In the 1930s, the community learned to speak out. Early in 1939, for instance, a black delegation from the Pembroke Political Association requested a meeting with Governor Hildyard to discuss their under-representation in the structures of Bermuda education, law, policing, medicine and military life. Having voiced their discontent with the 'policy of exclusion', the group ended with an expression of the coloured community's 'loyalty' to England.[49]

These two major injustices – the creeping exclusion of Jewish tourists and the systemic exclusion of blacks from full participation in their own society – were the only stains on Bermuda tourism in the thirties. Indeed, the concepts of loyalty and control seemed best to capture the spirit of the enterprise. Here was a society with a top-down paternalistic ethos that knew exactly what it wanted – 'quality tourism' – and brilliantly honed the business, social and political skills needed to realise its ambition. The Trade Development Board was bold in pursuing its conservative ends. There was nothing haphazard about Bermuda tourism; the board treated

tourism as an 'industry' capable of producing predictable results if the right tools were applied. The retailers, hoteliers and shipping agents who constituted the board had in fact made themselves tourism technocrats. And like all good entrepreneurs, they learned to protect their brand image – by shooing away the worst type of cruise ships – and how to stay on the cutting edge to prevent their product from becoming mature and stale.

The minutes of the Trade Development Board in the thirties are in many ways a catalogue of tourism trailblazing. Each challenge was met with appropriate tools: legislation targeted to exclude or stimulate was, for instance, applied to steamers, hotels, railways and retailing. In 1934, the board rethought its American advertising, deciding to sign on with a big New York agency, N.W. Ayer & Company, so as to obtain a broader creative reach. The use of full-page colour advertising was intensified; in the depths of the Depression Bermuda would spend $1900 for the back cover of *The New Yorker*. High-profile radio commentators like Lowell Thomas and Damon Runyon were brought to Bermuda to transmit shows back to America. New niches – tall ship races and rugby weeks for Ivy League collegians – were opened up. The board's publicity office, the Bermuda News Bureau, used its staff photographer to capture young honeymooners on film as they came off the tennis court or strolled on the beach. The photos were then fast-freighted to its New York office for distribution to the couple's home-town paper, 'which had the psychological effect of urging others to come to Bermuda'.[50]

The Bermudian magazine was perhaps the most innovative new tool employed by the board to project Bermuda's image. Founded in 1930 by R.J. 'Ronnie' Williams, a hard-drinking, boisterous Welshman who had come to Bermuda after an adolescence on the high seas, the magazine was meant to be a monthly capsule of Bermuda life attractively packaged for export. Williams wanted the magazine to be 'a bit facetious', 'witty and literary'. *The Bermudian* was consciously modelled on *The New Yorker*. Its monthly gossip column, 'From the Crowsnest', mimicked the 'Talk of the Town' column in *The New Yorker*. 'Queen Street wags' poked fun at the colony's foibles and at times might criticise the 'fumbling methods' of the local elite. Wry cartoons caught the social ambience of Bermuda tourism: a plump lady at a dinner party greets a late guest with 'You've missed turtle soup and Mr. Trott!' Sensing that Williams' magazine was a flattering mirror of the Bermuda aesthetic it had so long cultivated, the TDB subsidised *The Bermudian*. Every month the board took 1500 copies of the magazine and distributed them free in North America. Copies were, for instance, sent to posh golf and gentlemen's clubs, where members might flip through its pages and be prompted to plan a Bermuda holiday.

The Bermudian's 'At Home Abroad' column provided an impressive monthly kaleidoscope of Bermuda tourism. Punctuating brief write-ups of

The Children's Hour

BERMUDA is an ideal growing-up place for youngsters... due largely to the absence of many of the ordinary hazards of childhood.

For example, Parliament has eliminated the menace of motor traffic. There are no factories... no soot or smoke... no "tough" or violent element. Thanks to the Gulf Stream, cold weather is unknown.... And the superbly pure, sea-cleansed air has made Bermuda a recognized refuge for those who are subject to hay-fever.

The fun of Bermuda is found in protected harbours... on coral beaches and in gentle surf of lovely rainbow colours... in the Government Aquarium's fascinating collection of tropical fish... on fine tennis courts, cricket fields, golf courses.... And in bicycle tours through a tranquil land of oleanders, wild jasmine and hibiscus.

Bermuda's variety of modern hotels and charming cottages... her fine schools and hospitals... have enabled many parents of growing children to extend their visit indefinitely.

Such fortunate children find Great Britain's oldest colony rich in historical interest. Their residence here is an experience to be recalled in after-years, to be long cherished as a colourful adventure in beauty... and in health.

YOU CAN GO BY SEA OR BY AIR Luxury liners travel from New York to Bermuda in 40 hours... a round-trip total of nearly 4 days of delightful shipboard life. Sailings from Boston too.
• Splendid new transatlantic planes take off four times weekly, and descend at Bermuda 5 hours later... an enchanting experience in the sky. • A wide choice of accommodations is provided by Bermuda's many hotels and cottages. • No passport or visa is required for Bermuda.

• FOR BOOKLET: Your travel agent, or The Bermuda Trade Development Board, 500 Fifth Avenue, New York City. In Canada, Victory Building, Toronto.

More than any other magazine, *The New Yorker* brought Bermuda to the attention of North Americans. Its readership exactly matched the socio-economic profile of Bermuda tourism, so that full-page colour advertising was a worthwhile investment. This 1938 advertisement extols the island as a 'sea-cleansed' place for family fun. (*The Bermudian*)

visiting yachts, cocktail parties, honeymoons and amateur tennis matches were the names of America's social, business and political elite: William H. Vanderbilt, Gertrude Lawrence, Vincent Astor, Gifford Pinchot, Gene Tunney, E.F. Hutton, Dean Acheson, Senator Robert Wagner, Cordell Hull, Mayor Walker of New York and Edith du Pont. The list seemed endless. As had always been the case, literary celebrities took a special delight in Bermuda. Hervey Allen came to the colony to write *Anthony Adverse*. Georgia O'Keeffe came to rebuild her nerves, Serge Koussevitzky to escape the podium. Architects Frederick Law Olmsted and Ralph Adams Cram visited to escape 'the concrete mixer of this age of vast mechanisms'; each had provided glowing testimonials of Bermuda for a 1936 TDB publication, *Residence in Bermuda*, designed to draw more residential tourists to Tucker's Town. 'Bermuda is a place unspeakably satisfying because of what it is *not*', Olmstead wrote. English and Canadian visitors gave 'At Home Abroad' a more cosmopolitan appeal: Stephen Leacock, Noel Coward, Lord Baden-Powell, Christopher Morley and Rudyard Kipling.

What *The Bermudian* only hinted at was that Williams' home had become a magnet for an influential contingent of American *literati*. Sinclair Lewis, Dorothy Thompson (Lewis's columnist wife), James Thurber, E.B. White and Hervey Allen all became close to Williams. Ada Trimingham's 'Waterville' guest house (near the Pomander Gate) and the Tucker Sisters' Little Green Door Tea Room also won their loyalty. 'Nothing in my life,' Thurber wrote to E.B. White in New York, 'has ever tasted finer than the strawberries and cream and tea and toast' at the Green Door.[51] Echoes of Mark Twain! Other writers and editors – Robert Benchley, Clifford Orr, Joel Sayre – associated with *The New Yorker* drifted into the circle. There is even a photo of the razor-tongued critic Dorothy Parker, staring bleary-eyed into *The Bermudian*'s lens. Bermuda offered them all escape from America, the philistine civilisation of vulgar materialism that Sinclair Lewis had so effectively satirised in his famous 1922 novel *Babbitt*. Williams offered his literary friends a respite from the pressures of work, evenings of wit and gossip and a good deal to drink. In later years, Thurber (who contributed articles *gratis* to Williams' magazine) would end his letters to his Bermuda editor with the words: 'Gin Up! Sober to the Wheel! Sherry On!'[52]

So the thirties slipped pleasantly by in Bermuda. Very few other societies recall the Depression simply 'slipping by'. Yet in Bermuda, the rest of the world seemed so far away and in many ways so irrelevant. An American girl whose family wintered in the colony in the thirties measured her stay in 'Bermuda time – an effortless, slow-motion procession' of golf, fishing and lolling around the shore.[53] As far as Bermudians were concerned the *Pax Britannica* was still solidly in place. There was comfort in the sight of

Flying boats at anchor in the Great Sound; since only the very wealthy could afford air travel in the 1930s, aviation enhanced Bermuda's reputation for exclusivity, and the silver flying boats soon featured prominently in the colony's advertising. Later, wartime stop-overs by Allied flying boats brought famous visitors ranging from Joe Kennedy to Winston Churchill. (Bermuda Archives: Gift Charles Moss)

the white ensign fluttering on the sterns of the British West Indies Squadron anchored in Grassy Bay. Blanche Naylor, a Greenwich Village poet who frequented the colony, caught the mood in her 'A Manhattanite in Bermuda': 'The Navy men rush here and there,/ Whilst female tourists stand and stare'.[54] And when the occasional German cruiser or flying boat came over the horizon, the TDB sent their officers sightseeing and treated them to cocktails. Events in Europe were to Bermudians just that, events in Europe. Thus when war came in 1939, it hit the colony hard and unexpectedly.

A few days after Britain's declaration of war in September 1939 automatically made the colony a belligerent, Colonial Secretary Eric Dutton hurriedly scratched out a private note to Harold Beckett, head of the West Indies Department of the Colonial Office in London. 'The future of Bermuda is terribly obvious', he wrote. 'The thing is that the tourist trade is falling off fast and unless we are exceptionally lucky it will disappear entirely ... I must say that it seems terribly sad that this lovely place should be ruined by that foul man Hitler.'[55] Almost immediately, the 'Britishness' on which the colony had so heavily staked its image in American eyes became a liability. In late August, the Admiralty had requisitioned the speedy *Queen of Bermuda* for war duty; a week later the *Monarch* met a similar fate, slipping out of Hamilton harbour passengerless, with her portholes blackened. The board took the news in good part; Furness Bermuda had told them that cancelled reservations and ruinous war insurance had suddenly made the run unprofitable. Stanley Spurling, who had seen Bermuda's lifeline cut before, in the First World War, was philosophical: '... nothing should be done to offend Furness Withy because Bermuda would undoubtedly want their help in the re-establishment of the tourist trade after the war'.[56] The Pan Am Clippers kept flying; America was not at war. But reservations were down sharply. A Pan Am official told the board that when one recent passenger told her colleagues that she was bound for Bermuda 'they had draped her desk in crepe'.[57] The erosion of Bermuda's reputation for tranquillity was intensified when *Time* magazine ran a story entitled 'Paradise at War', which created the impression that the colony was latticed with trenches and barbed wire.[58] The Colonial Secretary believed that this and other malicious rumours were put about by Bermuda's 'lousy rivals in Florida'.[59]

With its usual resilience, Bermuda fought back. When TDB chairman Ambrose Gosling resigned to take up duties with the Bermuda volunteer regiment, local retailer Kenneth Trimingham took over. Within days, he was off to New York with Spurling and Trott in search of a new shipping contract with a neutral American company. American friends were quick to help. Vincent Astor, who had built a sprawling home at Ferry Reach in Bermuda in 1932, lobbied hard for the colony, going to Washington to

argue that it should be considered part of America's sphere for purposes of the Neutrality Act and that Americans might continue to travel there without passports. Back in Bermuda, American residents banded together to sign a circular letter that assured prospective tourists that the colony was 'as calm and peaceful as ever'. The Bermuda News Bureau distributed the letter to American travel agents.[60] The board's new promotional film – 'Vacation Diary', made by RKO-Pathé – was hurried to American movie theatres.

At first there were some encouraging signs. Thanks largely to Astor's influence with the American shipping industry, Trimingham returned with a contract with the Holland-America Line. He proudly announced that the colony was reconnected with its all-important American market. The price was steep, a $13 000 subsidy per trip out of New York. On 23 October, the *New Amsterdam*, a 36 000-ton sleek American liner, arrived for the first time. Within a month, Holland-America cancelled the agreement after only four trips. Only 91 passengers braved the last voyage; American newspapers had carried reports of a submarine attack on a Bermuda-bound vessel out of Nova Scotia.[61] Vincent Astor went to work again. Within weeks, a new contract was signed with the United States Line, of which Astor was a director. On 18 December, the *President Roosevelt* arrived with 125 passengers. Astor then turned to the public relations front. The 29 January 1940 issue of *Life* magazine carried an article entitled '*Life* Calls on Vincent Astor at Ferry Reach' in which Astor was pictured surrounded by fun-loving Austrian and Italian aristocrats (perhaps not the best choice in late 1939).

Like the phoney war in Europe, there was an air of unreality about Bermuda's attempts to keep its tourism alive in early 1940. Further subsidies were paid to the United States Line, but the *President Roosevelt* never covered her costs even after receiving the colony's subsidy. Some TDB members began questioning the whole gambit; one concluded that Bermuda was simply 'throwing good money after bad'.[62] The colony lost its battle for passportless entry by American visitors; photo identity cards were introduced for everyone on the island. British military officials harassed German and Italian-American seamen serving on the *President Roosevelt*.[63] Travel agents grew weary of reporting that there was 'too much sales resistance' for them to be able 'to sell Bermuda successfully'. The manager of the Bermuda News Bureau woefully reported that before the war the colony had been 'a newspaperman's paradise', but now Americans would believe only that Bermuda was in a war zone. The board's New York advertiser chimed in that there was no longer any profit in the account for them. A mood of quiet desperation settled over the colony. In the spring of 1940, the Assembly briefly debated imposing income tax in the colony to replace the lost staple of tourist-generated revenue.

The end came with a whimper. The United States Navy requisitioned the *President Roosevelt*, and the United States Line, smarting from losses of $165 000 on the route, said goodbye to Bermuda. On 26 October 1940, the *Roosevelt* sailed for the last time, and except for sporadic calls by American and Canadian ships, Bermuda was now a paradise without tourists. The unthinkable had happened: the cord to New York had been cut. Recognising the obvious, the board held a meeting in early December with its New York advertiser. The advertising executives advised that only one course of action remained: '... the best policy would be for the Board to concentrate on keeping the conception of Bermuda alive'.[64]

REFERENCES

1. See: J.L. Hammond, *The Growth of Common Enjoyment*, London, 1933 and J.A.R. Pimlott, *The Englishman's Holiday: A Social History*, London, 1947.

2. F.W. Ogilvie, *The Tourist Movement: An Economic Study*, London, 1933, vii.

3. Arthur Joseph Norval, *The Tourist Industry: A National and International Survey*, London, 1936, 271.

4. Astley-Cubitt to Secretary of State for the Colonies, 12 Feb. 1936; 1937 budget estimates, file #67566 and Hildyard to Secretary of State for the Colonies, 28 April 1937, all in CS 6/1/38 and CO 37 at BA.

5. W.C.J. Hyland diary, 30 Dec. 1886, BA.

6. Basil Woon, *The Frantic Atlantic: An Intimate Guide to the Well-Known Deep*, New York, 1927, 30.

7. All quotations from *Debates of the House of Assembly*, 5 June 1931 and TDBM, 16 Jan., 24 and 28 Feb., 11 and 21 March and 23 June 1931

8. Press Release, 27 Aug. 1938, in J.J. Outerbridge Papers, BA.

9. J.J. Outerbridge, TDB Secretary, to the Colonial Secretary, 8 Jan. 1932, Governor's Despatches, CO 37, BA.

10. *The Bermudian*, November 1937.

11. *The Royal Gazette*, 24 May 1919 and the *Bermuda Colonist*, 26 May 1919.

12. TDBM, 1 and 21 July 1927.

13. TDBM, 2 Dec. 1927 and 31 Jan. 1928.

14. *The Bermudian*, April–May 1930.

15. *Literary Digest*, 12 April 1930.

16. Sir Louis Jean Bols to the Secretary of State for the Colonies, 21 Jan. 1928, Governor's Despatches, BA.

17. TDBM, 25 Aug. 1928 and Governor Bols to Secretary of State for the Colonies, 6 June 1929.

18. *Debates of the House of Assembly*, 12 June 1929.

19. J.H. Thomas, Downing Street, to Secretary of State for External Affairs, Ottawa, 9 August 1935, State Confidential Circulars, 1935, BA. See: Matthew Josephson, *Empire of the Air: Juan Trippe and the Struggle for World Airways*, 1972 reprint of 1944 edition, Salem, New Hampshire.

20. TDBM, 14 June 1934.

21. John Pudney, *The Seven Skies: A Study of BOAC and its Forerunners since 1919*, London, 1989, 147–51.

22. R.J. Williams in *The Bermudian*, July 1937.

23. Lester Gardener, 'To Bermuda by Air', *Imperial Airways Gazette*, Jan. and Feb. 1938.

24. *The Literary Digest*, 19 June 1937.

25. E.B. White to Gustave Lobrano, March 1938, in Dorothy Lobrano Guth, ed., *Letters of E.B. White*, New York, 1976, 173–4.

26. J.A. Wales, TDBM, 26 April 1933.

27. TDBM, 19 May 1931, 9 Feb. 1932 and 10 July 1937. *The Bermudian*, April 1937 and Jan. 1938.

28. Governor's Despatches, file #67662, BA; *The Royal Gazette*, 13 June 1939; and Frank Giles, *Sundry Times*, London, 1986, 16.

29. *Debates of the House of Assembly*, 5 Feb. 1924 and 25 Oct. 1925.

30. Acting Governor to Secretary of State for the Colonies, 9 July 1930, Governor's Despatches, BA.

31. 'A Letter from Sinclair Lewis', *The Bermudian*, April 1934.

32. TDBM, 17 Feb. 1937.

33. All featured in *The Bermudian*, 1930–39.

34. Alice Sharples Baldwin, *The Days of Buck and Lynk: A Tale of Old Bermuda*, Hamilton, 1964, 5–11.

35. Horace Sutton, 'Sun, Sea, and Sand', *The Nation*, 20 Sept. 1947, 285. As early as 1912, Woodrow Wilson's lady friend Mrs Peck was complaining about '*Jews* innumerable' in Bermuda (Peck to Wilson, 19 Jan. 1912, in Arthur Link, ed., *The Letters of Woodrow Wilson*, Vol. 24, Princeton, 1974–).

36. 'Alleged Ban on Jews', file #67638, CO 37, BA.

37. TDBM, 17 Feb. 1937.

38. Hildyard to Secretary of State for the Colonies, 1 April 1937, Governor's Despatches, CS6/1/38, BA.

39. TDBM, 17 Feb. and 9 April 1937.

40. 'Emergency Powers Act, 1939', file #367730, CO 37, BA. See: the Transfer of Real Estate Property (Returns) Regulations, 1940.

41. Edward Acheson, 'America's Admirable Antidote', *House and Garden*, April 1939, 80. Acheson was an American writer living in Bermuda.

42. Frederick Lewis Allen, 'Bermuda, 1938', *Harper's*, April 1938, 473.

43. 'Deep Bay Public Bathing', file #67695, CO 37, BA.

44. 'Birth Control', file #67544, CO 37, BA. See: 'Bermuda Births', *Literary Digest*, 10 October 1936.

45. Phillis Garrard, *Banana Tree House*, London, 1938, 84.

46. Eve N. Hodgson, *Second Class Citizens, First Class Men*, Hamilton, 1988.

47. Cecile Musson Smith Papers, BA.

48. See: Randolf Williams, *Peaceful Warrior – Sir Edward Trenton Richards*, Hamilton, 1988.

49. 'Meeting with representatives of the coloured community', file #67715, CO 37, BA.

50. TDB Special Committee on Photo Publicity, 1 Sept. 1931, BA.

51. Helen Thurber and Edward Weeks, eds., *Selected Letters of James Thurber*, Boston, 1980, 3–4.

52. *Ibid.*, 149. See: John Weatherill, 'Thoughts on Thurber', *The Bermudian*, Aug. 1994.

53. Whitney Balliett, *The New Yorker*, 21 May 1979.

54. Cited in William Griffith, ed,. *Bermuda Troubadours: An Anthology of Verse*, New York, 1935, 89.

55. Eric Dutton to Harold Beckett, 11 Sept. 1939, file #67717, CO 37, BA.

56. TDBM, 16 Sept. 1939.

57. TDBM, 18 Dec. 1939.

58. *Time*, 30 Oct. 1939.

59. Eric Dutton, '1940 Estimates', file #67566, CO 37, BA.

60. 14 October 1939, circular letter by 12 American residents of Bermuda, J.J. Outerbridge Papers, BA.

61. Colonial Secretary file #2041/A – Holland America Line, BA and TDBM, 2 November 1939.

62. TDBM, 2 Nov. 1939.

63. Colonial Secretary's file #2041/B – United States Line, BA.

64. TDBM, 13 Dec. 1940.

CHAPTER FIVE

'... *this pint-sized paradise*': Recapturing America 1941–55

'Oh, Mr. Trimingham! Oh, Mr. Trott!
These Americans have made me mighty sore
We've done everything we know
To relieve them of their dough,
But the blighters seem to *still* have plenty more!'
<div style="text-align: right">Sung by the Talbot Brothers, c. 1945</div>

'... a tidy atmosphere among the kind of people you can depend on to behave as you do.'
<div style="text-align: right">*House and Garden*, 1956</div>

'And if we start just to pile a lot of people into hotels and pile people into ships, I believe that we can mutilate our own livelihood.'
<div style="text-align: right">H.D. Butterfield, 1954</div>

IN ITS REPORT for 1942, the Bermuda Board of Immigration listed only 35 tourist arrivals. There were no Bermuda advertisements in the *New York Times* or *The New Yorker*. The Trade Development Board closed its office in Rockefeller Center and the Bermuda News Bureau let its American staff go. The board itself went into a kind of hibernation, its membership chopped from thirteen to five and its requests for advertising funds denied by the Assembly on the grounds that wartime promotion of beaches and sunshine was unpatriotic. Fifty pounds was set aside each month as life support for *The Bermudian* magazine. Despite their New York advertiser's warning that they could not afford the 'luxury of silence', Bermuda tourism was unquestionably mute and dormant. Only vestiges remained. Club 21 on Front Street still served its famous mint juleps, but there were few to sip them. Trimingham's department store still proudly displayed its Liberty fabrics, but most shoppers concentrated on the necessities of life. The Clippers still landed at Darrell's Island, but their silver livery was soon gone, replaced by drab wartime grey.

Yet Bermuda was alive with foreigners. The Immigration Board reported that 9587 American 'base workers' had entered the colony in

A new American invasion: construction troops disembarking from a troopship. Bermuda played a key strategic role in the Atlantic theatre; American, Canadian and British personnel were stationed in the colony or passed through it en route to Europe, and a posting in Bermuda sowed the seed of a post-war holiday return in the mind of many a young GI. (Bermuda Archives: U.S. Bases Collection, No. 126)

1942. On any day, Front Street was crowded with men and women in khaki and navy blue – American, British and Canadian servicemen waiting for ferries or trains, loading trucks or heading for service clubs to enjoy their 'liberty'. In September 1942, *Life* magazine despatched one of its house artists, Floyd Davis, to capture the parade. Davis gave American readers a double-page colour mural of 'Bermuda in its battledress'.[1] In the early stages of the conflict, the TDB even tried to extract some promotional value from the military invasion: 'the sight of US "gobs" whirling by on a Bermuda tandem bike, or riding horseback along the flower-bordered lanes makes Bermuda more picturesque than ever. Come see Bermuda and witness wartime cooperation.'[2] But war tourism had a very different ethos from that of its peacetime cousin. Control, sacrifice and scarcity were its bywords. Change and modernisation would be its outcomes.

World War Two proved to be the greatest crux in modern Bermudian history. With it, Bermuda became a modern society. Before the war, the colony had traded on its isolation, on its status as a base for privateers, as a winter vegetable garden and, finally, as a mid-ocean antidote to the American way of life. Through all these phases, Britain's imperial pretensions buttressed the colony. The Bermuda Dockyard, as some rather dramatically put it, was 'a dagger pointed at the heart of America'. The war diminished the island's isolation and destroyed Britain's pretensions. Bermuda ceased to be the 'Gibraltar of the West' and became instead America's military outpost in the Atlantic. The colony finally slipped fully under the protection of the Monroe Doctrine, as a perimeter fence guarding first against Germany and later against the Soviet threat. While the British flag continued to fly over it, post-war Bermuda became part of the American sphere of influence, economically and militarily. Military necessity brought what pre-war tourism had hinted at: the American idea of progress – an airport, automobiles, the beginnings of a consumerist society and aroused black sensibilities – from which there was no post-war turning away. War thus profoundly affected the society on which Bermuda had so long staked its tourist appeal. Before 1939, the colony was 'an anachronism – an island living in a 19th century style in a 20th century world'.[3] After 1945, the tension between preserving the old aesthetic and accommodating the emerging imperatives of the 'new', American-centric Bermuda became the delicate sine wave of Bermuda tourism.

Britain's hasty withdrawal of the speedy Furness Bermuda liners provided the first push in the American direction. While the Dockyard remained a linchpin in Britain's naval strategy for the Atlantic, the colony was otherwise overlooked as Britain girded itself against putative German attack. Still-neutral America pursued the logic of Juan Trippe's peacetime strategy for commercial aviation: Bermuda offered an ideal mid-Atlantic way station for flyers, commercial and military. In September 1939, the

American government quietly won approval from London to build a naval seaplane base on Morgan's Island in the Great Sound. Britain's ignominious retreat from Dunkirk in the spring of 1940 hastened the American advance into the colony. Desperate for military equipment and eager to shed responsibility in its imperial outposts, London negotiated its famous 'destroyers for bases' agreement with Washington. From Newfoundland to the Caribbean, Britain leased military real estate to America in return for the sinews of war. Bermuda was no exception. In September 1940, an American cruiser, the *St. Louis*, brought American military engineers to inspect the colony. Washington's initial hankering for a seaplane base quickly grew into an ambitious blueprint for a fully fledged air and sea facility ringed by coastal defences. The centrepiece of this coral fortress would be an aerodrome capable of handling long-range aircraft.

Bermudians watched these activities with mixed alarm and relief. War meant employment. If Bermudians could not serve the vacation needs of Americans, then they would earn their living by helping them defend themselves. Tourism in 1938, the last unblemished year of peace, had brought £1 960 000 into the colony; the average American tourist generated £35. By 1940, this revenue had all but evaporated. The embodiment of Bermuda militia units, the creation of a Bermuda Service Corps – a New Deal-style works programme – and putting the huge Dockyard on a war footing partially stunted the growth of unemployment. But white Bermudian fears of large numbers of unemployed blacks in the colony remained; the spectre of 'coloured overpopulation' had haunted the elite throughout the thirties. There was agitation in the colony for a workers' association and the introduction of labour legislation, agitation fanned by the fiery black labour leader Dr E.F. Gordon, who found in the war an ideal opportunity to expand his campaign for greater black entitlement in the Bermuda economy and politics. Thus, from the perspective of the colonial elite, American bases meant jobs and an opportunity to buy racial, political and economic peace in the colony.[4]

On the other hand, the bases might wreck paradise. The American military surveyors were already roaring around the colony in jeeps; construction meant trucks and heavy equipment. Military men were likely to be 'loud' – uncultured, abrasive visitors in a land of tranquillity. Worse still, the facilities they were to build would scar Bermuda's quaint landscape. Rumours indicated that the aerodrome would be carved out of the central parish of Warwick, a coast-to-coast swath of asphalt and fencing that would bisect the colony. A quick grab at wartime employment might create an aesthetic nightmare and undo decades of careful cultivation of Bermuda as a mid-ocean garden. Lurking behind this idea of betrayal was the fear that the bases would erode Bermuda's sovereignty and reduce its Britishness.

With its usual dexterity, the Front Street merchant elite repositioned itself to regulate the colony's response to the war. Men tutored in peacetime retailing, wholesaling, shipping and tourism adroitly transferred their talents to the business of managing a society at war. The colony's ingrained habit of governing through appointed boards was simply reapplied to wartime needs. Henry Vesey, pre-war manager of the H.A. & E. Smith department store and member of the Trade Development Board, was redeployed to the War Supply Board. Menaced by U-boats, the island's beleaguered food supply forced Bermudians to regulate their wartime diet with ration coupons. Vesey issued the coupons and urged his countrymen to relearn their skills as market gardeners. Like other wartime democracies, Bermuda was also determined to control its costs in wartime. Hence Stanley Spurling was appointed in late 1940 to head a Labour Board, which would direct and control the Bermudian worker in a war economy. Ambrose Gosling resigned the chairmanship of the Trade Development Board to spearhead local defence of the colony as colonel of the Bermuda Volunteer Rifle Corps. The pinnacle of the colony's wartime administration was undoubtedly the powerful Finance Committee of the Assembly, headed by John Cox, a wily Front Street merchant and Assembly member for Devonshire parish. Here budgets were set, controls tightened and eased and plans laid. The war thus brought an abrupt shock to Bermudian life, but it did little to unsaddle the men who had traditionally controlled its destiny. The voice of German propaganda, Lord Haw-Haw, was said to have claimed that 'Howard Trott and the Forty Thieves were shaking in their boots' as the U-boats encircled their colony.[5] There was much to shake about on the open seas: news, for instance, that the freighter *The City of Birmingham* had been torpedoed, taking a rare cargo of food to the bottom, was perhaps the darkest day of the war for Bermudians. But back on Front Street it was business as usual.

One thing Front Street could not control was Bermuda's place in the Allied grand strategy. In the panicky atmosphere of late 1940 and early 1941, London had little time to consider colonial sensibilities. In March 1941, Churchill passed a secret message to the president in Washington: 'Need guns badly'.[6] The Americans would be given the right to develop their seaplane base and a massive aerodrome not as part of the 'lend-lease' scheme but as a simple gift, given 'freely and without consideration'. 'We have long neglected these Islands,' Churchill wrote.[7] Sensing Bermudian apprehension, American military engineers heeded suggestions that the location of the aerodrome be shifted to St. David's parish in the colony's east end and fashioned out of land built up by dredging Castle Harbour. While the ruggedly independent St. David's Islanders (who had only been connected to the 'mainland' by bridge since 1934) complained, the most

obvious American military incursion had at least been shunted off to a quiet corner of the colony.[8] The Americans even hired artist Adolph Treidler to paint scenes of the proposed base development to suggest that the 'amenities' of Bermuda architecture would be preserved. These sketches were shown to President Roosevelt.[9] Ironically, the first aesthetic victims of the new base were Americans. Vincent Astor, Bermuda's most loyal American friend, would soon lose his gorgeous view from Ferry Reach across Castle Harbour. Dredges, tarmac and bombers soon blighted the scenery. Other wealthy Americans also lost recreational land on St. David's Island.

Such American adjustments did little to allay Bermudian fears that they were losing part of their territorial birthright. A Bermudian delegation was sent to London to make the case for some softening of the American plans. Howard Trott and John Cox were joined by Henry Tucker, the general manager of the Bank of Bermuda; they soon discovered that while their voices were powerful in the colony, they had little resonance in the motherland. Persistent lobbying won them an interview with Prime Minister Churchill, who curtly told them that the war required 'sacrifices' and that 'it was not possible to distribute the sacrifices equally'. Bermuda would have to accept its 'heavy sacrifice'. Trott, Cox and Tucker bore this stern command home, softening the blow by reminding the colony that they had at least convinced London and Washington to relocate the base to St. David. The Assembly duly approved the base agreement and Churchill cabled his belief that the Bermuda bases would act as 'important pillars to the bridge connecting the two great English speaking democracies'.[10]

On 1 March 1941, the American flag was raised over Morgan's Island and Governor Bernard dutifully turned the sod for the seaplane base. Bermuda soon pulsed with American activity. The Castle Harbour Hotel was taken over as a dormitory – or 'a playground for American doughboys', as *The Bermudian* put it – for US servicemen. An old Hudson River ferry was anchored in Castle Harbour to serve as a floating dormitory for workers employed in dredging the harbour; it quickly acquired a reputation for iniquity and was the closest Bermuda has ever come to tolerating a legal casino. The Elbow Beach Hotel became a storage facility. Service clubs sprang up across the colony; Bermudian ladies poured tea and danced with Allied sailors and soldiers at the United Services Club in the Hamilton Hotel. 'Conservative islanders deplore change,' *Life* reported, 'but are proud to be helping the empire survive.'[11] However much the remaining members of the Trade Development Board instinctively tut-tutted over the presence of 'unruly sailors' in the streets,[12] Bermuda's ambience was being dramatically transformed. The St. David's air base quite literally emerged out of the water as scattered islands were linked with millions of tons of excavated coral. The Americans thus physically enlarged the colony; their leased domain soon totalled ten per cent of

Kindley Field c. 1942. The coral dredged from Castle Harbour would, after the war, give Bermuda a platform for commercial aviation, thus spelling the end of the flying boat service to the colony. (Bermuda Maritime Museum)

Bermuda's land mass. On 29 November, Kindley Field – named after a First World War flying ace – opened its control tower and two weeks later a Corsair fighter became the first land-based aircraft to touch down in Bermuda. As Churchill had predicted, Bermuda soon became a 'pillar' of the Allied war effort. Thousands of Europe-bound aircraft were ferried through the colony, while Bermuda-based seaplanes scoured the Atlantic for U-boats.[13] In one crucial respect, Bermuda had suddenly fallen into step with the twentieth century.

Almost overnight, Bermuda had a new tourism industry: war tourism. For half a decade, the colony found itself at a crossroads of the Allied war effort. Garrison troops, military engineers, ships' crews and transient airmen flowed through Bermuda, some for just a few hours, others for the duration. Allied naval ships 'worked up' – tested their capabilities before actual combat – in Bermuda waters; Boeing 314s dropped down on the colony for fuel before continuing to the Azores, Lisbon or England. War tourists spent less, stayed in barracks or on board their vessels. Officers might frequent the restaurants and the yacht club, but the rank and file looked for a place to drink, a rented bicycle and a sandwich in a service club. They were also red-blooded American boys who, as *Life* reported, 'pined' for girls. And the wartime Bermuda provided them too. Even before America's entry into the war, Churchill and Roosevelt had quietly decided that Bermuda was ideally placed to screen transatlantic mail and telecommunications, sieving it for military intelligence. Working in conjunction with the FBI, the British Imperial Censor set up shop in Bermuda, taking over the basement of the Princess Hotel, building radio towers and cramming deciphering equipment into the battlements of old British forts. Young English women were brought to Bermuda to work as 'trappers', deftly prying open mail taken off the Clippers and examining it for coded messages destined for the Nazis. Overseen by Sir William Stephenson – 'a man called Intrepid' – the 1200 'censorettes' found themselves at the centre of Allied intelligence, applying the secrets of the captured Enigma machine to unmasking the covert German war effort. The colony became 'an exotic satellite of the ULTRA establishment at Bletchley' in England; flying there, 'one sensed a promise of entry to enemy lines'.[14] (In the 1970s, James Bond aficionados speculated whether Ian Fleming, the spy's creator and a wartime espionage man himself, had been inspired by Stephenson's Bermuda operations. Many remarked on the resemblance between the Princess Hotel's fish-tank-lined Gazebo Bar and Dr No's notorious shark tank.)[15] When not picking apart German secrets, the censorettes found themselves entertained by Bermuda society and Allied servicemen. Tennis, croquet, amateur theatricals and dances filled their free hours. A sexist myth grew up that suggested that only women with well-turned ankles could be competent trappers.

One of the 'censorettes' at work, probably in the Hamilton Princess Hotel. Just as the American Civil War had done, World War II created a peculiar, transitory tourism that kept Bermuda's economy alive. (Bermuda National Library: 'History of the War', vol. 1)

The wartime parade of soldiers and censorettes did two things for Bermuda tourism. Firstly, it planted the colony squarely in mainstream American consciousness. Before the war, awareness of Bermuda was largely confined to its elite patrons. The whole thrust of the colony's tourism had been to attract the *best* classes. Now, the war brought *all* classes to Bermuda in uniform. It also transmitted the image of Bermuda back to all segments of North American society. *Life* carried no fewer than four feature articles on wartime Bermuda. Other mainstream magazines like *Time* and *Harper's* followed suit. The theme was invariably the same: 'Defence Outpost for North America – How Bermuda has become the Crossroads of the Atlantic', ran the *Canadian Geographical Journal*'s story.[16] Amid the descriptions of convoys and coastal defence, there were always hints of Bermuda's deeper beauty. 'One might almost say,' Frederick Lewis Allen wrote in *Harper's* in 1943, 'that except for an occasional automobile, and the fact that the tourists seem to have put on uniforms, it is still the old Bermuda' of oleanders and beaches.[17] The colony even worked its way into American popular fiction. In 1942, G.P. Putnam's in New York published a romantic pot-boiler called *Bermuda Calling* in which a dashing young American intelligence officer, Zach Rowland, falls in love with a censorette and, having first vanquished nasty German agents, marries her.[18] Zach had visited pre-war Bermuda and remembered cycling in 'cheerful abandon along winding white coral roads'. He also recalled the colony as 'an ideal place for a honeymoon'. Here was the implication of war tourism. Thousands of Americans carried fond memories of the colony and its charm home with them. When peace brought the opportunity for marriage, Bermuda automatically beckoned as a honeymoon destination.

Secondly, war tourism also reinforced the colony's patrician renown. Bermuda became a stopover point for Allied leaders shuttling between the continents. The pattern began late in 1939, when the newly appointed American ambassador to the Court of St. James, Joseph Kennedy, stopped over. In August 1940 the Duke and Duchess of Windsor sojourned en route to the Bahamas where the Duke was to become governor. The local establishment looked warily on the couple; hints of the Duke's Nazi sympathies and memories of the 1936 abdication grated on the colony's sense of Britishness. After a few rounds of golf and attending church at the cathedral, the Windsors departed. Many others followed, usually deposited in the colony for a night while their Clipper refuelled (and trappers sifted through its mail bags). Churchill came in 1942; a 'sudden descent' he called it. So did Commonwealth prime ministers on their way to London. King Carol of Roumania sought brief asylum in the colony. In 1943, Bermuda hosted an Allied conference on the plight of wartime refugees. Americans ranging from Wendell Wilkie to Averell Harriman completed

the procession. All were captured in the camera's eye and a Bermuda byline added to the resultant wire service story. The war was the story, but the memory for most readers was probably that there were sun and flowers in Bermuda.

Military and diplomatic visitors kept Bermuda's wartime governors busy. Sir Denis Bernard even devised a system of segregating less convivial guests from those he favoured: a card registry on which the less desirable were coded as 'GPO' – garden party only.[19] Other guests enjoyed tennis and dinners. When Bernard extended his haughtiness to American military officials stationed in the colony, London replaced him in 1942 with the younger and more pro-American Lord Knollys. If the doughboys tended to democratise the colony's image, the sojourning statesmen and politicians tended to flatter its established image of exclusivity. Throughout the war, rumours on the street in the colony suggested that Hitler had his eye on Bermuda as a war prize, a kind of semi-tropical Eagle's Nest. Others said that Roosevelt planned to retire in the 'isles of rest'. Twice in 1944, Churchill asked Roosevelt to join him in the colony for talk and relaxation; the ailing president declined. Peace did bring the first presidential visitor to Bermuda. In August 1946, the USS *Williamsburg* brought Harry Truman to Bermuda for an eight-day visit. Truman fished, swam, toured and said flattering things about the colony's restfulness.[20]

Bermudians were initially in two minds about the invasion of war tourists. A tight, insular society used to setting its own agenda and holding external influence at bay, Bermuda resented foreign dictation, even if it came with Churchill's patriotic exhortation. As the dredges and bulldozers went to work in 1941, foreign observers detected 'two schools of thought' among the colonists about the 'new' Bermuda. One was 'guardedly pessimistic', a sentiment 'generally to be found among those whom outsiders would call snobbishly inclined'. Wartime change would bring 'the end of the luxury trade'; it would cheapen Bermuda and open it to hordes of brash, low-spending Americans after the war.[21] John Hall, writing in *The New Republic*, detected a 'Battle of Bermuda' in which the colony's privileged classes feared that the war would erode their power and tranquillity. 'Mrs._____ objects to having a gun there because her oleander hedge has been in this place for one hundred years.'[22] Even *Life*, which otherwise lauded the colony's war spirit, noted a certain 'insularly self-complacent' reaction to such American innovations as automobiles and hot dogs.[23]

The modernisers handily won the Battle of Bermuda. There was, they argued, no escaping change in a global conflict. Just as it had capitalised on previous conflicts – for instance, by privateering in the Napoleonic Wars – Bermuda must seize the opportunities of the present conflict. Two opportunities beckoned powerfully: using the war to position the colony for a post-war tourist boom and using the US bases as a new economic

mainstay. Healthy tourism and American military vigilance in the mid-Atlantic would diversify the colonial economy, thereby protecting it from the kind of sudden shocks that 1914 and 1939 had previously dealt it. Some prescient observers argued that such gains could only be secured at the cost of modernising Bermuda society – broadening its democratic reach and economic benefits. Thus when Trott, Cox and Tucker went to London to try to stymie the 1941 Anglo-American base agreement, one local newspaper attacked their opposition to what seemed undeniable progress, labelling them 'pettifogging horse dealers'.[24] War had brought the twentieth century to the colony's shores; the challenge was to take advantage of its vigour while holding its deliriums at bay. When Churchill stood before the Bermuda Assembly in 1942 to thank it for accepting the American bases, he acknowledged that their loyalty to the Empire would unleash 'many changes and alterations in the balance of your community'.[25] The automobile, commercial aviation and the presence of an American military colony-within-a-colony were at the heart of the conundrum. By 1943, Frederick Lewis Allen, writing in *Harper's*, concluded that Bermuda confronted 'a forest of question marks' and that isolationism was not an answer to any of the colony's questions. Three years later, the *New York Times* applied the title of Edna St. Vincent Millay's famous poem to Bermuda: 'There Are No More Islands Any More'. The colony now had 'problems' familiar to most North Americans. But could it maintain its status as 'a small sample of heaven'?[26]

By late 1942, as the desperation of early war receded, tiny Bermuda, like the other western democracies, began to consider the challenge of postwar 'reconstruction'. After the First World War, Bermuda had relied on local adhocery and Furness Withy's determination to make the colony a tourist mecca to pull it back to prosperity. After the Second World War, it would rely on planning. With their usual pragmatism, the merchants of Front Street forsook their crusty conservative instincts and decided that Bermuda's future could be planned in the same way as Roosevelt had planned the New Deal and Lord Beveridge was planning 'cradle to grave' welfare in Britain. An Economic Advisory Committee was assembled out of key members of the elite, including prominent TDB men like hotelier Howard Trott, hardware merchant Arthur Gorham and former New York publicity man Freddy Misick. Headed by retailer Edmund Gibbons, the committee began meeting in December 1942, using the TDB boardroom. It was aided in its task of preparing a post-war blueprint by an imported expert, Professor J. Henry Richardson of Leeds University. A trained economist and acolyte of Beveridge, Richardson immediately countered Bermuda's entrenched ethos of individualism and laissez-faire with an article in *The Bermudian* entitled 'What is Economics?'.[27] The Advisory Committee did not need the professor's tutoring to know that the rehabi-

litation of tourism was 'one of the most urgent problems of post-war reconstruction'.[28]

Throughout the winter of 1942-3, the committee picked the brains of those best placed to divine the contours of post-war tourism – New York advertisers, travel agents, Furness Withy vice-presidents, Pan Am and BOAC airline officials – and listened to Bermudians who had prospered on tourism before the war. Through all the talk about aviation, steamers, hotel refurbishing and the need for skilled labour, there was one unshakeable common denominator – the kind of tourist on whom Bermuda would stake its post-war future. 'The type of people Bermuda would wish to attract,' TDB chairman Ken Trimingham declared, 'were those to whom the natural beauty and charm of the Islands would appeal and every effort should be made to enhance this natural beauty and make the colony as attractive as possible.'[29] About this, there was no dissent. The board's American advertiser, N.W. Ayer & Co., was in no doubt that 'the cultured type of visitor' was the colony's key to a prosperous future; 'the spectacular type of visitor, who was interested in gambling, horse racing and night life, would not wish to come to Bermuda, and would not be an asset to the Islands'.[30] But, as the committee's March 1943 report[31] made clear, adherence to the colony's old quality over quantity strategy entailed jettisoning some of its now worn-out tenets.

As always, getting tourists to and from the colony was of crucial importance, and even a casual observer could see post-war changes ahead. Military aviation would be a springboard to peacetime commercial aviation. Seven hundred miles from New York, Bermuda would be well within the range of a new generation of land planes – like the DC-4 – which were faster, larger and more comfortable than the Clippers. Kindley Field awaited them. Although leased to the Americans for 99 years, it was still Bermuda soil and would probably be opened to civilian aviation when peace returned. The TDB was initially sceptical about opening the colony up to the big planes and even made plans to remove Kindley Field from post-war tourist maps, believing that it would be seen as a blot on the landscape. But when Howard Trott told the Economic Advisory Committee that 'the land plane' was 'the plane of the future',[32] they quickly became air-minded. Pan Am officials endorsed the idea by promising to renew their pre-war partnership with the colony by introducing 125-seat airliners with the peace. Only the British resisted; BOAC would stick with Clippers after the war. There was, however, a vague sense that high-volume, scheduled air services would upset the rhythm of Bermuda tourism. The Advisory Committee reported that air travel would appeal to those 'who wish to make the most of a short holiday and will use air travel because of its greater speed'. The predictability of a weekly steamer service would be undermined; tourists would now arrive and leave when *they* wanted. Board

Like the steamship companies before it, Pan Am realised that art was a crucial tool in popularising Bermuda as a tourist destination. This poster from the late 1940s associates Bermuda with its long-established aesthetic of pink beaches, floral abundance, white roofs and 'Britishness'. (The Masterworks Collection, Bermuda)

members began using the word 'shuttle' to describe the imagined impact of airliners on tourist flows. The implication of unpredictable visitor arrivals and departures for hotels, sightseeing and government services like Customs was daunting. But there seemed to be no denying the notion that speed and convenience would dominate post-war tourism.

Bermuda was not, however, about to forsake its other pre-war partner, Furness Withy. Liner travel had become synonymous with the elegance of a Bermuda holiday. In 1943, Furness Withy began placing advertisements in *The Bermudian* promising to return to the colony 'in the not too distant future … with flying colours'. The problem was when. Its graceful workhorses, the *Queen* and *Monarch*, had been pressed into wartime service and would undoubtedly need major renovation to remove the grime of war. Could the liners continue to hold the line against cruise ships? How deeply would the speedy airliners bite into their supposedly loyal clientele? Furness Withy assured the TDB that 'there would always be a place for ships, and travellers, not primarily interested in speed, might still prefer them to aeroplanes'. Yet, in a telling moment of uncertainty, a vice-president of the steamship company admitted that 'the big shipping houses would have to get into air transportation as well in order to protect themselves'.[33] The colony thus shrewdly placed post-war bets both on the air and on the sea.

Speed and convenience would require other peacetime changes in the colony. The American bases had put cars on Bermuda roads and Bermudians 'had actually experienced the convenience of being able to go from Tuckerstown [sic] to Hamilton in twenty minutes (instead of an hour or more) in a conveyance that will stand without hitching'.[34] There would be no going back to a horse-drawn society after the war. The 1943 committee report saw 'inland transportation' as 'one of the most urgent of Bermuda's present and post-war problems'. It doubted that the Bermuda Railway, much abused in carrying troops and supplies around the colony, could meet the post-war challenge. Even before the war, the TDB had tacitly accepted the inevitability of the automobile in paradise; Furness Withy, Pan Am and American travel agents all told it that Americans wanted to get around the island without perspiring on bicycles and waiting for trains. By the middle of the war, all that remained was to decide whether the railway had any future at all and under what conditions cars would roll on Bermuda roads. All agreed that cars must be 'controlled'; they must be small, slow and preferably specially designed for the colony's narrow roads. The board's New York advertiser suggested that a 'Bermuda car' be commissioned and volunteered to approach Willys Overland, the builder of the Jeep, to explore the idea. Others felt that the car must be of British design; a steering wheel on the 'wrong' side and an unAmerican appearance would allow Bermuda to continue to look 'different' in visitors' eyes.[35]

Like Beveridge in Britain and the New Dealers in the United States, the Economic Advisory Committee sensed that planning extended beyond industries to the wider society, and that here outcomes were less manageable. Post-war Bermuda would therefore have 'social security', a blanket of 'sickness benefits, workman's accident compensation and old age pensions, based on contributions by working people and employers and administered by government'. Government, advised by a planning commission, would use public works to create employment. Implicit throughout the whole report was the assumption that healthy post-war tourism would foot the bill for Bermuda's brave new world, cars and all. The reality would prove somewhat different. Social modernisation can seldom be smoothly planned.

Construction of the American bases had provided the first hints of friction. Washington requested that a two-tier wage system be maintained: American wages for American workers and local wages for Bermudians. This, the Governor reported, had created 'a natural feeling of grievance' among black Bermudians. Surging wartime inflation exacerbated the problem. Dr Gordon had fanned the flames, demanding trade union recognition for his fledgling Bermuda Workers' Association. A brief longshoremen's strike followed. Labour legislation was introduced to the Assembly, declared tokenism by Gordon and withdrawn. It became apparent that black and white Bermudians had different schedules for modernisation. The white colonial elite was not, Governor Bernard told London, going to surrender its prerogatives in a hurry: 'I have told these people, in the words of Lord Macaulay, that a single breaker may recede; but the tide is evidently coming in'.[36]

Since most scenarios for post-war tourism emphasised the need for 'skilled' labour to run the hotels, such evidence of unrest did not augur well. Most saw the problem. In 1943, a local minister, Rev. Mr Smith, told the TDB that Bermuda's youth must be given a sense that the future belonged to them: 'there was a gap of sympathy between those represented by the Royal Bermuda Yacht Club and the masses'. Post-war Bermuda, he warned, must offer 'equality of opportunity ... get down to bedrock ... to de-racialize culture'.[37] The TDB invariably responded to these portents with its ingrained paternalism: Bermuda blacks were 'prosperous', the envy of the Caribbean, and should be content with their lot. The future of the colony's tourism would depend on the 'attitude' that Bermudians brought to the peace. Children must be trained 'in good manners and courtesy'. In 1944, a public relations officer was hired to design 'a systematic campaign to make Bermuda tourist-conscious'.[38]

With its plans in place and peace inching over the European horizon, the board spent much of 1944 easing Bermuda tourism out of its long sleep. The Assembly was persuaded into approving a small budget for

'information advertising'. Advertisements in *The New Yorker* and the *New York Times Magazine* reminded old faithfuls that their favourite resort awaited them. Slogans were devised to reinforce the message – 'After the War, the same enchanted islands' – and used to frank outbound letters. New audiences were identified. Chairman Ken Trimingham told the Chamber of Commerce that 'a new generation has grown up, a generation which has not heard of Bermuda except as a fortress'.[39] Initial contacts were made with American travel agents. Adolph Treidler was commissioned to prepare new posters. With the realisation that the American bases would outlast the war, military personnel became a new class of tourist. Peacetime soldiers would bring their families to the colony; parents and friends would visit. Slide shows and booklets featuring Bermuda's delights were distributed to United States military personnel slated for Bermuda posting. A clean-up campaign was started; fiddlewood brush was cleared to allow Bermuda's beautiful cedars to flourish. Thought was given to sprucing up old 'places of interest', like the Botanical Gardens, and to developing new sites, like the colony's old forts.[40] Hotels were surveyed to establish their post-war needs – new linen, for instance – and how soon they could reopen when peace came. The philosophy behind all these initiatives was to revitalise tourism and reestablish Bermuda's reputation for restfulness and decorum, while at the same time adding a few dashes of excitement to appeal to post-war hedonism.

Early 1945 saw actual decisions. A commission reported that the days of the Bermuda Railway were numbered. Its English owners had made a profit – a meagre £623 in 1942 – in one year only of its operation and they were unprepared to swallow the cost of post-war rehabilitation. At the very best, the railway might last another five years. The ferry system would take some of the burden, but there would be no denying cars, trucks and buses a place on post-war Bermudian roads. A Transport Control Board – more planning – was established to regulate Bermuda's gasoline revolution and to oversee the paving of the colony's famous coral roads. Shortly after the peace, the government bought the railway for £115 000, sold it to Guyana and established a publicly owned bus company. After a fractious parliamentary debate, a new Motor Car Act was passed early in 1946, allowing private cars and taxis into the colony. The Auto-Bicycle Act soon permitted gas-assisted bicycles onto the same roads. Not surprisingly, Front Street merchants were the first to negotiate dealerships with English car makers.[41]

In January 1945, Henry Vesey was appointed to the chairmanship of the TDB. A lanky 44-year-old, Vesey already knew the view down a boardroom table; he was chairman of the H.A. & E. Smith department store, and the war had put him on the colony's Food and Supply Control Board, its Board of Trade and the powerful finance committee of the Assembly.

Howard Trott joined Vesey as deputy chairman. Together, they would dominate the board's affairs for the next two decades. When later asked about their style of management, Vesey came right to the point: 'We directed'. The office from which Trott directed his hotel chain was right across a lane from Vesey's office at Smith's. The two frequently set the direction of Bermuda tourism by loudly exchanging opinions from their respective windows. Other board members – Eldon Trimingham and Stanley Spurling, most notably – were consulted, but Vesey and Trott set the agenda. Vesey's brother, Ernest, headed the finance committee in the Assembly, so, in typical cosy Bermuda fashion, one Vesey approved the colony's tourism budget and the other administered it. Henry Vesey immediately revitalised the TDB. Offices were set up in the old Hamilton Hotel. The staff was enlarged. The board's redoubtable secretary Joe Outerbridge soon had young Bermudians like Terry Mowbray and Jimmy Williams working beside him. The Bermuda News Bureau came back to life and plans were set afoot for office space in the prestigious Rockefeller Center. Bermuda's best-known architect, Will Onions, was commissioned to design the office in the style of a Bermuda cottage. Adolph Treidler then supplied the murals. In April 1945, Vesey and Trott sailed to London and then on to New York. Furness Withy chairman Sir Ernest Murrant told them that the *Queen* and the *Monarch* were still ferrying troops, but that he had two smaller ships, the *Fort Townsend* and *Fort Amherst*, available to serve the colony. In New York, Juan Trippe assured them that Pan Am flying boats would return to the colony as soon as peace came and that its new DC-6 land planes would follow as soon as the Bermuda government won American approval to use Kindley Field. Access to Kindley, Trippe promised, would allow him to deliver an additional 500 passengers a month to Bermuda.[42]

Bermuda greeted the European peace in May 1945 better positioned than any other pre-war tourist destination to take advantage of the expected post-war tourist boom. The colony was undamaged by war; its tourist infrastructure was chipped and dented by wartime abuse, but basically intact. With a little work, the glories of hotel life on Elbow Beach or Castle Harbour could quickly be recreated. Furness Withy's eagerness to return to Bermuda waters was complemented by new aviation technologies that put the colony within three comfortable hours of its lucrative traditional market. Potential competitors were still grappling with the implications of war. Europe was in disrepair or locked in the grip of austerity and food shortages; the Caribbean lacked the pre-war infrastructure or loyal clientele to launch a concerted assault on an American market that was hungry for travel and relaxation. As always, Bermuda beckoned – 'foreign', but not European; luxurious, but not part of the North American hurly-burly. Perhaps most importantly, Bermuda had consciously *planned* its

reentry into post-war tourism. Since 1943, it had been determined to get a jump-start on its competition. 'I am sure that you appreciate that it is highly important that we make long range plans at this time,' Vesey told Furness Withy's Murrant, 'as not only the resorts I mentioned [Jamaica, Nassau and Cuba] will be competitors, but we know that a concerted effort is being made to develop the tourist trade throughout the entire West Indies.'[43] Although Vesey and his compatriots would have their share of short-term problems, they had opened a marvellous window of opportunity for their colony, one that would give Bermuda a virtual monopoly of off-shore American carriage-trade tourism well into the 1960s. 'Describing Bermuda,' *House and Garden* would write in 1950, 'is about as superfluous as describing the Mona Lisa.'[44]

On 12 August 1945, the post-war parade began. The *Fort Townsend* arrived in Hamilton. Vesey and other board members were at dockside to renew 'the partnership that worked so well in the pre-war days' over a lunch at the Ace of Clubs restaurant. The pre-war subsidy to Furness Withy was also renewed. The *Townsend* was small – only 80 first class passengers – and the service at first irregular. Vesey immediately began agitating for the return of the *Queen* and *Monarch*; they would 'produce dollars'. Murrant reported that the Ministry of Shipping in London had other priorities and that Bermuda was lucky to have any ship at all in the tight peacetime market. There was less delay in the air. Pan Am Clippers were soon delivering New York passengers to Darrell's Island and on 15 October BOAC started a Clipper service from Baltimore for $144 the round trip. On 25 November, the Alcoa Line's *George Washington* docked in St. George with the colony's first load of cruise tourists. That same month, the TDB's office in the Rockefeller Center opened, bringing a colourful splash of Bermuda to the heart of Manhattan. Back in the colony, asphalt crews were busy paving the South Shore road, and the first taxis and buses were appearing. (Like everything else about Bermuda tourism, there was a uniqueness to the early Bermuda taxis – instead of the usual metal roof, they sported canvas sun roofs reminiscent of a horse-drawn surrey.) Over in the Assembly, the TDB's request for a budget of £84 884, including £50 000 for advertising, was sympathetically reviewed. Then, on 3 January 1946, a Pan Am DC-4 'Skymaster' roared over the colony and became the first commercial airliner to land at Kindley Field. The first of its 27 passengers to disembark, Miss Grace Warman of New York, soon found her photo in *The Bermudian*. A year later Pan Am introduced the bigger, faster and pressurised Constellation to the route and offered a New York return for $126. *Bride* magazine started carrying Bermuda honeymoon advertisements once again. Ocean racers began preparations for the first post-war 'thrash to the onion patch' from the East Coast. Posh American homes in Tucker's Town started to come alive, and grounds staff

began removing victory gardens from the edges of the colony's famous golf courses. The tourists were returning.

The words steady and inexorable best describe the colony's immediate post-war tourist growth. With giddy excitement, the TDB announced that 900 tourists had returned in October 1945. From there, the annual total visitorship climbed steadily to just under 30 000 in 1946 and then doubled to 61 000 in 1949, and finally broke the pre-war record of 82 000 arrivals in 1951 with 99 162. Initially, the resurgence was sea-borne. In 1948, for instance, 34 527 of Bermuda's 38 747 visitors landed in the colony down the gangplank of a scheduled passenger ship. Furness Withy's promise of a speedy return to full service proved a roseate dream. The British government pressed the *Queen* and *Monarch* into post-war service as troop and immigrant ships. Finally, the *Monarch* was released early in 1947, only to fall victim to a devastating fire while being refitted in England. Henry Vesey grew frustrated and chastised Furness Withy chairman Murrant. There were no other ships available, he replied, just 'old crocks at high prices'. The same shipping shortage crimped the return of the cruise ships; by 1951 only ten per cent of visitors came as cruise ship passengers. This did not cause great concern, as a TDB survey in 1949 showed that cruise visitors spent only £10 each per visit, while 'regular' tourists stayed an average of almost ten days and spent £100. The shipping shortage was somewhat alleviated in 1947 when the Canadian National Steamship liners *Lady Rodney* and *Lady Nelson* returned to service, bringing tourists from Halifax and Boston. Furness Withy's *Queen of Bermuda* finally returned to her majestic New York-Bermuda run early in 1949. Completely refitted and boasting air-conditioning for post-war comfort, the *Queen* was greeted in Hamilton by fire tugs, military bands and a throng of Bermudians, who sensed that her presence on the waterfront was the final assurance that the good old days had returned. So too had the glamour of sailing to Bermuda; in February 1950 the wire services carried a photo of Bob Hope and a smiling Doris Day – 'Furness Withy's Miss Valentine, 1950' – encircled by a *Queen* life belt.[45] In England, Furness Withy began construction of a new 'cruising ship of tomorrow', the *Ocean Monarch*, for the Bermuda run.

The future of Bermuda tourism was, however, unfolding at Kindley Field. At first, air travel to the colony conformed to its pre-war pattern: prestige travel for the well-heeled elite. In 1948, only 4220 of Bermuda's visitors came by air. Airliners were in short supply. There were also practical problems – Kindley at first lacked sufficient radio beacon equipment to guide the Pan Am airliners to the tiny colony and to service them once on the ground. A civilian terminal had to be built. But by the decade's end, air travel was clearly gaining momentum. On 17 January 1948, the last BOAC Clipper left Darrell's Island; in the 1950s the disused sea plane base was converted into a film studio. BOAC introduced a Constellation service

Doris Day and Bob Hope pose on the *Queen of Bermuda*, whose return in 1949 was greeted as the resurgence of the glory years of 1930s tourism. New York society pages soon carried pictures of prominent Americans sailing to Bermuda, although cheap commercial aviation was already undermining the liners' hold on travel to the colony. (Bermuda Maritime Museum)

from Baltimore. That same year, another American airline, Colonial, began offering Washington and New York flights. Trans-Canada Airlines then linked the colony to Montreal. Pan Am continued to set the pace. In 1949, it introduced the 75-seat Stratocruiser to Bermuda. Juan Trippe arrived on the first flight, telling the media that his new plane carried the same number of passengers in eight flights as the Constellation did in 14.[46] Airlines began strategically placing their advertisements in American newspapers right beside those of Furness Withy. 'Airlines zip to Bermuda in 3 hours,' one read. The *New York Times* quoted a travel agent asking: 'Do you want to have fun getting there or get there fast to have fun?' By 1950, air arrivals outstripped ship arrivals in Bermuda in every month except February, and there the margin was only 2095 to 2044. In 1953, the Port of New York complained that the *Queen of Bermuda* was belching too much smoke along the waterfront and would have to curb its emissions. It seemed an ill omen.

Once ashore, post-war visitors found both familiar and novel sights. The grand hotels of the thirties shed their drab wartime garb and reopened their doors. Only the Hamilton Hotel, the industry's grand duchess, stayed closed; it had become a government office building.

Post-war shortages slowed the return of the others, but by the decade's end all the resorts were back in operation. In 1947, Furness Withy sold control of the Bermuda Development Company and with it the ownership of its Bermuda hotels – the Castle Harbour, St. George's and Bermudiana – to the American Hilton chain. Sir William Stephenson, the wartime espionage master who resided in the colony, took a prominent role in the development company, thereby giving it a continued British patina. A massive renovation of the Castle Harbour began. When the refurbished Bermudiana opened in 1948, Conrad Hilton and 40 Baltimore 'socialites' arrived on a BOAC Constellation for the festivities. Also, in 1947, the Princess was acquired by Britain's king of the seaside resorts, Billy Butlin, who set about glamorising it with nightly entertainment and waterfront activities. The scarcity of local capital and the desperate need for expert management opened the door to this deeper incursion of foreign control into the colony's hotel industry. Foreign affiliation also connected Bermuda hotels with the advertising and reservation services of chains that were well rooted in the affluent American market. Local hotel ownership did persist. Howard Trott's Inverurie and Belmont and Harold Frith's Elbow Beach Surf Club quickly regained their pre-war clientele of golfers and beach lovers. But here too the foreign influence was evident. Frith hired an able American, Ev Hartland, to manage the Elbow Beach. Hartland was soon considered the doyen of Bermuda hotel managers. Foreign-trained department heads, maîtres-d' and waiters followed.

When the Castle Harbour finally greeted its first guests in 1950, *House and Garden* floridly suggested that the event 'must be causing quite a wave of nostalgic effluvium to flood the collective American traveller's breast'.[47] The big hotels were back. In 1947, the Trade Development Board began surveying departing visitors' motivation in visiting the colony. One survey indicated that 75 per cent came for 'rest and play'. A quarter had visited Bermuda before. When asked their favourite activity, 73 per cent said swimming and 67 per cent said 'loafing'. After the hardships of Depression and war, a stay in a Bermuda hotel – 1950 average: 9.6 days – offered the perfect escape. Consequently, hotels surged in popularity from 44.5 per cent of the colony's accommodation trade in 1947 to 64.2 per cent just three years later.[48] As the hotels reopened, another form of Bermuda accommodation faded fast. Part of the charm and economy of Bermuda tourism in the pre-war decades had lain in staying in private homes; these were cosy, friendly and affordable. Post-war affluence and gregariousness favoured larger, posher places and by 1950 only 18 per cent of visitors stayed in private homes.

Many, however, still wanted cosiness, but were now affluent enough to demand luxurious seclusion. On this impulse, Bermuda's small hotels and

cottage colonies flourished. Pre-war cottage colonies like Cambridge Beaches in quiet Somerset, Glencoe at Salt Kettle and Waterloo House on the Hamilton waterfront reopened and welcomed back a loyal clientele. The small hotel market was more within the reach of Bermuda entrepreneurs; the capital demands were less and their appeal lay in their friendly individuality. In 1947, The Reefs opened on the South Shore; in the 1950s Ariel Sands and the Lantana Colony followed. Horizons Limited, a local company in which Henry Vesey was involved, acquired Waterloo House and added it to the Coral Beach Club and Newstead, a small hotel overlooking Hamilton harbour. In 1954, Howard Trott formed a syndicate which bought control of the Mid-Ocean Club from the Bermuda Development Company. Cumulatively, the small hotels greatly enhanced Bermuda's reputation for exclusivity, friendliness and repeat customers. Every issue of *The Bermudian* ran pictures of prominent North Americans – like Canadian Prime Minister Louis St. Laurent at the Mid-Ocean – returning habitually to their favourite small hotel as if it were their second home. The impression was heightened in late 1953 when a 'Big Three' meeting of Churchill, Eisenhower and French President Lanier took place at the Mid-Ocean Club. The crowning glory, quite literally, came that

Boom times: TDB secretary Joe Outerbridge points with joy to Bermuda's statistical take-off as a tourist destination. For two decades after World War II, the colony was virtually unchallenged as an island resort for affluent American holidaymakers. (Bermuda Archives: J.J. Outerbridge Collection)

same year when the colony received its first visit of a reigning monarch, from Britain's Queen Elizabeth.

Beyond the airport and the hotels, post-war tourists found a more exciting Bermuda awaiting them. The colony's pre-war social stiffness seemed to slacken as post-war hedonism overtook America. The once obligatory ties and jackets slipped out of *The Bermudian*'s 'At Home Abroad' column photographs. Now beach-bound tourists were shown in shorts, checked shirts and swimsuits, and were often caught in antic poses. There was a novel exuberance in visitors' behaviour. 'We're just crazy about Bermuda and just can't keep away,' American film director David Selznick told the magazine in 1948. The availability of taxis stimulated the island's night life. The fast set were soon gravitating to the Ace of Clubs Club, the Eagle's Nest Hotel's Sky Top Terrace, Club 21, Angel's Grotto or even out to the White Horse Tavern in St. George's to dance and drink the night away.

Yet Bermuda's core of serenity remained. 'I have seen little that is garish and heard nothing that is raucous,' the Canadian broadcaster Leonard Brockington noted in 1947. 'The light of the sun and the moon are the best neon signs ever invented, and what a delight it is to walk or drive along roads where you are not invited to Drink Canada Dry (which is a large undertaking) or to use somebody's soap if you do not wish to be deprived of the opportunity of happy matrimony.'[49] As always, the Trade Development Board played its role as the colony's aesthetic policeman. In 1946, commercial radio arrived in the colony. When the manager of Station ZBM suggested that a radio be placed in every hotel room in the colony, the board quashed the idea, 'the intent being to keep Bermuda a place for complete relaxation'.[50] Nothing was beyond the board's watchful eye. In 1954, the Colonial Secretary was informed that there were too many 'dead frogs' on the roads and that something should be done about the problem. The Transport Control Board was instructed to crack down on young boys on mopeds whose reckless driving was forcing tourists off the road. The police were asked to enforce strict speed control on cars and mopeds; Bermuda was supposed to be a 'slow' place. The Attorney General was consulted about 'indecent bathing apparel' worn by men on the beaches.[51] The story often circulated among tourists that Hamilton police were armed with rulers to enforce a 1930s bylaw that stipulated that a woman's shorts must not wander more than two inches above the knee. There *was* a bylaw, but the constabulary was wise enough to ignore it.[52] The deliberate preservation of Bermuda's elegance and tranquillity was evident in other decisions. Noisy commercial airliners were not permitted to land at night. The Illuminated Signs Restriction Act of 1958 banned neon and strip lighting from paradise.

The TDB promoted as well as policed. Two objectives commanded its post-war energies: entertaining the tourists and inducing them to come in

seasons other than the popular summer months. The first steps were taken toward heritage tourism. By 1951, the Imperial sunset was complete. The British garrison departed and the Royal Naval Dockyard was closed, leaving the colony a legacy of mothballed fortifications. In 1949, the TDB cleaned up historic Fort St. Catherine outside St. George, installed dioramas depicting the colony's origins, and opened it to tourists. In 1953, it subsidised a production of Shakespeare's *Macbeth*, directed by Burgess Meredith and starring Charlton Heston, on the ramparts of the fort. Monies were also voted for the Easter floral parade along Front Street, the ancient Peppercorn Ceremony in St. George, dog shows, international bridge tournaments and any other event that diverted the tourist's attention. Early in the 1950s, a Bermuda Festival began offering music and theatricals to lure winter tourists. Each of these activities allowed the colony to build recognition and visitor loyalty in affluent niches of a North American society that was embarking on the greatest binge of prosperity it had ever experienced.

Two niches in particular reinforced Bermuda's traditional uniqueness: catering to honeymooners and to American college students on spring break. The men of the TDB were by no means disciples of managerial theory or demographic analysis; their deliberations were remarkably free of jargon and infatuation with fads in tourist development. They did, however, have an uncanny instinct for the colony's strengths and knew where to turn for sound advice on capturing the attention of would-be tourists. Late in 1946, the board switched New York advertisers, signing on with J.M. Mathes Inc., whose vice-president, Wilfred King, was to become the colony's strongest post-war ally in carrying its message into American minds. King intuitively understood Bermuda's potential: he told the Assembly in 1946 that Bermuda's tourist future would depend on the same qualities that had brought it success in the past – 'old time courtesy', its 'foreign' feeling, colour, and 'first class' service. Mathes' first slogan for the post-war would be: 'Everything is better in Bermuda'.[53] King advised adding new methods to old goals. Surveys of departing visitors were introduced and the results – tourists' likes and dislikes – were tracked over time. Experts were brought in to help the colony polish its image; in 1947 Thomas J. Ross, partner of the pioneer of modern public relations, Ivy Lee, was consulted on how the board might tackle 'bad press'.[54] One of the intuitions emerging from these new partnerships and consultations was that island resort tourism was no longer simply an indulgence of the rich. North American prosperity, the growing entitlement to an annual holiday and efficient commercial aviation were making overseas tourism not an episodic but a regular part of post-war life with a broad democratic reach. Bermuda's challenge was to capture and retain the most lucrative slice of this market, and that meant appealing to North Americans at every stage of life. Although it never used such a term, the TDB consciously began to

Just the kind of image that Bermuda wanted to transmit to America: a surrey-topped taxi carrying a couple to gaze out over the emerald waters, 1955. (Bermuda Archives: Bermuda News Bureau Collection)

pursue the possibilities of life-cycle tourism. Bermuda would satisfy American sensibilities from the time toddlers came with their parents for a summer holiday, through their college education, as a magic honeymoon destination and then as a rest station during years of affluent professional life. Somewhere late in the cycle the next wave of toddlers would acquire the Bermuda habit.

In the 1930s, rugby teams from Ivy League colleges had started coming to Bermuda early each spring to train by day and play by night. Games with the Royal Navy were arranged. The TDB donated trophies. And, as always, the girls followed the boys. During the war, the tradition was transformed by US servicemen into the Lily Bowl Game, an Army-Navy football contest. After the war, the Ivy Leaguers returned with their rugby balls and sweethearts. In 1948, *Life* magazine ran a feature article on rugby week in Bermuda, 'one continuous party for 500 U.S. collegians'. By 1950, College Week was attracting 2000 young Americans. There were suntans, picnics and 'just plain sitting in the moonlight'. Other aspects of college life followed: the Yale Whiffenpoofs started giving spring concerts in Bermuda. Boat tours and beach parties were arranged and a College Week queen was

duly crowned. One such debutante beauty was Joan Bennett, the future wife of Edward Kennedy. The TDB knew that there was not much money in the College Weeks. Indeed, there were complaints from other tourists whose serenity was spoiled by the late-night, beery hi-jinks of the collegians. But the College Weeks gave the hotels a shot of early season business before the Easter rush. And, as *Life* surmised, 'for tourist-conscious Bermudians, Rugby Week was sure to pay off. They can expect to meet at least one fourth of the collegians again – as honeymooners'.[55]

The science of converting rugby players into honeymooners was never exact, but the Mathes surveys showed that by 1950 a solid 16 per cent of Bermuda's visitors were honeymooners.[56] In the post-war marriage boom, the figure fluctuated little. They invariably came in the early summer or autumn. Many were military veterans; others clearly college graduates. The TDB kept copies of the American *Who's Who* and used them to cross-reference the tourist immigration cards collected at the steamer shed on Front Street or at the airport. Sons and daughters of prominent east coast families were spotted and a News Bureau photographer despatched to catch them on film at their hotel. (This vital research also allowed the young blades on the TDB staff to pick out eligible *single* women tourists, orchestrate 'accidental' encounters with them and secure dates.) Bermuda's honeymoon allure tinted its whole image as a tourist destination. 'Romantic, yet cosy, it attracts newlyweds the way sugar attracts humming-birds,' *House and Garden* enthused in 1951. The Saturday afternoon sailing of the *Queen of Bermuda* from New York became a kind of 'love boat' prototype; 'love at sea' on a ship where 'kisses are a dime a million'.[57]

The post-war invasion of footballers, lovebirds and their affluent parents proved a powerful stimulus to Bermuda culture. Defining national culture is always a perilous proposition. The aesthetic that Bermuda had traditionally projected to its visitors was always rooted in its intrinsic qualities. It was never an artificial concoction, a deliberate attempt to recast the place to satisfy the imagined desires of visitors. In Bermuda, visitors had always been expected to conform to the values of their hosts: courtesy, tranquillity, respect for nature and Britishness. Bermudians' compulsive habit of saying 'good morning' and 'good afternoon' was, for instance, applied to tourists and locals without differentiation. Unlike places like Niagara Falls, there was no veil in Bermuda between the tourist's world and the real world. 'Bermuda sells nothing to the world except itself,' wrote Mary Tweedy in her best-selling 1951 guidebook *Bermuda Holiday*.[58] Post-war success in tourism further stimulated the colony's cultural identity. In 1946, William Zuill gave Bermuda what continues to be its finest guidebook, *Bermuda Journey*.[59] Zuill, a wartime information officer, gave Bermudians and tourists alike a parish-by-parish 'highways and byways' tour of the colony. Reading it, one acquired an understanding not only of Bermuda sites but

FURNESS CRUISING SHIPS... S.S. QUEEN OF BERMUDA • S.S. OCEAN MONARCH

The *Queen of Bermuda* and the *Ocean Monarch* by Adolph Treidler (1886–1981). The TDB's most successful artistic liaison was with Treidler, who from the 1930s to the 1960s provided Bermuda with vivid posters that captured its colour and elegance. He also painted the murals at the board's New York offices in the Rockefeller Center; the *Queen of Bermuda* was one of his favourite icons. (The Masterworks Collection, Bermuda)

also of the Bermuda psyche. At the same time, the TDB urged the Board of Education to resurrect Walter Hayward's 1910 *Bermuda Past and Present* for use in the schools to build 'greater pride' in the colony's youth.[60] The TDB complemented these efforts with its own early initiatives towards heritage tourism – the Fort St. Catherine dioramas, for instance. On a more practical level, new guidebooks appeared. In 1947, *This Week in Bermuda* began appearing. And in 1951, Mary Johnson Tweedy, a former *Time* correspondent who had settled in the colony, published her *Bermuda Holiday*. Well-written, comprehensive and a bit cheeky, the book became *the* Bermuda guidebook; the TDB paid to have copies deposited in the libraries of prominent east coast colleges.

All of the images and values by which Bermuda chose to project itself into North America were essentially reflections of its white population. In passing, Bermuda blacks were portrayed as 'friendly' and prosperous, but they were never an active ingredient in the Bermuda mystique. The war changed that. The wartime economy gave blacks new opportunities and new awareness. In tourism, this was first evident in the field of entertainment. In the thirties, black 'orchestras' had occasionally amused the guests in the big hotels, but the sudden wartime appearance of officers' messes and service clubs had put black entertainers at centre stage. After the war, their natural talent kept them there. Best known and loved were the Talbot Brothers. Born in a one-room, partitioned home in Tucker's Town, they had been taught to sing in harmony by their mother before the family was uprooted in the famous expropriation of the early 1920s. Part of the expropriation money went to a piano; odd jobs around the new hotels brought a guitar. Sunday church services and singing for the crowd at Cup Match cricket polished their voices. One day the manager of the Mid-Ocean Club, Ford Johnson, spotted the eldest Talbot boy, Archie, singing on his bicycle and cajoled him and his brothers onto the club stage that evening. Wartime shows before American officers followed. After the war, the Talbots emerged as Bermuda's number one entertainment draw. Their music resembled calypso, but lacked the drums and boasted mellifluous harmony. One of the brothers, Roy, played a crude single-string bass fashioned out of a meat packing case. Roy's 'doghouse', colourful straw hats, and lyrics that caught the spirit of the colony – 'Bermuda Buggy Ride' – soon made the Talbots Bermuda's 'ambassadors of song'.[61] They greeted the liners, played on the tarmac at the airport, serenaded on the beach in College Week, at private parties and at all the leading hotels. In the off-season, they took to touring the golf courses and country clubs of eastern America. Later, they played the Ed Sullivan Show and headed for the recording studios. The Talbots became synonymous with Bermuda hospitality. Other groups, like the Sidney Bean Trio, followed. There was nothing obsequious in the Talbots' appeal. Americans loved them not just for the moonlight melodies

Two of the Talbot Brothers, Bermuda's 'Ambassadors of Song'. Roy Talbot and his famous 'doghouse' bass are on the right. (Bermuda Archives: Bermuda News Bureau Collection)

they provided, but also for their cheeky, mischievous lyrics. Perhaps their most popular song was built around a purported conversation between two of the colony's merchants, Mr Trimingham and Mr Trott. 'These Americans have made me mighty sore,' one confides to the other. 'We've done everything we know/To relieve them of their dough/But the blighters seem to *still* have plenty more!' Audiences loved it, perhaps because they knew the joke was on them.[62]

In 1955, 108 000 visitors came to Bermuda. An unflinching annual average of 80–83 per cent of these were American 'blighters' from the core states of the eastern seaboard. Bermuda remained, in the opinion of *The National Geographic*, 'a pint-sized paradise … a haven untainted by gas fumes, unruffled by the honk of horns', capable of teaching 'thousands of visitors a lesson in serenity'.[63] James Thurber suggested that a medal be struck to honour the colony's 'stimulating effect'.[64] Lurking behind this

magnificent achievement, however, there were hints of strain. Not all Americans found themselves welcome in post-war Bermuda. Despite the colony's participation in the Allied crusade against Germany's racial policies and its hosting of an international conference on refugees, the pre-war 'restricted clientele' policy of Bermuda hotels reappeared with the peace. As early as the autumn of 1945 the British embassy in Washington began to receive complaints from Jewish Americans that they were unwelcome in Britain's oldest colony. A Portland, Oregon attorney with a distinguished war record told ambassador Lord Halifax that the hotels' exclusion of Jewish tourists savoured 'of the Hitlerism we have all sacrificed so much to destroy'. American travel agents echoed the complaint, telling the TDB that the policy made 'the job of selling travel to Bermuda extremely difficult'.[65] London disliked receiving news that 'the ghost of Hitler's anti-semitism still stalks in the Western hemisphere', but in the end fell back on the old defence that Bermuda's hotels were privately owned and beyond its suasion.[66] For its part, the TDB cited the post-war hotel squeeze and the fear that 'undesirable' Jews might damage tourism's recovery. When the issue reached the Assembly late in 1947, TDB chairman Henry Vesey moved that the debate not be published and that the press be asked to suppress their coverage of the issue. *The Times* of London nonetheless carried the story.[67] Yielding to such pressure, some members of the Hotel Association quietly agreed in 1949 to take Jewish tourists on a quota basis. Otherwise, the policy remained.

The post-war changes prompted another group of Americans to look towards Bermuda: black Americans. Before the war, the prospect of black tourism seemed improbable: American blacks lacked the affluence to come and the whole ambience of Bermuda tourism projected a whites-only image. *De facto* segregation within the colony heightened the barrier; the American millionaire Seward Johnson found Bermuda in the thirties 'very much like the Deep South'.[68] In 1947, *Holiday* magazine did a feature spread on Bermuda, portraying it as a place where 'old families ... own and run' the economy and the blacks were 'secure' but behaved 'in the manner of American negroes in "Gone With The Wind"'.[69] The war shifted the balance on both sides of the Gulf Stream. Post-war prosperity nurtured the emergence of a black middle class in America, not large, but upwardly mobile and prone to the same travel bugs that bit white Americans. At the same time, Bermudian blacks traditionally employed in white tourism began to see entrepreneurial opportunities in catering to black Americans. In 1944, one group had purchased the Brunswick Hotel in Hamilton to run as a residential hotel. Others began opening restaurants and small guest houses, driving taxis and entertaining tourists. The Talbot Brothers typified the movement. But the clientele was almost exclusively white. Nothing in the TDB's annual wave of literature even hinted that black

tourists were welcome in Bermuda. Driven by the scent of a business opportunity, a handful of black businessmen formed the Bermuda Tourist Association in 1950 and set about fostering the Bermuda habit in the minds of black Americans. An accommodation bureau was set up to direct black tourists to a string of black guest houses. A New York travel agent, Hilton Hill Inc., was retained to promote the colony's charms in the black community. Brochures were printed stressing exactly the same virtues that the colony had always held out to white tourists: this was a restful, high-cost destination frequented by the 'best' sort of people. Prominent black actors were brought to the island to add kudos. At the same time, the Association tried to downplay the unflattering side of the colony, especially the fact that most hotels and local restaurants, beaches and sporting facilities were largely off-limits to blacks.[70] This vulnerability was laid bare in 1953 when a visiting Guyanese politician, en route to London for a knighthood, was denied a room in a local hotel.[71]

Not surprisingly, the Bermuda Tourist Association turned to the TDB for help. There seemed hope in this direction. In the late 1940s, the board had taken its first black member: George A. Williams, an Assemblyman and shopkeeper from Southampton parish. In the early 1950s, he was joined by Hamilton lawyer A.A. Francis and Wesley Gayle, the owner of the largest black hotel. Wilfred King, the board's trusted New York advertising man, advised that the TDB's Rockefeller Center office should begin offering accommodation information to black Americans. In 1951, the Bermuda Tourist Association therefore asked the TDB for a small slice of its advertising budget to help it place advertisements that would break the 'psychological barrier' that suggested Bermuda was for white tourists only. The board demurred. All sorts of arguments were marshalled. There was not enough accommodation to warrant a campaign dedicated to blacks alone. The board had never favoured particular hotels in its advertising. But the heart of the matter was that 'coloured tourism' was too 'radical' a departure and that its success might undermine the colony's mainstay – white tourism. It was not, Vesey insisted, a 'question of colour', but instead a matter of preserving the colony's principal industry; 'all Bermudians', he added, 'would starve without it'.[72] A select committee of the Assembly examining racial relations in the colony arrived at the same conservative conclusion a few years later: overactive promotion of black tourism would be 'most imprudent and unwise' because it 'might jeopardize the continuity of this trade'.[73] That same year, the board provided a financial bail-out for the whites-only Bermuda Jockey Club on the grounds that it attracted tourists. But the message of black tourism was not wholly ignored; in 1953 a small advertising budget was given to the Association and six advertisements pitched at 'successful' black Americans were placed in *Ebony* magazine.[74] By the end of 1957, the Association reported that 2562 black

tourists had come to the 'isles of rest'. As was nearly always the case in Bermuda, change came slowly.

Black tourism foreshadowed deeper racial shifts in the colony's society, shifts that touched the foundations of its vaunted tourism. The war had loosened the paternalism of Bermuda society. In 1944, women had finally won the vote. Wartime inflation, the two-tier wage system that had prevailed around the American bases and the constant exposure to outside influences had similarly aroused Bermudian blacks. Dr Gordon's Bermuda Workers' Association captured this impatience; it claimed to speak for 'the voiceless, voteless and underprivileged masses of Bermuda'. In 1946, Gordon organised a huge petition demanding a royal commission of inquiry into the colony's social, economic and political condition. He loved pointing out that only 7 per cent of Bermudians had the right to vote. If there were no changes, Gordon threatened, the 'isles of rest' would become the 'isles of unrest'.[75] This was troubling news for the Trade Development Board. There were already complaints of poor service and absenteeism in the hotels. Henry Vesey attributed this to 'false values' that had crept into the colony during the war. The board advocated that the hotels hold 'pep talks' that would promote a return to the traditional level of Bermuda courtesy.[76] The pep talk approach did nothing to avert a longshoremens' strike in May 1948 that closed the all-important port and sharpened racial and class relations as had never happened before in Bermuda. A parliamentary committee nonetheless recommended that 'the early adoption of universal adult suffrage would be prejudicial to the best interests of Bermuda'; tourism was too vital to be set at risk by political innovation. A fractious colonial election followed in which the colony's propertied voting class rallied to protect its privileges by voting early and often. Governor Leatham bemoaned the 'pigheadedness and the *fear* of the upper whites' to London and prayed that they would 'soon change their attitude and *lead* in a modern way'.[77]

By the late 1940s, race had entered Bermuda politics and showed no sign of disappearing until some fundamental shifts – universal suffrage, desegregation of hospitals and schools – took place in the structure of the colony's life. Bermuda's old yacht club democracy was feeling pressure. Through all this, tourism acted as a sheet anchor on Bermudian political behaviour. For all Dr Gordon's militancy and for all the Front Street elite's intransigence, there was a pervasive recognition that tourism was Bermuda's economic mainstay and that too much turbulence would have prejudicial effects on *all* Bermudians. This realisation tended to protect the political *status quo* and only gradually promote political alteration. Again and again, the elite implicitly warned black Bermudians that tourism was a fickle thing and that their high standard of living depended upon it. A 1953 select committee of the Assembly on racial relations surveyed the whole racial state of Bermuda

and concluded that cautious reform was warranted; a more open, less segregated Bermuda society was necessary. But, as in pre-Little Rock America, the tone was 'separate but equal'. Complete desegregation was ill-advised because it might alter Bermuda so dramatically that white Americans might no longer come.[78] 'The tourism trade had not just happened,' Stanley Spurling's son later warned the colony. 'It was built up by astute men.'[79] But by the early 1950s, many astute men could see that the old measure of pre-war social control that the Trade Development Board had enjoyed in shaping Bermuda was fast eroding and that change based on racial accommodation was in the wind. As always in Bermuda, it was a gentle breeze, but there was no doubt of its direction.

One other concern began to intrude on Bermudian sensibilities as the second half of the century dawned. How much was enough? In 1953, the colony broke the 100 000 tourist barrier for the first time. What were the limits to growth in a crowded community perched on 21 square miles of coral? Could the landscape sustain the demands of tourists and Bermudians alike? In the late 1940s, a blight attacked the colony's beloved cedars, leaving the landscape greyed with dead trees. Bermuda's countryside was shrinking in other ways. Between 1939 and 1950, the colony's population grew by 22.3 per cent to 36 136. Post-war prosperity had sparked Bermuda's version of the 'baby boom'; new home construction pushed out into hitherto thinly populated parishes like Warwick. Faced with this sprawl, the Bermuda Historical Monuments Trust commissioned the colony's best vernacular architect, Will Onions, to develop a series of cottage designs that would provide a young Bermuda family with 'an attractive and comfortable home in conformity with Bermuda tradition'.[80] Bermuda's pursuit of the affluent society in turn pushed up the cost of living. For the first time, tourists began complaining that a Bermuda holiday was an expensive holiday. In 1948, the ever-loyal *New Yorker* complained that 'the prices are now a bit out of whack'.[81] A year later, *Time* claimed that the colony was 'plucking the goose' and printed the lyrics of the Talbots' 'Mr. Trimingham and Mr. Trott' to make the case.[82] The chronically weak post-war British pound, on which Bermuda's economy operated, made the situation worse by pushing up the cost of everything the colony imported from the States to maintain its tourism.

Prescient Bermudians could see the dilemma in embryo. At the TDB's annual tourism round-table in 1947, Henry Vesey warned that 'there was a definite limit to the number of people that could be brought to Bermuda annually without detracting from its attractions. Bermuda must not be overdeveloped'.[83] Vesey knew that the board's early surveys showed that 55 per cent of visitors cited 'natural beauty' when asked why they came to Bermuda; only 'climate' exerted a stronger pull.[84] There was little that Bermuda could do about its climate, but natural beauty was within its

A late 1930s poster that captures the start of the transition from liner tourism to airborne tourism: a Pan Am Clipper circles Hamilton harbour, watched by tourists on the *Queen of Bermuda*. (Bermuda Masterworks Foundation)

power. As tourism revived in the late forties, items concerning litter, noise, speeding cycles and unseemly deportment began appearing on the board's agenda. Howard Trott preached the virtues of 'beautification'. It was not just a question of polishing a façade erected to please the visitors; it was instead a question of the coexistence of Bermudian and tourist in an atmosphere that melded their respective sensibilities. 'Bermuda,' TDB member Freddie Misick noted, 'is not merely a means whereby we in Bermuda derive our livelihood, but it is our home and we just jolly well are not going to turn the country upside down and precipitate all sorts of serious consequences.' His banker colleague H.D. Butterfield agreed: 'And

if we start just to pile a lot of people into hotels and pile people into ships, I believe that we can mutilate our own livelihood'.[85]

The Trade Development Board had only one response to the great existential challenge at the heart of their industry. *Quality* must always prevail over *quantity*. Henry Vesey would repeat this principle like a mantra: his board's 'job was that of promoting a high-class trade rather than a volume trade'.[86] 'Better' tourists made for a 'better' Bermuda. The wrong type of tourists – 'the rollicking, roistering, rum-seeking rabble', Freddie Misick called them – could destabilise the whole delicate balance of host and visitor, destroy the colony's unique image in the American traveller's mind, hurt its environment and dissolve the bond that had for so long made Bermuda a society united around tourism. There was constant outside reinforcement of this intuition. In the spring of 1954, the board met the staff of *The New Yorker* to celebrate a relationship that had spanned 25 years. The journalists were quick to compliment their hosts: 'Bermuda played its part extremely well and was doing things which they know are right'.[87] That same year Joel Sayre of the magazine's staff received a letter from James Thurber in Bermuda: 'It's been wonderful here without television and with the McCarthy news pushed over onto page 4'.[88] Humbler Americans reached the same conclusion. A New York apartment dweller, Elizabeth Lissitzyn, wrote to Governor Hood in 1953 after two weeks in the colony: 'How you all have managed, in this day of mechanization, to keep Bermuda the charming place it is with the least possible intrusion of 20th century monster machinery, is really a marvel. Many thanks from a visitor who has really achieved peace, quiet and relaxation on your shores.'[89]

REFERENCES

1. *Life*, 21 September 1942.

2. *Official Steamship and Airway Guide*, 1941, in J.J. Outerbridge Papers, BA.

3. Sir John Plowman, 'Bermuda at the Outbreak of War and the Coming of the U.S. Bases', *Bermuda Journal of Archaeology and Maritime History*, Volume 7, 1995, 129.

4. See: 'Labour Conditions, 1940–42', file #67765, CO 37, BA and 'Review of Economic Conditions, Policy and Organization in Bermuda by Professor J. Henry Richardson', Feb. 1943, file #67815, CO 37, BA.

5. *The Royal Gazette*, 26 July 1971.

6. Warren Kimball, ed., *Churchill and Roosevelt: The Complete Correspondence*, Princeton, 1984, Vol. 1, 138. The message was taken by Secretary of the Treasury Henry Morgenthau.

7. *Ibid.*, 140.

8. See: E.A. McCallan, *Life on Old St. David's*, Hamilton, Bermuda, 1948.

9. *The Bermudian*, October 1958.

10. Cited in Plowman, *op. cit.* at note 3, 127–8 and Robert Rhodes James, ed., *Winston S. Churchill: His Complete Speeches 1897–1963*, London, 1974, Vol. 6, 6549–51.

11. *Life*, 18 August 1941.

12. TDBM, 3 April 1941.

13. For an excellent account of the hectic wartime aviation in and out of Bermuda, see: Carl A. Christie, *Ocean Bridge: The History of RAF Ferry Command*, Toronto, 1995, Ch. 5. One German submarine, the U-505, was actually forced to surface and surrender off Bermuda. It was brought to the colony and after the war was despatched to Chicago's Science Museum.

14. William Stevenson, *A Man Called Intrepid: The Secret War*, London and New York, 1976, 185–201.

15. See: Stevenson, *op. cit.* above, 186 and John Pearson, *007 – James Bond: The Authorized Biography*, London, 1973. Pearson's book is in fact a fictionalised biography that places Bond in Bermuda.

16. D.W. Buchanan in the *Canadian Geographical Journal*, Sept. 1941.

17. Frederick Lewis Allen, 'Bermuda Base', *Harper's*, Sept. 1943.

18. David Garth, *Bermuda Calling*, New York, 1942.

19. Frank Giles, *Sundry Times*, London, 1986, 19.

20. *The Bermudian*, October 1946.

21. Buchanan, *op. cit.* at note 16, 112.

22. John Hall, 'The Battle for Bermuda', *The New Republic*, 4 August 1941.

23. 'Old Bermuda – Honeymoon Isles Become US Defence Bastion', *Life*, 1 August 1941.

24. Hall, *op. cit.* at note 22, 158.

25. James, *op. cit.* at note 10, 6550.

26. R.L. Duffus, 'There Are No More Islands Any More', *New York Times Magazine*, 2 June 1946, 10, 43.

27. J.H. Richardson, 'What is Economics?', *The Bermudian*, August 1942.

28. Minutes of the Economic Advisory Committee, TDBM, 15 Dec. 1942.

29. TDBM, 25 Jan. 1943.

30. TDBM, 4 Mar. 1943.

31. *Bermuda After the War: Problems and Answers*, Hamilton, Bermuda, 1943.

32. TDBM, 25 Jan. 1943.

33. TDBM, 5 Feb. 1943.

34. Allen, 'Bermuda Base', *op. cit.* at note 17, 350.

35. TDBM, 4 March and 22 October 1943.

36. Sir Denis Bernard to Colonial Office, 1 September 1941, file #67765, CO 37, BA.

37. TDBM, 21 and 25 May 1943.

38. TDBM, 2 June and 8 August 1944.

39. K.F. Trimingham, 'Post-war Tourism', *The Bermudian*, October 1944.

40. TDBM, 2 May 1944 and 'Report to the Board', 1 March 1944, J.J. Outerbridge Papers, BA.

41. See: *Final report of the Transport Commission*, Jan. 1945, file #67722, CO 37, BA; Motor Car Act, 1946 and *Assembly Debates*, Nov–Dec 1945.

42. TDBM, 16 June 1945 and Henry Vesey to Sir Ernest Murrant, 12 July 1945, Department of Tourism [hereafter DOT] file TDB CARR/2/3, BA.

43. Vesey to Murrant, 8 September 1945, *ibid*.

44. 'Bermuda, the Hardy Perennial', *House and Garden*, March 1950, 119.

45. All statistics from the TDB *Annual Reports*, 1946–55. Furness Withy details from Furness Withy files, Bermuda Maritime Museum archives.

46. *The Bermudian*, January 1949.

47. *House and Garden*, March 1950, 151.

48. See: 'A Report on Bermuda Travel Submitted to the TDB', by J.M. Mathes Inc., January 1951, Colonial Secretary file #3694, BA; and TDB *Annual Reports*, 1947–55. Full survey statistics are available in the DOT Papers, BA.

49. *The Bermudian*, March 1947.

50. TDBM, 17 Feb. 1948.

51. TDBM, 1 June and 31 August 1954.

52. *The Bermudian*, November 1950.

53. *The Bermudian*, January 1947.

54. TDBM, 19 August and 9 Sept. 1947 and file #1, J.J. Outerbridge Papers, BA. Ivy Lee died in 1934.

55. 'Life Goes to Rugby Week in Bermuda', *Life*, 1 March 1948.

56. 'Report on Bermuda Travel', Mathes, *op. cit.* at note 48.

57. 'Honeymoon in Bermuda', *House and Garden*, May 1951 and Washington *Sunday Star*, 25 June 1959.

58. Mary Johnson Tweedy, *Bermuda Holiday*, New York, 1951, 13.

59. William S. Zuill, *Bermuda Journey: A Leisurely Guidebook*, New York, 1946.

60. TDBM, 9 Sept. 1944. Hayward was perhaps one of Bermuda's most famous native sons, having risen to be the associate editor of the *New York Times*.

61. Margot Hill, 'Music Makers of Bermuda', *The Bermudian*, June 1948 and TDBM, 18 March 1949.

62. There is a persistent notion that 'Mr. Trimingham and Mr. Trott' was written near war's end by a young American naval lieutenant stationed in the colony. It seems unlikely that a relative stranger could have written a song so full of local nuance. Once, while performing at a cocktail party, Roy Talbot was approached by Howard Trott. 'Did you write this?' Trott demanded. 'Not me', Talbot responded, and headed into the crowd.

63. Beverley Bowie, 'Bermuda, Cradled in Warm Seas', *The National Geographic*, Feb. 1954, 203.

64. *The Bermudian*, July 1949.

65. TDBM, 29 Jan. 1946, 5 August 1947 and 18 Nov. 1949.

66. Colonial Secretary, Bermuda to Chancery, Washington, 8 Feb. 1946 and Philip Rogers to Sir Stafford Cripps, 18 April 1947, CS file #3694, BA.

67. 'Suppression of Reporting of the Assembly', CS file #67980 and *The Times*, 1 Dec. 1947.

68. Cited in Barbara Goldsmith, *Johnson and Johnson*, New York, 1987, 36.

69. *Holiday*, April 1947.

70. See: Bermuda Tourist Association file in the Cecile Musson Smith Papers, BA.

71. See: Eva N. Hodgson, *Second Class Citizens; First Class Men*, Hamilton, 1988, 88.

72. TDBM, 20 Feb. and 2 March 1951. See also minutes of special committee meeting with Bermuda Tourist Association, Feb. 1951, TDB Committee Minutes, vol. #6, BA.

73. Cited in Randolf Williams, *Peaceful Warrior – Sir Edward Trenton Richards*, Hamilton, 1988, appendix B.

74. TDBM, 23 Dec. 1953.

75. Bermuda Petition for a Royal Commission, 1946–7, file #67937, CO 37, BA.

76. TDBM, 26 Nov. 1946 and 10 Sept. 1947.

77. Governor Leatham to George Seel, Colonial Office, 10 June 1948, file #67748, CO 37, BA.

78. See: Barbara Harries Hunter, *The People of Bermuda: Beyond the Crossroads*, Hamilton, 1993, Ch. 3.

79. Cited in Hodgson, *op. cit.* at note 71, 132.

80. Bermuda Historical Monuments Trust, *Bermuda Cottage Plans*, Hamilton, 1948, preface.

81. *The New Yorker*, 3 April 1948.

82. *Time*, 4 April 1949.

83. TDB Minutes of the Tourism Trade Conference, April 1947, CS file #3694, BA.

84. 'Report on Bermuda Travel', Mathes, *op. cit.* at note 48.

85. 1954 Bermuda Travel Conference file, Colonial Secretary's Papers, BA.

86. TDBM, 1 March 1946.

87. TDBM, 7 May 1954.

88. Thurber to Joel and Gertrude Sayre, 1 June 1954, in Helen Thurber and Edmund Weeks, eds., *Selected Letters of James Thurber*, New York, 1980, 189.

89. Elizabeth Lissitzyn to Gov. Hood, 5 August 1953, CS file #3694/5, BA.

CHAPTER SIX

Glory Years 1956–80

'We must stick to our ideals.'
<div align="right">Sir Henry Vesey, 1963</div>

'We are like ladies-in-waiting ... dressing up this princess which is Bermuda with pretty stories and photographs, but we must be aware of the princess's flaws.'
<div align="right">Bermuda News Bureau official, 1969</div>

'I guess it's time to say goodbye to paradise.'
<div align="right">John Lennon, 1980</div>

READERS OF THE May 1956 issue of *House and Garden* found a familiar friend in the travel section – Bermuda was the place where 'nice' Americans holidayed. The colony was free of the 'vulgarities' that blighted so many 'of our own resorts'. The colony was 'one magnificent flower garden' and during College Weeks each spring became 'our offshore campus' for the 'wholesome cavortings' of America's collegians. Familiar praise. Less familiar was the magazine's comparison of the colony with Cuba, its rising southern competitor. Cuba had gambling and daiquiris. Unlike Bermuda, Cuba was charged with sexuality. Its 'beauties' with their 'great, melting brown eyes' attracted 'burning looks from the swains' past whom they seductively strolled. If Bermuda was prim and restful, Havana offered 'rum, roulette, rhumba and romance'. The affluent American traveller now had a choice. Bermuda had become just *one* of 'America's favorite offshore resorts'. The renowned, habitual devotion of Americans to the colony's coral beaches and stately resort hotels could no longer be taken for granted.

Post-war affluence, long-range commercial aviation and a hankering after foreign novelty in relaxation all meant that Bermuda would have to compete for its visitors. In 1949, for instance, Hawaii had sent a five-man delegation to the colony to study Bermudians' fabled success in attracting island vacationers. Five years later, it was the Bermudians who were

looking to the Pacific for hints on what made Americans travel in new directions. Los Angeles had smog, the Bermudians reported, but Hawaii was friendly and the service good. Even east-coast Americans were escaping to distant Hawaii. Bermuda, they concluded, was still 'as beautiful as any resort', its beaches 'unequalled'. Here the smugness ended: '... we are not operating as well as we could, and should, and can not be considered a first class resort in all categories'. The colony needed new hotel space, air-conditioning, better entertainment and a more reliable freshwater supply.[1] Throughout the next decades, this pattern would be repeated. Competitors – Jamaicans, Bahamians, Maltese – came visiting the grand duchess of island resorts, picking the brains of its tourist operators, and this was followed by Bermuda casting an anxious eye on their advertising, their airline and cruise ship deals and their annual arrival figures. What they saw was exponential growth in world tourism.

'Jimmy' Williams (right), known as Bermuda's 'Mr Tourism' for his work administering the TDB, with a visiting Nigerian official in the 1960s. (Bermuda Archives: Bermuda News Bureau Collection)

The tourism 'industry' that began as a trans-Atlantic shuttle for the rich in the 1920s became a mass industry of global reach in the post-war years. The World Tourism Organization in Madrid regards 1950 as the statistical base for modern tourism. That year, 25 282 000 people moved beyond their borders as 'tourists'. By 1960, the total had swollen 174 per cent to 69 320 000. By 1970, there were 555 per cent more tourists – 165 million of them – in motion than in 1950. 1980 saw the volume of world tourism reach almost 287 million, 1038 per cent greater than in 1950. 'Receipts' – income – from international tourism grew an astonishing 4757 per cent in the same years.[2]

Bermuda kept pace in this race for tourists. In the first post-war decade, the colony was simply *re*establishing its tourism. The 1950 total of 71 260 visitors reminded Bermudians of the happy days of the late 1930s. At 108 125 in 1955, the old benchmark was surpassed. Optimists talked of 200 000 visitors sometime in the distant future and the need to plan for this eventuality. A figure of 609 556 visitors by 1980, an 855 per cent increase over 1950, would have struck even such optimists as sheer fancy. Other places grew faster, but no place on earth equalled Bermuda's ability to pack legions of tourists so harmoniously into the tight confines of a 21 square mile ocean playground. By 1980, the colony annually welcomed into its midst more than ten times its own population – 55 000 – in visitors. That same year, visitors spent $278 million in the colony. In inflation-adjusted 'real terms', this was the high-water mark of tourism's impact on the Bermuda economy. Only once again, with 631 314 visitors in 1987, would the colony break the 600 000 barrier in visitorship.[3]

Bermudians look longingly back on this magnificent crescendo of growth as the 'glory years' of their tourism. In these halcyon years, Bermudians chased numbers, but they also prided themselves on maintaining their standards, on controlling and directing the impact of tourism on their delicate society. In marketing terminology, they preserved their niche, but deftly expanded its appeal. As early as 1963, tourism official Territt Mowbray assured former governor Sir Alexander Hood that 'generally speaking Bermuda is still "tops". We are doing our best to keep it a "quality" resort, for our requirements are not based on mass'. The colony's 'first economic duty' was to fill planes and ships, but right behind it was the need 'to keep the appeal and the amenities at a high level, so that the more desirable people will want to come here'. 'This should pay off,' he concluded, 'for so many resorts, such as Miami, Hawaii, Nassau and Jamaica, have gone to volume and lower prices as a means of meeting their requirements.'[4]

If participation in global tourism was lucrative, it was also nerve-racking. The post-war tourist had more time, more money and more whims. Tied umbilically to the American market, from which a constant 85–90 per cent of its visitors came, Bermuda felt every twitch in the

affluent American lifestyle. When the American economy malfunctioned, so did Bermuda tourism. In 1954, the North American economy experienced its first post-war downturn: Bermuda tourist arrivals stalled at just over the 100 000 mark for three years. Whenever inflation crept into an overheated American economy, prices soon pushed upwards in Bermuda. American presidential elections and stock market anxieties became proverbially tense times for Bermuda tourism planners. In 1964, for instance, the colony experienced its first large post-war drop in tourist volume. Changes in American tax policy – reduced duty-free allowances for returning tourists, ending tax write-offs for conventions held outside the US – could diminish Bermuda's attractiveness overnight. Airline regulation could quite literally deny the colony access to crucial 'gateway' airports or force it to open its own airport to new carriers. By the 1960s, the colony retained a lobbyist in Washington to protect its interests in the corridors of power. At other times, it had to pour huge amounts into advertising along the eastern seaboard in order to shore up its market share. Sometimes, on the other hand, Bermuda was the accidental beneficiary of American developments. When Washington's relations with Cuba soured in the 1960s, Havana and its daiquiris ceased to compete with Front Street's swizzles. When the cost of oil skyrocketed and terrorists targeted Europe in the 1970s, Bermuda appeared even safer, cheaper and closer.

Tourism's volatility was in large measure moderated by the remarkable durability of the post-war economic boom and the seemingly insatiable appetite for travel that it created. In only two years since 1950 – 1982 and 1991 – has the volume of global tourism turned downward, and then only fractionally. In Bermuda, however, the pattern began to break earlier; by the early 1980s the colony's tourist volume became erratic. Up to then, astute management and buoyant times kept Bermuda smartly in step with the world. But it was no longer like the thirties, when the *Queen of Bermuda* arrived punctually every Monday morning and automatically replenished the colony's hotels with happy Americans. After the war, Bermuda had to hustle to attract its visitors. Trade Development Board officials, for instance, complained of the 'January jitters'. With the least sign that advance bookings for the all-important Easter season were off-target, the telephone started ringing in the office of the colony's New York advertiser. The jitters usually passed, but the sense of vulnerability was persistent. 'Tourism is not anything that is secure,' tourism director Jimmy Williams warned Bermudians in 1971, 'it is one of the most fragile and fickle trades you can have … we can lose this trade very quickly and very easily.'[5]

The first major shift came in *how* Bermuda got its tourists. In 1957, more people crossed the Atlantic by air than by sea for the first time. The days of the great liners were numbered.[6] With the peace, Furness Withy had eagerly renewed its partnership with the colony, returning the refitted

Queen of Bermuda to service in 1949 and adding the smaller but newer *Ocean Monarch* in the early 1950s. But Furness Withy management was soon complaining that bookings, particularly in the winter, were down 'worse than we had any reason to expect'.[7] Costs were up. The *Queen* retained her glamour but her age was showing. Her seamen became militant unionists. In March 1955, management sailed the *Queen* to Bermuda empty when the crew went on strike and picketed her in New York. Furness Withy began complaining that even when it could fill its ships in the peak summer season, it was unable to land all its passengers because airborne tourists had snatched up all the available hotel rooms. Furness countered by asking the TDB to allow it to run more 'triangular' cruises out of New York to Bermuda and Nassau, on which passengers could live aboard the ship when in port. It also asked that the 'liv aboard' (sic) privilege be extended to its regular sailings to Bermuda. In 1955, the board acquiesced, allowing up to half Furness's passengers to 'liv aboard' at dockside on busy weekends like Easter. The hotels complained that this was the thin end of the wedge, but the Front Street retailers were delighted to see additional shoppers coming down the gangplank. When it became apparent that the hotels could still fill their rooms, the 'hotel ship' quota was raised in 1958 and again in 1960. Soon any Furness voyage could be a 'liv aboard' cruise as long as some 'regular' passengers came ashore.[8]

By the end of the 1950s, the writing was on the bulkhead. The once prized staple of Bermuda tourism, the 'regular' steamship passenger, who came ashore with a steamer trunk and headed for a grand hotel, was rapidly becoming a thing of the past. Some defected to cruising, but most simply took a cab to Idlewild or Logan and flew to Bermuda, where a room booked by a travel agent awaited them. Time and flexibility were the essence of post-war travel; glamour mattered less than getting to the beach as quickly as possible. In 1952, the last year in which the number of scheduled ship visitors actually increased, 27 per cent of Bermuda's 93 066 visitors came down a gangplank. By 1962, only just under five per cent of Bermuda's 192 802 visitors went home with a Furness Withy sticker on their luggage.

Not surprisingly, the colony's relations with its oldest ally in tourism became strained. The colony's subsidy to Furness Withy was the bone of contention. From the company's point of view, the contract saddled it with serving Bermuda through the lean winter months. The colony saw the contract as the unavoidable but costly linchpin of its tourism. The force of pre-war habit was strong. In 1958, the company suggested that it would drop its demand for subsidisation if it could 'operate as they please'. The head of the TDB's overseas communication committee, H.D. Butterfield, countered that the loss of the Furness link would be the 'greatest retrograde step'. Henry Vesey admitted that Americans were

not 'Bermuda-minded' in the winter. In 1958, a £50 000 subsidy was given to the company to shore up its Bermuda operations. When it became apparent that Furness had no plans for a new *Queen*, TDB member E.G. Gibbons complained that it had adopted a 'defeatist attitude'. Furness Withy's slow decline was poignantly underscored in 1959 by the appearance in Hamilton of the old *Monarch of Bermuda*, which had risen phoenix-like from the wrecker's yard as the Greek-registered *Arkadia*. When the *Queen* passed her former sister, now a cut-rate cruiser usually employed on the Cuba run, outside the harbour, the ignominious fate of the great liners was all too clear. Even Butterfield admitted that the contract was 'not producing for Bermuda or Furness Withy'. The *Queen* was refitted in 1962, the *Ocean Monarch* began offering 'sun tan' cruises and more 'liv aboards' were permitted, but the die was cast. The once vaunted partnership had gone sour. In 1966, Sir Errington Keville, the company's chairman, informed the TDB that it would not renew its contract. There was only a 'small trading profit' in peak season and a big loss in off-season. The New York *Herald Tribune* wrote the obituary: 'Two Bermuda Ships Bow to Jet Age'. On 23 November 1966, the *Queen* left Bermuda for the last time. The TDB arranged for a salute to be fired from Fort St. Catherine as the 'old gal' headed for deep water. 'Bless you all and good luck,' the *Queen*'s captain signalled back. The board signed one more steamer contract, a three-year deal with Cunard, but Cunard soon discovered what its British rival had known for a decade – the modern tourist would either cruise or fly, and getting there was no longer half the fun.[9]

Bermuda would now get its tourists by plane and by cruise ship. The definition of a 'regular' tourist had changed dramatically. The predictability of liner tourism – punctual weekly arrivals, neat one-week stays in pre-designated hotels – was gone. Now a tourist could fly in for a long weekend or a two-week stay. He could decide on his destination almost at the last minute and he could fly home early if the weather proved inhospitable. The old link of steamer company and a coterie of hotels and prominent small hotels was broken. Now a travel agent could put together a package deal: air fare and accommodation worked out from a sliding scale of airline and hotel prices. Bermuda tourism thus became more price sensitive; the tourist became more of a shopper. Some opted to visit Bermuda by cruise ship, paying an all-inclusive price for travel and accommodation and only coming ashore for shopping, touring and golf while sleeping aboard at dockside or at anchor. For all its security, cruising also became a question of comparison shopping. The cruise ship was footloose, chasing the best bargains, the most excitement and the warmest sun.

Since their initial appearance in Bermuda waters in the 1930s, the 'cruisers' had always been tolerated on the grounds that the 'trippers' they carried were sampling Bermuda and would later return as high-spending

'regular' tourists. In the late 1950s, however, cruise ship arrivals exploded. By 1962, 60 000 of Bermuda's 192 000 were trippers. Pursuing its earlier logic, the TDB facilitated the boom. New tenders for ferrying cruise passengers ashore were purchased, for instance. But the numbers suggested that cruise tourists were becoming a class of their own, and not necessarily Bermuda habitués in the making. The old urge to control the cruisers resurfaced. Henry Vesey, ever vigilant for the colony's quality image, warned that cruise ships were 'not always good for Bermuda, for Bermuda looked crowded from the point of view of the regular visitor, and also very little money was left'.[10] Dock facilities were becoming strained. Unlike the old-style, hotel-bound tourists, the cruise visitors tended to create schisms within the industry. While the hotels remained wary of the cruise ships as bed robbers, Front Street retailers welcomed their business. St. George's complained that Hamilton got the pick of the cruise ship crop. But cruise ship passengers were a demanding lot, seeking shopping, entertainment and diversion that were generally not available at the 'quiet' St. George end of the colony. The TDB set up a committee to try to spruce up the area with better services and attractions, but, as board member A.A. Francis warned, 'the St. Georgians must do something about this themselves and not sit back and let things go downhill'.[11]

By the mid-1960s, there was general agreement that the cruise ship boom had to be controlled. At first, the cheap ships, usually intent on one-day visits, were turned away. In 1964, for instance, the *Yarmouth Castle*, which the board deemed 'very uncomfortable and perhaps unsafe', was shunned. It proved a prophetic decision; within a year a fiery catastrophe would make the *Castle*'s name synonymous with the dangers of cheap cruising. Front Street concurred with the urge to control. In 1965, the Chamber of Commerce reported its members' belief that only 'bona fide cruise ships' were welcome. They benefited Bermuda 'financially'; 'cheap package tours' and hurried stop-overs on world cruises did not.[12] The pressure nonetheless continued to build. By 1969, the colony found itself signalling cruise ships at sea requesting that they delay their arrival until the harbour was cleared of ships already in port. On one frenzied weekend in August 1969, six cruise ships deposited 5000 tourists in the colony, choking Hamilton's streets. Tourism director Jimmy Williams therefore closed the gate another notch. A formalised policy of restriction was introduced in 1969 by amending the old Passenger Ship Act. Two ships were to be allowed at any one time to dock in Hamilton; two more could ride at anchor. Ideally, only about 2000 cruise tourists would come ashore on any one day. In 1969, 169 cruise ships bearing nearly 90 000 visitors were thus allowed to visit Bermuda.

Throughout the 1970s, Bermuda rigorously controlled its cruise ship industry. The formula was sometimes juggled in the hope of making

St. George a cruising destination, but the base line was a quota of no more than two ships alongside at any one time in Hamilton. A peak of 185 ship visits was reached in 1985. Underlying the whole policy was the realisation that cruise ship visitors were *different* tourists and were unlikely ever to change. The old hope of converting cruising tourists into 'regular' visitors faded. Surveys conducted on the cruise ships indicated that cruise visitors liked the same things about Bermuda – its cleanliness, beauty and friendliness – as the hotel tourists, but that they preferred ship to shore and, if they returned to the colony, would probably do so by cruise ship. Cruise visitors also spent less than regular visitors, much less. A 1976 survey revealed that the average cruise passenger spent $112.42 over a three-day visit. 'Regular' visitors stayed twice as long, spent much more, and were more likely to become repeat visitors. The same survey revealed that one in five cruise visitors had been on at least four previous cruises, and that although an overwhelming majority considered Bermuda 'very enjoyable' they were just as likely to sample another island the next year.[13]

The cruise ship visitor also had a different relationship with the colony's redoubtable benevolent aesthetic. The cruise ship was a self-contained floating society that for two or three days positioned itself in a sunny harbour, spilled its passengers ashore in the morning and then gathered them in again in the evening. Unlike Bermuda's regular tourists, who landed, dispersed to their hotels and then melded into the relaxing rhythm of their host society, the cruise visitors remained largely aloof from the traditional tourist ethos of the 'isles of rest'. They took taxis, ate in local eateries, played golf and went snorkelling, but were always skating on the surface of what Bermuda had traditionally offered North Americans – 'loafing' in friendly, tranquil surroundings. Cruise visitors were also less likely to be cut from the cloth of patrician American society; each ship bore a different slice of American society. They were therefore less likely to comport themselves according to the decorous standards of Bermuda tourism, standards that expected tourists to become friendly Bermudians, leaving the brusque manners of hurried, urban American life at dockside in New York. The implicit erosion of established Bermuda tourism by cruise tourism was well understood. 'I view with great concern the future [of] cruise business,' tourism official Territt Mowbray confided to a colleague in 1971. 'Resorts to the south have suffered because of too many … We were unique in setting a restrictive policy two years ago, and we were praised by the travel agents, press, and other resorts. We must not slip now. Cruises could ruin Bermuda and drive out the regular visitors.'[14] Yet Bermuda could hardly opt out of the cruise game. Cruising appealed because it was safe, its costs were contained, it had a cachet of glamour and was 'fun' in a way that Bermuda had never defined fun. Cruising was what North Americans wanted, and along Front Street where the big

white ships docked, there was many a Bermudian retailer and waiter who agreed. And every time a cruise ship passenger walked down a gangplank onto Front Street, the Bermuda government collected a head tax (rising to $60 per passenger by the 1990s). By 1980, one in five of Bermuda's 609 556 visitors came by cruise ship.

The airport offered Bermuda its best hope of preserving the loyalty of its precious 'regular' tourist. In September 1959, the colony entered the jet age. A brand new Pan American Airways Boeing 707 landed at Kindley Field after flying directly from Seattle. Bermudians flocked to the airport to inspect the jet. Henry Vesey, who had temporarily left the Trade Development Board to head the Civil Aviation Board, was with characteristic eagerness the first to tour the aircraft.[15] The flight from the distant west coast seemed to symbolise the new reach of commercial aviation, while the Boeing's silver and blue Pan Am livery reminded the colony that

Juan Trippe of Pan Am (left) showing off the Boeing 707 to Bermuda's Governor, Sir Julian Gascoigne, in 1959. Trippe had done more than anyone else to bring Bermuda into the aviation world. (Bermuda Archives: Bermuda News Bureau)

its oldest and most faithful partner in the air was still vitally interested in its tourism.

By the early 1960s, the jets had become daily visitors to the Bermuda tarmac, while the old Constellations and Strato-Cruisers were fast disappearing. The colony attracted three types of air service: scheduled shuttle flights from the east coast, through flights of airliners en route to the Caribbean, Latin America or further afield, and non-scheduled arrivals, like charters. The shuttles operated by Pan Am, Eastern, BOAC (which flew out of Baltimore and Montreal) and Air Canada provided the lifeblood of Bermuda tourism; they connected the colony with the heartland of its loyal clientele. Tourism officials in Bermuda instinctively favoured the shuttles, often noting that the colony was 'morally obligated' to Pan Am, BOAC and Eastern which had served it so 'faithfully' for so long.[16] In effect, these airlines became the new Furness Withy, the colony's privileged gatekeepers. They were expected to deliver high-quality tourists, protect the colony from cheap, low-end air tourism and buy into the colony's established aesthetic in their advertising. In return, Bermuda would protect their turf.

While the Civil Aviation Board had official jurisdiction, the Trade Development Board's opinion weighed heavily in aviation matters. When the American airline Flying Tigers offered the colony off-season cheap charter flights in 1963, tourism officials vigorously objected. Charters meant low-budget visitors who were unlikely to bond with the place. 'An operation of this sort,' warned the manager of the Bermudiana Hotel, Carrol Dooley, 'is completely contrary to the policy of the board and the image we have been trying to build up.' Henry Vesey agreed: 'We must stick to our ideals'.[17] When another airline proposed a £105 return London-Bermuda fare, the board demurred, arguing that it would attract the wrong 'type' of visitor.[18] On the other hand, the colony did everything in its power to ease the travel of the well-heeled visitor. In 1959, it negotiated pre-customs clearance with Washington for its American visitors. Holidayers returning from Bermuda could now clear US Customs in Bermuda. As usual, Bermuda's instincts were canny. In 1965, when air arrivals topped the 200 000 mark for the first time, an airport survey showed that the average airborne tourist came from 'professional and managerial occupations'. They stayed an average of 7.5 days, usually (72 per cent) in a hotel and would (97 per cent) recommend the colony to friends for a vacation. Many planned to return themselves. When asked why, they trotted out all the answers that reassured Bermudians: friendliness, restfulness, cleanliness and natural beauty.[19]

The colony's airline connections required constant vigilance. By the 1970s, commercial flying had lost its simplicity and become tangled in a skein of complex rate structures, competition and regulation. In 1965, the colony retained a Washington lobbying firm, Regan & Mason, to keep an

eye on its interests in the scrum of American public policy formation. In 1968, for instance, Henry Vesey was brought to Capitol Hill to fight an attempt before the Civil Aeronautics Board to open the lucrative Bermuda market up to other American airlines. 'We think that additional service to Bermuda should be in the context of controlled growth of the tourist industry', Vesey told the American regulators. The airport was small and the colony's established air partners understood its needs. When Washington sought to trim its balance of payments by reducing Americans' duty free exemption, Vesey was back arguing that every dollar an American spent in Bermuda soon found its way back in Bermudian purchases of American goods to sustain its tourism.[20]

Throughout the 1970s, Bermuda slowly expanded its airline 'club'. New gateway cities – Atlanta and Chicago – were opened up and new airline partners, like Delta, added. Careful growth was always the byword. For a few years in the late 1950s, Bermuda even had its own airline. The flexibility of air travel had created its own bottlenecks. In Bermuda's case, peak season flying at Easter and weekend access to the colony became congested and seats scarce. To alleviate the strain and yet keep control within Bermudian reach, a British entrepreneur, Harold Bamberg, secured a charter in 1957 for a Bermuda-based airline that would fly turbo-prop Viscounts from the east coast to Kindley Field. Eagle Airways had expatriate pilots but Bermudian maintenance and service personnel. Bamberg hired five 'lovely and lively local lasses' as stewardesses and planned to deck them out in pink Bermuda shorts, until he was convinced that such comely attire would attract undue attention from male passengers.[21] Eagle lasted only a few years, proving a bit player in what was becoming a global industry, and was gone from the skies in a couple of years. Eagle's brief flight confirmed Bermudians' intuition that they were best served by big American airlines. Even BOAC – latterly British Airways – slipped from the first rank of Bermuda's air carriers. A weak pound and a steady decline in British visitorship to expensive Bermuda obliged the British to drop their shuttle routes from America and revert to periodic service direct from London. The remaining American members of the colony's exclusive airlines took up the slack; by 1980 they were annually delivering almost a half million passengers to Kindley. Perhaps nothing better symbolised the success of the colony's airline strategy than its warm relationship with Juan Trippe of Pan Am. In the 1950s, Trippe bought a waterfront home, 'Avonville', in Tucker's Town and became active in Bermuda Properties Ltd.'s plans to modernise the Castle Harbour Hotel. Trippe loved bringing his New York friends to the colony for weekend golf and swizzles. It was said that the surest way to get to Bermuda on schedule was to take the late afternoon Pan Am flight from New York to Bermuda any Friday. Trippe was sure to be on board and there would be no delays.

Having applied the principle of tightly controlled growth to its airline and cruise ship partners, the colony adeptly reapplied it to its hotel industry. Bermuda had emerged from the war with its hotels largely intact and had coasted for over a decade on their pre-war capacity and grandeur. A handful of new cottage colonies opened in the 1950s, but no new hotels. By the late 1950s, however, the competition had closed the gap. There were brand-new Jamaican, Floridian and Bahamian hotels, while Bermuda's once unchallenged resorts were looking tatty and antiquated. The Princess in Hamilton and the St. George Hotel had grown decrepit. Complaints increased. 'I am wondering,' one irate American tourist wrote to the TDB, 'if it would be possible for you to send a skid row bum to the St. George Hotel in order to determine if he stayed in a cleaner room.'[22] Fate then lent a hand. On the afternoon of 4 September 1958, a wisp of black smoke was spotted curling from the roof of the Bermudiana Hotel on the Hamilton waterfront. Within an hour, the hotel was an inferno. 'What will the hotel look like next Monday,' a TDB official was heard to say as the hotel burned, 'when the Queen of Bermuda arrives?'[23] Although the Bermudiana represented only 5 per cent of the colony's hotel rooms, its loss galvanised the colony into modernising its hotels. Throughout the late 1950s, there had been talk of new resort hotels on the South Shore. Little happened, usually because local promoters could not muster sufficient capital.[24] But now, when the Bermudiana's British owner, Sir Harold Wernher, announced his wish to rebuild the hotel, the colonial government came to his assistance. An act was passed in 1959 waiving the payment of duties on material imported to rebuild the hotel. Construction began immediately. 'Bermuda's accommodations were not the best,' Henry Vesey acknowledged, 'and Bermuda can not sit pat for 3 to 5 years.'[25] Besides the rebuilding of the Bermudiana, a new shore-front hotel – the first new hotel in the colony in 30 years – was under construction on the South Shore. The Carlton Beach Hotel was a dramatic curved structure overlooking the ocean at Boat Bay. A local real estate promoter, Geoffrey Kitson, had led New York capital to the project, but before it was completed in 1961 ownership passed to the Hotel Corporation of America. The Carlton Beach, later renamed the Sonesta Beach Hotel, reflected North America's appetite for resort get-aways – pools, cabana bars, and a menu of recreational activities.[26] Few disputed that the colony needed more such hotels.

In 1960, the colony had 4630 beds for its visitors, 52 per cent of which were in large hotels. Airline seats and hotel beds were the prime regulators of Bermuda's tourism, but the hotels generated the jobs for Bermudians. By the early 1960s, sprucing up tourism's competitiveness was not the only imperative pushing hotel expansion. The colony's population had surged almost 18 per cent in the 1950s to 42 600; the sixties would see another burst of 24 per cent to almost 53 000. Tourism officials were acutely aware

that tourism, as the colony's largest employer, offered Bermuda the readiest means of keeping pace in this race to create jobs and feed mouths. Tourism director Jimmy Williams believed that population growth was 'the crux of Bermuda's problem today' and that new infrastructure for the industry was the best way to meet the challenge of 'new labour and new mouths to feed'. Sir Henry 'Jack' Tucker, the colony's leading banker and TDB member, agreed, pointing out that with 800 births a year in the sixties new hotels and more visitors were the colony's only option.[27]

Other imperatives checked any headlong plunge into new hotel construction. There was only so much space in Bermuda, and resort hotels, with their obligatory golf courses and beaches, brought the danger of overcrowding. And overcrowding might spoil the very aesthetic upon which Bermuda's appeal rested. Williams warned that 'the character of Bermuda must be considered. The question was at what point does Bermuda start to lose its attractiveness through over-development and still be in a position to maintain the standard of living'.[28] Outside experts saw the same risk. Thornley Dyer, an English urban planner hired to advise the colony on its development strategy down to the 1980s, noted that the 'greater the number of tourists, the greater the danger to Bermuda's attractions'. At some point tourism would impinge on Bermudians' 'rightful share of land, views, beaches and recreational opportunities'.[29] There was also a commercial aspect to the question. The easiest benchmark for hotel expansion might be the peak load carried in the Easter season and through the summer, but this meant a profit-draining under-utilisation of beds in the slow winter season. It would also impart a highly seasonal pattern to hotel employment. Surrounded by these pressures, Bermuda approached the question of hotel expansion with its inveterate cautiousness. If they got it wrong, the colony would suffer both a loss of income and a loss of social harmony. As Jack Tucker reminded the board, there was a long list of bankrupt Jamaican and Florida hotels.

Confronted by these pressures, Bermuda rediscovered the virtues of planning. The appearance of American billionaire Daniel K. Ludwig in the colony and the nagging fear of 'over-hoteling' combined by the mid-1960s to produce a policy of 'hotel phasing' that would guide the Bermuda hotel sector through the next two decades. Ludwig was rich, very rich. His foundation wealth came from innovative shipbuilding and the creation of a globe-circling fleet of tankers. By the late 1950s, Ludwig was beginning to diversify his empire and when an engineering project brought him to Bermuda he liked what he saw. The head of the TDB, Henry Vesey, also liked what he saw: a forceful, visionary entrepreneur with the means to vault the colony back into large resort prominence. Ludwig responded eagerly. Egged on by Vesey, he proposed to buy the run-down Princess Hotel from Billy Butlin and, almost as an act of good faith, renovate it, and

at the same time seek permission to build a huge new Princess Hotel on the South Shore. The Southampton Princess would be an American dream hotel with golf, beach access, extensive gardens and convention facilities. The proposed 900-room hotel was on a very unBermudian scale, requiring a huge contiguous land holding. Its beds would require an additional 20 000 new airport arrivals a year to fill them. But it promised to be an engine of employment and an image-maker for Bermuda tourism. Ludwig's ambitions quickly became the focus of intense scrutiny, by a special committee of the TDB, by the Assembly and by consultants hired by the government. News that the colony lacked sufficient hotel space for the Easter rush and indications that another developer, Norman Simons, was about to propose a second new resort hotel at the Astwood Estate on the South Shore intensified the pressure.

Late in 1963, the board reached its decision. The debate had at times been sharp. A minority believed that the new Princess was too large and 'that if Bermuda is overcrowded, dissatisfaction and not goodwill will be built up, and Bermuda will start on the downward trend'.[30] But the majority, vigorously led by Vesey and Tucker, prevailed. The Princess should be built, and possibly the Astwood resort, but then development should be capped. Future growth of Bermuda's tourism infrastructure would be 'along conservative lines' with all future development taking place 'on the acreage now being used for tourist facilities'.[31] The old St. George Hotel might, for instance, be renovated. By 1967, this advice had been refined into a policy of hotel 'phasing': slow annual expansion of the hotel sector by between six and ten percent to a projected 1982 total of 8560 beds. Ludwig fulfilled his part of the bargain. In 1964, the Hamilton Princess reopened as a hotel and cottage colony, sporting $9 million in renovations. In 1968, a 226-bed addition to the downtown Princess opened. Work on the Southampton Princess proceeded more slowly, but by 1969 the first wing of the hotel was open. By 1972, Ludwig had pumped $50 million into the project. A boxy, pink behemoth of a building dominating the Southampton parish skyline, the new Princess became the prestige trademark of Bermuda hotel vacations.

The hotel sector felt the hand of government in other benevolent ways. Although hotel employment was the largest segment of the Bermuda workforce, its ethos had always been one of on-the-job training. Where Bermudians lacked the skills, foreigners stepped into the breach. By 1967, 28 per cent of hotel jobs were held by 'imported' staff. Bermudians dominated in housekeeping, maintenance and table waiting, while foreign participation rose dramatically at the department head and front desk levels. The hotel expansion of the 1960s created pressure for more formalised hotel training to ensure that Bermudians captured most of the benefit of the new hotel expansion. The arrival of multinational hotel chains, like the Hotel

Gibb's Hill Lighthouse in Southampton parish; on the ridge behind it stands the Southampton Princess, Bermuda's largest hotel. Intended to modernise the colony's hotel infrastructure, it was the last to be built before hotel construction was capped. (Government Information Services, Bermuda)

Corporation of America at the Carlton Beach, accentuated the trend. Hotels in the sixties were increasingly run 'by the book', with systematised routines and job descriptions. The big hotels were without exception managed by foreigners – like the renowned Bodo Von Alvensleben at the Hamilton Princess – who set exacting standards. Since 1936, a privately-run domestic science school was all Bermuda had to offer to aspiring waiters and maids. In 1960, the Assembly voted funds for a Bermuda Hotel and Catering College to prepare Bermudians for careers in the hotels. It was Bermuda's first attempt at educating its citizens beyond the age of 16. In 1973, the School became a fully-fledged college.[32] That same year, the tourism department launched a 'Bermudians in Tourism' campaign, using biographical profiles of Bermudians in tourism, from tug boat captains to waiters, to extol the benefits of a life in tourism. Reggie Cooper, the owner of a small hotel, Glencoe, was quoted as saying that the days of 'sloppy' service were 'gone forever' and that the secret of success was 'long hours'.[33]

Hotels made money when their beds were filled. By the late 1960s, Bermuda hotels boasted a 73 per cent average annual occupancy, a considerable achievement considering that the colony had a soft winter season. At times during the peak Easter and summer seasons the hotels hit astonishing 100 per cent occupancy rates; one August the rate actually topped 101 per cent, as college students double-bunked in some hotels. Airlines began checking passengers' hotel reservations before their American departures to ensure that they would not be bringing angry, unaccommodated tourists home on the return flight. To alleviate this strain and to squeeze maximum capacity out of the system, the hotels started a 'space service' in 1965. A telephone hot-line to New York, and later Toronto, provided travel agents with the latest bed availability and allowed them to shift clients to comparable accommodation if their first hotel choice was unavailable.[34]

The hotel industry had one other important regulator, its hotel association. Bermuda had had a hotel association since just before the First World War, but it had faded in and out of existence as the intensity of tourism varied. The Depression and the hiatus of war had driven it into hibernation. The post-war boom brought it back to life and in the hectic 1960s made it a virtual cartel. In this demand-driven market, the association proved highly cohesive, overseeing the hotels' general publicity and the booking system. The association also acted as a policeman, ensuring that standards were maintained and that the colony's hotels never became cut-rate. Bookings were channelled through a prominent wholesaler in New York, the Haley Corporation, which allocated most Bermuda accommodation to travel agents. Other travel wholesalers grumbled that this was a trust that needed to be 'busted'. From Bermuda's perspective, the arrangement had the supreme virtue of placing the vast majority of the colony's hotel bookings in the hands of one wholesaler, thereby

minimising the chance of bidding wars over commissions. Furthermore, the Haley Corporation's practice of issuing pre-paid accommodation vouchers which tourists simply presented on arrival at their hotels allowed Bermuda hotels to shun the acceptance of credit cards (and their profit-eroding commissions) until well into the 1970s. The old commercial canniness of Front Street was still alive.

By the early 1970s, Bermuda's macroeconomic management of its tourism was a striking success. There were posh new hotels, controlled access for the best of the cruise ships and an efficient air bridge linking the colony with its loyal North American tourist heartland. Local newspapers grew weary in the early 1970s of proclaiming 'best ever' monthly arrival totals. In May 1973 the colony recorded a one-month arrival total of 43 879.[35] 'They just keep on coming!' editorialised *The Bermuda Sun*. Bermuda's addiction to quality tourists had not wavered; it had simply found a way to boost the flow-through of its traditional clientele. 'What

Sir Henry Vesey (second from left), the mastermind behind Bermuda tourism's post-war success, flanked by C.V. 'Jim' Woolridge, the United Bermuda Party politician who in 1977 would become Bermuda's first black minister of tourism, and J.W. 'Jimmy' Williams, the TDB's executive director. (Bermuda Archives: Bermuda News Bureau Collection)

we do want to avoid,' Henry (now Sir Henry) Vesey confessed on the eve of his retirement from the Trade Development Board in 1969, 'is over-expansion.' Bermuda, he reminded his compatriots, 'enjoys a very high standard of living, and to maintain that high standard we cannot go after the mass market, as a great many other resorts are doing'.[36] To clinch the point, Vesey was fond of underlining the fact that the colony had an enviable 26 per cent rate of return visits among its tourists.

As the tourists poured through the lounges at Kindley Field, the colony continued to groom its renowned aesthetic. A 1969 marketing study by the New York advertising firm of Needham, Harper & Steers concluded that 'above all' the colony's lodestar should be to 'maintain uniqueness'. 'The temptation to compete directly with more "active" resorts should be avoided' in the 'awesomely competitive 70s'.[37] Tourists came because the place seemed 'foreign' and 'tranquil'. To this end, Bermudians were urged to heed the cosmetics of their island. The old instinct to trim hedges, rake beaches and plant flowers persisted. Business signage was tightly controlled: store signs were to be no larger than 15 inches, nor were they to mention brand names. Prisoners were set to work making flower boxes. As the post-war consumer society took root in post-war Bermuda, litter became Public Enemy #1. The litter menace gave birth in the 1960s to civic activism in the form of the 'Keep Bermuda Beautiful' movement with its motto: 'Weed Out Litter – Sow Beauty'. The campaign was carried into the schools. Marjorie Bean, a government education officer, warned teachers that the colony was threatened by 'an invasion of litter-louts', a group of 'anti-social, beauty-destroying, health-hazarding polluters who couldn't care less about keeping our lovely Bermuda lovely'.[38]

The attack on litter was the latest manifestation of the urge towards social engineering that had always pulsed at the heart of Bermuda tourism. The society *was* the aesthetic. The aesthetic dictated and reflected the values of the society – what was acceptable behaviour and what was not. Bermuda was 'friendly' because it was friendly. In 1961, the colony's advertiser J.M. Mathes sensed that this social cohesion was at the heart of Bermuda's success as a tourist destination: 'What our competition are not able to find is the spirit of cooperation and a willingness to coordinate all the efforts of Bermuda's interests towards one goal'.[39] Bermuda writer Larry Burchall has brilliantly captured this ethos by describing the colony in these years as 'a 13 000 acre living room with naturally courteous, honest, and gentle hosts who were always extremely proud of their Living Room which was, then, always neat, clean, tidy, well kept, and uncrowded'.[40] Throughout the 1960s and 1970s tourism administrators tried hard to maintain this ethos. There were, for instance, campaigns to raise consciousness of tourism's importance to Bermuda's society. The 'I'm a Nice Guest' campaign in 1964 featured the travails of a visitor who gets 'pushed around'

and takes his revenge by not returning – 'So long – I'll not be seeing you'.[41]

The colony applied its controlling instincts to the tourists themselves. As always, Bermuda's tourists were expected to act as 'visitors', not interlopers at odds with the host society's mores. Proper dress was one aspect of this code. In the mid-1960s, for instance, the tourism board had green cardboard notices printed bearing the message: 'May we respectfully suggest that in order to feel "at home" in Bermuda, visitors should know that it is against Bermuda law and custom to wear abbreviated costumes on the public streets'.[42] Women needed the most policing. In 1964, a calypso song was commissioned to rid the colony's streets of tourist hair curlers:

> In Bermuda, it's taboo
> Look out: don't let de cops catch you.
> Keep your curlers out of sight
> Don't let' em show in broad daylight
> Pretty girls are super fine
> But no one loves a porcupine …[43]

In Bermuda, one dressed as though one were walking down the high street in an English village on a warm summer day. Much was made of Bermuda

A 'green ticket'; a punched hole allowed the card to be attached to a visitor's hired moped or bicycle.

> May we respectfully suggest that in order to feel "at home" in Bermuda, visitors should know that it is against Bermuda law and custom to wear abbreviated costumes on the public streets. Extremely short shorts and/or bra or halter ensembles should not be worn in any public place other than the beaches where, of course, the latest bathing and sports costumes are quite acceptable. Your kind cooperation will be greatly appreciated and will add to your vacation enjoyment as well as help Bermuda maintain its position as an attractive and pleasant holiday resort.

Bermuda shorts vs short shorts, c. 1960; a Bermuda policeman checks the length above the knee of a tourist's shorts. Few such incidents ever actually occurred – the photograph was probably staged – but such publicity served to draw visitors' attention to Bermuda's dress code. (Government Information Services, Bermuda)

shorts because they seemed to be a hybrid of Bermuda weather and British decorum.

As always, Bermuda proved adept at projecting its image across the Gulf Stream into America. 'Bermuda should only talk to those people who would enjoy this way of life', Mathes Advertising advised in 1963, stressing that the image should be conveyed in a 'conservative but extremely attractive manner'.[44] When it was suggested that a neon sign touting Bermuda's wares be erected on Broadway in New York, the TDB reacted with horror. Neon was too 'honky-tonk' and would attract the 'wrong' sort of visitor.[45] In 1965, the colony ended its relationship with its long-time advertiser, J.M. Mathes in New York. A succession of blue-ribbon American firms held the account through the next two decades – the D'Arcy Agency, Foote, Cone and Belding and finally Needham, Harper & Steers. The message, however, remained religiously the same: 'Above all, Maintain Uniqueness', Needham counselled in 1969.[46] A series of hallmark campaigns and slogans followed: 'There is only one Bermuda', 'Bermuda – the

quiet summer' and 'Bermuda. Where you still find the nineteenth century niceties'. Pastel colours and clusters of decorous scenes of tennis, golf and sightseeing, plus liberal use of Bermuda's distinctive red ensign flag, pervaded the advertising. Television advertising was shunned because television demographics were not the demographics of Bermuda tourism. Faithful advertising media like *The New Yorker*, *Fortune* and *Bride* were joined by new ones such as *Sports Illustrated*. When the volume of visitor arrivals dipped, the advertising was pushed down into the regional editions of *Time* and *Newsweek*. In 1959, Bermuda became the first tourist destination to sponsor a full supplement in the *New York Times*.

Advertising was expensive. And it was also becoming more competitive. By the 1960s, Nassau, Jamaica and Barbados were aggressively promoting themselves as get-aways sporting new facilities and a more active style of holiday. Bermuda tourism officials thus found themselves playing an annual game of tourism mathematics, dividing advertising expenditure by tourist arrivals. They often discovered that they were being out-advertised by Caribbean destinations, and often in the same magazines that they once considered their exclusive turf. The dynamic was perhaps different: Bermuda saw itself defending an established niche, while the Caribbean was trying to build one with new products – package holidays – drawing on a much broader demographic clientele. Nonetheless, by 1979 the colony was spending $11.93 to attract each of its visitors, up by three dollars since the early 1970s.[47] Tourism was becoming a yeasty global phenomenon. For all its redoubtable visitor loyalty, Bermuda was discovering that the modern tourist was flighty and more cost-conscious. The modern tourist's hankering after novelty tended to undermine the pattern of automatic annual returns to the colony. Similarly, the average length of stay fell steadily through the 1970s and 1980s – to 5.1 days by 1979. The shorter the stay, the more the colony had to hustle to fill its hotel beds. Contrary to all its ingrained instincts, Bermuda was learning to adapt its uniqueness to an age of mass tourism.

Even in the Darwinian world of mass tourism, Bermuda continued to display its entrepreneurial verve for tourism. In a bid to broaden its market beyond the core states of the Atlantic coast and central Canada, the old tourism offices in New York and Toronto were joined by new outposts in Chicago and Boston. The London office soldiered on, but English tourism to Bermuda was crimped by a weak pound and distance. Initial efforts were made to penetrate the European market, but here distance, abetted by the lack of regular air connection, conspired with cultural differences to blunt the appeal. Bermuda's market therefore remained unshakeably centred on the eastern United States from where 85–90 per cent of its visitors annually came. Central Canada contributed another steady 6–8 per cent.

Advertising caught the attention of these Americans, but travel agents actually steered the would-be traveller to a destination and booked the trip. So to maintain the agents' interest and loyalty, a Bermuda briefing tour was organised every autumn to barnstorm the east coast. Jointly funded by the tourism department, the hotels and air carriers, the briefing tour bused its way through every major eastern city from Buffalo to Boston with military precision. The uniform was Bermuda shorts. The drinks – Bermuda swizzles – and the music – usually provided by Hubert Smith – were pure Bermuda. Every year there was a theme; in 1969, it was 'Bermuda is another world'. The tour had Bermuda's quintessential friendliness at its heart. Hoteliers like Cy Elkins from the Elbow Beach and veteran tourism officials like Jimmy Williams, Colin Selley and Charles Webb charmed the travel agents, topped up their glasses and put them in a Bermuda frame of mind. In 1973, the process was reversed and the colony began bringing the travel agents to Bermuda in an annual 'At Home' that brought up to 5000 agents to the colony for a brief, all-expenses-covered stay. Little touches topped off the effort – every Easter Bermuda lilies were sent to beautify the foyer of Radio City in New York; Bloomingdales began selling Bermuda sherry peppers, a fiery sauce that Bermudians splashed on food. In the world of top-of-mind advertising, Bermuda thus found a way of keeping itself close to the American consciousness.

Back in Bermuda, constant attention was paid to the product itself. Old facilities were refurbished and new attractions developed. Golfing on the colony's challenging links and courses continued to exercise its magnetic pull on America. Two new courses opened, both in Southampton parish. The new Robert Trent Jones-designed Port Royal course won special praise. Other events ranging from international bridge tourneys to the finish of the glamorous Newport yacht race were slotted throughout the year to exert a steady magnetism on tourist arrivals. Special themes were developed for particular years: the 350th anniversary of Bermuda's founding in 1959, a royal visit in 1975 and the visit of the Tall Ships in 1976. The colony increasingly began to emphasise its heritage. In 1955, a local salvage diver and amateur marine archaeologist, Teddy Tucker, drew the world's attention when he came ashore with a trove of gold coins and a spectacular emerald-studded gold cross pulled from the wreck of a sixteenth-century Spanish galleon, the *San Pedro*. The find brought the colony a publicity windfall. Tucker, whose scuba prowess was featured in *Life*, seemed the modern embodiment of Bermuda's old swashbuckling ways on the seas. An unseemly fight ensued in which Tucker and the government squabbled over the treasure's ultimate disposition. Tourism officials suggested a wreck museum to display what was now called the Tucker Cross. Tucker balked and nothing happened. Four years later another amateur diver, Edmund Downing, displayed similar pluck in

finding the wreck of the *Sea Venture* off St. George's, exactly 350 years after it had foundered. The government paid to have the site surveyed, then declared it a heritage site and passed a treasure trove law asserting jurisdiction over Bermuda's wreck-strewn reefs.

Despite the frictions, Bermuda had acquired a reputation for its maritime heritage. Wreck diving became a tourist attraction. An interest in Bermuda's military heritage followed. In 1974, the British naval dockyard, derelict since the Royal Navy's departure from Bermuda in 1951, was leased to a group of volunteers intent on converting it into a maritime museum. The nine-acre site had at its heart the 1822 Commissioner's House, the oldest iron-structured building in the hemisphere. A laborious reconditioning of the Dockyard began, relying on volunteer labour and corporate donations. The Tucker treasure was installed as the centrepiece of the museum, minus the famous gold cross which had disappeared mysteriously during the 1975 royal visit. A thief had dexterously replaced the cross with a paste replica, which a shocked Teddy Tucker discovered as he readied the cross for the Queen's inspection. The real cross was never recovered and the paste impostor remained on display in its stead. The disappearance of the Tucker Cross was destined to become the subject of endless speculation among Bermudians. By the 1980s, the Maritime Museum drew as many as 50 000 visitors a year. Other mothballed British fortifications were refurbished and opened to the public, their rusting cannons serving as reminders of centuries of Britain's pretensions in the hemisphere. A military tattoo was staged annually. The Bermuda National Trust enhanced the tradition of combining volunteer effort and heritage opportunity by restoring historic homes like the early eighteenth-century Tucker House in St. George's and opening them to the public.

New attractions reflected the new mobility that tourists enjoyed in Bermuda. Government-owned buses and ferries made day trips from one end of the island to the other both feasible and comfortable. Taxis provided added flexibility; the government instituted a programme of training and certifying taxi drivers as tour guides. Americans knew all about taxis, but it was the petrol-powered auxiliary cycles – mopeds – that restored the colony's reputation for uniqueness. By the 1960s, the rented moped afforded the tourist the complete freedom of the colony. When the tourists complained that they kept getting lost, the Trade Development Board responded with its inveterate inventiveness by printing a small, foldable 'handy map' which it distributed free to all comers. The handy map was a brilliant invention: it conveyed a sense of Bermuda's postage-stamp smallness, and, bearing as it did names like Fractious Street and Aunt Peggy's Alley, Bermuda's quaintness. In a subtle way, it was also a means of controlling the tourists: roads leading to Tucker's Town, the millionaires' enclave, were simply left off the map.

A tourist surrounded by a sea of mopeds on the South Shore, 1977. Bermuda had always promoted itself as a place for individual retreat and exploration, and the moped tourist soon became an icon for a Bermuda escape. (*The Bermudian*, photo by Leslie Todd)

Some niches faded and new ones emerged. Throughout the early 1960s, the College Weeks boomed. 'Girls – don't hide your beauty under too much goo!', entrants in the College Queen pageant were advised. Volleyball, beach parties and free Coke fuelled the festive mood. In 1963, a record 7600 collegians invaded the colony. But this was the peak. Never a big money-maker, the students were getting out of hand. Beer and male hormones fuelled the chaos. In one notorious prank, the carpet in the foyer of the Elbow Beach Hotel mysteriously disappeared, only to reappear the next year as neat, one-inch squares on the lapels of the incoming crowd, no doubt the insignia of some holiday fraternity. The TDB naively tried appointing chaperons. Tourism director Jimmy Williams questioned the continued wisdom of pandering to 'these cocky students'; '... we are, basically, working *against* our policies of quality vs. quantity by encouraging the seven fifty per night college kid to come to Bermuda by supplying him or her with three free lunches'.[48] Bermuda therefore quietly surrendered the college spring break market to Fort Lauderdale and Daytona Beach. The decline of College Weeks hinted at the more fundamental trend: Bermuda was neither inclined nor equipped to cater to the emerging baby boom's idea of 'fun' – a more active, overtly hedonistic and individualistic style of leisure. Indeed, the surveys of cruise ship passengers began to indicate that some island visitors wanted 'more entertainment'. But, as one New York travel agent assured the board, the 'real Miami Beach types' were steered away from Bermuda. The colony's appeal lay in that it offered 'something for everybody but not an overabundance of activities'.[49]

The Caribbean's aggressive campaign to sell itself as a winter 'sun spot' accentuated the vulnerability posed by Bermuda's mild winter. Since the 1920s, the colony had built its reputation as a summer resort; the 'isles of rest' had only appealed as a winter retreat in the late nineteenth century because of the fortuitous combination of proximity to North America, poor transportation elsewhere and certain North American phobias about the Caribbean. A down season in the winter created seasonal unemployment in the colony and hit the hotels' bottom line hard. To build up winter tourism, an arts festival – Bermuda Rendez-vous, later the Bermuda Festival – was launched for the lean months of January and February.[50] Off-peak air fares, lower hotel rates and a programme of cultural events were combined to attract visitors who were more inclined to culture than suntanning. Winter golf and tea parties at City Hall were added to the formula. The appeal was essentially to Bermuda's traditional, well-heeled, older clientele. By 1980, for instance, 50 per cent of Bermuda's visitors had a college education; 22 per cent had post-graduate degrees.[51]

The grooming and repositioning of Bermuda's aesthetic was accompanied by other alterations to its appeal. Jewish and black Americans finally

found themselves more welcome in the colony. Racial discrimination in Bermuda succumbed in the late 1950s to a pincer movement of outside pressure and local agitation, much like the *de facto* coalition of Jewish and black activism in the United States. The common focus was the notorious Hotel Keepers' Protection Act, the Depression-era legislation that allowed hoteliers to screen their guests. For decades, the anti-Semitic application of the Act had drawn criticism from outraged American and British Jews. In the 1950s, the B'nai B'rith had joined the chorus of indignation. At the same time, Bermudian blacks railed against the Act, not only because it restricted black tourism but also because it kept black Bermudians out of restaurants, clubs and hotels in their own colony. Blacks were thus denied the right to spend their wages in the very places where they worked serving tourists. An association of black businessmen in the tourism trade – the Bermuda Resort Association – had won small victories in the early 1950s from the colony's elite. Advertisements for black visitors were placed in *Ebony* magazine. The Trade Development Board seemed to sense that change was in the wind, but always argued that too swift an end to Bermuda's quiet policy of racial segregation would undermine decades of building up an aesthetic around white racial values.

It took a crusade in the late 1950s by Edward Richards, a black lawyer-politician, to tip the balance. Richards argued that human rights came before economic expediency; 'it's a blot on this Colony's escutcheon', he scolded the Assembly.[52] Black members of the tourism board, like A.A. Francis (Richards' legal partner) echoed the complaint. Richards made a motion in the Assembly to abolish the Hotel Keepers' Act because it caused 'embarrassment, insult and humiliation suffered in Bermuda by Negroes, Jews and other non-Caucasian races'.[53] In the spirit of Bermuda gradualism, a select committee of the Assembly was set up to study the issue. Richards doggedly kept the issue in the press, and by June 1959 had created sufficient pressure that seven of the colony's leading hotels voluntarily dropped their colour bar. (On hearing the news at the TDB offices, veteran hotelier Howard Trott is said to have ordered that all files pertaining to the colony's 'restricted clientele' policy be burned.) A year later, the select committee recommended that a 'uniform open policy' be extended to all Bermuda restaurants and tourist facilities. Legislation banning racial discrimination followed, but vestiges of discrimination lingered. Prominent blacks, like boxer Joe Louis, runner Jesse Owens, boxer Cassius Clay and trumpeter Louis Armstrong, found themselves welcome, but others complained, for instance, that access to golf courses was still restricted. There was no rush of black tourism into the colony; only 2200 black tourists in 1963.[54] The colony had so long styled itself as a playground for whites that old perceptions lingered. Some Jewish visitors still complained that they encountered a 'sneering and condescending tone of

Cassius Clay (later Mohammed Ali) touring Bermuda in the late 1960s. Black tourism, like white tourism, was encouraged by the presence of prominent visitors. (Bermuda Archives: Bermuda News Bureau Collection)

voice', but most re-embraced the Bermuda aesthetic as eagerly as they had in the 1920s.[55]

The appearance of black and Jewish tourists at hotel reception desks was but one aspect of a massive change engulfing Bermuda society in the 1950s and 1960s. Sociologists broadly apply the label of 'modernisation' to the process by which societies restructure the way in which they distribute the prerogatives of power and the benefits of national wealth. By this measure, the modernisation of Bermuda society reached critical proportions in the 1960s and 1970s and, as the principal locomotive of Bermuda prosperity, tourism was unavoidably at the centre of the transition.[56] In many ways, tourism occupied an ironic role in the transition. The post-war tourism boom had generated much of the prosperity and population growth in the 1950s that underlay black Bermudians' agitation for a more equitable political and economic system in the colony. The narrow, self-appointed nature of the Trade Development Board – the control room of Bermuda tourism since 1913 – epitomised for many the old way of setting policy in the colony. The TDB was, in democratic terms,

irresponsible; a 'yacht club democracy', some said. Stocked with delegates drawn from the ranks of the propertied elite, the board seemed a power in its own right, only loosely accountable to an Assembly which itself represented only the property-owning class of the colony. Confronted with demands that tourism be opened up to democratic control, the old guardians of the industry argued that too much agitation might kill Bermuda's golden goose. Bad press might scare away the tourists; pandering to democratic whims might undermine the hitherto tight, efficient, admittedly elitist control of the colony's leading industry. Tourism had become Bermuda's lodestar, its central consensual point of agreement, and through all the political turmoil of the 1960s it was perhaps this universal recognition that Bermuda *was* tourism that underlined the dangers of extremism and promoted political moderation.

The unexpected death of Dr E.F. Gordon in 1955 robbed Bermuda blacks of their most stalwart champion. Gordon's confrontational approach to post-war labour relations and politics had shaken the colony awake. A 1954 select committee report in the Assembly had called for an end to segregation in the colony's civil service, hospitals and education system. Progress towards desegregation was predictably slow. In the white-dominated Assembly, a minority of black members began working together in a *de facto* bloc, backing, for instance, Richards' efforts to crack the colour bar in the hotels. Outside the colonial parliament, public agitation and boycotts focused on desegregating Bermuda's cinemas and sports facilities. Longshoremen and power company workers belonging to the Bermuda Industrial Union (BIU) kept up the pressure for collective bargaining and better wages. In all these endeavours, black Bermudians began to sense a solidarity and assertiveness, never quite as strident as the American Black Power movement of these same years, but nonetheless unprecedented in Bermuda history. Significant victories were won in 1959: the cinemas, restaurants and hotels of Bermuda opened their doors to all. The focus then shifted to prying open Bermuda's elitist politics.

In 1960, Bermuda's democracy, serving 43 000 citizens, rested on a narrow base of 5500 votes. Some citizens could vote more than once. Since property was still the principal determinant of the right to vote, large property owners had a 'plural' vote – a ballot in every parish in which they held property. Throughout the early 1960s, the Assembly inched towards universal suffrage. Bermuda's innate pragmatism permeated the campaign; Bermuda must change, but not too precipitately. A young Canadian historian visiting the colony in 1961 perceptively reported in *Saturday Night* that there was 'a strong conservative feeling among Negro Bermudians that to force the pace of change would, in the long range, bring no real advantage to themselves'. For its part, the 'white governing class' believed that 'just enough concessions should be granted to prevent serious

agitation'.[57] Too much agitation or too little flexibility meant too few tourists. In 1962, Bermuda accordingly took a step closer to universal suffrage: the franchise was extended to all Bermudians 25 years old and a simplified constituency map was drawn up. Large landowners were placated with a 'plus' vote, a second vote to reflect their place in a society deeply rooted in property.

The prospect of universal suffrage opened the way to party politics in Bermuda. Like so many of Britain's colonies before it, Bermuda was about to get 'responsible government'. Power would be delivered to the party offering policies that attracted the votes of the majority; 'Her Majesty's loyal opposition' would wait in the wings hoping to endear itself to the will of the majority. In a colony habituated to power being delegated by a privileged clique, political parties were a revolutionary prospect. In 1963, the first new coalition emerged: the Bermuda Progressive Labour Party. Shaped in the image of the British Labour Party, the PLP was closely aligned to the Bermuda Industrial Union and was implicitly designed to attract black Bermudian voters, voters who represented 60 per cent of the colony's population. Sensing the potential for division along racial and class lines, another coalition emerged in reaction to the PLP. Formed in 1964, the United Bermuda Party was a 'pepper and salt' party aimed at binding Bermudians across racial and class lines. The UBP was an act of quintessential Bermuda pragmatism, a recognition that small mid-Atlantic islands do not lend themselves to rigid racial and political demarcations. Whereas the PLP was predicated on the legitimate need to spread the benefits of Bermudian tourism more equitably through the colony, the UBP was explicitly dedicated to preserving tourism's stability. Its 'statement of intent' recognised 'the marginal and hazardous nature of our primary industry' and noted that it would be 'necessary to expand our tourist industry in order to provide for continued employment'.[58] Led by white banker Henry Tucker, the UBP succeeded in attracting bi-racial support, most notably from the champion of desegregation, Edward Richards. Constitutional talks, hosted by the British in London, followed. The resultant 1968 constitution made Bermuda a modern political society: responsible party government based on universal suffrage (now pegged at age 21 and without property privileges). Bermuda remained a colony of Britain, which continued to oversee matters pertaining to its defence and internal security. But in every other respect, the colony would govern its own destiny. The same year, 19 100 Bermudians cast their ballot and elected UBP candidates in 30 of the colony's 40 constituencies. Sir Henry Tucker, backed by a bi-racial cabinet, moved into the premier's office.

Bermuda's political modernisation would have profound implications for its tourism. Despite the seamless bi-racial nature of the UBP and its repeated victories at the polls in the 1970s, there was always a keen racial

edge to Bermudian public life. On occasion, these tensions slipped violently into the streets. Riots erupted briefly in 1968. In 1973, the unexpected assassination of Bermuda's Governor, Richard Sharples, by a crazed gunman, who later justified his deed as an act of anti-colonialism, shocked the tranquil island as never before. The 1977 trial and execution of Sharples' killer provoked another outburst of racially-charged rioting. Violence on the streets of Hamilton temporarily troubled Bermuda's image as a place of touristic law and order. But only temporarily, as deputy tourism director Colin Selley noted after Sharples' death: 'It's a sad reflection of the world we live in that most visitors are indifferent to violence'.[59] Cumulatively, however, Bermuda's social and political stability *was* imperative. And, as a royal commission on the 1977 riots pointed out, spreading the benefits of tourism broadly through Bermuda society was the surest guarantee of future stability.[60] As a persistent reminder that Bermudians did have other political options, the PLP championed the case for complete Bermudian independence from Britain, a shift that would have eroded the island's 'Britishness' in the eyes of tourists. The UBP thus offered itself as the party of the progressive renovation of the *status quo* as a base for continued prosperity.

Subtler but more far-reaching changes overtook Bermuda tourism in 1968. With responsible government, tourism became a public good, the object of public policy, accessibility and accountability. The industry would now have to be moulded to the will of the majority, transmitted through the office of an elected minister and put into practice by civil servants. The first casualty of this fundamental shift was the Trade Development Board with its cosy, self-perpetuating ethos of appointed authority and immunity from public scrutiny. Now a department of tourism would manage the industry with modern bureaucratic skills and a minister would answer to the voters for the outcomes of their decisions.

Even before the sea change of 1968, there had been signs that democracy was knocking on the door of Bermuda tourism. The TDB had always been confronted with the challenge of spreading the benefits of tourism out of the central parishes, away from Hamilton and the magnificent South Shore beaches. St. George's, with its old world quaintness and picturesque harbour, had persistently claimed that the east end of the colony had been slighted by the TDB. Its native son Stanley Spurling had been a thorn in the side of the board, constantly demanding more cruise ship visits and heritage development. By the 1960s, however, the town was in woeful condition, the St. George Hotel down at the heels and the cruise operators shunning its docks because the tourists complained that there was little to amuse them there. The TDB responded by making vague noises about rebuilding the St. George Hotel, *if* its owners, the Bermuda Development Company, could be convinced to risk the capital.

Architect's sketch of the proposed Holiday Inn, 1967 – a complete contrast to Bermuda's established aesthetic. (Bermuda Archives: records of Colonial Secretary: 4748)

The prospect of the colony's first fully-fledged general election added a political edge to the situation. Sensing that the voters of St. George might express their regional discontent by backing the PLP, backers of the fledgling UBP began pondering some damage control. They found their opportunity in a proposal brought to them by Dudley Spurling, Sir Stanley's lawyer son, and a local real estate developer, Geoffrey Kitson. In the spring of 1967, Spurling and Kitson announced that they had interested Kemmons Wilson, the founder-owner of Holiday Inns, in building a 500-bed shore-front hotel in St. George. Kitson boasted to Governor Martonmere that the Holiday Inn would bring half a million pounds into the colony every year and that 'more than half of this money would flow into St. George's itself, and turn it from a depressed area into a prosperous and thriving tourist centre'.[61] What Kitson and Spurling also implied was that a Holiday Inn would mean UBP votes in the colony's east end.

The TDB was shocked and appalled. The proposal clearly breached the colony's 'hotel phasing' guidelines which sought to cap hotel development. Other hoteliers, including the developer of the new Southampton Princess, Daniel Ludwig, cried foul. Holiday Inns were the kind of mass-market operator that Bermuda had always shunned. When an architect's sketch of the St. George Holiday Inn arrived from the chain's head office in Memphis, the fear was confirmed. The proposed complex looked like a suburban American motor inn, surrounded by asphalt and cars and totally out of sympathy with its Bermudian backdrop of emerald sea and pink coral. Kemmons Wilson compounded the impression of an alien insensitivity by repeatedly referring to the town as 'Georges' in his correspondence.[62] Harry Cox, scion of a prominent Front Street mercantile family, raised the loudest voice of complaint. 'What we know of Holiday Inns is it is not in the best interests of Bermuda,' he told the TDB, 'and has been spurred on by political and economic expediency.'[63] Sir Henry Vesey, head of the TDB, tried desperately to prevail on Bermuda Properties to save the situation by announcing a renovation of the colonial-style St. George Hotel. Juan Trippe, head of the company, demurred. Trippe's fascination with Bermuda was ebbing – he had just invested in a resort in Eleuthra – and he shared the traditional wisdom that St. George could not support a major hotel. When asked to approve the deal, the TDB vetoed the American proposal, arguing that Holiday Inns would cheapen and overcrowd the colony.

Then the political heat was applied. Sir Henry Tucker, UBP leader and long-time member of the board, reminded his colleagues of Bermuda's new political geography: 'the people of St. George's have a right to their share of the tourist business and this is the first piece of concrete business that has been offered in the last 20 years, and we cannot possibly do anything but support it'.[64] This message was reinforced by the news that

St. Georgians were eagerly adding their names to petitions supporting the Holiday Inn as an economic godsend. Sensing the shift in the wind, Henry Vesey reconvened the TDB in December, in what was to be its very last meeting, and told them that the board must 'stand behind the government'. For the first time in its half-century history, the board reversed a vote and the St. George hotel proposal went through. Many also sensed that for the first time *quantity* had won out over *quality*. A Development Act was hurriedly pushed through the Assembly leasing 70 acres of government land to Holiday Inns. In the subsequent 1968 election, all four St. George's seats went to the United Bermuda Party.

As construction began on the new Holiday Inn, demolition of the old policy infrastructure of Bermuda tourism was completed. The new Department of Tourism replaced the Trade Development Board, bringing a 55-year-old tradition of brilliant hands-on, entrepreneurial, if sometimes self-serving, tourism management to an end. Senior TDB staff, led by tourism director Jimmy Williams, became full-time civil servants. Sir Henry Vesey, having won a UBP seat in Smith's, briefly became the 'member' or minister for tourism, before stepping down because his hotel investments created a conflict of interest with his political duties. Looking back over his 24 years as head of the TDB, Vesey warned his countrymen of the danger of overdeveloping their tourism: the only way to protect the colony's high standard of living was to shun the mass market. Quality mattered above all else.[65] By the early 1970s, the old guard of Bermuda tourism seemed much depleted: death had taken Stanley Spurling in 1961, the TDB's founder Goodwin Gosling in 1968 and Howard Trott in 1971. Now new men – tourism ministers David Wilkinson, DeForest Trimingham and C.V. 'Jim' Woolridge – faced new challenges and opportunities, and did so under new constraints.

Statistically, Bermuda's tourism continued on its crescendo through the 1970s: 388 000 visitors in 1970 became 609 000 by 1980. The new Department of Tourism inherited and competently maintained its predecessor's cruise ship, hotel and airline policies. It encouraged other policies aimed at enhancing the colony's attractiveness to North American tourists; in 1970, for instance, Bermuda adopted a decimal currency system, expressed in dollars rather than pounds, and pegged it to the American dollar. But, like any mature product, the aesthetic was becoming harder to maintain. The glory years of Bermuda tourism were increasingly marked by a growing anxiety. Costs rose sharply. The inflationary adrenalin of America's Vietnam-driven economy quickly spilled over into Bermuda, so that all through the 1970s the colony battled with inflation that constantly eroded its competitiveness. In this environment, the Bermuda Industrial Union became more confrontational and the hotels were dogged by wildcat strikes and steep escalations in wage demands. As part of one

contract with the hotels the union negotiated the automatic inclusion of a 15 per cent gratuity in all hotel and restaurant bills. Government also took its bite; in 1973 a 2 per cent tax was added to all hotel bills. Future budgets increased the tax. Tourism was increasingly being cast in the role of the colony's principal bill payer, and the calculation of the tariff was now subject to a variety of political, racial and class pressures which were often removed from any sense of what the trade would bear. The tocsin occasionally sounded: labour strife and increasing costs, Tourism Minister DeForest Trimingham warned in 1974, could lead to Bermudians reverting to 'going barefoot and eating mussel pie and fennel stew'.[66]

Bermudians also had new career options. The wartime military bases built by the Americans had stayed open and become part of North America's Cold War shield. For Bermudians, they offered new forms of employment and exposure to the 'good life' lived by American servicemen. By 1965, for instance, the bases contributed $10.3 million annually to Bermuda's national income, compared with tourism's $38.5 million.[67] Since the 1950s, the colony had also shrewdly been trying to diversify its economic life away from what was virtually a monoculture economy in tourism. A freeport had first been opened in the old naval dockyard for the duty-free assembly of electronics and pharmaceuticals. Far more successful was the wooing of tax-exempt 'off-shore' businesses to the colony. Long-standing prohibitions on foreign ownership were waived as long as these 'captive' companies directed their business off-shore. In the 1970s, the reinsurance industry found a welcome locale in Bermuda for the tax-exempt reinsuring of the pooled risk undertaken by myriad North American and European insurance companies. Bermuda, in effect, insured the insurer. At the same time, Bermuda's two banks – the Bank of Bermuda and the Bank of Butterfield – grew globally, extending the colony's tax-free appeal as far afield as the South Pacific. This expansion and the influx of the exempt companies opened up glamorous new career avenues for young Bermudians. Once much sought-after jobs as waiters or front desk clerks started to pale in comparison with a business job in Hamilton as a risk analyst or computer trainee, jobs not subject to the seasonal fluctuations and shift-work of tourism. The venerable aesthetic around which Bermuda had built its tourism and disciplined its society was beginning to lose its potency. Other social goals and norms of organisation began to assert their claim to the 'isles of rest'. And they did not always embody Bermuda's traditional reputation for tranquillity and friendliness.

The old simplicity of elite-managed tourism was thus gone by the 1970s. In place of the old paternalism was a crosshatch of pressures, some internal and others external. Global tourism was increasingly volatile, as revolutions, energy crises and terrorism proved capable of sending shock waves through the tourist marketplace. Bermuda was generally well

The author's wife, Dr Sandy Campbell, on honeymoon in Bermuda, 1976. (Duncan McDowall)

insulated from this buffeting; only the riots of 1977 troubled its reputation. Bermuda had never been a place of electrifying change, but by the seventies there were hints that its redoubtable aesthetic was under persistent and contradictory strain. And, for the first time, there was dissension over just what it was that made Bermuda so favoured a tourist destination.

Department of Tourism surveys of departing tourists invariably revealed high recognition of Bermuda's 'natural beauty, friendliness and tranquillity' and the joys of 'loafing' along its lanes and beaches. Princess Louise, Mark Twain and Eugene O'Neill would have ticked the same boxes. But by the 1970s, there was rising alarm that the colony's tranquillity and unspoilt environment were being overwhelmed by 'modern' Bermuda. 'You are despoiling your lovely islands,' a couple from Maine complained to *The Royal Gazette* in 1973, 'with the rush of noisy and dangerously educated traffic to the point where people cannot enjoy the sights, be relaxed and go at their own pace.'[68] Visitor surveys also began reflecting concern over noise, traffic congestion and discourtesy. Tourism officials fretted that Bermuda's reality was drifting away from its vaunted image. 'We are like ladies-in-waiting,' W.J. Breisky of the Bermuda News Bureau candidly told his colleagues, 'dressing up this princess which is Bermuda with pretty

stories and photographs, but we must be aware of the princess's flaws.'[69] Even some of the colony's oldest allies began expressing doubts. In April 1979 *The New Yorker* published a long article on the colony, warts and all. Prompted by the 1977 riots, the article was full of commentary on the 'strain' felt by Bermudian blacks and the 'stupendous success of the Forty Thieves' along Front Street. It was, and probably remains, the most astute analysis of Bermudian society ever written, but it was not the jovial stuff of bygone *New Yorker* coverage of the colony.[70]

At the same time, the Bermuda aesthetic was feeling new impulses that urged it in new, unfamiliar directions. Departure surveys began indicating a desire for 'more entertainment' in the colony. There was growing criticism of Bermuda shopping; it was dull, expensive and narrow in range. Perhaps reflecting the ethos of the maturing baby boom, calls were made for more active outdoor diversions for visitors, like para-sailing and wreck diving. Loafing was not enough. A disco opened on Front Street. Nothing better symbolised this emerging vision of Bermuda than the demand that more cruise ships visit the colony; cruising represented the ultimate generic in late twentieth-century tourism. And, in effect, the new St. George Holiday Inn was a piece of cruise ship culture on dry land. The shadow of homogenised global tourism was beginning to fall across the 'isles of rest'.

Carol Burnett camping it up in the late 1960s. Just as Mark Twain and Eugene O'Neill had sought respite in Bermuda from the pressures of American literary life, so too would the stars of the television age. (Bermuda Archives: Bermuda News Bureau Collection)

The shadow was hardly menacing. For every naysayer, there were literally thousands of contented Bermuda holidayers. When a Canadian family wrote in 1964 to praise their stay in Bermuda and the 'invaluable' little handy map that had guided them around the colony, tourism director Jimmy Williams scrawled in the margin of their letter: 'Somebody appreciates us'.[71] The honeymooners still came and posed beneath the coral moon gates that symbolised good fortune. This was the essence of Bermuda tourism in its glory years. By the early 1980s, tourists were annually spending just over $300 million in Bermuda. For the vast majority of visitors, Bermuda was still another world. 'Bermuda has taken charge of us', Noel Coward confided to his diary in 1956 shortly after he had bought Spithead, Eugene O'Neill's one-time Bermuda home. 'It is a sweet island, much, much nicer to live on than I expected.'[72] Other pre-war celebrities returned: Charlie Chaplin, Terence Rattigan, Tennessee Williams and Shirley Temple. The film makers followed the writers. The film version of Sir James Barrie's tale of paradise island castaways, *The Admirable Crichton*, was shot on a Bermuda beach in 1956. And as television became America's dominant cultural vehicle in the 1960s, TV celebrities and popular entertainers discovered Bermuda as a respite from the pressures of public adulation and as an idyllic backdrop for enhancing their prestige. There was Frankie Avalon on a scooter, Carol Burnett fishing, Ed Sullivan at the Mid-Ocean Club, Hoagy Carmichael golfing, Lionel Hampton displaying a prize marlin, Mary Martin relaxing and John Wayne grinning. The Bermuda News Bureau found them at leisure, photographed them and transmitted their images back to the North American media. Politicians sensed the same reward of relaxation and kudos in Bermuda – John Foster Dulles, U Thant, John F. Kennedy, Robert Wagner, Clare Booth Luce, Marshall Tito, John Diefenbaker and Lyndon Johnson all sought out the 'isles of rest'. So did the super rich; Greek shipping moguls Stavros Niarchos and Aristotle Onassis were 'seen' in the colony. A new generation of writers-in-Bermuda-residence emerged. In the 1930s, American humorist Robert Benchley had come to the colony with his *New Yorker* coterie. In the 1970s, Benchley's son Peter came and reported to *The National Geographic* that the colony was still 'balmy, British, and beautiful'.[73] Benchley's Bermuda-inspired novel of deep-sea intrigue, *The Deep*, was made into a film in 1975. A year earlier, Charles Berlitz's *Bermuda Triangle* had impressed on millions of readers that Bermuda *was* definitely someplace different.

In June 1980, Bermuda received another visitor wearied by popular acclaim and in search of rest and diversion. Former Beatle John Lennon, suffering from writer's block, fled New York for two months in the colony with his son Sean. 'See you in paradise, boys', he told friends. In rented accommodation, first on Knapton Hill and then in posh Fairylands,

John Lennon on Front Street in July 1980. Like many before him, Lennon retreated to Bermuda to rediscover his muse. (From *The Last Days of John Lennon* by Frederic Seaman. Copyright © 1992 by Frederic Seaman. Published by Birch Lane Press of the Carol Publishing Group)

Lennon strummed his guitar and soaked up the atmosphere. He sailed, mingled with other tourists, danced at the disco and soon discovered that the muse had found him again. On a visit to the Botanical Gardens, he asked the name of a particularly striking flower. 'Double Fantasy', he was told. The name stuck, and reappeared on the album – his last – he released that autumn back in the United States. Late in July, Lennon departed. The night before he left he stood beneath the Bermuda moon and sighed to a friend: 'I guess it's time to say goodbye to paradise'.[74] Just as Lennon had powerfully caught the romantic fancy of the baby boom generation with his lyrics of peace – 'Imagine all the people, living life in peace' – so too had Bermuda given Lennon a brief glimpse of a mid-Atlantic Elysium.

REFERENCES

1. Report on a Survey Trip to Hawaii, San Francisco and Los Angeles, 17 Oct. 1955, CS file #3694/3.

2. World Tourism Organization, *Yearbook of Tourism Statistics*, Madrid, 1994, 2. The WTO statistics reflect only 'arrivals of tourists from abroad' and therefore do not capture the large number of domestic tourists who holiday within the borders of their own country.

3. Department of Tourism, *A Statistical Review of the Years 1980–89*, Hamilton, 1991.

4. T.H. Mowbray to Sir Alexander Hood, 18 Dec. 1963, file pilc/1, DOT Papers, BA.

5. *Bermuda Sun Weekly*, 10 April 1971.

6. See: A.J. Burkart & S. Medlik, *Tourism: Past, Present and Future*, London, 1974, Ch. 3.

7. Sir Ernest Murrant to Sir Alexander Hood, 20 Dec. 1949, CS file #3694, BA.

8. See: Passenger Ships Act file, 1964, DOT Papers, BA.

9. Furness Withy details in: TDBM, 21 May and 12 Dec. 1956, 27 Feb. 1958, 29 Jan. and 9 June 1959, 12 Jan. 1960, 1 August 1961, 28 Feb. and 21 Dec. 1966 and 10 Jan. 1967; NY *Herald Tribune*, 1 March 1966 and File CARR/2-/3, DOT Papers, BA.

10. TDBM, 27 Nov. 1962.

11. TDBM, 28 Dec. 1965.

12. Report of Survey re: Cruise Ships and Chartered Flights, Bermuda Chamber of Commerce, June 1965, Cruise Ship Policy file, DOT Papers, BA.

13. 1976 Bermuda Cruise Study, Foote Cone & Belding, DOT Papers, BA.

14. T. Mowbray to W.J. Williams, 31 May 1971, Cruise Policy file, DOT Papers, BA.

15. *The Bermudian*, November 1959. Military jets had been landing at Kindley since the early 1950s. For legal reasons, Pan Am always took delivery of its new aircraft outside American territory.

16. TDBM, 30 Jan. 1959. Trans-Canada Airlines, which had begun Bermuda services in 1948, changed its name in 1965 to Air Canada.

17. TDBM, 27 Sept. 1963.

18. TDBM, 30 Jan. 1959.

19. Continuing Survey of Tourists Departing by Air from Bermuda – 1965, D'Arcy Advertising, New York, 1966, DOT Papers, BA.

20. US Government Hearings, 1965–, Lobbying files, DOT Papers, BA. In 1966, tourism brought Bermuda $44.2 million, while the colony imported $31.7 million from the US. See: Airport/Ship Survey 1966–7 file in DOT Papers.

21. Al Perkins, 'Bermuda's Own Airline', *The Bermudian*, July 1958.

22. Eugene Merle, American Express, to TDB Chicago Office, 20 July 1965, Complaints file, DOT Papers, BA.

23. *The Royal Gazette*, 5 Sept. 1958.

24. Proposed New Hotel at Boat Bay, Southampton, file #1248, DOT Papers, BA

25. TDBM, 14 Jan. 1960 and 19 Dec. 1961.

26. Southampton Hotel Company, file #EC354, Colonial Secretary's Papers, BA.

27. See; TDBM, 19 Dec. 1961 and W.J. Williams, 'A Realistic Approach to Hotel Development in Bermuda', Feb. 1967.

28. TDBM, 19 Dec. 1961.

29. H. Thornley Dyer, 'The Next Twenty Years: Report on the Development Plan for Bermuda', May 1963.

30. Carrol Dooley, TDBM, 16 Dec. 1961.

31. TDBM, 30 Dec. 1963.

32. Hotel School Advisory Committee files, DOT Papers, BA.

33. 'Careers Booklet' file, DOT Papers, BA.

34. Space Service file, BER/HOT/5, DOT Papers, BA.

35. *The Bermuda Sun*, 3 June 1973.

36. *The Royal Gazette*, 31 Dec. 1969.

37. 'A Look at Needham, Harper & Steers, Inc.', March 1969, DOT Papers, BA. The firm was bidding for the colony's tourism contract.

38. 'General Clean-up of Bermuda' file, PRO/BER/10, DOT Papers, BA.

39. 'Tourism and Trade Development – Advertising Plan 1961–65' file, DOT Papers, BA.

40. Larry Burchall, *The Other Side (Looking Behind the Shield)*, Detroit, 1991, 39.

41. File PULC/BER/35, DOT Papers, BA.

42. File PULC/BER/12, DOT Papers, BA. The police soon refused to issue these cards.

43. File PULC/TDB/32, DOT Papers, BA.

44. 'Advertising and Promotion Plans for 1964' file, DOT Papers, BA.

45. TDBM, 22 April 1960.

46. Marketing Study – Needham Study – March 1969, DOT Papers, BA.

47. *The Bermuda Report 1972–79*.

48. Williams to Senior Assistant Secretary, 6 July 1963, file PRO/BER/2, DOT Papers, BA. See also: Colonial Secretary file #3694/E and TDBM, 3 Sept. 1963.

49. Depth interviews among travel agents, D'Arcy Agency, New York, 1966, file TDB/NY/2, DOT Papers, BA.

50. See, for instance: 'Bermuda Rendez-vous season, 1966–7' file, DOT Papers, BA.

51. Bermuda Department of Tourism, *A Statistical Review of the Years 1980–89*, Hamilton, 1991.

52. *The Royal Gazette*, 6 April 1957.

53. *Debates of the House of Assembly*, 9 April 1957. See: file #425: racial discrimination in hotels, 1930–67, Colonial Secretary's Papers, BA and Randolf Williams, *Peaceful Warrior – Sir Edward Trenton Richards*, Hamilton, 1988, 126–32.

54. TDBM, 24 March 1963.

55. David Simberloff to TDB office, NY, 12 Feb. 1965, Complaints file, DOT Papers, BA.

56. A solid account of these changes is found in Barbara Harries Hunter, *The People of Bermuda: Beyond the Crossroads*, Hamilton, 1993.

57. Ken McNaught, 'Bermuda: Crown Colony or US Protectorate?', *Saturday Night*, 30 Sept. 1961, 20–24. The Trade Development Board was furious with McNaught, whose article was 'full of half-truths, incorrect statements and was not a credit to Bermuda'. The Board of Education, which had brought McNaught to the colony, wrote a letter of complaint to the University of Toronto where McNaught worked. TDBM, 2 Oct. 1962.

58. Hunter, *op.cit.* at note 56, 137.

59. *The Bermuda Sun*, 11 Aug. 1973.

60. See: *Report of the Royal Commission into the 1977 Disturbances*, Hamilton, 1978.

61. Geoffrey Kitson to Lord Martonmere, 19 May 1967, file #4748, Colonial Secretary's Papers, BA.

62. Kemmons Wilson to Kitson, 11 May 1967, *ibid*.

63. TDBM, 6 Dec. 1967.

64. *Ibid*.

65. *The Royal Gazette*, 31 Dec. 1969.

66. *The Royal Gazette*, 20 July 1974.

67. Airport/Ship Survey file 1966–7, DOT Papers, BA. Bermuda's total national income in 1965 was $91.9 million.

68. *The Royal Gazette*, 20 November 1973.

69. TDB Sales Conference Report, Jan. 1969, DOT Papers, BA.

70. Suzannah Lessard, 'Profiles: A Close Encounter', *The New Yorker*, 16 April 1979.

71. File PULC/BER/21, DOT Papers, BA.

72. Graham Payn and Sheridan Morley, eds., *The Noel Coward Diaries*, London, 1982, 328. Coward later grew to dislike Bermuda's winter dampness and tight society and moved to Jamaica.

73. Peter Benchley, 'Bermuda: Balmy, British, and Beautiful', *The National Geographic*, July 1971.

74. Frederic Seaman, *The Last Days of John Lennon: A Personal Memoir*, New York, 1991, 189, and Roger Crombie, 'Lennon's Last Summer', *The Royal Gazette Magazine*, December 1995, 17.

EPILOGUE

'... the still-vex'd Bermoothes'

'Greedy kill piggy'
 Caribbean adage cited by former tourism minister about Bermuda

'... we began to lose the atmosphere of the Living Room'
 Larry Burchall, *The Other Side* (1991)

'Some people think you just turn on the tap and a tourist comes out.'
 Reggie Cooper, Bermuda Hotel Association president, 1986

'WHERE WILL IT ALL END?', Hudson Strode wondered in his sprightly 1932 travelogue, *The Story of Bermuda*. 'Can Bermuda maintain its essential distinction and integrity in the face of the tourist invasion? ... How long will they be able to stand up against the pressure of modern civilization? No one can say.'[1] The last fifteen years have provided a partial answer. Bermuda remains in the regal circle of island resorts, but it is now a crowded and anxiety-ridden group in which the colony lives a precarious existence. On the surface, much remains unchanged; Bermuda is still in many ways another world. The big, white cruise ships still slide through the Town Cut into St. George and squeeze through Two Rock Passage into Hamilton Harbour. The midday skies still buzz with the sound of arriving airliners. The oleanders still bloom and the gombeys still dance on holidays. The shoppers still stroll along Front Street and the sun-worshippers still amble along Elbow Beach.

Yet the glory years are clearly gone, a fact that newspaper editorials and politicians harp on almost daily. Bermudians no longer comfortably regard their tourism's future in terms of prosperous decades; talk now focuses on what the *next* year might or might not bring. In the middle of the nineteenth century, Bermudians fretted in a similar way over the decline of their seafaring economy. After the brief, lucrative respite of the American Civil War, the wood, wind and water economy deserted Bermuda, leaving the colony scrambling to replace its once-hardy economic mainstay with the raising of onions and potatoes for export to the snow-bound United

Cruise ship entering the Town Cut en route to St. George. In 1995, a total of 169 712 cruise ship visitors came to Bermuda. (Government Information Services, Bermuda)

States. Now, over a century later, Bermudians are facing a similarly jarring question: what to do if the tourists stop coming?

In a quantitative sense, Bermuda tourism probably peaked for the foreseeable future in 1987. The colony welcomed 631 314 visitors that year. When measured in terms of the longer-staying, bigger-spending 'regular' tourists who arrived by air and stayed in hotels, the peak had in fact come in 1980 with 491 035 air arrivals. By 1987, regular visitors totalled only 477 877, while the cruise ship visitors, with their lower economic impact, had increased to 153 437 from 117 916 in 1980. As has usually been the case in recent years, the 1987 surge was the result of allowing more cruise ships into the colony – a record 187 of them that year. The undeniable statistical trend of Bermuda tourism in the 1980s and early 1990s has been gracefully downward. The recession of 1992 brought a nadir of 506 237, while the average has ranged around 550 000. Only cruise ship arrivals have grown, to as high as 172 865 in 1994. Other vital signs of the industry have slowed. Hotel employment, hotel occupancy, visitor spending in inflation-corrected real terms and length of stay have all inched downward. By 1996, per capita spending by tourists had slipped to $240 – a reflection largely of the low-spending cruise ship visitors – meaning that Bermuda would need another 200 000 visitors a year to match tourism's economic impact in the peak years of the early eighties. Tourism's share of the gross domestic product slipped too. Government and international business have ceased being junior partners in the Bermudian economy and have begun challenging tourism's once paramount role as the leading sector. Government spending in 1987–8, for instance, represented only 18 per cent of Bermuda's gross domestic product; by 1996–7 it had jumped to 26 per cent.[2] In the same period, tourism's impact has declined. Schooled by decades of fluid growth, Bermudians now anxiously look for glimmers of revival in their tourism statistics, often at the expense of addressing the long-term, structural predicament of the industry that has served the colony so well for so long. Were Hudson Strode still alive, he would probably point out that in the past Bermuda made its own market in tourism, expanding in the face of the Depression, growing while others languished. Now Bermuda seems increasingly less able to shake the competition, beat the international economic odds and carve its own niche.

Understanding the current ills of Bermuda tourism requires an understanding of what was so right about the industry for so long. From its inception in the first decade of the century, Bermuda tourism thrived because it provided a perfect matching of visitors' needs and local product. In the late nineteenth century, intrepid early tourists, who were in fact more like adventurers probing an island long notorious for disease, humidity and tempests, identified a new, more benevolent aesthetic in Bermuda. Through their writing, painting and personal enthusiasm, the Mark

Twains, Charles Dudley Warners, Winslow Homers and Frances Hodgson Burnetts demonstrated to the local commercial elite that their colony could do better than grow potatoes and onions: their island was in fact a paradise with natural and social attributes that North Americans craved. These attributes – a 'friendly' people, a 'British' way of doing things and a salubrious climate – were innate, the kernel of a successful tourism industry. Given the postage-stamp size of Bermuda, there was never any hope that those things which intrinsically appealed to would-be North American tourists could be hived off in some protected corner of the colony, groomed and put at the privileged disposal of tourists. Instead, the aesthetic of Bermuda tourism would have to permeate the *whole* of the island and its society. Every hibiscus, every cheery 'good morning', every tranquil lane or beach and every moonlit dinner dance had to exude the sense that these were the 'isles of rest'.

Theorists of modern tourism have often remarked that most societies relying on tourism for their livelihood have learned to erect façades around the real nature of their societies. These façades demarcate the tourist's experience from the actual nature of the society. Such recreational aesthetics are only tenuously connected to the pulse of real life in the host society. Niagara Falls is thus a bubble of tourist excitement that bears practically no relationship to the worlds of New York State and Ontario suburban society which surround it. The American intellectual historian Daniel Boorstin once suggested that the modern tourist 'has demanded that the whole world be made a stage for pseudo-events', events that take place inside an 'environmental bubble'. Tourism is therefore nothing more than a series of 'cultural mirages'.[3] Sociologist Dean MacCannell has similarly suggested that tourism is an exercise in 'staged authenticity', by which 'signs' – myths, icons and social customs – are erected or enacted to attract tourists' attention and to precondition their reaction to the place.[4] Recent post-modern criticism has arrived at much the same conclusion. Tourists, the post-modernists argue, never see or experience the real society they visit; instead, they simply 'gaze' on a façade or a collection of 'signs' that seem to project the essence of that society. Canada, for instance, is 'the true north, strong and free' whereas Paris is the 'timeless romantic' city of lovers. The more cleverly a society arranges and projects its 'signs', the more successful its tourism will be. Tourism thus exists not only to distance tourists as far as possible from their own 'normal' society, but also to place visitors in an artificial aesthetic environment within the host society.[5]

In Bermuda, it has always been different. Tourists in Bermuda are 'visitors'. They spilled down the Furness-Withy gangways or into the jaunty pastel-coloured taxis at the airport and then melted into Bermuda society. It has always been as if – in Bermudian writer Larry Burchall's brilliant

Front Street, Hamilton, whose merchant class masterminded the emergence of Bermuda tourism. The arrival of two cruise ships can now turn this colonial street, peaceful even in the 1990s, into a crowded shopping strip. (Government Information Services, Bermuda)

metaphor – visitors were invited into a huge Bermuda living room and left to their own devices. All that was asked was that they abide by the decorum of the place and leave it as clean and peaceable as they had found it. When the vogue for statistically measuring visitors' perceptions overtook Bermuda in the late 1940s, the surveys invariably reached the same conclusions. When asked what they liked about the colony, the tourists replied 'loafing'. They strolled on beaches, shopped, and never got much more active than a round of golf or a stint in an angler's chair. Few tourist destinations have ever offered their visitors so few 'sights', so few planned activities, so few contrived diversions. In fact, Bermuda itself was the diversion. The ambience of 'naturalness', 'friendliness' and unhurried courtesy were a holiday in themselves. All the abrasiveness of modern urban, industrial life vanished; the Bermudians seemed to be born civil and genteel and the tourists miraculously conformed to their demeanour. This relaxed civility seemed to be the insuperable advantage of Bermuda tourism that no other destination could ever challenge: a genuine blending of the susceptibilities of host and guest. The feeling was like that one had after a successful dinner party – amiable hosts, superb food and entertainment and the comfort of being with fellow guests cut from the same social cloth.

In 1952, when Trade Development Board secretary Joe Outerbridge boasted to the Canadian Tourist Association that the 'Bermudas are the world's most famous "Island Resort" bar none and that is not a "commercial" but simply a statement of fact', he knew that the essence of this success lay in the communion between Bermuda host and visitor. Bermuda's tourists, he concluded, were not 'cookies' – mass consumers of prearranged events. They were instead visitors who had found a place which induced a tranquillity, a serenity, a renewal that Miami Beach, Niagara Falls or even bustling Paris could never replicate.[6] In 1939, the up-market magazine *House and Garden* put its finger on why Americans returned to Bermuda again and again. 'Every nation,' it concluded, 'needs an antidote to itself.' Bermuda was 'old-fashioned ... It has both manners and a manner ... This quaint lack of interest in "progress" as such seems at first strange, then comforting and finally completely charming. In this last stage the antidote has begun to work'.[7]

Musicians talk of the fugue as that most wonderful contrapuntal intertwining of two dissimilar tunes into one sustaining melody. For over a century, Bermuda and large, affluent and loyal segments of North American society produced a fugue. Bermuda the holiday destination existed because it offered what America lacked: it supplied the lyrical, soothing part of the melody that life in America could no longer sustain. 'It still warbles on,' noted the English poet Christopher Isherwood, arriving from New York in 1952, 'this daydream experience, like the very best

of Mozart. La-de-da-da-da, la-de-da. After all, it is possible, under optimum conditions, and within a time limit, for human beings to behave like angels.'[8] Psychiatrists have supplied another meaning for the term: a fugue denotes a temporary flight from reality, a loss of memory coupled with a disappearance from one's usual haunts. Bermuda was the garden in which Americans fell into a forgetful reverie that temporarily lifted the anxieties of modern life. In whatever guise, the colony seemed destined to be America's fugue – 'another world'.

Bermuda's ability to sustain itself as America's antidote was above all else rooted in the persistence in the colony of a set of social and political values that were as unique as its natural endowment. For almost a century, until the Constitution of 1968 finally introduced universal suffrage, Bermuda tourism rested on an inchoate democracy that allowed the colony's commercial elite to mould the local society and its economy to the dictates of tourism. This they did brilliantly. Other British colonies built broad, inclusive democracies out of the right of responsible government – the notion that political power must reflect the wishes of the governed. But in Bermuda, responsible government – first acknowledged in 1620 when the colony's eight 'tribes' or parishes elected members by voice vote to sit in an Assembly – evolved only glacially into inclusive democracy. The rights of property in Bermuda remained paramount for over three centuries. To this day, many Bermudians half pungently and half affectionately refer to the narrow commercial elite that long ruled the colony's affairs as the 'forty thieves'. Their power reached from Front Street, through the Assembly, to the councils of the Governor and beyond to the Church and into almost every nook and cranny of Bermuda society. The elite deftly redirected Bermuda's commercial ambitions from privateering and seafaring in the early nineteenth century, to mid-century agriculture and finally, as the onion patch began losing its grip on the east coast American market in the late century, to the hedonism of affluent twentieth-century Americans.

The Goodwin Goslings, Howard Trotts, Stanley Spurlings and Henry Veseys who built Bermuda into the 'isles of rest' were able to do so not only because of their unchallenged political power but also because of their sense of *noblesse oblige*. Gathered around the boardroom table of the Trade Development Board, they could always see beyond their hotel profits, their retail sales and their steamer agencies. They realised that Bermuda tourism would only work if all Bermudians somehow shared in engineering its success. With meticulous social engineering, the men of the Trade Development Board groomed not only the physical beauty of the colony. They also groomed the colonists themselves to live up to the expectations of the island's visitors. Every 'good morning', every errant bit of litter, every friendly taxi ride mattered. Implicit in the board's exhortations was the

notion that if the fabric of friendliness ever began to fray, the whole enterprise would come undone and the visitors would go elsewhere. This exercise in paternalistic control was always offset by tangible returns. The elite, of course, took their generous rewards first – hotel receipts, reappointment to the Trade Development Board, knighthoods and the ego gratification of controlling an entire society. But the elite was never oblivious to the need for trickle-down benefits through the whole of Bermuda society.

The benefits admittedly trickled down into a segregated society, but there was remarkable cross-racial accord in Bermudian society over the absolute centrality of tourism's friendly and efficient prosecution. As one influential black Bermudian once told this author, Bermuda's only natural resource was sunshine: without the tourist it was worth nothing. Consequently, Bermudian blacks came to enjoy one of the highest standards of living in the black world, although the political quality of their life before the 1960s failed to reflect their material well-being. As this author was told by a Bermudian who began 33 years in tourism behind a bar at the Sonesta Beach Hotel in the 1960s, every black in the industry believed that he or she had a 'stake' in the industry and worked accordingly. In recent years, Bermuda's premier, Dr David Saul, tried to reinvoke this crucial communal aspect of the colony's early success in tourism by talking of the need once again to think of the colony in terms of 'Bermuda Inc.'.

The last two decades have seen little of the early corporatism of Bermuda tourism. The demise of the Trade Development Board in 1968 and the advent of party politics diminished the commercial elite's monopoly over the direction of the industry. Tourism became a department of government, its officials appointed on the merit principle and its elected minister subject to the conflicting currents of an educated and affluent democratic society. The benevolent paternalism that had guided Bermuda tourism for so long became inoperable; tourism now became an overt blend of racial, social, economic and nationalistic criteria, pushing it in different, often contradictory directions from one year to the next. Some stability was induced by the uninterrupted success of the United Bermuda Party in power. By offering itself as a bi-racial coalition dedicated to balancing Bermuda's *status quo* – shunning independence from Britain and supporting tourism and tax-exempt business – and social development, the UBP has held office without interruption since 1968. Tourism has been a pivotal portfolio in UBP cabinets. Some of its incumbents have been drawn from the ranks of the old elite – for example, retailers like De Forest 'Shorty' Trimingham and lawyer David Wilkinson. They possessed all the sociability and Bermudianness of their Trade Development Board predecessors; Trimingham was, for instance, a champion sailor. But the UBP also gave the colony its first black minister of tourism: C.V. 'Jim' Woolridge. Woolridge's easy-going charm reflected a life in tourism, a life

that had seen him drive a taxi, tend bar and wait on tables throughout the 1950s. His own life seemed a testament to the power of tourism to generate prosperity in Bermuda across class and racial lines. By 1968, Woolridge was a natural recruit in the eyes of UBP leader Sir Henry Tucker. From the Assembly, Woolridge graduated to the tourism post in 1977 and quickly acquired a reputation as Bermuda's ambassador, moving up and down the American eastern seaboard carrying the news about Bermuda to travel agents and journalists. When asked about the roots of his personal success, Woolridge was quick to acknowledge that he had had 'good teachers' in the likes of Henry Vesey.

If the friendly style was still familiar, the spirit of Bermuda tourism was slowly changing, however. Modern, pluralistic democratic Bermuda appeared unable to create a replacement for the Trade Development Board's hands-on management of the industry. There was no explicit or concerted national tourism strategy. An advisory Tourism Board of political appointees proffered advice to the minister, but tourism's direction increasingly became the product of short-term political expediency. The key elements of tourism – cruise ship, hotel, airline and employment policy decisions – tended to be political footballs. Much rhetoric was heard about the importance of tourism, but little actual articulation of the industry's goals or of coherent policies to achieve them. In a democracy, this lack of coherence was a predictable and probably unavoidable outcome. But in the absence of an overarching strategy, the colony's social dedication to tourism began to slacken. Tourism ceased to be seen as a broadly-felt national opportunity and began to be seen as an automatic national entitlement. 'Some people think that you just turn on the tap and a tourist comes out', complained Hotel Association president Reggie Cooper in 1986.[9] The notion that tourism was greater than the sum of its parts began to drift out of the national consciousness. The principal partners in the industry – management and labour – became as prone to disagreeing as to cooperating. Each claimed to be operating in the colony's best interests; each declared that it was simply trying to level the playing field.

The first dramatic indication of disharmony in the industry came in the spring of 1981, when for the first time in its history Bermuda tourism was shut down by a general strike. The conflict began in the public sector, but quickly spread to the hotel and taxi industry. For almost a month, tourism was frozen. The strike came on the heels of the record-breaking 1980 tourism year and hit at the peak Easter season. By the time a settlement was reached in May, the damage had been done. Arrivals in 1981 dropped to 535 246 visitors from the height of 609 556 the year before. Many would argue that the two-year 35 per cent wage increase achieved by some government workers out of the strike was worse news, another inflationary pressure on Bermuda's already high-cost economy. The exponential tourist

growth of the 'glory years' of the 1960s and 1970s had quietly bred the colony-wide belief that tourism was an assured thing, a bountiful guarantee of unending national prosperity. 'Greedy kill piggy', a tourism minister of the time would later reflect with regard to a breakdown of the national tourism consensus. Every wage increase demand was wrapped in the allegation that hotel and retail profits were more than adequate and protected by a cocoon of monopolistic rights. The hoteliers and retailers countered that profits were weak and costs high.

Tourism's descent into a game of political football continued all through the 1980s. Cruise ship policy was perhaps kicked about the most. Lifting the restrictions on cruise ship arrivals was seen as the quickest fix for the industry; the more ships allowed to dock, the more shoppers, the more taxi rides, and so on. Echoing the debate over 'trippers' in the 1930s, opponents of more cruise ships argued that the ships often brought the wrong kind of tourist – vulgar and penurious – and thereby diluted the precious ambience of Bermuda tourism. Most agreed that Bermuda should always accommodate high-end cruise ships; the debate heated up when low-cost, package cruise ships sought to land large numbers of low-spending trippers. The controversy provoked cabinet resignations, petitions and angry letters to the newspapers. Similar, perhaps less hotly disputed, controversies raged around airline and hotel policy. Amid these frictions, some grew nostalgic for the glory days of the Trade Development Board, when policy was decided and pursued with little patience for protracted debate. The last of the TDB-era tourism directors, Jimmy Williams and Colin Selley, had left the Department by 1984; efforts to find a competent successor proved difficult. An American hired as tourism director in 1984 lasted only a year, hurriedly leaving the colony after a fire bomb was thrown at his home. Two years later, a Bermudian, Gary Phillips, a school teacher by training and the former head of the post office, assumed the post. In 1992, retailer Eldon Trimingham publicly suggested that the management of tourism be returned to a panel of top businessmen who would set about revamping the industry. While the Chamber of Commerce backed the idea, others decried the proposal, saying that it undermined the Constitution. Union leader Ottiwell Simmons threatened to organise a boycott of the Trimingham department stores. Tourism minister Jim Woolridge attacked Trimingham's 'bright boys' proposal and defended the Department of Tourism. 'The Department of Tourism aims to benefit all,' he said, 'not just a select few.'[10] There was clearly no going back.

Thus full-fledged democracy, while it enlivened Bermuda society as a whole, tended to whittle away the colony's ability to fine-tune its tourism and correct its strategic direction. This was nowhere more evident than in the colony's seeming inability to modernise its hotels. Since the completion of the Southampton Princess and the Holiday Inn early in the 1970s,

the colony had capped hotel expansion and prohibited the building of any new hotels. The Holiday Inn in St. George, as the Trade Development Board had suspected, failed to establish a Bermuda clientele, closed and was sold to Loew's. In 1980, the Stonington Beach Hotel, a small and charming beach-side resort in Paget, was built by the Bermuda College with government money to provide a venue for its hotel students to train in. In 1981, an act was passed to permit a limited number of 'timeshare' beds in the colony; when the resulting St. George Club opened late in the decade, the town of St. George could finally offer accommodation to Bermuda visitors. Other than these small initiatives, Bermuda has built no new hotels in the last twenty-five years, thus denying itself the chance to enliven its image. Hoteliers remark that one new hotel, well-positioned in the market, will oblige the rest of the local industry to spruce up their facilities. But when the Ritz Carlton chain announced plans in the late 1980s to build a new luxury hotel on the South Shore, the proposal was immediately confronted with stiff opposition. In a kind of Bermuda version of the 'not-on-my-pink-beach' syndrome, environmentalists and adjacent property owners stymied the idea. Not surprisingly, Bermuda's unrefurbished hotels have enjoyed an occupancy rate in the early 1990s that has hovered around an unprofitable 60 per cent.

Other rigidities have eroded the ability of Bermuda hotels to compete and have pushed up costs. Hoteliers complain that mandatory tipping – 15 per cent on all bills – and contractual job demarcations deny them the ability to trim their costs and improve service. The Bermuda Industrial Union counters that the best jobs in the hotels go to outsiders and that guaranteed tips are a necessary protection for workers serving allegedly stingy tourists in an era of economic retrenchment. These frictions have slowly ground down the colony's reputation for friendly service, at least to some degree. For decades the Trade Development Board had used its commanding presence to drive the message into every nook and cranny of Bermuda society that friendliness and good service were at the heart of Bermuda's tourism success. Few tourist destinations have ever succeeded so thoroughly in inculcating a service mentality. Almost imperceptibly, all through the 1980s, the attitude crept through Bermuda society that service was tantamount to servitude. Many young Bermudians complained that the tourists were not behaving as they had in their parents' generation; politeness had been supplanted by the brusqueness of cruise ships' day visitors. Enrolment, for instance, in Bermuda College's hospitality training programmes fell. One young drop-out from the college told this author that he had grown tired of the tourists 'working his nerves'. For their part, tourists began writing to the local papers complaining about deteriorating service and friendliness. 'We have been repeat visitors for many years,' a Massachusetts couple typically wrote to *The Royal Gazette* late in 1996,

'and have watched Bermuda decline in friendliness, service and, most importantly, prices for hotels, stores, restaurants, etc ... As a result, last year was the first year we did not return to Bermuda for our annual visit.'[11] Many other letters still testified to the resilience of Bermudians' charming ways, but for the first time there were hairline cracks in the colony's foundation of friendliness. Perhaps most tellingly, both critic and friend alike now tended to compare the colony with other holiday destinations, the implication being that other places were mastering the art of friendliness.

The problems of Bermuda's hospitality industry were another reflection of the anxieties and aspirations unleashed by the rapid modernisation of its society since the 1960s. If young Bermudians came to regard careers in tourism as demeaning, it was perhaps because other career paths beckoned. While fathers and mothers had found a life's work and rising prosperity in tourism – driving a taxi, tending a bar or making beds – the younger generation came to reject such lives 'in service'. The glamour of working in a posh resort hotel in the 1960s was displaced by the new-found glamour of sitting in front of a computer screen in an exempt-company office, crunching numbers or tracking the twists and turns of foreign financial markets. Here were business skills and salaries in tune with the 1990s. Furthermore, exempt-company employment was not subject to the seasonal vagaries of tourism. By 1993, the so-called exempt companies – largely engaged in reinsurance and offshore financial transactions – pumped $391 million into the Bermuda economy and employed 5000 Bermudians. Not only did international business compete with tourism for the minds and labour of Bermuda's best and brightest, but its vitality imparted powerful inflationary pressures to the Bermuda economy. Expatriate business managers, for instance, pushed up rents and in turn house prices, obliging a young Bermuda family dependent on a breadwinner in the hotel or taxi industry to pass the increase along in new wage or fare demands. And, unlike the American military presence in the colony, which was relatively cloistered in nature, international business introduced a noticeable dose of affluent North American life into the midst of the local society. Unlike their vacationing compatriots, these more permanent 'visitors' did not necessarily blend inconspicuously into Bermuda society.

If employment in the exempt companies paid better, it also demanded a higher initial skills level – in accountancy, computer programming and risk management. Tourism, on the other hand, had always had the potential to create more employment on a broader, less skills-intensive level. Here, however, islanders were reluctant not only because the industry had acquired the stigma of 'service', but also because there was a perception that 'glass ceilings' prevented Bermudians from rising to the top in an

industry in which foreign hotel chains and airlines favoured their own senior managers. Only in 1996 was a black Bermudian first appointed as manager of a major Bermuda hotel, the Stonington Beach.

The colony's venerable aesthetic came under other enervating pressures in the 'new' Bermuda. Television came to the colony in the late 1940s and, together with the large American military presence at Kindley Field, was serving by the 1970s to pump American mass culture into Bermuda. Ironically, for instance, while Carol Burnett got away from it all by relaxing on a Bermuda beach, the Carol Burnett Show was aired in many a Bermuda living room. The trend was undeniable and its influence slowly began to dilute the 'Britishness' of the colony. A McDonald's restaurant opened on the base and, one day a week, Bermudians were allowed to sample American fast food. The growing inundation of cruise ship tourists gave Bermudians another weekly glimpse of mass North American culture, a culture predicated on common denominators and homogeneity. 'A T-shirt culture', lamented one of the colony's former tourism ministers, built around the 'hot dog and hamburger trade', began to invade the 'isles of rest'. Aware of the threat to the colony's distinctiveness, the Bermuda government introduced legislation in the 1980s barring foreign franchise operations from Bermuda, but not before Kentucky Fried Chicken slipped under the wire and opened in Hamilton. Bermuda thus faced the quintessential and painful dilemma of modern democratic society: balancing the legitimate consumerist demands of its people against the imperatives of preserving a unique national identity that served as the heart of an industry that monopolised the colonial economy.

Bermuda was changing in other ways. The very affluence that tourism had brought to the colony in the 1950s and 1960s – best exemplified in a booming birth rate in those decades – began to have consequences in the 1970s and 1980s. Since conquering its image as an isle of devils in the nineteenth century, nature had seemed to smile on Bermuda. But now nature became the 'environment' and there were signs that all was not well in 'Nature's Fairyland'. The colony had become one of the world's leading examples of a 'built environment', more densely populated than Hong Kong. In many ways, island life was a triumph of cooperation between man and nature: each household was, for instance, limited by law to one automobile. The speed limit was officially set at 20 mph. There was still no gaudy commercial neon signage. Despite this, Bermuda had undeniably become crowded. 60 000 Bermudians plus a floating population of tourists were crammed onto a 21 square mile piece of coral. Bermuda thus came to have one of the highest population densities in the world – 3160 people per square mile by 1991. In 1946, when cars were permitted onto the island, the elite had smugly assured itself that only the rich and responsible would have access to the costly new innovation. By 1994, there were

48 677 vehicles on 'the Rock', a land which Mark Twain and Woodrow Wilson had once campaigned to keep carless. Over 20 000 private cars vied for space on the roads with an equal number of scooters and mopeds. There was incongruous talk of a 'rush hour' in Hamilton as exempt company and service industry employees hurried to work every morning. Such haste, reminiscent of any North American suburb, begot speed and noise. Dozens of speeding mopeds, weaving in and out of the traffic with illegally modified exhausts, became the noisy telltale of Bermuda's new aesthetic. Bermudians themselves were not blind to the changes. 'Bermuda is truly a microcosm of the entire planet,' argued a 1981 National Trust report entitled *Bermuda's Delicate Balance*, 'finite in size, limited in resources, and containing a complex mixture of races, nationalities, and lifestyles.'[12] The 'isles of rest' were in danger of becoming the 'isles of stress', their ecology strained by man's increasing demands. But environmental legislation has been slow in coming in the colony, the delay the outcome of the argument that recycling and stricter controls would pile added costs onto an already high-cost and uncompetitive economy.

Bermuda's visitors have been quick to pick up on these shifts. They have reacted by becoming a little perplexed, at times annoyed and nostalgic, yet on the whole remarkably loyal. Perhaps the sharpest reaction has been to the soaring cost of a Bermuda vacation. The late-twentieth-century traveller has become a comparison shopper. Steadily falling airfares have placed a wide array of novel and affordable destinations at the disposal of the modern tourist. Islands as distant as the Seychelles, Mauritius and Bali beckon the North American in search of tropical respite. The Pacific Rim is ringed with luxury hotels. Palatial cruise ships, now topping 100 000 tons, offer amenities and destinations undreamed of twenty years ago. This profusion of travel options has, as one former Bermuda tourism official stated, 'raised the bar' on what is considered a quality resort experience and on what is considered good value. Bermuda has increasingly found itself offering a sixties product at nineties prices. In earlier decades, Bermuda had been the 'only game in town', so much so that the word 'Bermuda' was applied as a word synonymous with quality and exclusivity. Now efficient air travel has diminished the exclusivity and the quality comes at a price which even affluent North American professionals have begun to question. The situation worsened in the late eighties and early nineties as recession-educated America adjusted to an almost zero inflation world while high-cost, off-shore Bermuda allowed costs to continue to float upward. 'Many of the so-called "best" hotels are in terrible condition, have awful service and rest on their (former) reputations', one disgruntled New Yorker wrote to *The Royal Gazette*. 'They charge more than most resorts in the Western Hemisphere … One look at any hotel properties in Hawaii, Antigua, etc. shows how Bermuda is far behind.'[13]

Under these pressures, there has undeniably been a distinct deterioration in visitors' reaction to the colony. Bermuda aficionados – the repeat, 'regular' visitors who arrived by air and stayed at a hotel – detected the erosion of the old Bermuda aesthetic with dismay. Declining service, rising costs, noisy mopeds, the perceived intrusion of petty crime into the colony, the appearance of litter and a sense that Bermuda's renowned friendliness was acquiring a sour face undermined their love of the place. It was still a love affair, but one tinged with disillusionment. On the other hand, the colony's more transient visitors – cruise ship 'trippers', weekend get-away package tourists – tended to come away disappointed. Bermuda, they reported, was expensive and there was not much to do. Cruise ship visitors wanted excitement, not loafing; they wanted entertainment, not tranquillity. The shopping was old-fashioned, the bus service poky and the waiters all got 15 per cent regardless of the quality of their service. There was more fun in Florida and Jamaica at half the cost.

The most striking example of Bermuda's trouble in attracting and keeping a new clientele came when Club Med leased the old Holiday Inn in St. George. The Club Med formula – cloistering its guests in an all-expenses-met enclave of fun – was the antithesis of Bermuda's traditional strategy of welcoming its visitors into its midst. This, with high costs and a finicky winter climate, soon killed Club Med in Bermuda. Now the derelict hulk of the Holiday Inn provides a gloomy reminder that mass tourism formulas have never succeeded in Bermuda.

As the century slips away, Bermuda thus faces a fundamental dilemma: should it dedicate its tourism energies to shoring up and rehabilitating the old 'isles of rest' aesthetic or should it surrender to the imperatives of the new homogenised global tourism? Should it strive to remain a Juneland deliberately distanced from the hurly-burly of North America or should it become a kind of mid-Atlantic Busch Gardens? By the mid-1990s, the continued decline in tourist arrivals transformed the dilemma into a hard-edged political debate. Seldom would a day pass in which the local newspapers did not talk of a 'crisis'. Editorials spoke longingly of the 'glory days' when an endless stream of happy tourists seemed to pour through the airport and down the gangplanks. As had always been their penchant, Bermuda's visitors joined in the debate, pouring out their joys and frustrations in letters to the editor. The debate over the future of the island acquired added urgency when the United States, triumphant in the Cold War, announced that its Bermuda air base would close. By the end of 1995, the American and two smaller British and Canadian bases were gone, leaving a $50 million hole in Bermuda's GNP or about a seven per cent drop in national income. Could tourism take up the slack?

As with debate in any democratic society, Bermudians found it difficult to reach a resolute consensus. Political jealousies, vested interests and the

inclination to seize upon quick fixes all conspired to undermine any attempt at common action. There were, however, encouraging signs for those concerned with tourism above all. In 1995, a national referendum affirmed that 73 per cent of Bermudians wanted to remain a colony of Britain. The option of independence was decisively rejected. While Bermudians in fact enjoyed virtual *de facto* independence, their wish to maintain their status as British colonials would bolster the long-standing appeal of 'Britishness' in the colony. That same year, the United Bermuda Party appointed a new tourism minister who seemed to have the credentials to reestablish the once-powerful umbilical connection between tourism and its political masters. David Dodwell, owner of The Reefs, a successful cottage colony on the South Shore, took over the portfolio and began making encouraging noises. Dodwell told Bermudians that they had to rise to the challenge of the new global tourism yet preserve their traditional advantages. 'There are new destinations, new products and new forms of tourism – eco-tourism, cultural tourism, cruise ships, better air service to other parts of the world', he told *The Bermuda Sun*. 'The traveller of the nineties is looking for something new and exciting ... We have to do something better, more unique, more value-driven than they are doing.'[14] The crux of the matter would be defining what exactly 'more unique' would mean.

Bermudians responded in varying ways to the challenge. The renovation of the old right-of-way of the Bermuda Railway into the Railway Trail, a footpath winding through the entire colony, had introduced eco-tourism to the islands in the 1980s. Reef diving, nature preserves, special educational programmes at the Bermuda Biological Station and special eco-sites like Nonsuch Island all drew the visitor's attention to what the National Trust had suggested was Bermuda's role as 'a test-tube for the world'. Heritage tourism similarly emerged. Under the guidance of professional historians and archaeologists, the old British naval dockyard in the west end has been transformed into a showpiece that attracts over 50 000 visitors annually. A new institute of underwater exploration was built on the Hamilton waterfront and opened to the public. The Bermuda Festival flourished every January and February, attracting artists as renowned as Wynton Marsalis to Bermuda stages to delight tourists and Bermudians alike. There were new attractions; a dolphin show was introduced, using a natural setting on the South Shore. Hotels like the Elbow Beach announced major renovations. All of these niches were in fact extensions of the old Bermuda aesthetic, amplifying the colony's natural beauty, British heritage and tranquillity.

Other Bermudians proposed more abrupt change. The Tourism Department administered its own dose of shock treatment by dropping its staid 'Bermuda Shorts' advertising image – pastel, visual vignettes of

The Dockyard at Ireland Island. Closed as a naval base in 1951, it has been revitalised as a maritime museum, cruise ship reception centre and freeport, thus combining heritage and viable tourism. (Government Information Services, Bermuda)

school children, cricket players and hibiscus – and adopted a sexually-titillating slogan: 'Let Yourself Go!' in Bermuda. Bermuda was a 'sin island' where North Americans could rediscover their inner selves and frolic on golf courses and pink beaches with their significant other. Outrage followed. The campaign, some said, was a betrayal of everything Bermuda stood for – decorum, dignity and measured elegance. Former tourism minister 'Jim' Woolridge angrily charged that Bermuda was throwing away its treasured image – '... as a comfortable, sophisticated, clean place just like home' – in a desperate attempt to attract younger tourists who would inevitably be disappointed by the pace and amenities of the colony. Others argued that the advertisements were just the shock treatment that the colony needed. 'Bye Bye Boremuda,' *Bermuda* magazine editor Charles Barclay wrote cheekily, '... we are getting far too dull and self-satisfied, even for the most devoted of Bermudaphiles.'[15] To make the point, the colony's New York agency ran the advertisements on the immensely popular television yuppie comedy show 'Seinfeld'.

In the autumn of 1996, a group of local retailers launched a petition and campaign for the introduction of a casino into Bermuda. Traditional Bermuda tourism was in its death throes, they argued. 'Transition or Crisis? You decide', their full-page advertisements provocatively asked. Casinos could be the engine of rejuvenation. Again, controversy followed.

Casinos would bring the 'wrong' kind of tourists. They spawned crime. But, their champions countered, casinos created jobs; they were at the heart of the cruise ship culture of the nineties. Without them, the Coalition for Change argued, Bermuda was passing up the opportunity of huge amounts of government revenue and relegating its tourism to the level of Haiti's.

The casino debate paled in comparison to the other modernisation controversy of 1996. Would McDonald's golden arches rise in Bermuda? The departure of the American Air Force from Kindley Field had meant the closure of the base McDonald's. Despite the United Bermuda Party's long-declared injunction against foreign franchise operations in the colony, recently retired UBP premier Sir John Swan became a partner in a holding company designed to obtain and operate a McDonald's franchise in the colony. A political fire fight followed. The issue became a lightning rod for all sorts of political currents flowing through the colony. The governing UBP agonised and ultimately split over the issue. From a Bermuda perspective, there were good reasons for allowing the 'average' citizen to indulge his desire for an inexpensive hamburger. Some citizens agreed with this view, but questioned the propriety of delivering such a lucrative privilege into the hands of a former premier. Tourism was seldom far from the centre of the debate. The tourists wanted cheap food, some said, and McDonald's offered global cuisine. But many disagreed. A New Jersey tourist warned *The Royal Gazette* that 'when franchise litter has found its way from Ferry Reach Point Park [to] the Royal Naval Dockyard and the local fish chowder and fish sandwiches have been supplanted by the Big Mac and fries, then Bermuda will have lost an irretrievable piece of her uniqueness'.[16] The Trade Development Board would have resolved the issue with despatch, but in democratic Bermuda, given the lack of a strong consensus about the direction of Bermuda tourism, the outcome was by no means preordained. Finally, in December 1996, an *ad hoc* coalition of renegade UBP and opposition politicians prevailed and the Prohibited Restaurants Act – reminiscent of the colony's earlier injunctions against motor cars and neon signs – was passed. McDonald's was scotched. Yet there was still no consensus about exactly what Bermuda tourism was supposed to be offering its visitors. Tourism minister Dodwell, for instance, deplored the Act as 'regressive'.

As Bermudians agonise over the 'vex'd' future of their tourism and talk about casinos, hamburgers, cruise ships and T-shirts, it is easy to forget that the colony wrote the textbook on island resort tourism. Despite the current downturn, nearly 600 000 visitors annually come to Bermuda and the vast majority go away with the happiest of memories. Many return. Many return repeatedly. 'Our experience during eight trips over a period of 24 years has found an island of beauty and serenity matched only by the

Horseshoe Beach, perhaps the most famous of the beaches on the South Shore. (Government Information Services, Bermuda)

beauty and personality of the Bermudians them[selves]', a Rhode Island family told *The Royal Gazette*. 'It truly is Another World. To all our Bermuda friends, until we return next year, keep up the good work.'[17] Patterns established in the 1920s are still reassuringly evident in the colony. Out in Tucker's Town, plutocrats – like American billionaire H. Ross Perot and former Italian prime minister Silvio Berlusconi – still find a retreat from the madding crowd. The colony still serves as the 'isles of rest' for America's rich and famous. Whether Clint Eastwood golfs at the Mid-Ocean Club or Jimmy Carter fishes offshore with his son, Bermuda still seems quintessentially different from Florida or California. The colony still offers celebrities the kind of prestigious backdrop that soothes their souls: rocker David Bowie and supermodel Iman have been seen strolling along Front Street. And the phrase 'a Bermuda honeymoon will follow' still punctuates the marriage notices of every east coast American newspaper. As it did for Mark Twain a century ago, life under Bermuda's 'pink cloud of oleanders' continues to exert its appeal. Bermuda remains a land of aggressive friendliness; a visitor unequipped with a cheery 'good morning' will feel like a stranger in paradise.

Throughout the twentieth century, Bermudians have responded to the spiritual and social needs of North Americans with a canny pragmatism that has allowed them to thrive on another society's inner needs while building a society of remarkable stability, tranquillity and prosperity for themselves – a double fantasy for islander and visitor alike. Bermudian democracy perhaps long lagged behind the colony's material progress, but even without such political equality, Bermudians have constructed a society of durable harmony out of the aesthetic values of tourism. For tourist and Bermudian alike, Bermuda has proved 'another world'. Above all, the challenge for Bermudians today is to preserve the 'very unique' nature of their land, to ensure that the Gulf Stream separates them to some extent from the homogenising pressures of modern global, consumerist culture. If Bermudians surrender, or fail to find a formula for accommodating change that preserves their society's uniqueness, they will cease to occupy 'another world'. And the world will be a poorer place for it.

REFERENCES

1. Hudson Strode, *The Story of Bermuda*, New York, 1932, 152–4.

2. Figures drawn from Charles Vaughan-Johnson, CEO, Bank of Bermuda, letter to shareholders, 15 April 1996.

3. Daniel Boorstin, *The Image or What Happened to the American Dream*, London, 1961, 80, 99.

4. Dean MacCannell, *The Tourist: A New Theory of the Leisure Class*, New York, 1978.

5. John Urry, *The Tourist Gaze: Leisure and Travel in Contemporary Society*, London, 1990, Ch. 1.

6. J.J. Outerbridge speech notes, Niagara Falls, 1952, Outerbridge Papers, BA.

7. Edward C. Acheson, 'America's Admirable Antidote', *House and Garden*, April 1939.

8. Katherine Bucknell, ed., *Christopher Isherwood – Diaries, Volume One: 1939–1960*, London, 1996, 445.

9. *Mid-Ocean News*, 14 March 1986.

10. *The Royal Gazette*, 6 March 1992.

11. *The Royal Gazette*, 22 November 1996.

12. Stuart J. Hayward, Vicki Holt Gomez and Wolfgang Sterner, eds, *Bermuda's Delicate Balance: People and Environment*, Hamilton, 1981, 333.

13. *The Royal Gazette*, 1 September 1996.

14. *The Bermuda Sun*, 29 September 1995.

15. *Bermuda*, Summer 1996.

16. *The Royal Gazette*, 20 November 1996.

17. *The Royal Gazette*, 23 July 1996.

Index

Page numbers in *italics* refer to illustrations

accommodation 36, 162, 191–2; *see also* hotels
advertising: Bermuda Tourist Association 62; campaigns 199–200; celebrities 60; class 88; expenses 200; legislation 70; magazines 74, 91, 102, 157, 172, 200; J.M. Mathes Inc. 165, 197, 199; Quebec Steamship Company 47–8; Wales Advertising Agency 88–9
aesthetics of tourism 5–6, 66, 98, 99–100, 122, 144, 164–5, 167, 192
air travel 159, 160, 161, 183, 188–9, 234; *see also* aviation
alcohol 94–6
Allen, Charles Maxwell 16–17, 20–1, 24, 25, 27
Allen, Frederick Lewis 129–30, 150, 152
Allen, George 77, 79–80
America: Bermuda 26, 48, 99, 101, 150, 183, 200–1; black tourists 171–3; celebrities 58, 60, 81, 85; military 141–2; Prohibition 94–6; protectionism 53–4
American Civil War 22–5, 73
anti-Semitism 98, 126, 128–9, 171, 205, 206
aquarium 50, 96
Astor, Vincent 96, *111*, 136–7, 146
Auto-Bicycle Act 157
aviation 107, 112, 113–14, 153, 188–90; *see also* air travel

Bamberg, Harold 190
banking 213
beautification 175, 197
Benjamin, S.G.W. 31
Berlitz, Charles 17, 216
Bermuda v–vii, 10, 12, 233; appeal 1, 4–5, 100–1, 174–6; competition for tourists 39, 101, 113, 180–1, 200; as corporation 228; exports of vegetables 25–6, 35, 53–4, 145; as isles of rest 8, 10, 21; sports 80–3, 85, 91–2, 97, 201, 205; unhurried ways 38;

war 150, 151–2; as way station 116, 143–4
Bermuda Almanack 48, 50
Bermuda-American Steamship 75
Bermuda Dockyard 143, *237*
Bermuda Festival 236
Bermuda Historical Monuments Trust 122
Bermuda Hotel and Catering College 195, 231
Bermuda Industrial Union 207, 212
Bermuda National Trust 202
Bermuda News Bureau 214–5
Bermuda Progressive Labour Party 208
Bermuda Report 99
Bermuda Resort Association 205
Bermuda Tourist Association 62, 172
Bermuda Triangle (Berlitz) 17, 216
Bermuda Volunteer Rifle Corps 145
Bermuda Workers' Association 156, 173
Bermudian 46, 75–6, 79, 80
The Bermudian magazine 132, 141, 155
Bermudiana Hotel 86, 191
bicycles 48–9, 105, *121*, 125
billboards banned 68, 70
biological research station 96
bird watching 22
black Bermudians 129–31, 144, 156, 169, 173–4, 205–7
black tourists 171–3, 205
Blackiston, Harry 79, 80–1
blockade running 23, 24–5
Bluck, Arthur 77, 79–80
Boorstin, Daniel 224
botanists 18, 20
Britain 13, 164, 236; *see also* Imperial Airways
British Airways (BOAC) 189, 190
Burchall, Larry 221, 224, 226
Burnett, Frances Hodgson 56, 60
buses 68, 125, 157, 202
Bushell, John J. 51
Butlin, Billy 162
Butterfield, H.D. 141

Canada 99, 200
Canada Steamship Lines 74, 75
Canadian National Steamship 160
Carlton Beach Hotel 191
cars 68, 122–3, 125, 155, 233–4
casino 238
Castle Harbour Hotel *127*, 162
Cavalier 118
cedars 51, 174
celebrities *161*, 239; black 205; golf 85; Jewish 126; literary 60, 134, 216; television 216

241

censorettes 148, *149*
Charybdis 76–7, 79
class: advertising 88; cruise ships 109, 110, 184, 187; quality/quantity 4–5, 31, 175–6, 182, 196; steamship packages 64
Clay, Cassius 205, *206*
clientele restrictions 105, 171
climatotherapy 20, 21
Clipper flights 107–8, 159
Club Med 235
College Week 166–7, 180, 204
competition, tourism 39, 101, 113, 180–1, 200
convicts 7, *14*
Cook, Thomas & Son 48
Cooper, Reggie 195, 221, 229
coral reefs 10, 11
cottage colonies 162–3, 174, 236
Coward, Noel 216
Cox, John 145
credit cards/vouchers 196
cruise ships 107, 108–10, 184, 185–8, *222*, 233
crystal caves 50
Cuba 113, 180, 182
currency 212

Darwin, Charles 21
Dashwood, Richard Lewes 13
Davis, Floyd 143
democracy 229, 230
Depression 106, 107, 108
Dill, Tom 68, 70
dioramas 165, 169
disease 13, 16, 22, 25
Dorr, Julia 36, 38
Doubleday, Frank N. 60–2, 70
Downing, Edmund 201–2
dress code 164, 198, *199*
Dutton, Eric 105, 136

Eagle Airways 190
Easter floral parade 165
Ebony 172
Economic Advisory Committee 152–3
ecotourism 236
elites 227, 230
Elizabeth, Queen 164
employment, war 144
entertainment 96, 204, 217–8
exclusivity 151, 234
exempt-companies 232
expense 174, 234
expropriation 82–5, 169

ferries 157, 202
flying boats 107, 117, 120, *135*, 158, 159
Fort Amherst 158

Fort Hamilton 80
Fort St Catherine 165, 170
Fort Townsend 158, 159
Fort Victoria 80
friendliness 201, 232, 235, 241
Furness Bermuda Line 83, 108, 109, 110
Furness Withy 77–80, 86, 155, 158, 160, 161, 183–5
Fussell, Paul 101

geologists 18, 20, 21–2
golf 80–3, 85, 201, 205
gombey dances 8, 221
Gordon, Dr E.F. 131, 144, 156, 207
Gosling, Ambrose 117
Gosling, Goodwin 60–2, 64, 66, 75, 84
Gray, Bessie 1
guest houses 126, 128
guidebooks 20, 22, 50–1, 57, 89, 167–9
Gulf Stream vi, 20, 21, 35–6

Haley Corporation 195–6
Haliburton, T.C. 22
Hamilton vii, 41–2, 47, 209, *225*
Hamilton Hotel 41–2, 44
Hand, J.P. 77, 79–80, 109–10, 114, 116, 117
handy map 202
Harper's 150, 152
Hayward, Walter 169
Heilprin, Angelo 21–2, 38
heritage tourism 96–7, 164–5, 169, 201–2, 236
Holiday Inn *210*, 211–12, 215, 235
holiday concept 105–7
Holland-America line 137
Homer, Winslow 55, 56, 88–9
honeymoon tourism 92–4, 159, 167, 216
Hotel Keepers' Protection Act (1930) 128, 205
hotel phasing 192, 193, 211
hotels 41, 42; capacity 64; closing 231; Furness Withy 86, 161; inadequacies 26, 36, 38, 191, 234–5; management 195, 233; ownership control 162; racial discrimination 205; redevelopment 157, 192–3; small 126, 162–3
house building 174
House and Garden 141, 162, 180
Howells, William Dean 27, 28, 92

Illuminated Signs Restriction Act (1958) 164
Immigration Board 141–2
Imperial Airways 114, 117, 118
independence, rejected 236
industrial unrest 212–3, 229–30
inflation 156, 212, 229–30, 232
insurance industry 213
invalids 20–1, 26

Isherwood, Christopher 226–7

Jews 126; *see also* anti-semitism
Jones, Matthew 38, 50
Jourdain, Silvester 12

Kentucky Fried Chicken 233
Kindley Field *147*, 148, 153, 158, 159
King, W.L. Mackenzie 99

Laffan, Sir Robert 38
Lefroy, Sir John H. 18, 21, 35, 38–9
Lennon, John 180, 216–18, *217*
Lewis, Frederick 79, 80–1, 82, 110
life-cycle tourism 165–6
Life magazine 143, 150, 151
lighthouses 50, *194*
lilies 51, 201
literary figures 60, 134, 217; *see also* Twain
litter 197
Lloyd, Susette 7–8, *9*, 20
loafing 162, 226
Louise, Princess 28–30
Ludwig, Daniel K. 192–3

MacCannell, Dean 224
Macdonald, Charles Blair 81–2, 85
McDonald's restaurant 233, 238–9
maps 202
marine archaeology 201–2
marine research 96
Maritime Museum 202
Marvell, Andrew 18, 112
Marx, Leo 18
Mathes, J.M. Inc. 165, 197, 199
May, Henry 10–11, 17
Mid-Ocean Club 85
military intelligence 148
military parade 63
military spending 77
Misick, Freddie 175
modernisation 206–7
Monarch of Bermuda 110, 112, 136, 155, 158, 160, 185
Moore, Tom 18, 24, 112
mopeds 164, 202, *203*, 234
Morgan's Island 146
Motor Car Act (1946) 123, 125, 157
Motor Car Bill (1908) 68
Mowbray, Louis 96
Mowbray, Territt 182, 187

Nash, Ogden 2
The National Geographic 170
naturalists 20, 21, 39
Nature's Fairyland 70, 89
Nelmes, Hamilton S. 51
neon signs 164, 199

New York Times 29–31, 53, 152, 200
The New Yorker 133

Ocean Monarch 160, *168*, 184, 185
oceanographers 20
off-shore business 213, 232
O'Neill, Eugene 73, 100
onions 25–6, 35, 53
Onions, Will 158, 174
O'Quinn, Bob 17
Osler, Featherstone 7, 8, 41
Outerbridge, Emilius 44
Outerbridge, Joe *163*, 226
Outerbridge, Mary 91

palaeontologists 18, 20
Pan American Airways: Atlantic 117, 120; and Bermuda 153; Boeing 707 188–9; flying boats 158, 159; posters *154*; shuttles 189; Trippe 114, 190; war 136
Passenger Ship Acts 110, 186
paternalism 156, 173, 228
Peck, Mary 58–60
Phillips, Gary 230
places of interest 157
plutocracy 216–17, 239
poetry 1–2
political parties 208
politicians, as visitors 216
politics and tourism 229, 230
Pomander Gate 126, 128
population vi–vii, 233
Porter, Katherine Anne 100
postcards 51
posters 112, *154*, *175*
President Roosevelt 137, 138
Princess Hotel *43*, 44, 191–2
Prohibited Restaurants Acts 239
Prohibition 94–6
protectionism 53–4
public relations 165–6

Quebec Steamship Company 45–8, 53, 64, 74
Queen of Bermuda 110, *111*, 112, 136, 155, 158, 160, *168*, 184

race 129–30, 208–9; *see also* anti-semitism
racial discrimination 205
racial segregation 98, 130, 171
radio 164
railway 97, *121*, 123–5, 157
Railway Trail 236
reconstruction, post-war 152–3
The Recorder 131
Rees, E.P. 128–9
restrictions in clientele 105, 128
Richards, Edward 205

roads, coral 48, 157

Saul, David 228
seaplane base 117, 146
Second Development Company Act (1920) 84
service mentality 231
sherry peppers 201
shipping contracts 136–7
shipping crisis 75, 160
shopping 215
signage 197, 199
Smith, Dinna 84–5
Smith, Hubert 2–3
social engineering 98, 197
Somers, Sir George 11–12
song (national) 2–3
Southampton Princess 193, *194*
souvenirs 51
sports 80, 91; *see also* golf; tennis; yachting
Spurling, Stanley 64, 66, 77, 83, 125, 209
St David's Island 145–8
St George 50, *210*, 211–12, 215
St George Club 231
St George's Hotel 86
steamships 36, 37, 44–5, *52*, 86; subsidies 86, 184–5
Strachey, William 12
strikes 214, 229–30
Strode, Hudson 94, 96, 221, 223
suffrage, universal 174, 207–8, 227

Taft, William Howard 73, 89, 97
Talbot Brothers 141, 169–70
Tapp, Henry 20, 22
taxis 159, *166*
television 233
The Tempest (Shakespeare) 12, 17, 18
tennis 91
Thurber, James 170, 176
timeshare beds 231
tipping 231
tourism 3–4, 10; aesthetics 5–6, 66, 98, 99–100, 122, 164–5, 167, 192; class 4–5, 31, 88, 109, 110, 175, 182, 183, 196; competition 39, 101, 113, 180–1, 200; as cultural mirage 224; as industry 106; volatility 184, 213–5; world economy 4, 182
tourism types: ecotourism 236; life-cycle 165–6; heritage 96–7, 164–5, 169, 201–2, 236; war 142, 148; winter 165, 204
tourist arrivals 182, 223; from America 99, 212; post-war 160, 183; strikes 229–30; Trade Development Board 73–5; war 76, 141
tourists 204, 224, 226; *see also* class
Trade Development Board: alcohol 94; booklet *Nature's Fairyland* 70, 89; control of tourism 5, 66, 97–8, 131–2, 164–5, 174; created 54; demise 228; outmoded 206–7, 209; revitalised 158; tourist arrivals 73–5
treasure 201–2
Treidler, Adolph 112, 146, 158, *168*
Trimingham, Kenneth 136–7, 153, 157
Trippe, Juan 113, 114, 116–17, 120, 122, 158, *188*, 190
trippers 107, 109
Trollope, Anthony 16, 23–4
Trott, Harley 42–3, 47
Trott, Howard 126, 129, 158, 175, 205
Truman, Harry 151
Tucker, Henry 208, 211–12
Tucker, Henry James 41–2
Tucker, Teddy 201
Tucker sisters 67, *69*, 100
Tucker's Town 50, 82–5, 159, 169, 202
Twain, Mark 26–8, 31, 36, 58, *59*, 60, *61*
Tweedy, Mary 167, 169

United Bermuda Party 208–9, 236
United States Line 137

vegetable exports 25–6, 35, 53–4, 145
Vesey, Henry 145, 157–8, 160, 171, 180, 184, 190, *196*, 197
Vesey, Captain Nathaniel 54
violence, racial 208–9
vouchers/credit cards 196

wages, two-tier 156, 173
Wales Advertising Agency 88–9
Waller, Edmund 18
war 73, 75, 136, 144, 151–2
war tourism 143, 148
Warner, Charles Dudley 27–8
Wetmore, Charles D. 81, 86
White, E.B. 105, 118
Whittingham, Ferdinand 13, *15*, 38
Williams, George A. 172
Williams, Jimmy *181*, 183, 186, 192, *196*, 204
Williams, R.J. 132, 134
Wilson, Woodrow 35, 56, 58–60, *61*
winter tourism 165, 204
Winter Water Carnival 96
Women's Work Exchange 51
Woolridge, C.V. 'Jim' *196*, 228–9, 230, 238
World Tourism Organization 182

yachting 91–2, 97, 201
yellow fever 13, 16, 22, 25

Zuill, William 167, 169